CO-AWJ-454

WOMEN AND WORK

An Annual Review

volume 1

Women and Work 1: An Annual Review

The new Sage series **Women and Work: An Annual Review** brings together research, critical analysis, and proposals for change in a dynamic and developing field—the world of women and work. Cutting across traditional academic boundaries, the series approaches subjects from a multidisciplinary perspective. Historians, anthropologists, economists, sociologists, managers, psychologists, educators, policymakers, and legal scholars share insights and findings—giving readers access to a scattered literature in a single comprehensive yearly volume.

Women and Work will examine differences among women—as well as differences between men and women—related to nationality, ethnicity, social class, and sexual preference. The series will explore demographic and legal trends, international and multinational comparisons, and theoretical and methodological developments.

WOMEN
AND WORK

An Annual Review

volume 1

EDITORS
Laurie Larwood
Ann H. Stromberg
Barbara A. Gutek

 SAGE PUBLICATIONS Beverly Hills London New Delhi

For information address:

SAGE Publications, Inc.
275 South Beverly Drive
Beverly Hills, California 90212

SAGE Publications India Pvt. Ltd.
M-32 Market
Greater Kailash I
New Delhi 110 048 India

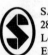

SAGE Publications Ltd
28 Banner Street
London EC1Y 8QE
England

Printed in the United States of America

International Standard Book Number 0-8039-2458-5

International Standard Series Number 0882-0910

FIRST PRINTING

CONTENTS

ACKNOWLEDGMENTS

We would like to gratefully acknowledge the assistance of the many individuals who have worked with us on this project, in particular our secretaries Teresa Hidalgo, Jacqueline Kurzeja, and Beverly Scales.

We also appreciate the assistance of the following ad hoc paper reviewers for this volume:

Robert A. Cooke

Susan Feigenbaum

Evelyn L. Lehrer

Denise M. Rousseau

Jeanne M. Stellman

Nina G. Stillman

Ronald Teeples

Rudi Volti

SERIES EDITORS' INTRODUCTION

This is the inaugural volume of an exciting series that brings together research, critical analysis, and proposals for change in a new and important field of inquiry: women and work. We hope that the series will serve as an incubator and a catalyst for future research in an area that is the focus of new scholarship cutting across established boundaries. This series is founded on the belief that those working within one academic discipline must acknowledge the importance of research being done in other disciplines on the same topic. Those studying new topics that have no one traditional disciplinary home (such, as the historial roots of patriarchal organizational hierarchies, unpaid work, nonlinear career pathing, and whistle blowing) often advance knowledge most when they intentionally cross traditionally distinct disciplinary boundaries. As the field of women and work matures, it will generate further subtopics, new theories and research techniques, and policy changes. We hope to contribute to these developments.

Purpose of the Series

Women and Work: An Annual Review has three major purposes: to spotlight women and work as an important and intriguing social reality and area of research; to provide a multidisciplinary emphasis; and to contribute to the development of this field of scholarly endeavor.

The importance of women and work. A series dedicated to examining women's work experiences reflects common experience—and common sense. More than half of all working-age women in the United States are now working outside their homes. Women outnumber men in colleges across the country and are beginning to make strong inroads in training in such nontraditional areas as management, medicine, and the military. Increasingly women are staying in the labor force throughout their life cycle. At the same time, some features of women's work—lower wages, concentration in relatively few female-dominated

9

occupations, and dual responsibilities for home and employment roles—continue to persist from one generation to another. Similar changes and trends are occurring throughout the industrially developed world.

The greater involvement of women in the paid labor force will inevitably affect organizations, policies, and work patterns, just as new employment experiences and policies will affect women. As researchers, we cannot close our eyes to such important social change. We must record it, study it, and, when appropriate, recommend changes in policy required by it.

There are other important reasons for focusing on women *and* work together. Until recently much social science research on women ignored women's paid work and failed even to recognize women's unpaid labors as being work. At the same time, research on work tended to focus on the employment experiences of men, with investigators sometimes making unfounded extrapolations to women. Neither of these traditions provided much understanding of the complex reality of women's paid and unpaid labors. Such neglect of women's work, of course, also meant that certain topics (for example, gender differentials in earnings, day care, sexual harassment in the work place, the effects of toxic work environments on fetal development, the consequences of intermittent labor force attachment for long-term career potential, and unpaid work) were not considered to be subjects for serious investigation. Additional topics will emerge as women *and* work becomes a primary research interest for increasing numbers of academics and professionals.

Multidisciplinary emphasis. Academia divides the world into disciplines, each with its own assumptions, theories, and methods. Its practitioners sometimes feel a little smug, believing that their approach to a topic is the best one; some are even unaware of the research done in other disciplines on the same topic. Others believe that it is important to work with scholars from other disciplines on topics of common interest and concern, but for various reasons they find such projects difficult to develop or, if successful, hard to publish in the literature of the individual disciplines.

Women and work is a multidisciplinary topic of research, pursued by historians, anthropologists, economists, sociologists, psychologists, and management, educational, policy, and legal researchers, among others. We have created this series partly in recognition of the need for a

forum that brings together these many facets of the field and partly in response to our own problems in keeping up with a fragmented literature spread throughout many diverse publications.

There are both advantages and disadvantages to a multidisciplinary series. *Women and Work* will present key ideas from one discipline to those working on the same topic in other disciplines. These ideas can then be used, tested, and expanded upon. Nonetheless, articles written from one perspective may seem simplistic or incomplete to those in other disciplines. Equally problematic, ideas may seem interesting and novel outside their home discipline when they are already passé within it. We are convinced, however, that the benefits of a multidisciplinary series far outweigh the risks.

Developing the field of women and work. We hope to do more than simply present collections of articles on the common theme of women and work. Our goal is to develop a forum in which our contributors may inform and stimulate one another and in time contribute to the further growth of this field. As research on various subtopics moves from observation to theory, from theory to testing, and from testing to more refined understandings, we also hope to contribute to the development of new theoretical perspectives.

Some of these developments will result from more investigation of previously neglected aspects of women's work. We wish to encourage, for example, research on women's work experiences in *all* industries and occupations and among those who are self-employed as well as those who work as employees in organizations. Such studies will complement the relatively greater amount of information we have on highly trained professional and managerial women, although much remains to be learned about these groups as well. Theory-building may also be advanced by more cross-cultural research. It is crucial to recognize both the differences among women and the differences between women and men. Nationality, race, ethnicity, social class, and sexual identity are among the variables that we encourage authors to bring into the discussion. In addition, it is important that attention be turned to unpaid as well as paid work, to work in the home and in voluntary organizations as well as in the labor force.

We believe that our multidisciplinary approach will encourage these developments by helping us avoid overspecialization. We welcome

readers' ideas about other ways in which we can make this series one that will truly contribute to the development of women and work.

Types of Chapters to Be Included

The major types of chapters that will be considered for inclusion in *Women and Work* are briefly described below. Although not all of these categories could be represented in the first volume, we hope that they will be in the future.

Reviews of research. This series will publish reviews that integrate and interpret current findings on selected topics. Although each author will handle reviews somewhat differently, all will, we hope, go well beyond the usual treatment. At their best, research reviews should summarize and synthesize the material on a topic, exposing the central thrusts of work in the area to researchers in other disciplines. They should be current in both theory and data, and thought-provoking in the ideas they provide for further research or practical policy.

Trend updates. We would like to publish a number of original analyses of ongoing social, demographic, and legal trends. In addition to examining the trends themselves, the analyses should suggest some of the policy and social implications of those trends.

Research series or series conclusions. In some cases, a researcher has performed a series of related examinations centered on a comon topic of concern to multiple disciplines. *Women and Work* will publish such a series as a unit if the studies are complete, if the topic is of widespread interest to a multidisciplinary audience, and if space permits. Alternatively, we will publish summaries of series contributed by the researcher when the work is concluded.

International and multicultural comparisons. Some researchers have access to data or published sources that allow important cross-group comparisons. These will be especially welcome when the experiences of the comparison groups allow the analyst to offer important insights into the impact of group characteristics on women's work experiences.

New theories and techniques. In a search for sharply focused research, many journals discard the unusual piece that deviates from traditional approaches. We would like *Women and Work* to become the publisher of choice for such unusual work. We especially encourage risk-taking when it is backed by a review that indicates why the new theory or technique is needed and how it will help us to learn more about women and work.

Case studies. One little-used technique of inquiry in the field of women and work is the case study. Although cases can seldom provide an exhaustive analysis of a topic, they allow us to gain knowledge about topics on which there has been little prior observation, help us to conceptualize these problems, and inspire further research. We will encourage and publish significant case studies when they are available.

Symposia. Each volume will contain several articles that focus on the same topic. In some cases, contributors from different disciplines will present articles that demonstrate the particular contributions their disciplines make to knowledge about the topic. In other cases, contributors will come from the same discipline but will differ in their methodological approaches or theoretical orientations. We hope that authors will sometimes disagree strongly with one another. Future volumes of *Women and Work* may dedicate one-third to one-half of the chapters to the symposium, and we will consider the possibility of working with guest symposia editors.

What will not be published. Single empirical studies or narrowly based reviews are usually more suitable for existing disciplinary journals. Similarly, research that replicates prior work or updates prior reviews without adding to the field conceptually should be submitted to the journal that published the original work.

Information for Contributors

Articles published in the first two volumes of *Women and Work* have been invited. We encourage inquiries about publication in all subsequent volumes. Interested authors should send the editors a letter of intent that describes the proposed chapter and its significance. Prospective contributors should *not* send completed manuscripts until requested to do so. All chapters must be scholarly, original, and written expressly for *Women and Work*. The completed chapter must be suitable for an academic audience beyond the confines of a single discipline and should be accessible to advanced students as well as to established scholars. We will supply further editorial guidelines for those chosen as authors.

INTRODUCTION TO VOLUME I

Before deciding on the contents of Volume I, we surveyed the members of our Editorial Board, who had been invited to join us in this venture because of their high professional standing and commitment

and contributions to the study of women and work. We asked them what essential topics we should review in the inaugural issue, topics that might help to set the stage for subsequent contributions. We also queried them about who in their respective discipline was doing important research or developing new ideas that would stimulate others. We then had to make difficult choices among the many excellent suggestions that we received.

At least two outside referees have reviewed each of the resulting chapters. One referee came from the author's discipline whereas the second was from another field, a procedure that we hoped would contribute to the multidisciplinary perspective of the series. Sometimes the referees disagreed with one another because of different training, their different evaluations of authors' risk-taking attempts to move between traditional disciplines, or because they simply had different opinions about a chapter. In all cases, however, the referees' comments were stimulating and helpful to the contributors and to us.

The chapters included in Volume I represent several of the types of contributions (mentioned above) that we hope to present in the series over the next few years. Several are comprehensive reviews of key areas of research on women and work. We commend the authors of these reviews for their special efforts to obtain the most up-to-date information available. In one case, for instance, the contributors relied on 1980 census data that were not generally available at the time the topic was negotiated.

Three chapters form a symposium titled "Current Views of Earnings Differentials." The authors were asked to approach the topic from different perspectives and to marshal data reflecting those points of view. The result is a lively group of discussions that demonstrate how different explanatory frameworks may be applied to the same topic.

One chapter in this volume resulted from our asking the author to develop provocative theoretical ideas she had put forth at a conference, and the result is a well-framed argument that introduces research not generally brought to bear on the study of women and work. Another chapter is a case study that, to the best of our knowledge, is the first such case analysis of the topic; we hope that its presentation will encourage further use of this rather infrequently employed analytic vehicle. Several of the chapters collected at the end of the volume are concerned with major policy issues. They too should lead the way to further discussions of important policy issues regarding women and work.

OVERVIEW OF VOLUME I

In the introductory chapter economists Francine Blau and Marianne Ferber assess the extent to which economic equality, one of the main goals of the new wave of feminism, has been approached over the last 20 years in the United States. They identify both persistent patterns and striking changes as they carefully examine trends in labor force participation, labor force attachment, occupational segregation, and earnings differentials between men and women, as well as the allocation of time between household and market work. This comprehensive retrospective view of women's labor force experience also stimulates thinking about the future, which the authors view with guarded optimism. Blau and Ferber provide an excellent springboard to this volume and the entire series.

The first of three chapters in the symposium on Current Views of Earnings Differentials is "Role Differentiation and the Gender Gap in Wage Rates" by June O'Neill. The author was asked to review and analyze the human capital view of earnings differentials—one of two overall theories developed by economists to explain this phenomenon. O'Neill sees the earnings differentials of men and women as largely related to their role differentiation—the extent to which women and men prepare themselves for differential life patterns in the family and in work outside the home. She notes, for instance, that until recently few women expected to continue working outside their homes for long periods of time. Thus it was rational for them to invest relatively little in terms of training and to enter jobs that did not require progressive career development. She notes that employers who ignore human capital expose themselves to higher costs and lower profits.

Our second symposium chapter, "The persistence of pay differentials: The economics of sex discrimination," by Janice Fanning Madden is focused on the work done by economists concerning views that earnings differentials reflect discrimination—the major alternative in economic theory to the human capital view. The first part of her chapter describes the techniques most commonly used to determine whether pay differences are discriminatory. This section also summarizes the results of an extensive series of articles studying the ratios of women's to men's earnings. In a later section, Madden examines three different approaches explaining the maintenance of discriminatory pay differentials between women and men. A brief final segment of this chapter relates to

policy; in it Madden summarizes the findings reported earlier and suggests that their interpretation and solution necessarily depend partly on the point of view of the observer.

James E. Rosenbaum has contributed the third chapter for the symposium in this volume. His chapter, "Persistence and change in pay inequalities between men and women: Implications for job evaluation and comparable worth," reports the results of a longitudinal study of the pay practices of a single large organization over the period of 1962 to 1975. He is able to document the differences in the positions of men and women in the organization throughout this period—and to show that the changes in their positions correlated with (but were not necessarily caused by) the organization's strong affirmative action program. Whereas the starting pay of young women appears to have moved close to the starting pay of men, the pay of experienced women was less likely to be improved. Similarly, some jobs were integrated by sex, whereas many were not. Rosenbaum finishes this thorough analysis with the conclusions that the impact of affirmative action is not evenly distributed and that job evaluation may legitimize traditional values rather than objectively overcoming them.

In her chapter historian Alice Kessler-Harris reflects upon reasons for the relatively disadvantaged status that women continue to have in the U.S. labor force. She traces the evolution of two feminist traditions—"humanist" feminism, which emphasizes the similarities of women and men, and "gynocentric" feminism, which accepts women's differences from men—and indicates the strategies for change that each of these views has inspired in the nineteenth and twentieth centuries. In recent decades neohumanist feminism has been the dominant influence in strategies to improve women's labor market position. Kessler-Harris advances the thought-provoking argument that policies that accept women as different might more rapidly speed movement toward gender equality in the marketplace.

In her chapter, "Work and family linkages," Veronica Nieva notes that the employment of women has substantially altered, but not completely changed, the relationship of women to their families. Rather than shifting from one set of roles (mother and wife) to another (work outside the family), women have added the latter role to the former. Whereas early research focused on the disadvantage to the family of this behavior, more recent research has found both advantages and disadvantages to holding these multiple roles. Nieva reviews the literature relating work and family life for women and men and concludes with suggestions for future development in this area, including research into

the interrelationship of work and the single parent role, and considera-
tion of the possibilities for maintaining career commitment while
planning interruption of careers by family life.

Sociologist Jerry Jacobs's contribution examines trends in sex segre-
gation in fields of study for recipients of associate, bachelor's, master's,
professional, and doctoral degrees between 1948 and 1980. The study
focuses on the timing and direction of change as well as the degree of sex
segregation at the various levels of higher education. It also considers
the extent to which students have members of their own and the other
sex as colleagues in their specialties. Some of Jacobs's findings are what
we might expect (for example, the decline in sex-segregation by specialty
among recipients of most types of degrees), but some are surprising (for
example, the asymmetry in the likelihood of men's and women's having
same- and other-sex colleagues).

William Kahn and Faye Crosby, in their chapter, "Change and stasis:
Discriminating between attitudes and discriminating behaviors," exam-
ine the substantial discrepancy between the considerable improvement
in surveyed attitudes toward working women and the stubborn discrimi-
nation still found in the work place. Most attitude theorists assume a
close link between attitudes and behavior, yet such a link is becoming
more difficult to find concerning women and work. Kahn and Crosby
suggest three theoretical models that may be used to explain the discrep-
ant findings and offer the conclusion that we are in a period of transition
requiring behaviors to catch up with attitudes.

The chapter by Caroline Dexter, "Women and the exercise of power
in organizations: From ascribed to achieved status," develops the theory
that women's training in and identification with the roles ascribed to
them are counterproductive to potential success in most organiza-
tions—that ascribed status from family roles does not lead to achieved
status in organizations and may conflict with it. The chapter further
shows that the problem of achieving status depends in part on the
assumed reaction of third parties to a decision potentially giving a
woman achieved power and on the nature of the organization and its
society.

Donna Randall's chapter is concerned with a controversial corporate
practice, the exclusion of fertile women from toxic work environments.
In a case study she examines the Bunker Hill Company's practice of
excluding fertile female employees from working with high levels of
lead. The particular case leads to a broader discussion of relevant federal
policies, the role of regulatory agencies, and recent court decisions
regarding such practices. Randall raises a number of related medical,

economic, social, technological, legal, and political issues that will continue to compel the attention of workers, unions, employers, and federal policymakers.

Sharon Harlan's chapter is a critical review of the impact of federal job training policy on economically disadvantaged women. The author examines policies and practices that influence enrollment in job training; women's and men's differential involvement in on-the-job training and classroom programs; and the ways in which these programs reflect and perpetuate established patterns of occupational sex segregation. Throughout her analysis Harlan demonstrates how both national policy priorities and local program control influence the experience of eligible women. She underscores notable differences between the 1982 Job Training Program Act (JTPA) and its predecessor, the Comprehensive Employment and Training Act (CETA)—differences that may make the current program less favorable for women.

> —*Laurie Larwood*
> *Ann H. Stromberg*
> *Barbara A. Gutek*

1

Women in the Labor Market

THE LAST TWENTY YEARS

FRANCINE D. BLAU
MARIANNE A. FERBER

This chapter presents an overview of the most important developments in the economic status of women in the United States over the last 20 years. Information is provided on labor force participation, the division of household tasks, occupational distribution, and the male-female earnings gap. The main emphasis is on presentation of facts, but they are also briefly discussed in the light of existing knowledge of economics and evaluated in terms of the goal of achieving equality. In the concluding section we offer some speculation about how women are likely to fare in the economy in the future.

It has now been about 20 years since the publication of Betty Friedan's *Feminine Mystique* and the passage of the Equal Pay and Civil Rights Acts, banning discrimination against women in the labor market. These events are generally viewed as marking the beginning of the present wave of feminism. One of the main goals of this movement has been the achievement of economic equality for women. The time seems right for summing up what has happened over these two decades, in what respects and to what extent there has been progress, and in what respects there has been a failure to move ahead. Such an evaluation is not only of interest in illuminating the past and the present, but should also be helpful in charting a future course for those who would have us continue down the road on which we have started.

A number of steps on the road toward economic equality between the sexes may be identified. The first is economic independence, and for this, labor force participation is a prerequisite. This is necessary, but of course not sufficient. If women are to achieve economic equality with

AUTHORS' NOTE: Portions of this chapter draw upon our forthcoming book, *The Economics of Women, Men, and Work* (Englewood Cliffs, NJ, Prentice-Hall, 1986). We are grateful to the publisher for giving us permission to reproduce some of that material here.

19

men they must either do the same type of work men do or the earnings in women's jobs must be comparable to those in men's jobs. The outcomes that women attain in the labor market in turn depend upon both their qualifications for work (the supply side) and the rewards they are able to obtain for those qualifications (the demand side). One of the most important determinants of women's qualifications for paid work is the degree of their labor market attachment. Both labor force participation and attachment are in turn closely intertwined with the roles of women and men in the household. As long as women have household responsibilities and men only help out, as long as women, even those who are employed, spend a disproportionately large amount of time on homemaking, they will be at a disadvantage in preparing for, obtaining, and moving upward in labor market jobs.

We shall, therefore, examine labor force participation, labor force attachment, and the allocation of time of men and women between the household and the labor market. We shall then go on to consider occupational segregation, and finally briefly review recent developments with respect to the earnings gap between men and women.

LABOR FORCE PARTICIPATION

To be included in the labor force, a person must be employed for pay or other monetary reward for at least one hour per week, work as an unpaid family worker for at least fifteen hours a week, or, if not working, must be actively looking for a job. Based on this definition, Table 1.1 presents data for the years since 1963 by sex and by race.[1] They show that participation rates for women have been increasing throughout the period, while those for men have been declining. It can also be seen that participation rates for white women have increased more rapidly than for black and other women, so that they are now almost equal. Those for black and other men have declined more rapidly than for white men, so that they are now considerably lower. This means that nonwhite participation rates have been declining relative to those of whites and that the decline for one gender cannot be explained by a relative increase for the other. It is not clear why this is the case. One possible explanation is that the increasingly high unemployment rate for blacks as compared to whites has caused relatively more of them to become discouraged and to drop out of the labor force.

The main reasons for the decline in male labor force participation are that young men are spending more years in school and older men are retiring earlier. Because this is true for women as well, labor force

TABLE 1.1
Labor Force Participation Rates by Sex and Race
for Those Age 16 and Over, 1963-1983

			Men		Women	
	Men	*Women*	*White*	*Black and Other*	*White*	*Black and Other*
1963	81.4	38.3	81.5	80.2	37.2	48.1
1964	81.0	38.7	81.1	80.0	37.5	48.5
1965	80.7	39.3	80.8	79.6	38.1	48.6
1966	80.4	40.3	80.6	79.0	39.2	49.3
1967	80.4	41.1	80.7	78.5	40.1	49.5
1968	80.1	41.6	80.4	77.6	40.7	49.3
1969	79.8	42.7	80.2	76.9	41.8	49.8
1970	79.7	43.3	80.0	76.5	42.6	49.5
1971	79.1	43.3	79.6	74.9	42.6	49.2
1972	79.0	43.9	79.6	73.7	43.2	48.7
1973	78.8	44.7	79.5	73.8	44.1	49.1
1974	78.7	45.6	79.4	73.3	45.2	49.1
1975	77.9	46.3	78.7	71.5	45.9	49.2
1976	77.5	47.3	78.4	70.7	46.9	50.2
1977	77.7	48.4	78.5	71.6	48.0	51.1
1978	77.9	50.0	78.6	72.5	49.5	53.3
1979	77.8	50.9	78.6	72.1	50.5	53.7
1980	77.4	51.5	78.2	70.6	51.2	53.2
1981	77.0	52.1	77.9	70.0	51.9	53.5
1982	76.6	52.6	77.4	70.1	52.4	53.7
1983	76.4	52.9	77.1	70.6	52.7	54.2

SOURCES: 1963-1976 data from U.S. Department of Labor, Bureau of Labor Statistics, *U.S. Working Women: A Databook* (1977); 1977-1982 data from U.S. Department of Commerce, Bureau of the Census, *Statistical Abstract* (various years); 1983 data from U.S. Department of Labor, Bureau of Labor Statistics, *Employment and Earnings* (January 1984).

participation must have risen very sharply for them between the time they leave school and reach retirement age. Table 1.2 shows just that. The proportion working for pay actually declined very slightly for women above 65 years of age, and went up relatively modestly for those between 55 and 64. The most striking change has been for women between 25 and 44, and particularly those in the 25- to 34-year-old age group.

Because it is these middle years that encompass the period of child rearing, a concomitant development is that there is now a very high labor force participation of women with children, including rather substantial participation by those with youngsters under 3 years old.

TABLE 1.2
Labor Force Participation of Women by Age
(selected years 1960-1983)

	1960	1970	1976	1983
16 and 17	29.1	34.9	40.7	39.9
18 and 19	50.9	53.6	59.0	60.7
20 to 24	46.1	57.7	65.0	69.9
25 to 34	36.0	45.0	57.1	69.0
35 to 44	43.4	51.1	57.8	68.7
45 to 54	49.8	54.4	55.0	61.9
55 to 64	37.2	43.0	41.1	41.5
65 and over	10.8	9.7	8.2	7.8
Total 16 years and over	37.7	43.3	47.3	52.9

SOURCES: 1960-1976 data from U.S. Department of Labor, Bureau of Labor Statistics, *U.S. Working Women: A Databook* (1977); 1983 data from U.S. Department of Labor, Bureau of Labor Statistics, *Employment and Earnings* (January 1984).

Information on the extent to which women with varying marital and parental status are in the labor market is provided in Table 1.3.

Some of the data in Table 1.3 seem surprising at first glance and hence require some explanation. The reason that the participation rate tends to be relatively low for women with no children at home is that this group contains a disproportionate number of older women of retirement age. The reason the participation rate is considerably lower for "never married" than for "divorced" is that many of the former are very young and still in school. The reason that the rate for widows is very low is because many of them are of retirement age. Obviously this is far less true for widows with children under age 18, and they are, accordingly, far more likely to be in the labor force. The remainder of the patterns are about as would be expected. With respect to marital status, participation rates are lower for wives with husbands present than for any other group except widows and are highest for divorced women. As for parental status, mothers of young children, especially under 3 years old, have lower participation rates than other groups. Nonetheless, both those women who are married with spouse present and those with small children present were considerably more likely to be in the labor market in 1981 than in the mid-1960s.

Although, as we have seen, family status continues to have a strong association with women's labor force participation, so do a number of other factors. As is shown in Table 1.4, there is a strong positive relationship between the number of years of schooling a woman has and the likelihood that she will be in the labor force. This is as would be

TABLE 1.3
Labor Force Participation Rates of Women by Family Status
and Age of Children, 1981 and 1966

Marital Status	Total	No Children Under 18	Children 6-17 Only	Children 3-5	Children Under 3
1981					
Never married	62.3	62.9	64.6	54.7	41.0
Married, husband present	51.0	46.3	62.5	54.8	43.7
Other ever married	45.1	36.1	76.5	62.8	51.6
Married, husband absent	60.8	59.9	70.0	53.9	48.7
divorced	75.0	72.4	83.4	69.9	58.1
widowed	22.3	19.9	63.0	n.a.	n.a.
1966					
Never married	40.8	n.a.	n.a.	n.a.	n.a.
Married, husband present	35.4	38.4	43.7	29.1	21.2
Other ever married	39.5	34.7	65.9	57.5	38.6

SOURCE: U.S. Department of Labor, Bureau of Labor Statistics, *Special Labor Force Report No. 2163*, and *Special Labor Force Report No. 80*.
NOTES: Data are for March of each year and include women 16 years of age and over in 1981 and 14 years of age and over in 1966. n.a. = Not available.

expected, as more education tends to open opportunities for obtaining not only better pay, but more interesting jobs with greater possibilities for upward mobility. Table 1.4 also shows that, for given amounts of education, women are more likely to be in the labor force in the early 1980s than in the mid-1960s. Only the extraordinarily low (and decreasing) labor force participation rate of women with less than eight years of schooling deserves comment. Women in this country who have not completed grade school are likely to be very elderly, and hence many of them would be of retirement age. This was even more true in 1982 than it was in 1964.

So far we have only discussed labor force participation, making no distinction between those who work part-time, less than 35 hours a week, and those who work full-time. For adult men this is not much of an issue. The proportion of men 20-years-old and older who worked less than full-time was only one in twenty even during the recession of the early 1980s when more than one-third of these men worked part-time involuntarily. Among adult women, on the other hand, one out of five

TABLE 1.4

Labor Force Participation of Women by Years of Schooling

| Years of Schooling Completed | Percentage of Women in the Labor Force | |
	1964	1982
8 years or less	28.0	22.4
High School		
1-3 years	38.3	40.6
4 years	44.6	57.6
College		
1-3 years	42.2	65.1
4 years	53.0	70.2
5 years or more	72.1	79.2

SOURCE: For 16 years and over (1982), U.S. Department of Commerce, Bureau of the Census Current Population Reports, Consumer Income Series P-60, No. 142, *Money Income of Households, Families, and Persons in the United States: 1982.* For 18 years and over (1964), U.S. Department of Labor, Bureau of Labor Statistics, *Special Labor Force Report No. 53,* 1964.

had been working part-time, about four-fifths of them by choice. Further, those who work full-time at some point during the year do not necessarily work year round, defined as at least 50 weeks.

Hence, although women are working for pay in increasingly larger numbers, their labor force commitment is still often less than complete. Just as labor force participation itself is strongly related to level of education, so is the proportion of women in the labor market who work full-time year-round, comprising a mere 8.8 percent of women with only grade school, but reaching 49.5 percent for college graduates with at least some additional schooling.

Summarizing the most salient facts, we found that women's labor force participation, especially that of white women, has been steadily increasing, whereas that of men, especially nonwhite men, has been declining. We saw furthermore that the rate of increase has been greatest for women in the middle years and that, although it is highest for divorced women, it is now quite substantial even for mothers of very young children in intact families. Last, we observed that it is particularly more highly educated women who are in the labor force, and they are also most likely to work full-time year-round.

TRENDS IN LABOR FORCE ATTACHMENT

The changes in the pattern of women's labor force participation by age that have occurred since 1940 suggest that rising female participation

TABLE 1.5
Labor Force Turnover of Men and Women
(selected years, 1957-1981)

Year	Males			Females		
	Labor Force Participation Rate[a]	Labor Force Experience Rate[b]	Labor Force Turnover Rate[c]	Labor Force Participation Rate[a]	Labor Force Experience Rate[b]	Labor Force Turnover Rate[c]
1962	78.4	85.1	108.5	36.6	48.7	132.9
1967	80.4	86.7	107.8	41.1	53.1	129.2
1972	79.0	86.7	108.5	43.9	54.3	123.9
1977	77.7	83.4	107.4	48.4	58.2	120.1
1981	77.0	81.2	105.5	52.1	59.4	114.0

SOURCES: 1962-1977 data are from Cynthia B. Lloyd and Beth T. Niemi, *The Economics of Sex Differentials* (New York: Columbia University Press, © 1979, Table 2.6, p. 7). Reprinted by permission of the publisher. 1981 data are from U.S. Department of Labor, *Employment and Training Report of the President* (1982, Table A-5, p. 155) and Sylvia L. Terry, "Work Experience, Earnings and Family Income in 1981," *Monthly Labor Review* 106 (4), April 1983, Table 4, p. 17 and p. 19.

NOTE: Refers to civilian labor force.

a. The labor force participation rate is the proportion of individuals in the labor force during the survey reference week (annual averages).
b. The labor force experience rate is the proportion of individuals in the labor force at some time during the year.
c. The labor force turnover rate is equal to the labor force experience rate divided by the labor force participation rate.

rates have been associated with an increase in the labor force attachment of women over the life cycle. That is, women are tending to remain in the labor force more consistently over a period of time.

Some indication of women's increasing labor force attachment is provided in Table 1.5. This shows the labor force partipation rate, which, it may be recalled, is the proportion of women who are in the labor force at a particular point in time (the week preceding the survey). It also shows the labor force experience rate, which is the proportion of women who are in the labor force at some time during the year. If the same group of women are in the labor force consistently over the year, the labor force participation rate would exactly equal the labor force experience rate and there would be no turnover of the labor force group.[2] Alternatively, if women tend to move into and out of the labor force over the year, the labor force experience rate would exceed the labor force participation rate. In this case, the group of labor force participants would include some different individuals at different points in time (that is, there would be turnover in the labor force group). The labor force turnover rate is equal to the labor force experience rate divided by the labor force participation rate. It is an indicator of labor force attachment and tells us the extent to which the composition of the labor force group turns over or changes during the year.

As may be seen in Table 1.5, the labor force turnover rate of women has declined since 1962, indicating that women are becoming more firmly attached to the labor market. Although the rate is still higher than that of men, the gender differential has also fallen considerably. A further indication of women's increasing labor force attachment is that the percentage of women who were full-time, year-round workers has been increasing steadily over the past 20 years. Currently, 45 percent of women hold such jobs in comparison to 65 percent of men.

This growing labor force attachment of women has contributed to the increase in their labor force participation rate. The labor force group is increased by flows of entrants into the labor force and decreased by flows of exits from the labor force. To the extent that the number of entrants exceeds the number of exits, the relative size of the labor force is increased. Thus both *increases* in flows of *entrants* and *decreases* in flows of *exits* may contribute to the growth of the female labor force. The data in Table 1.5 suggest that both factors have in fact played a role in raising women's participation rates.[3]

Work experience is an important determinant of labor market earnings. The lesser amount of work experience accrued over time by women relative to men has traditionally been cited as an important reason for their lower earnings. It is not clear whether recent increases in

women's labor force participation have been associated with increases or decreases in women's *average* amount of work experience. This is because two changes are going on here, which would tend to have opposite effects. On the one hand, the growing number of new entrants, who have little work experience, has a negative effect on women's work experience. On the other hand, the growing tendency for women to remain in the labor force for longer periods of time has a positive effect.

Unfortunately, the usual published statistics on labor force participation do not help to answer the question of what the net effect of increased labor force participation on women's experience has been. Estimates have been made, however, using longitudinal data as well as various indirect information. The evidence suggests that before the late 1960s, rising female labor force participation rates were associated with constant or slowly increasing average levels of work experience among women workers. In recent years, notable gains in experience have occurred, particularly among younger women (Goldin, 1983; O'Neill, 1985; Smith & Ward, 1985).

For the female population as a whole, rising labor force participation rates have unambiguously worked to increase the average number of years women tend to spend in the labor force over their lifetime. The Bureau of Labor Statistics estimates that, in 1940, a 20-year-old woman had an expected work life of about 12 years. This was 30 percent of the estimated male work-life expectancy of about 40 years. In 1977, the most recent year for which this information is available, the estimated work-life expectancy of a 20-year-old woman had risen to 26 years or 71 percent of the male figure of 37 years (U.S. Department of Labor, 1982).

The continued shortfall of women as compared to men in labor market experience is undoubtedly closely related to women's continued primary role in the household in most American families. Hence, before going on to examine how women fare in their paid work we shall provide evidence about the amounts of housework done by women and men.

PARTICIPATION IN HOUSEWORK

As we have seen in the previous section, women's labor force participation has been rising rapidly over the last two decades. This is particularly true of married women with husbands present. Less than one-third of this group was employed in the early 1960s, but more than one-half were working for pay 20 years later. We now turn to the question of whether during the rapid influx of wives into the work force there have been corresponding changes in the husbands' participation in housework.

Regrettably, data on the allocation of work in the household are relatively sparse. Further, because of differences in the nature of the samples used,[4] in the methods employed to obtain the information,[5] and in the definition of work,[6] such information as we have is at times inconsistent and must be interpreted with considerable caution. Nonetheless, the available evidence is useful in shedding some light on the trends in the allocation of time of employed and nonemployed women as well as their husbands. Table 1.6 shows the lowest and highest estimates from a number of the most widely cited surveys done between 1965-1966 and 1975-1976.

Nonemployed wives tended to work fewer hours than any of the other groups—especially so in the 1970s when the amount of housework they did had considerably decreased—while, by definition, they continued to do very little market work.[7] Employed wives who worked longer hours than anyone else in the 1960s also cut back on housework, so that during the latter period they worked virtually the same number of hours as men, even though they increased the amount of time they worked for pay. Husbands of nonemployed wives spent the most time in the labor market—somewhat more than husbands of employed women—though their time in the labor market in turn exceeded that of their wives. Both groups of husbands spent about the same rather small amount of time on housework during both periods.[8]

More recent evidence suggests that the differences in allocation of time between married men and married women is beginning to narrow significantly. A study that compares data from 1975-1976 and 1981-1982 surveys found that men's market work declined by somewhat more than one hour per week, and work in the home increased by about the same amount. During the same period women's work in the market rose by about 1½ hours per week, and time spent on housework went down by the same amount. Further, the changes were considerably larger for the younger group (25 to 44 years of age). These men worked one hour less per week in the market and three hours more at home; the women worked 3½ hours more per week in the market, and one hour less at home (Juster, 1984b).[9]

All such data, however, tend to underestimate the problems of many employed wives because they only represent averages. First, about one out of four employed women works part-time, the other three full-time. The former are likely to face a smaller and less attractive choice of jobs, lower earnings, less fringe benefits, and fewer opportunities for promotion. The latter probably face a considerably higher work overload. Second, the sample includes women with and without young children. The former face a far heavier burden; they are also likely to be

TABLE 1.6
Range of Estimates of Time Use Data on Housework and Market Work
(hours per day)

	Wives				Husbands			
	Nonemployed		Employed		Nonemployed Wives		Employed Wives	
	1960s	1970s	1960s	1970s	1960s	1970s	1960s	1970s
Housework	7.6-8.0	4.6-6.8	4.0- 5.3	2.3-4.0	1.0-1.6	0.6-1.8	1.1-1.6	0.6-1.9
Market work	0.0-0.6	0.1-1.9	4.8- 5.3	5.0-6.5	7.5-7.8	7.0-7.7	6.3-6.9	6.9-7.1
Total work	7.6-8.6	6.5-6.8	9.3-10.1	7.9-9.3	8.4-8.5	8.3-8.9	7.9-8.0	7.7-8.8

SOURCES: Martin Meissner, Elizabeth W. Humphreys, Scott W. Meris, and William J. Scheu, "No Exit for Wives: Sexual Division of Labour and the Cumulation of Household Demands," *Canadian Review of Sociology and Anthropology, 12 (4),* 1975, pp. 424-439. Joseph Pleck, "Husbands' Paid Work and Family Roles: Current Research Issues," *Research in the Interweave of Social Roles: Jobs and Families, 3,* 1983, pp. 251-333. John P. Robinson, *Changes in America's Use of Time* (Cleveland: Communications Research Center, Cleveland State University, 1977). Kathryn E. Walker and Margaret E. Woods, *Time Use: A Measure of Household Production of Family Goods and Services* (Washington, DC: American Home Economics Association, 1976).

at the age when workers need to prove themselves on the job and to begin to show that they are worthy of promotion if they are to make much progress. It must be relatively cold comfort to them to know that they will have more leisure at a later stage of the life cycle. Last, the distribution of housework by type of task and time of day may still be unfavorable to women (Berk & Berk, 1977).

It has been pointed out that many tasks women perform are no longer as physically exacting as those their grandmothers faced. In addition, such activities as shopping and, to a considerable extent, child care may be enjoyable enough to be regarded as quasi-leisure (Cain, 1984). But much of paid work has also become less onerous, and such time on the job as chatting with fellow workers and entertaining clients is as much quasi-leisure as any family work. In fact, a recent study indicates that, on the whole, people enjoy child care more than any other activities included in a comprehensive list, but enjoy their jobs far more than any other type of housework and considerably more than many leisure activities (Juster, 1984a).

In summary, the most recent evidence suggests that women are continuing to spend increasing amounts of time on paid work and that men are now finally increasing their participation in housework. Thus the proportion of time spent on the two different types of work has been moving more rapidly toward equality for the sexes during the last five years than during the preceding decades. Even though the ultimate locus of responsibility for household work most likely continues to rest with women, and they are accordingly the ones who are expected to give family needs priority over market work when unexpected problems and small emergencies come up, the more egalitarian distribution of unpaid work would be likely to affect occupational choices and earnings.[10] These topics will be discussed next.

OCCUPATIONAL DISTRIBUTION

As we have seen, the differential in labor force participation of men and women has narrowed very considerably. Whereas in 1963 the rate for women was only 47.1 percent as high as that of men, it was 68.9 percent by 1983. We have also seen that women who are in the labor market spend considerably less time on housework than do full-time homemakers, but continue to do far more than do men. We now turn to the question of the extent to which employed women continue to do work in the labor market that differs from that done by men.

It is not possible to obtain a precise answer to this question because fully adequate descriptions of the work people do are not generally

TABLE 1.7
Women as Percentage of the Employed Civilian Labor Force
by Occupation (selected years 1960-1982)

	1960	*1970*	*1982*
White Collar			
Professional and technical workers	36.2	38.6	45.1
Managers and officials	15.6	15.9	28.0
Clerical workers	67.8	74.6	80.7
Sales workers	38.5	43.1	45.4
Blue Collar			
Craft workers, supervisors	2.6	3.3	7.0
Operatives	27.8	30.9	32.3
Laborers	2.2	3.6	11.7
Service Workers			
Private household workers	98.0	97.4	96.9
Other service workers	53.2	60.2	59.0
Farm Workers			
Farmers and farm managers	3.9	4.6	11.8
Farm laborers, supervisors	35.3	32.4	24.1
Total	33.3	37.7	43.5

SOURCE: U.S. Department of Commerce, Bureau of the Census, *Statistical Abstract* (various issues).

available (Spaeth, 1984). It is well-known that two people with the same occupational title may not be doing the same thing, and two people doing the same thing will not always have the same occupational title.[11] Although using detailed occupational categories reduces the chances of encountering the former problem, it increases the probability of the latter difficulty. Thus no matter what level of detail is used, the results must be interpreted with caution. Table 1.7 shows the representation of women by major occupational category.[12] These groupings are very broad, and hence are only suggestive of the degree of segregation.

Even at this level of aggregation the differences between the male and female occupational distributions are quite apparent. In each year, women are disproportionately heavily represented in clerical and service jobs, whereas men are considerably more likely to be managers and blue-collar craft workers and supervisors, as well as laborers and farmers. Moreover, such aggregated figures conceal quite a bit of occupational segregation within each category. For example, among professional and technical workers, women are more likely to be in predominantly female categories like elementary school teacher or nurse, whereas men are more likely to be in predominantly male categories like engineer and lawyer.

On the other hand, the figures in Table 1.7 suggest that occupational segregation has been decreasing, particularly since 1970. Between 1970 and 1982, women increased their representation in the managerial and craft worker categories to a greater extent than their share of the labor force as a whole. Meanwhile, their relative overrepresentation in service jobs also declined somewhat over this period.

Another way to study occupational segregation is to use the detailed (three digit) classifications employed by the Bureau of Census in an index of occupational segregation. The index most often used is the one developed by Duncan and Duncan (1955):

$$S = 1/2 \, \Sigma \, | \, M_i - F_i |$$

where M_i F_i are the percentages of the male and female labor force respectively employed in occupation i. S represents the proportion of women, or men, that would have to change jobs in order to have complete occupational integration and can, in principle, range between 0 and 100.

A recent study by Blau and Hendricks (1979) estimated an index of segregation, based on census data, of 68.3 in 1960 and 65.8 in 1970. Using the Annual Demographic File, which encompasses a slightly different set of occupations, the index is reported to have been 68.1 in 1971 and 61.7 in 1981 (Beller, 1984). These results show a substantial degree of occupational segregation. Even the most recent figure indicates that three out of five workers of one sex would have to move to a different occupation to duplicate the distribution of workers of the opposite sex. However, the amount of segregation does appear to be declining, albeit at a modest rate. Moreover, the pace of change appears to have increased in the 1970s in comparison to the 1960s.

During this same period occupational segregation by race has also declined for both men and women. The most notable improvement for black women has been the rapid decrease of their number in domestic service, a major source of their employment in earlier years.

There is good reason to expect that occupational segregation may decline at an even more rapid rate in the near future. If there is to be a substantial change in occupational distribution, it would first be evident in a choice of different fields among students, and next in a choice of different occupations among young people entering the labor market. Both these trends have been evident in the 1970s.

Over the 1970s, women increased their share of advanced degrees received, as well as their representation in traditionally male fields. As may be seen in Table 1.8, between 1970-1971 and 1979-1980, the

TABLE 1.8
Bachelor's Degrees Conferred by Major Field of Study
(1970-1971 and 1979-1980)

	1970-1971		1979-1980	
	Total Degrees Awarded	Percentage Awarded to Women	Total Degrees Awarded	Percentage Awarded to Women
All Fields	846,110	43.4	940,251	49.2
Agriculture and natural resources	12,710	4.2	22,903	29.6
Architecture and environmental design	5,578	12.0	9,176	27.8
Biological sciences	36,033	29.3	47,111	42.4
Business and management	116,709	9.3	189,224	33.8
Communications	10,802	35.3	28,649	52.3
Computer and information sciences	2,388	13.6	11,213	30.3
Engineering	50,357	.8	69,265	9.3
Law	545	5.0	683	45.5
Mathematics	24,918	38.1	11,473	42.3
Physical sciences	21,549	14.0	23,661	23.9
Social sciences	156,698	37.0	104,878	43.7
Theology	3,744	27.2	6,238	25.4
Interdisciplinary studies	14,084	29.2	34,908	50.2
Area studies	2,497	52.9	2,489	60.5
Education	177,638	74.4	120,680	73.9
Fine and applied arts	30,447	59.7	40,953	63.2
Foreign languages	20,433	74.8	11,325	75.7
Health professions	25,484	77.2	64,597	82.3
Home economics	11,271	97.3	18,583	95.4
Letters	73,398	61.0	40,925	59.4
Library science	1,013	92.0	398	95.0
Psychology	38,154	44.7	42,513	63.3
Public affairs and services	9,303	49.1	38,155	55.3

SOURCES: National Center for Education Statistics, *Earned Degrees Conferred 1970-1971* and *Earned Degrees Conferred 1979-1980*.

proportion of bachelor's degrees awarded to women increased from 43.4 to 49.2 percent. Table 1.8 also shows the extent to which the percentage of bachelor's degrees awarded to women has changed in fields in which women were less than proportionately represented in academic year 1970-1971, as compared to those that were disproportionately female (a higher ratio of women than for all fields combined) at that time. Over the next nine years, the share of women in the former rose, on the

average, by 15.6 percentage points, in the latter by only 4.1. Another way of looking at this change is that the number of women in the predominantly male fields rose by 88.6 percent. while the number of men rose only 3.5 percent. In predominately female fields, the number of women rose by a mere 1.4 percent, and the number of men declined by 11.3 percent.

The situation is quite similar for master's degrees. The proportion of such degrees earned by women was 40.1 percent in 1970-1971 and 49.5 percent in 1979-1980. The ratio of women to men in male-dominated fields increased by an average of 10.5 percentage points, in female dominated fields by only 5.7 percentage points. Similarly, the number of women in male fields increased by 135.7 percent, in female fields by 44.8 percent, while the number of men rose by 19.9 percent and fell by 6.0 percent, in male and female fields, respectively, between 1970-1971 and 1979-1980. The representation of women among recipients of first professional degrees also increased dramatically in such traditionally male fields as dentistry, medicine, and law.

Turning to Ph.Ds, the share of degrees earned by women was so low in all fields, other than home economics, in 1970-1971, that a rise in their proportion in any of them may be regarded as a movement into nontraditional areas. Hence the most relevant fact shown in Table 1.9 is the increase in the percentage of degrees conferred on women from 14.3 percent in 1970-1971 to 29.7 percent in 1979-1980. Here, too, by far the largest percentage increases were in the fields that were most predominantly male in 1970-1971; but when the base is as small as that in engineering, theology, computer and information sciences, business management, and agriculture and natural resources, percentage changes are not especially meaningful. Nonetheless, these patterns once again confirm the tendency for women to increasingly get their education in nontraditional fields, as well as going on to a higher level.

The best evidence on differences in occupational distribution between younger and older women is again found in Beller (1984). When comparing the extent of occupational segregation among recent entrants (women who have been out of school less than 11 years) with women who completed their education 11 or more years ago, she finds that the younger cohort is less segregated in both 1971 and 1977, and that segregation declined more rapidly for them than for the remainder of the labor force during the 1970s. By 1977, the index was 62.5 for the former and 66.3 for the latter. She also finds that segregation for the younger cohort fell from 67.5 to 64.0 between 1971 and 1977 as this group aged over the period. Both these developments suggest that the

TABLE 1.9
Doctoral Degrees Conferred by Major Field of Study
(1970-1971 and 1979-1980)

	1970-1971		1979-1980	
	Total Degrees Awarded	Percentage Awarded to Women	Total Degrees Awarded	Percentage Awarded to Women
All Fields	32,113	14.3	32,632	29.7
Agriculture and natural resources	1,086	2.9	991	11.3
Architecture and environmental design	36	8.3	79	16.5
Biological sciences	3,645	16.3	3,638	26.0
Business and management	810	2.8	796	14.4
Communications	145	13.1	193	37.3
Computer and information sciences	128	2.3	240	11.3
Engineering	3,638	.6	2,507	3.8
Law	20	–	40	10.0
Mathematics	1,199	7.8	724	13.8
Physical sciences	4,391	5.6	3,095	12.5
Social sciences	3,659	13.9	3,225	27.1
Theology	312	1.9	1,319	5.8
Area studies	149	17.4	145	34.5
Education	6,398	21.2	7,940	44.3
Fine and applied arts	621	22.2	655	36.9
Foreign languages	781	38.0	549	57.4
Health professions	466	16.5	786	44.7
Home economics	123	61.0	192	76.0
Interdisciplinary studies	91	15.4	401	29.4
Letters	2,416	23.5	1,877	41.0
Library science	39	28.2	73	52.1
Psychology	1,782	24.0	2,775	42.2
Public affairs and services	178	24.2	392	35.2

SOURCES: National Center for Education Statistics, *Earned Degrees Conferred 1970-1971* and *Earned Degrees Conferred 1979-1980.*

movement of women into nontraditional fields is at least beginning to show up in the labor market as well as on college campuses.

HIERARCHIES WITHIN OCCUPATIONS

We have discussed the fact that there has been a substantial influx of women into the labor market, and that, albeit very slowly, women are breaking out of the female ghettos of largely segregated occupations.

TABLE 1.10
Distribution of Male and Female College and University Faculty by Rank (1980-1981)

Rank	Number of Men	Number of Women	Total (Men and Women)	Percentage Female in Each Rank	Percentage of All Men in Each Rank	Percentage of All Women in Each Rank
Professors	91,950	10,376	102,326	10.1	32.5	10.3
Associate Professors	75,455	19,228	94,683	20.3	26.7	19.0
Assistant Professors	61,313	32,694	94,077	34.8	21.7	32.4
Instructors	14,158	15,302	29,460	51.9	5.0	15.1
Lecturers	3,294	2,845	6,139	46.3	1.2	2.8
Undesignated Rank	36,675	20,561	57,236	35.9	13.0	20.4
Total	282,845	101,006	383,851	26.3	100.0	100.0

SOURCE: National Center for Education Statistics, *Digest of Education Statistics* (1982).

TABLE 1.11
Female-Male Earnings and Employment Ratios
by Occupational Work Level (1981)

Occupation	Work Level	Average Monthly Salary*	Female-Male Earnings Ratio	Percentage Female
Accountant	I	1,377	99	46
	II	1,679	98	34
	III	1,962	96	19
	IV	2,402	95	11
	V	2,928	90	5
Auditor	I	1,364	98	36
	II	1,651	97	27
	III	2,033	92	21
	IV	2,456	90	8
Attorney	I	1,873	103	28
	II	2,338	99	24
	III	3,031	95	13
	IV	3,738	94	9
Chemist	I	1,508	96	38
	II	1,757	94	29
	III	2,120	93	15
	IV	2,567	92	10
Buyer	I	1,350	96	52
	II	1,689	95	23
	III	2,100	92	9
Director of personnel	I	2,321	101	21
	II	2,933	94	10
	III	3,574	90	7
Job analyst	I	1,412	87	75
	II	1,525	92	85
	III	1,900	90	66
	IV	2,393	94	29
Engineering technicians	I	1,137	97	24
	II	1,307	98	17
	III	1,527	97	9
Drafter	I	923	103	34
	II	1,075	101	26
	III	1,301	96	18
	IV	1,611	94	8

(continued)

TABLE 1.11 Continued

Occupation	Work Level	Average Monthly Salary*	Female-Male Earnings Ratio	Percentage Female
Computer	I	906	99	37
operator	II	1,049	102	49
	III	1,220	97	35
	IV	1,475	97	24
	V	1,733	92	17

SOURCE: Earl F. Mellor, "Investigating the Differences in Weekly Earnings of Women and Men," *Monthly Labor Review, 107* (6), June 1984, pp. 17-28.
*Includes data for workers not identified by sex.

There is, however, generally also segregation within occupations, with women constituting smaller proportions the higher the level or rank. We are all familiar with many instances of this phenomenon, most easily documented where there is a formal hierarchy.

Among school teachers, for instance, 83.1 percent of those at the elementary level, 48.9 percent of those at the secondary level, and 36.5 percent of the postsecondary level are women. Second, as shown in Table 1.10, among university and college teachers almost one-third of men are full professors, about one-fourth associate professors, and only one-fifth assistant professors, whereas only one-tenth of women are full professors, one-fifth associate professors, and as many as one-third are assistant professors. Third, Table 1.11 illustrates the importance of hierarchical segregation in a variety of other occupations and also shows that women tend to earn less than men in the same occupation more because of their concentration at lower levels of the hierarchy than because they are paid much less than men who are at the same level. As we have seen, of course, women also tend to be in different occupations.

The extent to which men and women are at different levels within the same occupations is often referred to as vertical segregation. No adequate data are available that would enable us to construct economy-wide quantitative measures for this type of segregation, but, as the above examples suggest, there can be little doubt that such hierarchical differences are substantial.

Last, Table 1.12 provides a good illustration of the overall effect of occupational segregation combined with the hierarchical structure in the Federal Civil Service. Women comprise more than 70 percent in grades 1 to 6, in which average salaries are less than $16,500. On the other hand, less than 15 percent are women in grades 12 to 18, in which salaries range upward from $30,000.

There is no question about the existence of both occupational segregation and hierarchical segregation within occupations. There is,

TABLE 1.12
Full-Time Civilian White-Collar Employees in the Federal
Civil Service and Salary by Grade and Sex (October 1981)

Grade	Men		Women		Percentage of Women
	Number	Average Salary	Number	Average Salary	
01	879	8,468	1,979	8,423	69.2
02	4,010	9,694	11,452	9,572	74.1
03	19,654	10,922	62,675	10,901	76.1
04	39,516	12,654	131,669	12,762	76.9
05	57,212	14,549	141,473	14,579	71.2
06	24,515	16,388	67,814	16,467	73.4
07	61,461	18,124	74,646	17,992	54.8
08	14,951	20,461	16,449	20,210	52.4
09	94,074	22,115	68,486	21,428	42.1
10	17,690	24,848	11,221	23,958	38.8
11	125,690	26,917	44,488	25,674	26.1
12	164,079	32,403	26,947	30,771	14.1
13	103,378	37,217	12,225	35,848	10.6
14	56,512	43,241	4,889	42,126	8.0
15	35,164	48,626	2,639	48,536	7.0
16	835	50,234	53	50,148	6.0
17	176	50,234	12	50,112	11.1
18	80	50,112	9	50,112	10.1
Total	801,922	27,570	679,126	17,417	45.3

SOURCE: Federal Civilian Workforce Statistics, *Occupations of Federal White-Collar and Blue-Collar Workers* (October 31, 1981).

however, little agreement about the causes for this situation. Two quite different explanations have been proposed. One emphasizes the role of human capital (Boskin, 1974; Polachek, 1976, 1979). It points to the importance of the greater amount of education and training men have tended to acquire in preparation for, and in the course of, spending virtually all their preretirement years in the labor market. This is used to explain both men's choices of occupations that require more education and training and why they reach higher levels in whatever occupations they choose.

The second explanation views discrimination as the main factor keeping women from entering nontraditional jobs and from climbing the higher rungs of the occupational ladder. Discrimination may take the form of differences in early socialization of boys and girls, at home and in school. They are not raised with the same expectations, the same role models, or the same incentives. We have already seen in the previous section that until quite recently there was little change in the division of housework between men and women. Even today sharing is hardly equal. This may, at least in part, be the result of differential

TABLE 1.13
Median Annual and Usual Weekly Earnings of Full-Time
Women Workers as Percentage of Men's Earnings
(selected years 1955-1984)

	Annual	*Weekly*
1955	63.9	
1960	60.8	
1965	60.0	
1970	59.4	62.4
1975	58.8	62.0
1976	60.2	62.2
1977	58.9	61.9
1978	59.7	61.3
1979	60.0	62.4
1980	60.2	63.4
1981	59.2	64.6
1982	61.7	65.0
1983	63.6	65.6
1984		64.8

SOURCE: 1955-1975, Bureau of Labor Statistics, *U.S. Working Women: A Data-book* (1977); 1976-1983, Bureau of the Census Population Reports, Consumer Income Series P-60, Money Income of Households, Families, and Persons in the United States (various years); weekly earnings 1970-1983 from Earl F. Mellor, "Investigating the Differences in Weekly Earnings of Women and Men," *Monthly Labor Review, 107* (6), June 1984, pp. 17-28; 1984, Department of Labor, Bureau of Labor Statistics Press Release, January 30, 1985.

socialization, and it in turn helps to socialize the next generation differentially. Further, unequal distribution of family work makes it difficult for women to devote as much time and energy to paid work as men do.

Discrimination may also exist in the labor market in which equally qualified men and women are not always hired or rewarded on equal terms (Brown, Moon, & Zoloth, 1980; Blau, 1984). Employers, employees, and/or customers with preferences for men over women, at least for traditionally male work, may be involved in such behavior. When qualified women do not achieve as much as comparable men, this in turn feeds back by depressing women's expectations.

Research has provided some evidence for each of these hypotheses (Blau & Ferber, in press; Reskin, 1984; O'Neill & Madden, this volume). This is not surprising, for the two are not mutually exclusive. On the contrary, the differences in men's and women's lifestyles and in their human capital may be to a greater or lesser extent caused by discrimination, and differences in treatment can in some part be attributed to the fact that men's and women's preparation for and behavior in the labor market is not the same (Phelps, 1972; Aigner & Cain, 1977). In practical terms, accepting that human capital also plays

a role does not necessarily lead to different policy decisions than if it were discrimination alone. The crucial intervention that can, at least over time, break the vicious circle is to give equal opportunity to women, which will in turn encourage younger women to prepare for more demanding and rewarding positions. Equal treatment in the labor market will also remove some of the rationale for treating women as the primary homemaker and secondary wage earner in the family.

THE EARNINGS GAP

One reason, perhaps the main reason, for concern with segregation between and within occupations is that both undoubtedly contribute to the very substantial extent to which women earn less than men.[13] As the data in Table 1.13 show, annual earnings of year-round full-time women workers continue to lag substantially behind men's. As in the case of occupational differences, there is considerable disagreement over the cause of these earnings differences. However, most of the empirical work in this area suggests that here too both sex differences in qualifications and labor market discrimination play a role, with discrimination accounting for as much as one-half of the earnings differentials (Blau, 1984; Lloyd & Niemi, 1979; Treiman & Hartmann, 1981; Blau & Ferber, in press).

The data in Table 1.13 showed little sign of women's earnings catching up with those of men for a long time. Indeed, the relative earnings of women actually declined somewhat between 1955 and 1975. In contrast, annual earnings of black men, once lower than those of white women, grew to be considerably higher and have been rising relative to those of white men. Black women today earn only marginally less than white women. The ratio of women's and men's weekly earnings, however, is somewhat higher, in part because they refer to "normal" rather than actual earnings and therefore understate overtime pay received over the year.[14] In contrast to the annual earnings figures, however, this ratio has been steadily increasing since 1978, suggesting that women may be starting to close at least the gap in base pay (Blau & Beller, 1984).

Even more encouraging is an examination of the earnings gap by age. As can be seen in Table 1.14, there are striking differences in the ratio of earnings by age. The data show earnings profiles for men and women over the life cycle. As would be expected, women earn less than men in all age groups, but the extent to which this is the case varies considerably. The differential is only 24 percent for the youngest group, but increases to 45 percent for those between ages 45 and 49. This clearly indicates that young women do better than older women.

TABLE 1.14
Median Earnings of Men and Women Working
Year-Round Full-Time by Age

Age	Men	Women	Women's Earnings as Percentage of Men's
25-29	18,359	13,904	75.7
30-34	21,526	14,953	69.5
35-39	24,748	15,256	61.6
40-44	25,541	14,481	56.7
45-49	25,543	13,985	54.8
50-54	25,294	14,290	56.5
55-59	24,998	14,566	58.3
60-64	24,380	14,134	58.0
Total	21,655	13,663	63.1

SOURCE: Bureau of the Census, Current Population Reports, Consumer Income Series P-60, No. 142, *Money Income of Households, Families and Persons in the United States* (1982).

Does this merely show that men's earnings tend to rise more steeply with age than do women's, or does it show that young women are doing better now than their predecessors did? If the former is true we would expect the women who were, say, age 25 to 29 in 1982 and earned 76 percent as much as men at that time to earn only 62 percent as much as their male contemporaries 10 years later in 1992. If, however, the latter is the case, these women would still earn 76 percent as much as men at that time. The data for one point in time do not enable us to answer this question. Information in Table 1.15, however, does help to shed some light on this subject.

If young women's incomes were a higher percentage of men's than that of older women, but the relative income of women in each age group were the same for all years, no improvement would be taking place over time. Older women would fare less well than younger ones only because of the life-cycle effect. If, on the other hand, young women's incomes were a higher percentage of men's than that of older women in the earlier year, and remained just as high as they age, there would be no evidence of life-cycle effects, but rather would indicate an upward trend. Members of the younger cohort would do better throughout their life cycle.

Our data, which focus on adults in the prime working ages, conform to neither of these two extremes. Women's incomes were a larger percentage of men's for each age group in 1982 than in 1967 and 1972. The gains were most pronounced for the 25 to 34 age group whose relative income increased by almost 10 percentage points between 1967

TABLE 1.15
Median Income of Women Working Year-Round
Full-Time as Percentage of Men's Income by Age

Age	1967	1972	1982
25-34	62.2	64.9	71.8
35-44	55.1	52.3	59.4
45-54	54.0	52.3	55.7

SOURCE: U.S. Bureau of the Census, Current Population Reports Nos. 60, 89, 142, *Money Income of Households, Families and Persons in the United States* (1967, 1972, 1982).

and 1982. Although the income of the 35 to 44 age group was a smaller percentage of men's in 1982 than that of the 25 to 34 age group in either of the previous years, the difference is relatively modest. Further, the fact that the income of the 45 to 54 age group was actually a slightly larger percentage of men's incomes than that of the 35 to 44 age group in either of the previous years is most encouraging.

These data suggest that younger women are likely to retain a substantial amount of the improvement in their relative earnings as they age. Moreover, the fact that young women are now entering less traditional occupations and are likely to spend more time in the labor market reinforces the expectation that they are likely to continue faring better than their predecessors at each point of the life cycle. As this occurs, the overall gap in earnings, and income, should decline considerably more as earlier cohorts of women with relatively low earnings are replaced increasingly by the more recent cohorts with relatively higher earnings.

This expectation is further supported by the fact that the earnings gap has already narrowed considerably in a number of other advanced industrialized countries. This has been true not only for those that have had policies reducing wage differentials in general, such as Australia and Sweden, but in many of the other countries as well (Blau & Ferber, in press).

CONCLUSIONS

The influx of women into the labor market, and particularly that of married women with children, has been very large in recent decades. Young women today may be expected to spend most of their adult lives working for pay, and the labor force participation rate of very highly educated women is beginning to approach that of men. These are the

developments that have brought about the widespread impression of radical changes. The information we have provided shows that in other respects women's economic status has changed considerably more slowly. For the most part, however, these data suggest that progress may be more rapid in the future.

There is evidence that in recent years men, and particularly young men, are doing a larger share of the housework. As the division of family responsibilities becomes more equal, it becomes easier for women, and more difficult for men to give a high priority to paid work, thus reducing the likelihood of large sex differences in preparation for and behavior in the labor market.

During this same period, occupational segregation, which had been considerable, has also begun to decline. There have been substantial shifts in choice of field by college students, which should accelerate this trend for white-collar jobs in the future. On the other hand, there has been far less progress of women making inroads in skilled blue-collar jobs, perhaps in part because these occupations have not been expanding as rapidly. Moreover, to the extent that data are available, hierarchical differences between the sexes still appear quite pronounced. It may be that the resistance to upward mobility of women is even greater than to their entry into nontraditinal occupations. Safilios-Rothchild (1978) suggests that the more women aspire to high positions the more informal sex discrimination they encounter. Last, the sex gap in earnings has only begun to decline recently, though in this respect too, younger cohorts are doing much better than their elders. It should also be noted that now that black women earn virtually as much as white women, any further progress on their part is likely to be crucially dependent on the reduction of sex differences.

In view of these facts it is not surprising that there is still concern about how more rapid changes could be brought about. There is now general agreement that the high hopes many people had for the equal pay for equal work legislation were largely misplaced. For the most part, even now, men and women do not do the same work, and even when they do, nominal distinctions in job titles, although not a valid legal defense, may in practice be a way of circumventing the law. It is difficult to know how common this is, but there is little doubt that such practices exist. Obvious examples are when the same tasks are at times performed by secretaries and administrative assistants, by claims representatives and claims adjusters[15]

There is less agreement about the effects of legislation prohibiting discrimination and the executive order mandating affirmative action, but in general the view is that success has, at best, been modest. Although some researchers have reached more optimistic conclusions

than others, none are sanguine about achieving rapid desegregation or earnings parity.[16] This is all the more true because many believe that both the interpretation and enforcement of these laws by the government have recently been changed so as to make them even less effective. The growing interest in an alternative approach may be a mark of disillusionment with the existing methods of reducing disparities between women and men.

Equal pay for work of comparable worth has been called the women's issue of the 1980s (see Rosenbaum, this volume). It has considerable appeal for many people. This approach accepts the fact that there is, and for some time will continue to be, substantial occupational segregation because workers trained and established in particular occupations cannot be expected to change to other fields in most cases. Such women's earnings are to be increased by recognizing the full value of the work they do, rather than by having them do different work.

This is not the totally unrealistic and unwarranted interference with a market equilibrium brought about by the unfettered operation of demand and supply in a competitive market, as laissez-faire economists would have us believe.[17] But neither is equal pay for work of comparable worth a ready cure-all, as some of its proponents appear to suggest. First, it is no easy matter to establish what is work of comparable worth because work and the necessary qualifications to do the work are multidimensional and cannot be measured by a simple yardstick. Second, a successful effort to increase pay rates in traditionally female jobs could adversely affect women's employment, as employers cut back the quantity of labor demanded in these jobs. The consequent increase in unemployment among women or reduction in their hours of work would lower their annual earnings. Finally, it is unlikely that economic equality between men and women may be obtained on the basis of the "separate but equal" principle.

It is not clear at this point how rapid progress in implementing the comparable worth principle is likely to be.[18] However, like equal pay, nondiscrimination legislation and affirmative action regulations, equal pay for work of comparable worth is likely to contribute to the ongoing changes we have been observing. The importance of such contributions should not be underestimated. Existing discrimination does not only have direct effects, but it also has indirect effects on women's preparation for work and attachment to the labor force, which may turn out to be far greater. The other side of this coin is that the eventual impact of any improvements may also be far greater than the immediate results would suggest.

First, there is likely to be a "benign circle" as greater rewards provide greater incentives for women to acquire market-oriented human capital,

and not to specialize in homemaking, which in turn will lead to still greater rewards in the market. Second, such changes may be expected to change employers' perceptions of women workers and to reduce statistical discrimination. Third, even a few women in nontraditional occupations and in high-level positions may make a significant impact on stereotypical notions. Fourth, women who have succeeded in getting such jobs are likely to smooth the path for successors, making it easier for a trickle to change into a flow.

Last, as all these changes take place in the position of women in the labor market, they interact with changes in allocation of work in the household. As we have seen, these changes were slow to come, but are beginning to be apparent now. Thus there is reason to expect that progress in the future will be more balanced, with women not only continuing to increase their labor force participation, but achieving greater equality both in the home and the labor market.

NOTES

1. "Black and other" includes such groups as native Americans and Asian Americans. Hispanics are included partly among whites, partly among "black and other," as appropriate.

2. The term "turnover" is also frequently used to refer to workers quitting jobs. We use it here in reference to individuals moving in and out of the labor force.

3. That is, labor force experience rates have risen, but they have declined *relative to* participation rates.

4. Factors such as urban or rural residence, family composition, level of education, and others are all potentially important and may vary between the samples.

5. Some surveys rely on home diaries provided by respondents; others merely ask them to report from memory.

6. Definitions of what should be counted as work are not standardized. This is a crucial issue with respect to activities such as nonbasic child care. Examples are taking a youngster for a walk or watching television together.

7. The reason the market work figure is not zero is that a person is not counted as being in the labor force if paid work is less than a specified minimum.

8. It is interesting to speculate on why husbands of women who are not in the labor market do as much family work as those married to employed women. One obvious explanation is that they are likely to have more and younger children. It is also possible that men who prefer for their wives to remain full-time homemakers have to make an effort to make this proposition attractive to them.

9. The results cited in the text must be viewed with some caution because, as noted earlier, findings tend to vary across studies. For example, another survey, conducted in 1984, also found far less difference in the number of hours employed husbands and wives spent in the market than earlier studies, but a somewhat greater difference in their hours of housework (Louis Harris Associates poll conducted in April, 1984, for the MS Foundation for Education and Communication).

10. As reported in the Wall Street Journal (September 7, 1984, "Working fathers feel new pressure arising from child-rearing duties"): "A recent Wellesley College study of 160

middle class families in the Boston suburb of Dedham, Mass., found that fathers with working wives spent more time alone with their children than other fathers, but that nearly all the women were in charge of remembering, planning and scheduling children's activities."

11. Since equal pay and affirmative action legislation have been introduced there is even reason to believe that such confusion has, at times, been created on purpose as a means of circumventing the law.

12. Men and women are also segregated by industry. In 1982 only 16 percent of the work force in mining and 8 percent in construction was female, but 61 percent of workers in service and 57 percent in finance were women (U.S. Department of Labor, Bureau of Labor Statistics, 1984). We follow the general practice of putting emphasis on occupations because they are more indicative of what work a person does.

13. There is, furthermore, evidence that women are also segregated in firms that pay lower wages for the same job than those that primarily employ men, Blau (1977).

14. The question in the survey asks how much the worker usually earns per week, so that earnings received for rather regular overtime work would be included but those for occasional additional hours would not.

15. Evidence of the latter distinction was found in a sex discrimination case (see Bergmann, 1976).

16. For evidence of a small positive effect of the federal antidiscrimination laws on women's earnings, see Beller (1979).

17. As Treiman and Hartman (1981) document, many large private firms and governmental units have been using job evaluation schemes for some time. However, it should be noted that data on prevailing market rates for benchmark jobs are generally taken into account. More than 80 member nations of the Intenational Labor Organization have ratified Convention 100 in support of equal pay for work of equal value.

18. It should be noted, though, that *Pay Equity Trends,* Vol. 1, No. 1, May 1984, p. 5, reported that pay equity studies had been completed in seven states and are ongoing in two more, as well as in a great many municipalities.

REFERENCES

Aigner, D. J., & Cain, G. C. (1977). Statistical theories of discrimination in labor markets. *Industrial and Labor Relations Review, 30*(2), 175-187.

Beller, A. H. (1979). The impact of equal employment opportunity laws on the male/female earnings differential. In C. B. Lloyd, E. S. Andrews, & C. L. Gilroy (Eds.), *Women in the labor market.* New York: Columbia University Press.

Beller, A. H. (1984). Trends in occupational segregation by sex and race 1960-1981. In B. E. Reskin (Ed.), *Sex segregation in the workplace: Trends, explanations, and remedies.* Washington, DC: National Academy Press.

Bergmann, B. R. (1976). Reducing the pervasiveness of discrimination. In E. Ginzburg (Ed.), *Jobs For Americans.* Englewood Cliffs, NJ: Prentice-Hall.

Berk, R. A., & Berk, S. F. (1977). *Labor and leisure at home.* Beverly Hills, CA: Sage Publications.

Blau, F. D. (1977). *Equal pay in the office.* Lexington, MA: Lexington Books.

Blau, F. D. (1984). Discrimination against women: Theory and evidence. In W. A. Darity, Jr. (Ed.), *Labor economics: Modern views.* Boston: Kluwer-Nijhoff.

Blau, F. D., & Beller, A. H. (1984, December). *Trends in earnings differentials by sex and race, 1971-1981.* Paper presented at the American Economic Association Annual Meetings.

Blau, F. D., & Ferber, M. A. (in press). *The economics of women, men and work.* Englewood Cliffs, NJ: Prentice-Hall.

Blau, F. D., & Hendricks, W. E. (1979). Occupational segregation by sex: Trends and prospects. *The Journal of Human Resources, 14*(2), 197-210.

Boskin, M. (1974). A conditional logit model of occupation choice. *Journal of Political Economy, 82*(2), 389-398.

Brown, R. S., Moon, M., & Zoloth, B. S. (1980). Occupational attainment and segregation by sex. *Industrial and Labor Relations Review, 33*(4), 506-517.

Cain, G. G. (1984). *Women and work: Trends in time spent in housework.* Madison, WI: University of Wisconsin-Madison, Institute for Research on Poverty, Discussion Paper No. 747-84.

Corcoran, M., & Duncan, G. J. (1979). Work history, labor force attachment, and earnings differences between the races and sexes. *Journal of Human Resources, 14*(1), 3-20.

Duncan, D. & Duncan, B. (1955). A methodological analysis of segregation indexes. *American Sociological Review, 20*(2), 210-217.

England, P. (1982). The failure of human capital to explain occupational sex segregation. *Journal of Human Resources, 17*(3), 358-370.

Federal Civilian Work Force Statistics. (1981, October 31). *Occupations of federal white-collar and blue-collar workers.*

Friedan, B. (1963). *Feminine mystique.* NY: Dell.

Goldin, C. (1983). Life-cycle labor force participation of married women: Historical evidence and implications. National Bureau of Economic Research Working Paper No. 1251.

Juster, F. T. (1984a). *Preferences for work and leisure.* Unpublished manuscript.

Juster, F. T. (1984b). *A note on recent changes in time use.* Unpublished manuscript.

Lloyd, C., & Niemi, B. (1979). *The economics of sex differentials.* New York: Columbia University Press.

Meissner, M., et al. (1975). No exit for wives: Sexual division of labor and the cumulation of household demands. *Canadian Review of Sociology and Anthropology, 12*(4), 424-439.

Mellor, E. F. (1984). Investigating the differences in weekly earnings of women and men. *Monthly Labor Review, 107*(6), 17-28.

National Center for Education Statistics. (1982). Earned degrees conferred 1970-1971 and 1979-1980. *Digest of education statistics.*

O'Neill, J. (1985). The trend in the male-female wage gap in the United States. *Journal of Labor Economics, 3*(1), S91-S116.

Phelps, E. S. (1972). The statistical theory of racism and sexism. *American Economic Review, 62*(4), 659-661.

Pleck, J. H. (1983). Husbands' paid work and family role: Current research issues. In H. Lopata (Ed.), *Research in the interweave of social roles: Jobs and families* (Vol. 3, pp. 251-333).

Polachek, S. W. (1976). *Segregation among women: A human capital approach.* U.S. Department of Labor, Report No. ASPER/PUR-75/1909A.

Polachek, S. W. (1979). Occupational segregation: Theory, evidence and prognosis. In C. Lloyd, E. S. Andrews, & C. L. Gilroy (Eds.), *Women in the labor market.* New York: Columbia University Press.

Reskin, B. F. (Ed.). (1984). *Sex segregation in the workplace: Trends, explanations, remedies.* Washington, DC: National Academy Press.

Robinson, J. P. (1977). *Changes in America's use of time.* Cleveland: Cleveland State University, Communications Research Center.

Rytina, N. (1983). Comparing annual and weekly earnings from the current population survey. *Monthly Labor Review, 106*(6), 32-35.

Safilios-Rothschild, C. (1978). Women and work: Policy implications and prospects for the future. In A. H. Stromberg & S. Harkess (Eds.), *Women working: Theories and facts in perspective.* Palo Alto, CA: Mayfield.

Smith, J. P., & Ward, M. P. (1985). Time series growth in the female labor force. *Journal of Labor Economics, 3*(1), S59-S90.

Spaeth, J. (1984). *Work power and earnings.* Unpublished paper. University of Illinois at Urbana-Champaign.

Terry, S. L. (1983). Work experience, earnings, and family income in 1981. *Monthly Labor Review, 106*(4), 17-19.

Treiman, D. J., & Hartmann, H. I. (Eds.). (1981). *Women, work, and wages: Equal pay for jobs of equal value.* Washington, DC: National Academy Press.

U.S. Department of Commerce, Bureau of the Census. (1982, September). *Labor force statistics derived from the current population survey: A databook.*

U.S. Department of Labor. (1982). *Employment and training report of the president.*

U.S. Department of Labor, Bureau of Labor Statistics. (1977). *U.S. working women: A databook.*

U.S. Department of Labor, Bureau of Labor Statistics. (1982). New work estimates. In *Special labor force report no. 2157.*

U.S. Department of Labor, Bureau of Labor Statistics. (1983, May). *Special labor force report no. 2163.*

U.S. Department of Labor, Bureau of Labor Statistics. (1984, January). *Employment and earnings.*

Walker, K. E., & Woods, M. E. (1976). *Time use: A measure of household production of family goods and services.* Washington, DC: American Home Economics Association.

2

Role Differentiation and the Gender Gap in Wage Rates

JUNE O'NEILL

This chapter examines the sources of the gender gap in wages, emphasizing the factors that stem from differences in the roles of women and men within the family. Historically, the division of labor in the family has been such that men have specialized in market work and women have specialized in child care and other household work. As a result, women have had less incentive and opportunity to invest their time and money in developing the market skills that enhance earnings. In addition, when women become employed they continue to have household responsibilities that are likely to restrict their choice of jobs and impose other constraints that reduce market productivity at lower earnings. Although in principle the division of labor in the home could itself result from discrimination in the labor market, this chapter points to fertility and other factors that have given women a strong comparative advantage in performing household work.

One of the more politicallly provocative statistics before the public today is the gender gap in wages. In 1983, the ratio of women's earnings to men's was 72 percent, as measured by the hourly wages of full-time workers, leaving a wage gap of 28 percent (O'Neill, 1985). Measured by the annual earnings of full-time workers, the gap was 36 percent. However, the gap in annual earnings has narrowed significantly over the century: From 54 percent in 1890 to 45 percent in 1930, to 36 percent in 1955 (Goldin, 1984b). After 1955 the gap widened and fluctuated around 40 percent until the late 1970s. Between 1979 and 1983 the gap narrowed sharply back to 36 percent.

Two broad explanations have been given for the wage gap. One explanation points to discrimination in the labor market, which results in lower pay for women than for men with equal labor market

productivity. The second explanation stresses that women's earnings are lower than men's because women are less specialized in market work, spending a considerably larger portion of their time and energy on child care and other household work. As a result, women do not develop market skills to the same extent as men. In addition, when employed in the market, women may be constrained by household responsibilities in their choice of jobs, which may further reduce their earnings.

These two explanations are not mutually exclusive. Given the division of labor in this volume, this chapter emphasizes the second explanation—"role differentiation"—a term attributable to Fuchs (1971). The first section discusses the factors underlying the division of labor in the family by gender and the effects of this allocation of tasks on women's investments in human capital and in their choice of jobs. Data on women's present-day allocation of time between home and market are reviewed, and the effects of these patterns of work on earnings are examined. The effect of discrimination in the labor market on earnings is also briefly discussed. The second part of the chapter reviews empirical studies of the pay gap and examines the results in terms of their consistency with the role differentiation hypothesis.

ROLE DIFFERENTIATION: EFFECTS ON HUMAN CAPITAL, JOB CHARACTERISTICS, AND MARKET EARNINGS

In order to evaluate the difference in earnings of two groups it is usually agreed that account must be taken of differences in worker productivity. True worker productivity is exceedingly difficult to measure directly. A large volume of research has, however, identified many of the characteristics associated with higher wages and, presumably, higher productivity. Many of these characteristics involve investments in "human capital" that improve the worker's market value. These investments include formal schooling and training as well as training acquired on the job. Other investments include the search for a job with higher pay either in one's own geographic region or another region and the migration to a higher paying region.

Human capital theory provides an explanation of why women may have lower earnings than men and may pursue different occupations than men even in the absence of discrimination. The theory stresses that individuals make schooling, training, and other investment decisions on the basis of their perceptions of the costs of the available options and of the expected benefits associated with each (Becker, 1975). Men and women are likely to evaluate these options differently because of

differences in anticipated lifetime work patterns stemming from different roles in the family. Although the average woman of today is much more likely to work in the market after marriage than was the case in the past, it is still unusual for women to work continuously from the time of leaving school and to spend as many hours at market work as men, even when employed.

Because at the root of this argument is the division of labor in the home, in which tasks are allocated systematically by gender, this section first looks at fertility and other factors that have influenced role specialization. The changes in these underlying factors over the past century are then considered along with implications for the changes in women's roles. The lifetime market work experience of recent cohorts of women and their time use in the home is examined, and these patterns are then related to human capital investments and earnings and to the characteristics of jobs. The section closes with a discussion of discrimination and its possible effects on earnings.

Factors Underlying the Division of Labor in the Family

The traditional family organization has been characterized by pronounced differences in the functions performed by different family members. These functions have also been divided sharply by sex: Women have specialized in child care and home production; men have specialized in market activities. Becker's analysis of the family suggests that strong economic incentives underlie the observed division of labor in the family (Becker, 1981, 1985). Families use their time and other inputs to produce the goods they consume. Some of these goods are produced in the home; others are purchased in the market with money earnings. Both market and home work activities, however, involve investments in specific skills. These investments have costs, which can include both direct money costs of tuition and training or the opportunity costs resulting from time foregone in a job or other activity. Becker also argues that these specific investments are subject to increasing returns. That is, the rate of return to the investment rises with the hours and years spent using the skills. Therefore, an hour taken away from the investment activity has a high opportunity cost. Because families pool their incomes, the whole family gains when individual family members practice their specific skills.

The efficiency of specialization also depends on the demand for goods and services produced. Because there are limits to the family's consumption of any one good produced in the home—food, laundry, a

clean house, children—the homemaker typically is more diversified than the market worker. I suspect that this factor, combined with the potential for substituting market goods for home goods, has contributed to the increasing market specialization of women. This issue is discussed further below.

Why is it that those who specialize in home production are almost always women? Becker's theory does not require a systematic division of labor by gender. If productivity in different activities varied randomly among women and men, the incentive to specialize would still be strong, but it would not be gender-related. The observation that the division of labor in the family is gender-specific suggests two hypotheses. One is that the division of labor in the home is a response to discrimination in the market that reduces women's potential earnings relative to men's. The other hypothesis is that women have an inherent comparative advantage in home production.

Certainly, one can point to compelling biological and environmental factors that would have led to gender differences in the division of labor in the past. Women's market productivity may well have been lower than men's when physical strength was a relatively important work characteristic. In addition, however, the high fertility of earlier periods and the circumstances related to the rearing of young children gave women an intrinsic advantage in home production. High fertility, of course, may not be entirely exogenous because in part it may have been a response to lower market earnings of women, whether due to discrimination or to lower market productivity. (If women are already specializing in the home, the cost of an additional child is lower.) However, high fertility is also likely to have been a response to high levels of child mortality. Child mortality can increase fertility because families replace children who have died with additional births, or because additional children are born in anticipation of mortality based on current experience observed outside the family (Schultz, 1978). In the 1880s there was a 20 percent chance that an infant would not survive to age one and a 40 percent chance that a child would not survive to age 15.[1] Thus even if parents desired the same number of children surviving to adulthood as today, women would on average have to give birth to 1.6 children for each desired surviving child. The cohort of women who began their childbearing years in the 1880s eventually gave birth to an average of 4.7 children; 46 percent of the cohort had given birth to 5 or more children. In periods before low-cost substitutes for breast feeding were available it is plausible that the bearing and nursing of children gave women a natural advantage in home production.

Changes in Women's Roles Over the Century

Over the course of the century several developments likely altered the relative importance of home production and affected the potential gain from the traditional division of labor in the home. One factor is the rise in the market wage, which alone would have increased the attractiveness of market work relative to work in the home (Mincer, 1962).

In addition, economic growth contributed to a change in the cost of home production through technology, which greatly reduced the amount of time needed to produce household services. The full-time homemaker in 1900 worked 84 hours a week in the home (Lebergott, 1976); by 1975 her work hours were 41 hours per week (Hill, 1981). Thus bread is more often purchased and not baked in the home, refrigerators and freezers reduced the number of trips to the market, supermarkets reduce the number of markets to be visited, washers, dryers, and no-iron fabrics ease laundering, and a plethora of innovations provides quick meals (microwave ovens, frozen foods, "fast food" shops). Most importantly these technologies have become available at an even lower real cost: The price of a hand-cranked washing machine was $150 in 1926 ($890 in 1983 prices); the price of a mechanical refrigerator was $900 in 1916-1917 ($5,500 in 1983 prices; see Oppenheimer, 1970). As the level of real earnings was only a fraction of what it is today, it is not surprising that in 1920 only 8 percent of American families owned a washing machine and 1 percent owned a mechanical refrigerator (Lebergott, 1976). Overall, the Consumer Price Index (CPI) for household appliances fell by 15 percent between 1957 and 1967 while the overall CPI increased by 19 percent; between 1967 and 1977, CPI increases for the two categories were 40 and 82 percent, respectively.

The care of children is one household activity for which market alternatives may be less readily substituted, although it has shifted somewhat to the market through earlier school starting ages and increased use of group day-care arrangements. The time demands of childcare activity have been reduced, however, through declining fertility. The decline in fertility is likely to have been in part a response to rising wage rates and the rising labor force participation of women. But other factors affect fertility as well. Child mortality no longer imposes any significant uncertainty about the numbers of births that will be required to achieve the desired family size. The probability that a child would not survive to age 15 fell to 8 percent by 1940 and to 2 percent in 1980. Modern contraceptives such as "the pill"—which first gained wide usage in the United States in the early 1960s—enable women to plan more precisely the number and timing of these births.

Childbearing no longer needs to occupy substantial portions of a woman's adult years, unless larger size families are desired (as was the case during the post-World War II baby boom). The availability of low-cost substitutes for mother's milk enables other adults (such as the father) to feed infants. Thus the considerable comparative advantage in home production that women held relative to men at the start of the century has likely diminished over time. It is still an open question, however, whether fertility or other innate traits still give women a significant enough advantage in household production to perpetuate gender differences in the specialization of work within present-day families.

Current Work Patterns

The proportion of married women working outside the home has increased sharply over the course of the century, rising from less than 6 percent in 1900 to 14 percent in 1940, and to 50 percent in 1980. Despite this change, pronounced gender differences remain in work specialization, even when employed women are compared to men. Women still spend a substantial portion of their adult lives out of the labor force specializing in household activities exclusively and while working in the market tend to retain considerable responsibility for homemaking chores.

Years of work experience. Data from the National Longitudinal Survey (NLS) provide information on the work experience accumulated by women over their lifetimes. In 1977, the average white woman age 45 to 49 had spent about half of the years since leaving school in the labor market (Table 2.1). Employed women of the same race and age had worked more years than the average, but still only 60 percent of the years since leaving school. By contrast, most men remain in the labor force continuously after leaving school.

Younger women, it should be noted, seem to be accumulating much more market work experience; for example, white women aged 25-29 years in 1978 had worked 79 percent of the years since leaving school. To some extent this may reflect delayed marriage and family formation. However, it also seems likely that these younger cohorts will continue to accumulate more market work experience than earlier cohorts. (Note the sharp increase in the accumulated experience of the cohort reaching ages 25-29 in 1978 compared to 1973.) Another point of interest is that black women in their forties show greater lifetime work experience than white women, although this difference narrowed between 1967 and 1977.

TABLE 2.1
Proportion of Years Worked Since Leaving School: NLS Data
by Age and Race for All Women and Employed Women,
1977-1978

| | Proportion of Possible Years Worked | | | |
| | White Women | | Black Women | |
	All	Employed	All	Employed
25-29 years:				
1973	.50	.67	.41	.56
1978	.69	.79	.60	.70
30-34 years:				
1967	.44	.59	.53	.63
1972	.48	.63	.53	.66
40-44 years:				
1967	.44	.57	.59	.67
1972	.46	.59	.56	.68
1977	.50	.62	.57	.68
45-49 years:				
1972	.46	.59	.58	.72
1977	.49	.61	.58	.68

SOURCE: O'Neill (1985).

The data shown in Table 2.1 suggest that employed women gained in lifetime work experience between the late 1960s and the late 1970s, particularly younger women. This is consistent with data on job tenure from the Current Population Survey that indicate a similar rise in work experience, but with a single employer (see O'Neill, 1985). Earlier in the century, however, the experience level of employed women did not increase, or barely increased, as new entrants to the labor force with little work experience depressed the average experience level of employed women as a group (Goldin, 1983; Smith & Ward, 1983; O'Neill, 1985).

Time allocation of employed women. Although the time demands of household work have declined significantly since 1900, and married women now spend considerably more hours at work in the market than in the past, it is still the case that women are responsible for the bulk of household work and child care. Data from a survey of time use conducted by the Survey Research Center of the University of Michigan reveal the pattern of hours spent at work in the home and work in the market in 1975-1976 by married women and men. Thus although women's hours of work in the home are reduced as their hours of market work increase, even those women who are employed full-time outside

TABLE 2.2
Hours Spent at Home and at Work

	Weekly Hours of Market Work (includes travel to work)	Weekly Hours of Work in the Home (includes child care)
All married women	16.3	34.9
Full-time homemaker	—	41.0
With a part-time job	20.9	33.4
With a full-time job	38.6	24.6
All married men	39.1	12.8
With a full-time job	47.8	12.1

the home continue to spend a substantial amount of time on household tasks (25 hours per week). Married men, whether or not they hold a full-time job, work considerably fewer hours in the home. Although married women with full-time jobs spend nine hours less a week than married men on market work activities, their additional burden of household work gives them a total work load (home and market work combined) that exceeds that of married men or of women who are full-time homemakers or part-time workers.

The data shown in Table 2.2 refer to married men and women of all ages. Table 2.3 shows the allocation of time to work in the home among a cohort of youth aged 16 to 24 in 1981, reporting in the National Longitudinal Survey (NLS). The data are organized to indicate how housework time and responsibilities change as youth change their living arrangements and family situations, from residence with parents to living alone, to living with a spouse and children. The smallest gender differences in time spent on household chores exist between young women and men living alone; women in this situation spend only two hours more a week than men on household tasks. However, when living with parents, young women spend somewhat more time on household tasks than when living alone, whereas young men spend less time than when living alone (two hours less). Thus families seem to make more demands on their daughters than on their sons. When sons provide assistance with chores it is more likely to be on outdoor work or house repairs, activities that men are more likely to undertake in the market as well as in the home. This may reflect the passing on of societal norms, but may also reflect physical differences.

Marriage and children raise the home work inputs of both men and women, but the effect is much more dramatic for women, whether or not

TABLE 2.3
Time-Use Patterns for Household Chores and Child Care by Living Arrangements, Men and Women Aged 16 to 24 in 1981

| | Lives with Parents | | Lives Alone[1] | | Lives with Spouse and Children[2] | | | |
| | | | | | Male | | Female | |
	Male	Female	Male	Female	Wife Not Employed	Wife Employed	Not Employed	Employed
Hours spent per week on:								
Household tasks except children	7.3	11.9	9.4	11.5	11.7	13.1	34.5	25.4
Child care								
Dressing and feeding	—	—	—	—	6.2	5.6	24.7	19.3
Reading and playing	—	—	—	—	16.0	14.3	21.9	22.5
Other time in supervision	—	—	—	—	14.6	11.1	52.4	37.2
Degree of responsibility (scale of 1 to 5) for:[3]								
Meals	1.5	2.0	3.7	4.4	1.4	1.6	4.6	4.1
Laundry	1.5	2.5	3.8	4.7	1.4	1.4	4.8	4.6
Cleaning	1.8	2.8	4.1	4.7	1.6	1.8	4.7	4.4
Shopping	1.4	1.8	4.1	4.6	2.4	2.4	4.3	4.3
Outdoor chores	2.6	1.8	3.4	3.0	3.7	3.7	2.3	2.2
House repairs	2.6	1.6	3.8	3.4	4.0	4.2	2.0	1.9
Child care	—	—	—	—	2.3	2.5	4.7	4.1

SOURCE: National Longitudinal Survey as reported in Ronald d'Amico, "The Time-Use Behavior of Young Adults," in M. E. Borus, (Ed.), *Youth and The Labor Market* (Upjohn Institute for Employment Research, 1984).

NOTE: Hours can be reported for more than one activity in a given time period. Therefore, hours spent on specific childcare tasks or on household chores cannot be summed to obtain total hours spent on home work.

1. Excludes youth living in dorms or other group quarters.
2. Excludes full-time students.
3. The degree of responsibility for each chore was obtained by asking respondents to place themselves on a 5-point scale, in which a score of 1 = almost never does the chore and a score of 5 = has almost sole responsibility for this chore.

they are employed in the market. Employed women, as in the Michigan data, spend fewer hours at home chores (nine hours less) than women who are not employed, but still spend twice as much time on these tasks as their husbands. These NLS data also suggest that the wife's employment has only minimal effect on the husband's household responsibilities, as men with an employed wife only spend 1.4 hours a week more on household tasks than those with a wife who is a full-time homemaker. Moreover, the latter group spend more time on child care than husbands with employed wives. (However, families in which the wife is a full-time homemaker may simply have more children.) The child-care activity of "reading and playing" is of particular interest because it is one on which employed women spend slightly more time than full-time homemakers and on which men also spend a relatively large amount of time. Presumably this activity relates to the child's cognitive development and may therefore be regarded as particularly important. (Alternatively, or in addition, it may be regarded as leisure rather than work.)

In sum, the picture that emerges from the time-use data is that women remain responsible for most of the work in the home even though they may be employed in the market. The reduction in time spent on housework (as noted, the full-time homemaker worked 84 hours a week in 1900 and 41 hours a week in 1975) freed women's time for more market work and/or leisure. Although there is some evidence that married men increased their hours of work in the home by about 9 percent between 1965 and 1975 (Robinson, 1977), men remain specialized in market work, spending relatively little time on household chores. Even among husbands of women executives (vice presidents of companies with annual sales of $100 million or more) who were surveyed by the Wall Street Journal and The Gallup Organization, few assume full responsibility for home tasks (Rogan, 1984). Only 5 percent of the husbands assume full responsibility for children and 7-8 percent assume full responsibility for laundry and meals. But 30-70 percent of the executive women were solely responsible for child care and household tasks, depending on the task. Perhaps not surprisingly, 52 percent of all of the executive women are childless; 64 percent of the executive women under the age of 40 are childless. Although marriage and a demanding career are a more feasible combination for women now than in the past, it is still evidently no easy matter.

It is far simpler to describe the current patterns of time use than to explain them. Biological and environmental factors essentially dictated the division of labor by gender earlier in the century. But it is difficult to determine the extent to which these factors are still relevant. We may be

in a period of transition in which families are experimenting with the transfer of traditionally female activities to the market and to men. It is also possible that entrenched beliefs linger after they have outlived their basis in fact and may result in prejudiced treatment of daughters by their parents or prejudiced views of women in the labor market by employers, fellow workers, or consumers. Without resolving these questions the next section looks at the effect women's work experience and home responsibilities would have on their earnings.

Effects of Work Experience and Home Responsibilities on Earnings

What effect does women's smaller amount of work experience have on their earnings? The relationship between women's work experience, market investments, and earnings has been examined in a series of articles by Mincer and Polachek (1974) and Mincer and Ofek (1982). Theoretically, years of work experience are expected to increase earnings in part because a substantial amount of training occurs on the job (Mincer, 1962; Becker, 1975). During the training period wages are expected to be lower to compensate for the employer's monetary investment; after the training period the worker's new skills command a higher wage. Other investments that enhance earnings are also associated with time in the labor force: Job search may lead to information about higher paying job opportunities; job experimentation provides the worker and the employer a way to better match the worker's talents and tastes with the job and the firm.

In addition to the *number* of years in the labor force, several other aspects of women's work experiences are relevant for understanding the extent to which women's work experience is converted into higher pay. One factor is that women's employment is often discontinuous, and a long period of work interruption is associated with depreciation of the skills that may have been accumulated (Mincer & Polachek, 1974). Using actual longitudinal observations on earnings in the period before a work interruption and earnings after reentry, Mincer and Ofek find a significant decay in earnings associated with career breaks.

Another factor is that women who eventually spend a considerable number of years in the labor market did not anticipate that they would do so. Data from the National Longitudinal Survey illustrate the unrealistically low work expectations of women in their developing years. In 1968, only 32 percent of a panel of women aged 20-24 indicated that they expected to be in the labor market when they reached 35; but more than 60 percent were in fact in the labor force 10 years later when

the group reached 30-34 (O'Neill, 1983). If human capital investments are based on future work expectations, even women who eventually accumulate considerable work experience may have invested little because at younger ages they anticipated they would primarily be homemakers.

Expectations have been changing, however. Younger cohorts of women are more likely to anticipate a market career—among the group who reached age 25-29 in 1978, 77 percent responded that they intended to be in the labor market at age 35. Because they expect to remain in the market longer, the payoff to human capital investments would be increased. These young women in fact have shown signs of an increased rate of human capital investment. Their enrollment in college has been increasing more rapidly than men's, and women appear to be choosing more vocationally oriented training—medicine, law, business and engineering (O'Neill & Braun, 1981).

The way in which women's patterns of work investment and career interruptions may influence earnings is summarized in Figure 2.1. Line AB portrays the growth rate of wages for a continuous worker who had planned to work continuously. A worker who plans an interruption might take a job with initially higher earnings but with a lower training component so that the slope is flatter (CD). After a work interruption such as (EF), Mincer and Ofek find that women who return do so at a lower level of pay than their last wage, reflecting depreciation of skills. But women who return to the labor force seem to have firmer plans for the future and make more intensive investments. Therefore their earnings grow rapidly (as in HI). One may note that in a statistical analysis of the effect of experience on earnings in which some continuous workers with profiles like AB are mixed with large numbers of workers with interrupted profiles like CDEFHI, the effect of experience variables on earnings will not be fully comparable to that estimated in an equation for men who are virtually all continuous workers. The slope coefficient of experience for men will always be derived from an equation in which increases in age and experience coincide, whereas the experience coefficient for women will be derived from an equation in which age and experience interact in diverse ways, depending on the pattern of interruptions.

Perhaps a better comparison of men's and women's earnings would restrict the analysis only to those women with continuous participation. However, such a comparison may not fully adjust for differences in earnings growth based on differences in voluntary investment. As noted, some women who work continuously did not plan to do so initially. Thus some women may expect to spend some time out and start along a career path such as CDP, but with a change in marriage plans or other

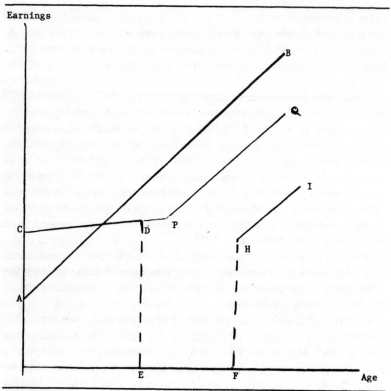

Figure 2.1

plans remain in the labor force. Although investment activities may increase at point P, when expectations are adjusted, and follow the path PQ, it may be too late to ever attain the earnings of the planned continuous worker, AB. However, other women who are balancing home and career may choose to remain in the labor force, taking less demanding jobs requiring less investment. Their earnings profiles would also be flatter than AB (but are not shown). As discussed below, however, reduced investments by women may also result from labor market discrimination, and it may be difficult empirically to distinguish between hypotheses.

Home Responsibilities, Gender Differences, and Job Characteristics

Because many women continue to be responsible for a dispropor-tionate share of household maintenance and child care even after they

enter employment, women may also evaluate certain job characteristics differently than men, which could have implications for their occupational choices as well as for their earnings. (See the analysis of the allocation of energy among household and market activities, the gender division of labor, and implications for gender differences in earnings in Becker, 1985). For example, some women may place a premium on a job with a workday and calendar year corresponding to the time children are in school or on flexible hours in more informal work settings. A shorter workday may make a long trip to work a poor investment; women working part-time may therefore place a premium on work located closer to home. In addition, the burden of household responsibilities may deter women from taking jobs requiring a considerable commitment of responsibility. In a study of the determinants of the male-female earnings differential in the Soviet Union (based on a sample of Soviet emigrees), Ofer and Vinokur (1983) concluded that it was the extremely uneven division of household work between husbands and wives that led Soviet wives into relatively undemanding and lower paying occupations, even though their labor force participation appears to be almost as high as that of men.

Tastes and physical and personality characteristics may also differ between men and women and create differences in occupational choice and possibly in earnings. The extensive but inconclusive psychological and physiological literature has explored gender differences in behavior manifested in childhood, arising from a combination of genetic endowment and social conditioning. In a review of studies (mostly of children) in the psychological literature, Maccoby and Jacklin (1974) found support for greater visual-spatial and mathematical abilities, energy expenditure, and aggressive behavior among boys and for greater verbal ability among girls. Some evidence has also been found for parental encouragement of sex-typed activities and behavior, ranging from choice of dolls and play activities to occupational aspirations.

Whether derived from nature or nurture, these differences are also reflected during high school and college in significant differences in the choice of subject matter. Although women have been greatly increasing their representation in nontraditional college subjects such as business, engineering, and law, they are still disproportionately overrepresented in education, English, and nursing. At the high school level, women are overrepresented in vocational courses such as secretarial subjects and home economics while men specialize in trade and industrial arts (O'Neill & Braun, 1981).

Physical differences (e.g., in weight and height) between men and women are likely to have been more important in influencing occupational differences in the past than they are today because of the lesser importance of manual labor in the economy.

What effect would differences in tastes and responsibilities have on earnings and the pay gap? Differences in tastes related to job characteristics would influence wages if workers on the whole found particular job characteristics to be desirable or undesirable. Some studies have attempted to estimate the magnitude of any "compensating wage differential" for such characteristics but with mixed results. Thaler and Rosen (1975) found evidence of a premium paid for hazardous work. O'Neill found that among blue-collar occupations those requiring lifting, outdoor work, or noisy conditions tended to pay more, other things the same, but the results were not as consistent as one might wish (O'Neill, 1983). This study did find, however, that men were much more likely to be in jobs with these characteristics than women. One recent study using longitudinal data finds stronger effects of working conditions on earnings (Duncan & Holmlund, 1983).

The payoff to individual effort, motivation, or responsibility has proven difficult to measure, although one expects these factors to be important.

Discrimination and Labor Market Barriers

Discrimination against women can lead to lower pay for women and higher pay for men even if men and women are identical with respect to labor market productivity. The theory of labor market discrimination developed by Gary Becker (1957) demonstrates that discrimination may arise even in competitive markets if employers are so strongly prejudiced against a group that they would employ them only at a discount, equivalent to the employer's "taste for discrimination"—the employer's disutility or psychic cost from employing the worker at all, or in a particular capacity.

Discrimination is not costless to the employer, however. If the group that is being discriminated against—suppose it is women—is equal in productivity to the preferred group—suppose it is men—an employer would increase the firm's money profits by hiring more women because women would have a lower wage rate. The "taste for discrimination" would therefore have to be strong for employers to continue indulging their prejudices. If more and more nondiscriminating employers were to enter the market, women's earnings would eventually be bid up and the gap due to discrimination would close. It is perhaps because market

forces do tend to erode discrimination that societies wishing to perpetuate particular forms of discrimination have sought to institutionalize it through legislation. For example, at one time in the United States, state laws restricted the economic and social mobility of blacks and kept women from working long hours, lifting heavy weights on the job, or pursuing occupations designated as hazardous. Thus unprejudiced employers were prevented from freely employing blacks and women.

In Becker's model, coworkers and customers may also be the source of discrimination, even if employers themselves have no prejudices. If male workers demand a premium to work with women, however, unprejudiced employers would have an incentive to operate segregated establishments because integration would be more expensive. In this case the wages of women and men with the same productivity would tend to be equalized, though they would work in different establishments. Consumer prejudice could lead to discriminatory pay differentials if consumers, for example, were willing to pay a premium for a male doctor, lawyer, or automobile salesperson. Again, if women and men were equally productive in these tasks, unprejudiced or less prejudiced consumers would have an incentive to switch to a woman, thereby increasing the demand and the pay of females in these jobs.

Although Becker's theory allows for discrimination in competitive markets it also suggests that competition would tend to reduce discrimination in the long run. To explain the persistence of a wage gap, some authors have developed the idea of statistical discrimination, in which employers may not be prejudiced, but may treat individual women as having the average characteristics of all women (Phelps, 1972; Arrow, 1973). Thus if women on average are believed to have lower productivity than men, employers might deny opportunities to individual women who are potentially more skilled than the average man (and presumably the reverse for those less skilled). The implicit assumption is that the cost of obtaining information about individuals would exceed the gain from better matching workers to jobs. Aigner and Cain (1977) question the empirical validity of this asumption. They also point out that if the employer's assessment of average female productivity is correct, then employers are not discriminating in an economic sense if they pay women less as a group. Moreover, if employers have mistakenly underestimated the average woman's productivity, competition would favor those employers who did not make the mistake and eventually eliminate the practice.

The acquisition of skills is to some extent under the control of employers who offer on-the-job training. Arrow (1973, 1976), Blau

(1977, 1983), and others have developed a theory of feedback discrimination, in which employers, by denying women training, ensure that women will in fact exhibit the characteristics they attribute to them. Thus if women are restricted to low-level jobs they will have high turnover, confirming the employer's prejudice. Although this feedback or "vicious circle" theory could explain why competitive forces might take longer to erode discrimination, it does not really explain how discrimination could be perpetuated indefinitely. If women did not in fact differ from men in work expectations, motivation, and labor force turnover, employers who trained women would gain at the expense of discriminating employers, and again competition would eventually raise women's pay to the level of men's.

Theoretical arguments suggest, therefore, that in basically competitive markets, forces are at work to erode discrimination. The extent to which this occurs depends, however, on the prevalence of the "taste for discrimination." It also depends on the strength of noncompetitive forces. Monopolies could use their monopoly profits to pay for discriminatory tastes. Monopsony—the case of a single dominant employer in the labor market—is not considered to be empirically important in modern times. As noted, overt barriers restricting women's choices were evident in the past, but have largely been eliminated. Thus the economic theory of discrimination provides a reason why discrimination might persist for a while, but it also provides reasons for optimism about the eventual erosion of discrimination.

EMPIRICAL EVIDENCE ON THE WAGE GAP

A growing body of econometric studies has investigated the extent to which differences in human capital investments and other characteristics can account for the earnings gap (see the reviews in O'Neill, 1984; Cain, 1984.) The studies use different data sources, refer to different populations, and control for many, but not always the same set of, variables. The gross earnings gap—defined as the difference between men's and women's earnings expressed as a percentage of men's earnings (before adjusting for skill and other factors)—also varies from study to study, depending on the type of population considered as well as on the measure of earnings used. Studies based on national samples of the entire working population most often show larger differentials. A gross hourly wage gap of about 35 percent is common for the United States in studies referring to the late 1960s and early 1970s. Studies based on more homogeneous populations, selected on a basis that narrows the skill

range, tend to start out with smaller gaps even before adjustment. Thus the gross wage gap is 22 percent among college faculty (Astin & Bayer, 1972), 16 percent among economists (Strober & Reagan, 1977), and 7 percent among persons with recent doctorates (Johnson & Stafford, 1974).

After accounting for the effects of gender differences in various explanatory factors, the earnings gap generally narrows but does not disappear. However, because of the difficulty of measuring and interpreting many of the variables believed to be important in explaining the wage gap, the studies tend to be inconclusive. Findings on the effects of work experience, schooling, and other measured variables are reviewed below, and interpretations of the explained and unexplained components of the gap are considered.

Work experience. As noted, men and women differ considerably in the amount of work experience they have accumulated over their lifetimes (refer to Table 2.1). This difference is expected to explain a significant portion of the wage gap, and it does, when direct data on lifetime work experience are available. Such data, however, are available in only a limited number of surveys. For example, the decennial census contains no information on total years of work experience. Some studies, lacking a direct measure of work experience, have tried to infer it with estimates of potential experience, a measure that is essentially based on age (or current age minus the age of leaving school). Such studies find little or no effect of "work experience" on the wage differential (Blinder, 1973; Oaxaca, 1973; Fuchs, 1971). But this is to be expected (and is recognized by the authors) considering that age or potential experience greatly overstate actual work experience for women, particularly at older ages, whereas for men, potential and actual experience closely correspond.

Differences in work experience are found to account for a substantial share of the wage gap in those studies which use longitudinal or retrospective information to measure actual years of labor market experience, the pattern and length of career breaks, and current job tenure (Mincer & Polachek, 1974; Corcoran & Duncan, 1979; O'Neill, 1983; Strober & Reagan, 1977; Gustafsson, 1981).

It has also been found (e.g., Mincer & Polachek, 1974; O'Neill, 1983) that the wage gap would be further reduced if account were taken of differences in the effect of work experience on wages—the coefficients of the work experience variables in wage equations.[2] In these studies men's earnings rise more rapidly per year of experience than women's. One interpretation of this relation is that women invest less intensively in

on-the-job training, job search, and other job-related investments because of home commitments and uncertainty about future years of market work. It has been argued, however, that such differences in investment rates are measures of labor market discrimination, not voluntary investment decisions (Blinder, 1973; Gronau, 1982). Thus employers may deny women entry into training programs or fail to promote them to higher levels of supervisory responsibility. If women were restricted to jobs in which advancement is unlikely, the observed lower investment would be a form of discrimination.

It is difficult to establish conclusively whether lower investment rates reflect discrimination or voluntary decisions. Some circumstantial evidence suggests that women do control the degree of investment in work skills. Thus investment rates vary at different stages of the life cycle in ways that are compatible with changes in home responsibilities. Investment rates have been found to be lower at ages corresponding to childbearing years or to years when children are young; but investment rates are high for married women after a return to the labor force (Mincer & Polachek, 1974; Mincer & Ofek, 1982; O'Neill, 1983). Those who do return to the labor force are more likely planning a sustained period of work and invest accordingly, whereas plans are likely to have been more uncertain in early years. Stronger work motivation may also be expected among those who have already made extensive investments in work-related schooling and other training. Thus higher work experience coefficients have been found for college educated women than for those with 12 years or less of schooling (O'Neill, 1983a; Mincer & Polachek, 1974). More direct evidence on the relation between work motivation and investment rates has been found by Sandell and Shapiro (1980), who show that women who planned to work at a younger age had steeper wage-experience profiles later on.

Schooling. Although the mean level of schooling does not differ significantly between women and men, the distribution of this schooling does differ by gender. Women are less likely than men to leave school before completing high school, but have also been less likely to complete college and university training. Thus women are more concentrated at the high school graduate level. However, several studies have found that women obtain a higher rate of return to college and university training than men, whereas men obtain a higher return to schooling than women at levels below college (Smith, 1979; O'Neill, 1983). It is possible, however, that these are not simply returns to education per se but also reflect selectivity factors. Women who expect careers are more likely to attend college.[3] Thus a variable measuring college training in an earnings function for women may be partly capturing motivation. The

high apparent returns to women that have been found to accrue in job training programs have also been attributed in part to selectivity bias (see, for example, Kiefer, 1979). Selectivity factors may also be important at education levels below the high school graduate level because labor force participation is relatively low for women with less education. Those who do participate may be unique with respect to motivation or ability, and these factors could counterbalance their low measured educational attainment. In this case failure to adjust for selectivity factors could give the appearance of low returns to additional schooling between zero and twelve years of schooling for women.

Differences in field of study in school may also affect gender differences in wages, although the data needed to investigate this are not commonly available. One study did find that women majoring in science at the college or university level received considerably higher earnings than other women (O'Neill, 1983). This result was obtained holding constant variables measuring work experience, years of schooling, degrees obtained, and other factors. Because such an effect was not found for men, one might conclude that unmeasured personal characteristics, such as career motivation, are correlated with science and have a strong effect on earnings.

Occupation and Nonwage Job Characteristics

Pronounced differences have been found in the occupational distributions of men and women in the United States as well as in other countries. To what extent do these differences actually affect earnings? Because occupation is an outcome measure like earnings, it is expected that many of the factors determining earnings will also influence occupation, such as the quantity and quality of schooling and training. However, some studies have found that even after controlling for the effect of human capital variables, occupation or job level appears to have an independent effect on earnings and sex differences in occupation can account for an additional component of the wage gap (Malkiel & Malkiel, 1973; Oaxaca, 1973; Ofer & Vinokur, 1981; O'Neill, 1983).

The interpretation of an occupational adjustment is controversial. Cain (1984) argues that such an adjustment should be regarded with caution because occupational assignments may be a mechanism for discrimination. However, as noted, women may choose different occupations than men because of differences in career expectations and in the priority placed on home responsibilities. In addition women and men may evaluate job characteristics differently because of differences in culturally determined attitudes and in physical ability for performing certain tasks.

It is difficult to obtain quantitative measures of discriminatory barriers to entry into occupations or of nonwage job characteristics and the attitudes of individuals. Some fragmentary data suggest that women's occupational selection is related to early plans and expectations about their future roles in regard to career and family. Blakemore and Low (1984) find that factors such as expected labor force absences (measured by expected fertility) and work orientation explain a sizable amount of the male-female difference in college major. Moreover, their findings suggest that the subjects chosen by women with high fertility expectations are those that are less subject to the obsolescence that would occur during periods of labor force withdrawal (see McDowell, 1982). O'Neill (1983), in an analysis of other (longitudinal) data, finds a strong relation between expectations about future career/home roles and eventual occupations held.

The relation found between the atypicality of a woman's occupation and her actual (as opposed to expected) work experience is more complex. Analysis of the NLS data (O'Neill, 1983; England, 1982) has shown that women who work more continuously are actually more likely to be in female occupations. England interprets this finding as evidence that human capital factors fail to explain job segregation. Another interpretation is that traditionally female occupations are characterized by working conditions that make it easier to combine home responsibilities and work; therefore women employed in these occupations need not leave their jobs during periods when home responsibilities become more demanding (e.g., when they have small children at home). Consistent with this explanation is the observation (O'Neill, 1983) that the positive association between continuity of work experience and the "femaleness" of an occupation holds only for married women, not for unmarried women who have fewer household responsibilities.

Data show that predominantly female occupations are much more likely to offer part-time work and less likely to require a work week of excessively long hours (O'Neill, 1983; Shaw, 1983). Direct measures of stressful work, job responsibility, or the actual effort and motivation of individuals were understandably more difficult to obtain and do not seem to have been incorporated into any empirical studies of occupational choice or the wage gap (see, however, the analysis of Becker, 1985).

Evidence on environmental characteristics of jobs shows that predominantly female occupations are less likely to have characteristics that would more commonly be considered a disutility, for example, exposure to hazardous work, heavy lifting, excessive noise, and outdoor

work. As noted, these characteristics were found to be only weakly related to earnings and, therefore, contributed only a small share to the measured wage gap (O'Neill, 1983). Because of the inherent difficulties of measuring nonwage job characteristics, these results cannot be regarded as conclusive.

In sum, women and men may evaluate job characteristics differently because of differences in their roles in the home. Characteristics related to the time and energy demands of jobs have been difficult to quantify. Thus a variable denoting occupation or job level may serve as a proxy for these intangible characteristics. Although there is some evidence that women choose their occupations, a role for discriminatory behavior of employers cannot be ruled out. If women's access to certain occupations were restricted because of discriminatory hiring and promotion policies, women's choices would likely be affected. I wonder, however, whether barriers that depend on elusive employer prejudices would be sustained over long periods when employers have a substantial pecuniary gain from accepting women and women have a real gain from entering the occupation. Borrowing from U.S. history one can in fact find several examples of job categories that changed gender over time. For example, at one time, secretary, bookkeeper, and telephone operator were "male jobs." Where analyses of the economic circumstances of the jobs have been conducted (see Goldin, 1984, on clerical work), the results have suggested that changes in the economic circumstances that made the occupations more attractive to women were quickly followed by women's entry into the occupation, even if men had earlier dominated the occupation.

CONCLUDING COMMENTS

A large share of the gross earnings gap between men and women stems from differences in lifetime labor market experience, both in terms of the sheer amount of hours and weeks spent in the labor force and in the amount of planned investment made in acquiring labor market skills and information. Even after controlling for these and other measurable characteristics that affect earnings, an unexplained residual remains of about 10 to 20 percent. As Mincer has noted (1979), the residual should be viewed "as a measure of our ignorance."

Identifying the villain in this gray area is difficult to do with available data and standard social science tools. Some or all of the unexplained differential may be attributable to discriminatory treatment of women in the labor market. Moreover, some of the explained portion, such as

labor market experience, may also be attributed to discrimination if women's work incentives have been affected (but this would be past discrimination, not necessarily current discrimination).

On the other hand, the unexplained residual may reflect unobserved gender differences in labor market productivity that stem from the division of labor in the home. Women still have the primary responsibility for maintaining the home and child rearing, and this responsibility imposes restrictions on the type of market career the average woman can pursue. Thus, in a study of the wage gap in a single firm, Malkiel and Malkiel (1973) found that a variable denoting job level could explain virtually all of the remaining 12 percent difference in pay between women and men (after accounting for a wide array of human capital variables). But it could not be determined whether women voluntarily chose jobs with smaller demands on their time and energy or were barred from advancing to jobs with greater responsibility.

The uncertain results of the studies leave an uncertain role for policy. Overt discrimination in pay and promotion is now against the law. Women who believe they have been unfairly treated, therefore, do have legal recourse. Barriers to advancement that operate in a more elusive way—for example, through harassment or through exclusion from informal interaction—are more difficult to remedy through legislation. Efforts by government to monitor all hiring and promotion would impose intrusions that a free society would have difficulty accepting. However, competition in the economy imposes financial costs on prejudiced employers, so that self-correcting mechanisms are at work.

Some signs of change have been observed in the past decade with respect to women's earnings prospects. Women have been increasing their schooling at the college and university level and have been marrying later and working longer. The gender gap in wage rates has perceptibly declined among persons under the age of 35 in the United States. There is also evidence in the United States of an increase in the rate of return women receive from work experience, suggesting that a narrowing in the wage gap should occur over the next decade.

NOTES

1. These statistics are calculated from age-specific mortality rates from the State of Massachusetts from *Historical Statistics of the United States.*

2. In many studies the adjusted wage gap is based on estimates that show what women's wage rates would be if they had men's characteristics but obtained the female increment in pay for a given change in the characteristic. The additional adjustment would take into account the higher male increment in pay associated with a change in the characteristic (if the male increment is in fact higher).

3. The National Longitudinal Survey young women's panel shows that among employed women 24 to 34 years of age in 1978, 50 percent of those with 12 years of schooling or less 5 years earlier had indicated that they expected to be a homemaker at age 35; the figure was only 27 percent for college graduates.

REFERENCES

Aigner, D. J., & Cain, G. C. (1977). Statistical theories of discrimination in the labor market. *Industrial and Labor Relations Review, 30*(2), 175-187.

Arrow, K. J. (1973). The theory of discrimination. In O. Oshenfelter & A. Rees (Eds.), *Discrimination in labor markets*. Princeton, NJ: Princeton University Press.

Arrow, K. J. (1976). Economic dimensions of occupational segregation: Comment. *Signs, 1*(3).

Astin, H. S., & Bayer, A. E. (1972). Sex discrimination in academe. *Educational Record,* 101-118.

Becker, G. S. (1957). *The economics of discrimination.* Chicago: University of Chicago Press.

Becker, G. S. (1975). *Human capital.* New York: Columbia University Press.

Becker, G. S. (1981). *A treatise on the family.* Cambridge, MA: Harvard University Press.

Becker, G. S. (1985). The allocation of effort, specific human capital and differences between men and women in earnings and occupations. *Journal of Labor Economics, 3*(1).

Bergmann, B. (1974). Occupational segregation, wages and profits when employers discriminate by race or sex. *Eastern Economic Journal, 1,* 103-110.

Blakemore, A. E., & Low, S. A. (1984). Sex differences in occupational selection: The case of college majors. *Review of Economics and Statistics, 66*(1), 157-163.

Blau, F. D. (1977). *Equal pay in the office.* Lexington, MA: D.C. Heath.

Blau, F. D. (1983). Discrimination against women: Theory and evidence. In W. A. Davitz, Jr. (Ed.), *Labor economics: Modern views.* Boston: Martinus Nijhoff.

Blinder, A. (1973). Wage discrimination: Reduced form and structural estimates. *Journal of Human Resources, 8.*

Cain, G. (1984). *The economic analysis of labor market discrimination: A survey.* Unpublished manuscript, University of Wisconsin-Madison.

Corcoran, M., & Duncan, G. J. (1979). Work history, labor force attachment, and earnings differences between the races and sexes. *Journal of Human Resources, 14.*

Duncan, G. J. & Holmlund, B. (1983). Was Adam Smith right after all? Another test of the theory of compensating wage differentials. *Journal of Labor Economics, 1*(4).

England, P. (1982). The failure of human capital theory to explain occupational sex segregation. *Journal of Human Resources, 17*(3), 358-370.

Fuchs, V. (1971). Differences in hourly earnings between men and women. *Monthly Labor Review, 94,* 9-15.

Fuchs, V. (1974). Recent trends and long-range prospects for female earnings. *American Economic Review, 64.*

Goldin, C. (1983, December). *Life-cycle labor force participation of married women: Historical evidence and implications.* NBER Working Paper No. 125.

Goldin, C. (1984a). *The historical evolution of female earnings functions and occupations: Explorations in economic history.* Unpublished manuscript, University of Pennsylvania, Philadelphia.

Goldin, C. (1984b). The earnings gap in historical perspective. In U.S. Commission on Civil Rights, *Comparable worth: Issue for the 1980s* (Vol. I).

Gronau, R. (1982). *Sex-related wage differentials and women's interrupted careers: The chicken or the egg?* Cambridge, MA: National Bureau of Economic Research.

Gustafsson, S., & Jacobson, R. (1981). Male-female lifetime earnings differentials and labor force history. In Eliasson, Holmwood, & Stafford (Eds.), *Studies in labor market behavior in Sweden and the United States*. Stockholm: IUI.

Gustafsson, S., & Jacobson, R. (1983, June). *Trends in women's work, family formation and earnings in Sweden*. Paper presented at the Conference on Trends in Women's Work, Education and Family Building, The White House Conference Center, Chelwood Gate, Sussex, England.

Hill, M. S. (1981). *Patterns of time use*. Unpublished manuscript, Survey Research Center, University of Michigan.

Johnson, G. E., & Stafford, F. P. (1974). The earnings and promotion of women faculty. *American Economic Review, 64*, 888-903.

Kiefer, N. M. (1979). Training programs and the employment and earnings of black women. In C. B. Lloyd, E. S. Andrews, & C. L. Gilroy (Eds.), *Women in the labor market*. New York: Columbia University Press.

Lebergott, S. (1976). *The American economy: Income, wealth and want*. Princeton, NJ: Princeton University Press.

Malkiel, B. G., & Malkiel, J. A. (1973). Male-female pay differentials in professional employment. *American Economic Review, 63*(4).

McDowell, J. M. (1982). Obsolescence of knowledge and career publication profiles: Some evidence of differences among fields in costs of interrupted careers. *American Economic Review, 72*(4), 752-768.

Mincer, J. (1962). Labor force participation of married women: A study of labor supply. In *Aspects of labor economics*. Princeton: Princeton University Press.

Mincer, J. (1979). Comment. In C. B. Lloyd, E. S. Andrews, & C. L. Curtis (Eds.), *Women in the labor market*. New York: Columbia University Press.

Mincer, J., & Ofek, H. (1982). Interrupted work careers: Depreciation and restoration of human capital. *Journal of Human Resources, 17*(1), 3-24.

Mincer, J., & Polachek, S. (1974). Family investments in human capital: Earnings of women. *Journal of Political Economy, 2*.

Oaxaca, R. (1973). Male-female differentials in urban labor markets. *International Economic Review, 14*.

Ofer, G., & Vinokur, A. (1981). Earnings differentials by sex in the Soviet Union: A first look. In S. Rosefield (Ed.), *Economic welfare and the economics of Soviet socialism: Essays in honor of Abram Bergson*. Cambridge, MA: Cambridge University Press.

Ofer, G., & Vinokur, A. (1983, June). *The labor force participation of married women in the Soviet Union*. Paper presented at Conference on Trends in Women's Work, Sussex, England.

O'Neill, J. (1983). *The determinants and wage effects of occupational segregation*. Washington, DC: The Urban Institute.

O'Neill, J. (1984). Earnings differentials: empirical evidence and causes. In G. Schmid & R. Weitzel (Eds.), *Sex discrimination and equal opportunity*. Hampshire, England: Gower.

O'Neill, J. (1985). The trend in the male-female pay gap in the United States. *Journal of Labor Economics, 3*(1).

O'Neill, J., & Braun, R. (1981). *Women in the labor market: A survey of issues and policies in the United States*. Washington, DC: The Urban Institute.

Oppenheimer, V. (1970, November 5). *The female labor force in the United States*. Population Monograph Series. Berkeley: University of California Press.

Phelps, E. S. (1972). The statistical theory of racism and sexism. *American Economic Review, 62*, 659-661.

Robinson, J. P. (1977). *Changes in Americans' use of time, 1965-1975: a progress report.* Cleveland State University: Communications Research Center.

Rogan, H. (1984, October 30). Executive women find it difficult to balance demands of job, home. *Wall Street Journal.*

Sandell, S. H., & Shapiro, D. (1980). Work expectations, human capital accumulation and the wages of young women. *Journal of Human Resources, 15,* 335-353.

Schultz, T. P. (1978). Fertility and child mortality over the life cycle: Aggregate and individual evidence. *American Economic Review, 68*(2).

Shaw, L. B. (1983, April). *Does working part-time contribute to women's occupational segregation?* Paper presented at the annual meetings of the Midwest Economics Association, St. Louis, MO.

Smith, J. P. (1979). Convergence to racial equality in women's wages. In C. B. Lloyd, E. S. Andrews, & C. L. Gilroy (Eds.), *Women in the labor market.* New York: Columbia University Press.

Smith, J. P., & Ward, M. P. (1983, June). *Time series changes in the female labor force.* Paper presented at the Conference on Trends in Women's Work, Education and Family Building, Sussex, England.

Thaler, R., & Rosen, S. (1975). The value of saving a life: Evidence from the labor market. In N. E. Terleckyj (Ed.), *Household production and consumption.* New York: Columbia University Press.

3

The Persistence of
Pay Differentials

THE ECONOMICS OF SEX DISCRIMINATION

JANICE FANNING MADDEN

This review critically examines the empirical and theoretical economic research regarding labor market sex discrimination. The first section focuses on empirical studies of the sex-wage differential in the United States, while the second section reviews three alternative approaches to explain pay differentials. The final discussion suggests the implications of this research for government policies concerning employment discrimination.

Economists consider a sex differential in wages to be discriminatory if the differential cannot be explained by sex differences in productivity. Economists have studied sex discrimination in two principal ways: (1) They have conducted numerous statistical studies adjusting for sex differences in productivity to verify their existence and to measure the extent and the sources of discrimination; and (2) they have developed analytical models of the labor market that attempt to explain the existence of sex discriminatory outcomes in U.S. labor markets.

No statistical study has been able to explain the major part of the sex-wage differential by differences in productivity. No analytical model has demonstrated convincingly how sex discrimination in the labor market can persist. Consequently, both proponents and opponents of government intervention in the labor market find support for their

AUTHOR'S NOTE: The comments and suggestions of Barbara Bergmann, Francine Blau, Clair Brown, Glen Cain, Marianne Ferber, Clifford Hawley, Jerry Jacobs, and an anonymous referee have improved this chapter immensely. I am solely responsible for any errors or omissions that remain.

positions in economic research. The proponents of government intervention base their case on the empirical research that is uniformly consistent with both extensive and persistent sex discriminatory differences in the labor market. Opponents argue that these empirical studies are not convincing because they cannot adjust fully for the effects of less tangible sources of wage differentials, such as motivation, innate ability, or personality, and because no labor market theory can give a convincing explanation of the persistence of sex discrimination.

This chapter critically reviews the state of both the empirical and theoretical economic research on sex discrimination in the labor market.[1] The first section considers the analytical problems posed by the question of whether sex differences in pay are discriminatory, explains the methodologies commonly used to answer the question, and summarizes and evaluates the results of empirical studies of the sex-wage differential in the United States. The second section reviews three different basic approaches to explaining the motivation for and, thus, the existence of discriminatory pay differentials. Each approach is evaluated in terms of its predictive ability. The three approaches or motivations for discrimination that are reviewed include: (1) Personal prejudices of employers, consumers, or coworkers; (2) a judgment (which is sound in economic efficiency terms) of individual workers by the average characteristics for their group; and (3) a profit maximizing action by employers or coworkers who can exert control in the labor market. The chapter concludes with a discussion of the implications of this research for government policies on employment discrimination policies.

DETERMINING WHETHER THE SEX-PAY DIFFERENTIAL IS DISCRIMINATORY

Conceptual Problems with Measuring Discrimination

In the simplest terms, women are paid less than men either because they are women (i.e., discrimination) or because they are less productive. This simple dichotomy suggests a straightforward approach to defining and measuring discrimination: Sex discrimination in pay is the difference in wages between men and women with the same level of physical productivity.

Potential Interaction Between Productivity Level and Discrimination

Unfortunately, this dichotomy is complicated because differences in physical output by sex may be the result of discrimination. The amount

of output produced by any worker is affected by the worker environment: the technology of production, the preferences of consumers, and both the opportunities to learn on the job and the rewards for such learning that are provided by employers and/or coworkers. Consideration of each of these factors complicates the determination of whether a differential is due to discrimination or productivity.

Technology of production. The technology of production includes both the physical and organizational structure of the job. Jobs that have been historically male are often "organized" around male characteristics. To illustrate this point, consider the following "hypothetical" examples:

(1) Climbing rungs on telephone poles are spaced to facilitate the climb of a 5'9" person weighing 150 pounds—the physical dimensions of the average male worker. A 5'4" person weighing 120 pounds—the physical dimensions of the average female worker—would have more difficulty climbing and thus would be less productive as a lineman. Women, in this case, are less productive because equipment has not been designed for their use. If the equipment were designed for women's physical dimensions, they would be more productive.

(2) Sports reporters have traditionally followed winning teams into the locker room to obtain those emotional "after the game" interviews. This custom developed in a world where male reporters covered male team competition. When the sports reporter is a female, players and clubs have tried to bar her entrance to the locker room claiming a violation of the male players' rights to privacy. Barring female sports reporters from these interviews makes their reporting less interesting to readers and therefore lowers their productivity. The problem is that the entire ritual of "after the game" interviews in the locker room could develop only because sportswriters were men. If there always had been female sports reporters and if male players wanted their privacy protected, a different protocol for "after the game" interviews would be developed.

If jobs are physically designed to make men more productive than women or if jobs are organized in such a way that women cannot be as productive as men, sex discrimination has occurred. In this case, women with the same productive capacity are not able to exercise that capacity because of the design of the work place. Under a different design, women would be at least equal to men in productivity.

Consumer preferences. Consumers who do not want to be served by women in some (or all) situations involving more skilled jobs such as lawyers, professors, and consultants will behave as if women are less able to provide the service—even when they are, in fact, equally able. (All of this is complicated further by measurement questions of sorting out differences in actual quality of service from differences in perceived

positions in economic research. The proponents of government intervention base their case on the empirical research that is uniformly consistent with both extensive and persistent sex discriminatory differences in the labor market. Opponents argue that these empirical studies are not convincing because they cannot adjust fully for the effects of less tangible sources of wage differentials, such as motivation, innate ability, or personality, and because no labor market theory can give a convincing explanation of the persistence of sex discrimination.

This chapter critically reviews the state of both the empirical and theoretical economic research on sex discrimination in the labor market.[1] The first section considers the analytical problems posed by the question of whether sex differences in pay are discriminatory, explains the methodologies commonly used to answer the question, and summarizes and evaluates the results of empirical studies of the sex-wage differential in the United States. The second section reviews three different basic approaches to explaining the motivation for and, thus, the existence of discriminatory pay differentials. Each approach is evaluated in terms of its predictive ability. The three approaches or motivations for discrimination that are reviewed include: (1) Personal prejudices of employers, consumers, or coworkers; (2) a judgment (which is sound in economic efficiency terms) of individual workers by the average characteristics for their group; and (3) a profit maximizing action by employers or coworkers who can exert control in the labor market. The chapter concludes with a discussion of the implications of this research for government policies on employment discrimination policies.

DETERMINING WHETHER THE SEX-PAY
DIFFERENTIAL IS DISCRIMINATORY

Conceptual Problems with Measuring Discrimination

In the simplest terms, women are paid less than men either because they are women (i.e., discrimination) or because they are less productive. This simple dichotomy suggests a straightforward approach to defining and measuring discrimination: Sex discrimination in pay is the difference in wages between men and women with the same level of physical productivity.

Potential Interaction Between Productivity Level
and Discrimination

Unfortunately, this dichotomy is complicated because differences in physical output by sex may be the result of discrimination. The amount

of output produced by any worker is affected by the worker environment: the technology of production, the preferences of consumers, and both the opportunities to learn on the job and the rewards for such learning that are provided by employers and/or coworkers. Consideration of each of these factors complicates the determination of whether a differential is due to discrimination or productivity.

Technology of production. The technology of production includes both the physical and organizational structure of the job. Jobs that have been historically male are often "organized" around male characteristics. To illustrate this point, consider the following "hypothetical" examples:

(1) Climbing rungs on telephone poles are spaced to facilitate the climb of a 5'9" person weighing 150 pounds—the physical dimensions of the average male worker. A 5'4" person weighing 120 pounds—the physical dimensions of the average female worker—would have more difficulty climbing and thus would be less productive as a lineman. Women, in this case, are less productive because equipment has not been designed for their use. If the equipment were designed for women's physical dimensions, they would be more productive.

(2) Sports reporters have traditionally followed winning teams into the locker room to obtain those emotional "after the game" interviews. This custom developed in a world where male reporters covered male team competition. When the sports reporter is a female, players and clubs have tried to bar her entrance to the locker room claiming a violation of the male players' rights to privacy. Barring female sports reporters from these interviews makes their reporting less interesting to readers and therefore lowers their productivity. The problem is that the entire ritual of "after the game" interviews in the locker room could develop only because sportswriters were men. If there always had been female sports reporters and if male players wanted their privacy protected, a different protocol for "after the game" interviews would be developed.

If jobs are physically designed to make men more productive than women or if jobs are organized in such a way that women cannot be as productive as men, sex discrimination has occurred. In this case, women with the same productive capacity are not able to exercise that capacity because of the design of the work place. Under a different design, women would be at least equal to men in productivity.

Consumer preferences. Consumers who do not want to be served by women in some (or all) situations involving more skilled jobs such as lawyers, professors, and consultants will behave as if women are less able to provide the service—even when they are, in fact, equally able. (All of this is complicated further by measurement questions of sorting out differences in actual quality of service from differences in perceived

quality.) Discriminatory consumers demand fewer services/sales from women. Thus firms who sell to sex discriminatory customers get less revenue when they employ women. If the firms, in turn, hire men rather than equally able women (who produce less revenue), sex discrimination in the labor market has occurred, although consumers are the cause.

Employer-influenced characteristics. Some worker characteristics are clearly productivity-related but employers or the marketplace influence which workers possess these characteristics. For example, employers and coworkers control access to on-the-job training. If women's productivity is lower because they have less of the "right" kind of on-the-job training or work experience, the wage differential is due to the discrimination of employers and coworkers. Clearly, the quality of experience attained is an effect of sex differences in labor market opportunities and rewards. Similarly, sex differences in job tenure itself may reflect the smaller rewards (promotion possibilities) awarded women's tenure (Blau & Kahn, 1981; Ragan & Smith, 1981; Viscusi, 1980).

Unobserved Productivity

Most firms do not keep records of an employee's productivity. In fact, for the large majority of jobs in the United States, quality is such an important component of productivity that the physical output of an employee would be very difficult, if not impossible, to measure directly. For this reason, economists measure the productivity-related characteristics of workers, rather than productivity itself. These productivity characteristics include a worker's stock of *human capital,* the investments in education and experience that make a worker more productive, as well as attributes such as innate ability, promptness, and motivation.

So now our simple method for measuring the contribution of discrimination to the sex-wage differential has become yet more complicated. Rather than comparing the wages of men and women who produce at the same rate, the wages of men and women with the same productivity-related characteristics are compared. This is more complicated because argreement on both the characteristics to include and how much each characteristic contributes to productivity is required.

Measurement Problems

Even if it were possible to determine the characteristics that actually are productivity-enhancing and to quantify their contribution to productivity, it would then be necessary to measure sex differences in these characteristics in order to adjust the sex earnings differential. Several characteristics are observable to the social scientist and the

employer: level of education, years of work experience, job tenure, hours worked per week, absenteeism, and tardiness. However, other characteristics are difficult, if not impossible, for the social scientist to measure, although they may be observed by the employer: motivation or attitude and other relevant aspects of personality, innate ability or intelligence, dependability, strength, and so forth. The true or actual productivity is seldom observed by either the social scientist or the employer.

There can be no question with respect to comparisons of individuals that: (1) there remains substantial variation in productivity across individuals with equivalent education, work experience, and work hours; and (2) this variation is due in part to unmeasured factors such as innate ability, motivation, personality, and so forth. These conclusions for individual comparisons may not be relevant to comparisons of the relative productivity of groups of individuals with the same objective characteristics. When aggregated into groups with equivalent characteristics, individual variations are averaged out. Unless there is some reason to presume that women as a group have inferior innate ability, motivation, or personality relative to men *with the same objective characteristics*—such as education, experience, and work hours—these unmeasured factors cannot explain the sex differential.

If there is some credible basis to a presumption of systematic female inferiority with respect to unmeasured characteristics, social scientists cannot control for these factors with the methods described below. As long as there are unmeasured worker characteristics that are plausibly productivity-enhancing, and not correlated with measured characteristics, it will never be possible to attribute a sex-wage differential to discrimination with certainty; that is, we can never dismiss the possibility that there are sex differences in an unmeasured characteristic such as motivation that fully account for the wage differences. Alternatively, the unmeasured characteristics could create yet greater sex differences, or the measured characteristics might overcompensate if they are partially the result of discrimination. The point is that the social scientist simply cannot establish either the presence or the absence of sex discrimination with statistical certainty when there are unobserved qualifications that affect wages.

Empirical Methods Used to Measure Discrimination

Empirical work by economists has concentrated on measuring and accounting for sex differentials in productivity. The basic procedure used in empirical investigations of sex discrimination is to determine the

magnitude of the pay differential after adjusting for quantifiable sex differences in productivity-enhancing characteristics. Two approaches have been used by economists: (1) multivariate regression analysis and (2) standardization of characteristics using a frequency distribution or tabulation. Each technique is described in more detail below.

Multivariate Regression Analysis

The primary technique used by economists to control for sex differences in productivity is an ordinary least squares regression estimation of the form:

$$Y = \beta_0 + \beta_1 X_1 + \beta_2 X_2 + \ldots + \beta_n X_n, \qquad [1]$$

where Y is the (natural logarithm of) worker's earnings and X_1 through X_n are the worker's characteristics including human capital and other potential productivity-related factors. The regression coefficients, β_i, measure the effect of each worker characteristic (X_i) on earnings after adjusting or controlling for the effects of the other characteristics included in the regression. The statistical significance of the regression coefficient tests whether the characteristic is related to earnings. As it is possible for a characteristic to be related to earnings and not be associated with productivity (i.e., if a bank required all supervisors to be able to run a four-minute mile, running speed would be significantly associated with promotion and, hence, earnings, but of questionable productivity value on its face), this test is a necessary but not sufficient test to establish the productivity-enhancing value of a characteristic.

The conventional approach to decomposing the pay differential into a productivity and a discriminatory component (Blinder, 1973; Oaxaca, 1973a, 1973b) is to: (1) Estimate the regression coefficients β separately for men (β^M) and women (β^F); and (2) use these estimates to compute the following:

$$Y^M - Y^F = (\overline{X}^M - \overline{X}^F)\, \beta^M + (\beta^M - \beta^F)\, \overline{X}^F \qquad [2]$$

where \overline{X}^M and \overline{X}^F are the mean value of productivity-related characteristics for men and women workers. The first term, $Y^M - Y^F$, is (the natural logarithm of) the ratio of the pay differential by sex (because Y is a natural logarithm); the second term, $(\overline{X}^M - \overline{X}^F)\, \beta^M$, is the pay differential due to productivity (i.e., sex differences in the productivity-related characteristics by sex); the third term, $(\beta^M - \beta^F)\, \overline{X}^F$, is the pay

differential due to discrimination (i.e., sex differences in the pay attributed to the same characteristics).

Another regression approach is to include both men and women workers in the statistical estimation of Equation (1) and to include sex as a worker characteristic. The regression coefficient for sex measures the approximate percentage effect of sex on wages after adjusting for the effect of the other characteristics included in the regression equation.[2] This approach differs from the previous one in that it weights the wage value of each productivity-enhancing characteristic according to the average for both men and women workers; the former approach uses the male weights only. The former approach implies the male structure is the nondiscriminatory norm. The latter implies that the aggregate structure is the nondiscriminatory norm.

Recently, some authors have suggested that the regression techniques just described result in an upward bias in the estimate of the sex discriminatory differential if women are on average less qualified than men (Roberts, 1980, pp. 177 and 188; Kamalich & Polachek, 1982, p. 460). They propose reverse regression as an alternative approach to yield an unbiased estimate of discrimination. In reverse regression, wages and sex are placed on the right-hand side of the regression and measures of qualifications are placed on the left-hand side. It is argued that discrimination has occurred if the resulting estimate of the coefficient of sex is positive; that is, women earning equivalent wages to men have a greater level of qualification. Kamalich and Polachek present an empirical analysis in which direct regression results in significant discrimination in pay against women, whereas reverse regression on the same data results in no discrimination against women. The two techniques yield different results because the analysis is stochastic; that is, the relationships between variables are not deterministic.

Goldberger (1984) has carefully reviewed the scientific case for the use of direct regression and reverse regression in the measurement of the discriminatory differential. He convincingly demonstrates that direct regression is not inherently biased toward finding discrimination (as the advocates of reverse regression claim) and that the circumstances under which reverse regression yields an unbiased estimate of discrimination are quite limited and certainly do not apply to the few cases in which reverse regression has been applied.

Frequency Distribution or Tabular Standardization

An alternative approach to regression analysis is to sum pay differentials across homogeneous subgroupings of the male and the female labor force. The productivity adjusted sex pay differential is:

(text continues on page 86)

TABLE 3.1

Summary of Studies of Ratios of Women's Earnings to Men's Earnings, Unadjusted and Adjusted for Various Characteristics of Workers and Jobs

Author and Year of Publication[a]	Data Sources and Population Studied[b]	Measure of Earnings[c]	Statistical Method and Explanatory Variables[d]	Women's Earnings as a Percentage of Men's Observed[e]	Adjusted[f]	Percentage Explained[g]
Blinder (1973)	PSID, white working household heads and spouses, age 25+	w, 1969	R,S: 2,(3),9,12-14, 32,34	56	56	0
Gwartney and Stroup (1973)	Census, age 25+, full-time, year-round workers	ann. ȳ, 1959	R: 1,2,(10)	56	58	4
	all with positive incomes	ann. ȳ, 1959, ann. ȳ, 1969	R: 1,2 (grouped data)	33, 32	39, 40	9, 12
Kohen and Roderick (1975)	NLS, full-time wage and salary workers, age 18-25, white, black	w, 1968-1969	R,S: 1(2),(3),4, 7-9, 13-15	76, 82	78, 81	8, 6
Fuchs (1971)	Census (1/1000 sample), nonfarm workers	w, 1959	R: 1,2,3,8,12, 25,33	60	66	15
Featherman and Hauser (1976)	OCG, married workers	ann. y, 1961 and 1972	R,S: 1,(2),7,(8), 10,23	38	48	16*
Sawhill (1973)	CPS, wage and salary workers, age 14+	ann. y, 1966	R: 1,3,10,13	46	56	18
Oaxaca (1973b)	SEO, urban workers, age 16+: white, nonwhite	w, 1967	R,S: 1(2),(3), 7-10, 12,13	65, 67	72, 69	20, 6
Roos (1981)	GSS, white workers, age 25-64	ann. y, 1974-1977	R,S: 1,2,(3),10,22, 23,26,29-31	46	63	31*

(continued)

83

TABLE 3.1 Continued

Author and Year of Publication[a]	Data Sources and Population Studied[b]	Measure of Earnings[c]	Statistical Method and Explanatory Variables[d]	Women's Earnings as a Percentage of Men's		Percentage Explained[g]
				Observed[e]	Adjusted[f]	
Blinder (1973)	PSID: white, working house-heads and spouses, age 25+	w, 1969	R,S: 1,2,(3),5,9, 11-14,21,27,32,34	54	70	35*
Cohen (1971)	Survey of working conditions, full-time nonprofessional wage and salary workers, age 22-64	ann. y, 1969	R,S: 1,2,10,11,16, 24,27,28	55	71	36
Filer (1983)	Private data from national clientele of management of consulting firm	monthly y, 1967-77	R,S: 1-4,6,8,11,14, 15,35,36	64	77	37
Suter and Miller (1973)	NLS, CPS wage and salary workers, age 30-44	ann. y, 1960	R,S: 1,(2), 6,10,23	39	62	38*
Oaxaca (1973b)	SEO, urban workers, age 16+ white nonwhite	w, 1967	R,S: 1,(2),3,7-10,12, 13,21,25-27	65 67	78 80	37* 39*
Mincer and Polachek (1974)	NLS, SEO, white wage and salary workers, age 30-44 married single	w, 1967	R,S: 1,(2),(3),6, (8),11	66 86	80 87	41 7
Treiman and Terrell (1975)	NLS: married workers, age 30-44: white nonwhite	ann. y, 1966	R,S: 1,(2),(3),6,7, (8),10,17,22	42 54	67 68	43 30
Sanborn (1964)	Census, wage and salary workers	ann. \bar{y}, 1949	F: 1-3, 10, 18, 20	58	76	43*
Corcoran and Duncan (1979)	PSID, married workers, age 18-64, white	w, 1975	R,S: 1,(2),(3),5,6, (8),9,11-13,17	74	85	44

Ragan and Smith (1981)	Census, workers in manufacturing industries	ann. y, 1969	R,S: 1,3,7-10,13, 21,(26),28	71	87	55*
Sanborn (1964)	Census, wage and salary workers	ann. y, 1949	F: 1-3,6,10,16, 18-20,24	58	88	71*
Daymont and Andrisani (1984)	NLSHC: College graduates	\bar{w}, 1978	R,S: 1,(2),3;6,8, 12-14,35,36	87	97	77

SOURCES: Adapted from Treiman and Hartmann (1981, pp. 20-37), Cain (1985), along with additional information.

a. Full citations are given in the references. The same study may appear more than once in the table.

b. Sources for the individual studies use the following shorthand terms: Census = the decennial census of the U.S.; CPS = the Current Population Survey of the U.S. Bureau of the Census; OCG = the CPS survey of Occupational Change in a Generation, 1962 and 1972; GSS = General Social Survey, 1975-1978; SEO = Survey of Economic Opportunity, 1966-1967; NLS = National Longitudinal Survey, 1967 and subsequent years (Ohio State University); PSID = Panel Study of Income Dynamics, 1968 and subsequent years (University of Michigan); and NLSHC = National Longitudinal Studies of the High School Class of 1972. Terms such as "age 25+" refer to "workers age 25 or older" and so on.

c. ann. y = annual earnings (or income); ann. y = a group's mean (or median) annual earnings (or income); w = wage per hour; and \bar{w} = mean wage per hour.

d. F = frequency distribution or tabular standardization; R = regression analysis; and S = regression analysis using separate equations for men and women. Explanatory variables are listed by number at the end of these notes. The use of parentheses around a number indicates that this variable is implicitly held constant for both the observed and the adjusted differential. For example, if only whites are sampled, then race is being held constant in the observed differential, but race does not affect the percentage explained. The variable does not affect the percentage of the differential explained.

e. Observed earnings ratio is the mean female earnings (or income or wage) expressed as a percentage (whole number rounded) of mean male earnings.

f. Adjusted earnings ratio is the ratio of the conditional mean earnings of women to the mean earnings of men. The conditional mean earnings of women is the earnings predicted for women if they had the same values of the explanatory variables as do men.

g. This is given by (adjusted-observed)/(100-Observed).

*The explanatory variables include a control for the occupation of the worker. Explanatory variables are (1) education, (2) age, (3) race, (4) mental ability (intelligence), (5) formal training, (6) actual labor market experience, (7) proxy for labor market experience, (8) marital status, (9) health, (10) hours of work (annual, weekly, full-time/part time), (11) tenure (length of service with current employer), (12) size of city of residence, (13) region of residence, (14) SES background (parental education, occupation, income, number of siblings, migration history, ethnicity, etc.), (15) quality of schooling, (16) absenteeism record, (17) dual burden (number of children, limits on hours or location, plans to stop work for reasons other than training, etc.), (18) urban/rural, (19) turnover, (20) occupation (census 1-digit), (21) occupation (census 3-digit), (22) occupational prestige, (23) occupational SEI (Duncan scale of a socioeconomic index), (24) other occupational classification or scale, (25) class of worker (self-employed, government, or private wage and salary), (26) industry, (27) union membership, (28) type of employer (government/private, sex segregated/integrated, size of work force), (29) supervisory status, (30) percentage female in work group, (31) median income of male incumbents, (32) local labor market conditions, (33) length of trip to work, (34) veteran status, (35) major subject of study. (36) measure of preferences.

$$\sum_{i=1}^{n} Q_{mi} \left(\frac{y_f}{y_m}\right)_i$$

where $i = 1, 2, \ldots n$ represents subgroups of the labor force that are assumed homogenous with respect to productivity-related characteristics; $(Y_f/Y_m)_i$ is the pay differential by sex within the homogeneous subgroup; and Q_{mi} weights the subgroup by the number of males in the labor force subgroup. (It is also possible to use female weights, but, as explained above, the male weights are thought to represent the nondiscriminatory norm and are also standard across the literature.)

Results of Empirical Studies of the Sex-Wage Differential

Numerous empirical studies have applied these basic methods to various data. Table 3.1, based on a similar table developed by Treiman and Hartmann (1981), summarizes these studies. The studies are listed in the order of the percentage of the sex-wage differential explained by "productivity" considerations (last column). Most studies "explain" substantially less than one-half of the observed differential. Four characteristics account for most of the sex-wage differential explained by the studies listed in Table 3.1: hours worked (variable 10), amount of past work experience and/or job tenure (variables 6 and 11), occupation and/or industry (variables 20 through 24 and 26), and race (variable 3). Contols for sex differences in experience, hours worked, and broadly defined occupation or industry typically account for 30 to 40 percent of the differential. Studies that control for job title in a more detailed way (such as Sanborn, 1964) or for sex differences in reported preferences within a limited population sample (Daymont & Andrisani, 1984) have accounted for 55 to 77 percent of the differential. Characteristics such as education and location, which strongly influence pay difference by race, have little effect on the adjusted sex differential, reflecting the fact that there is little difference in these characteristics between women and men.

Although the empirical studies *unanimously* provide substantial evidence that there is a sex discriminatory pay differential, there is significant variation in the estimates of magnitudes. The "adjusted" ratio of women's earnings to men's earnings reported in Table 3.1 range from .39 to .88. The variation is due primarily to differences in the characteristic used to adjust the differential, that is, differences in the characteristics that are deemed productivity-related. Are sex differences in hours worked, work experience, and occupation the result of different choices by men and women (based either on individual preferences or a reaction to social norms) or are they the result of differential opportunity

in the labor market? If the differences in these characteristics are the result of choices, then it is proper to adjust for these differences when estimating the extent of labor market discrimination. If the differences are the result of differences in either the direct opportunity to obtain the credential or in the rate of return on the credential, sex differences in the credential are part of the labor market discrimination that is being quantified. Therefore, the sex-pay differential should not be adjusted for these differences.

Family and housekeeping duties are frequently cited as the reason why women as a group might make different choices about work hours, type and amount of work experience, and occupation or industry (Mincer & Polachek, 1974; O'Neill, 1983, for example). The argument is that at any given time, women choose to work fewer hours in the labor market due to their greater work hours in the home. Over time women accumulate less on-the-job experience, a form of human capital investment. Furthermore, because women anticipate their lower levels of lifetime employment and, consequently, their lower returns due to the shorter period over which they can reap the benefits of human capital investments, they devote less effort to acquiring skills when working and choose jobs (i.e., occupations and industries) that require less human capital.

The data used to infer that women devote less effort to acquiring human capital when working and choose jobs that require less human capital are indirect. The extent of on-the-job human capital accumulation is inferred from the rate at which earnings increase as job tenure increases. Individuals who experience a higher earnings growth rate are presumed to be investing more in on-the-job training than are those with lower earnings growth rates. Similarly, occupations in which earnings rise more rapidly with worker experience are presumed to require greater investments in on-the-job training. These inferences are valid if two conditions hold: (1) Earnings increases reflect true productivity increases; and (2) on-the-job training imposes a cost on workers in either time or money (i.e., lower wages).

The few direct tests of the relationship between productivity and experience have not strongly supported this proposition. Medoff and Abraham (1980, 1981) find evidence in studies of two different firms that worker productivity declines with experience. However, Maranto and Rodgers (1984) find a positive relationship between productivity and experience for the first six years of experience in another establishment.

Similarly, there is little empirical support for the proposition that workers in jobs with higher earnings growth rates (i.e., involving investment in on-the-job training) start out at lower wages than

equivalently qualified workers in jobs with lower earnings growth rates (i.e., less on-the-job training; see Zellner, 1975).

To support the argument that women's lower wages are due to their lower productivity, which results from their decision to spend work time with the family, some economists point to the narrower sex-pay differential within those population subgroups for which women spend relatively less time in family maintenance. Specifically, it is argued that (1) the sex-pay differential is lower among blacks (Kohen & Roderick, 1975; Oaxaca, 1973a, 1973b; Treiman & Terrell, 1975) because black women historically have spent more time in the labor market and less of their adult lives married than have their white counterparts; (2) the sex-pay differential is lower among young workers (Kohen & Roderick, 1975; Daymont & Andrisani, 1984) because younger women have not yet engaged fully in housework; and (3) the sex differential is lower among never-married workers (Mincer & Polachek, 1974; Gwartney & Stroup, 1973; Sandell & Shapiro, 1978) because single women are much less likely to have household demands that interfere with their work.

The economists who believe that women choose to be less productive in the labor market so they can be more productive at home point out that family responsibilities (i.e., number of children) and labor market expectations explain some wage differences among women.

The alternative hypothesis is that as a result of labor market discrimination, women have more difficulty in finding jobs that are full-time, offer opportunities for training and advancement, or are in "male" occupations or industries. The sex-wage differential is narrower for blacks due to the interaction of race and sex discrimination in promotion. Black women's earnings are closer to black men's earnings because race discrimination in promotion lowers black men's earnings. Younger women's earnings are closer to those of their male counterparts because sex discrimination in promotion has not had as much time to widen the gap. Single women's earnings are closer to single men's due to the operation of the marriage market, not the labor market. If women prefer to marry high earners and men are indifferent to earnings capacity of wives, or if women with better labor market prospects are less eager to marry, there would be less of a sex difference in pay among singles regardless of labor market considerations. The facts that single men earn less than married men, single women earn substantially less than married men, and single women have equivalent rates of earnings growth to married women are consistent with the marriage market explanation of the lower pay differential among singles. The equivalent earnings growth rates for single and married women are not consistent

with the hypothesis that women's family choices account for their lower earnings and/or human capital.

Similarly, women's choices with respect to fertility, as well as their expectations as teenagers, are known to be influenced by labor market opportunities (Cain & Dooley, 1976; Waite & Stolzenberg, 1976). Women who are frustrated by a lack of job opportunities or who simply face fewer earnings opportunities are more likely to find work at home attractive.

The data show a negative correlation between women's household activities and their labor market activities. The debate centers on the direction of causation. If women face equal opportunity in the labor market but choose to invest less in labor market skills because they prefer household activities, the sex-wage differential should be adjusted for differences in experience, industry, occupation, expectations, and so forth. These adjustments should then explan the sex-wage differential in its entirety. No study has ever achieved this result. But the studies by Corcoran and Duncan (1979), Ragan and Smith (1981), Sanborn (1964), and Daymont and Andrisani (1984), which find adjusted sex-pay ratios in excess of 85 percent, have led some to believe that finer controls for sex differences would ultimately explain all of the differential.

On the other hand, if women invest less in labor market skills and resort to more time in household activities because they have fewer opportunities either to acquire skills in the first place or to use the skills acquired, then adjustments for sex differences in experience, industry, occupation, or expectations are improper. Sex differences in these characteristics are part of the discrimination to be quantified. In this case, less than 20 percent of the sex-wage differential is explained by productivity differences and there is little likelihood that any other adjustments could explain the remaining 80 percent of the differential.

EXPLAINING THE EXISTENCE OF A DISCRIMINATORY PAY DIFFERENTIAL BY SEX: THE ECONOMIC THEORY OF DISCRIMINATION

The economic theory of discrimination attempts to explain the conditions under which women workers with equal productivity to men workers would earn a lower wage rate. Discriminatory sex differences in earnings can arise from several types of practices:

(1) Wage discrimination or unequal pay for equal work. In this case, males and females perform identical jobs, but females are paid less.

(2) Job placement discrimination. In this case, sex rather than productivity determines whether women are hired, the jobs to which

they are assigned initially when they are hired, and the jobs to which they are later promoted. Job discrimination that reduces the number of higher paying jobs open to women increases the wage differential by sex. It lowers women's earnings by increasing artificially the supply of labor to those jobs "appropriate" for women; it increases men's earnings by decreasing artificially the supply of labor to those jobs "appropriate" for men.

(3) Devaluation of jobs performed primarily by women or unequal pay for jobs of comparable worth. In this case, the jobs that are performed primarily by women—either because women are more likely to enjoy the work or because they are, on average, better able to perform the job—pay less *precisely* because the job is female. This case is different from the case of job placement discrimination. In the case of job discrimination, the jobs that employ women pay less because women are crowded into them and not "permitted" to move into men's jobs. If men's jobs were opened to women, then women's jobs would no longer pay less than men's jobs. However, in the case of devaluation of jobs performed by women, wages are not less because of barriers to entering men's jobs. Rather, the wages are less because women do the work, and any work performed by women is valued less. Opening men's jobs to women would do less to alter the pay structure in women's jobs.

There are three different premises from which economists construct a theory of sex discrimination. First, one can take personal prejudice, defined as a personal preference or taste for not associating with women under some circumstances, as given and explain how this personal prejudice interacts with market forces to produce discriminatory practices or outcomes. In this case, the prejudice is a given and is not the subject of any economic analysis. Second, one can assume that employers are not personally prejudiced in that they would hire women for jobs for which they are judged qualified, but that they do make employment decisions on the basis of stereotypes or statistical prejudgments. In this case a female employee is judged on the basis of the expected or actual average characteristics of a group of women rather than on the basis of her own credentials. We would then explain how this statistical prejudgment affects and is affected by market forces to produce discriminatory outcomes. Although the use of statistical prejudgments is given or assumed, this view of discriminatory behavior permits economic analysis of how the market influences the formulation of the stereotype. Third, we can construct a theory in which prejudice is the *result* of group behavior rather than its cause or the given. In this case, the causes of discrimination are not attributed to the personal feelings of the parties involved or to a shared stereotype; rather,

discrimination is viewed as a rational act within the objective economic self-interests of the discriminators. That is, discriminatory outcomes are the direct result of power to manipulate the labor market, not of personal prejudices or shared stereotypes.

These economic models of discrimination have concentrated almost exclusively on explaining discrimination in wages with less attention to job placement. No attention has been focused on analyzing the conditions under which jobs would pay less solely because they are performed by women. In the following sections, the main approaches to modeling discrimination are reviewed as they apply to wage and job discrimination. The extension of discrimination theory to the issue of the devaluation of jobs performed by women is raised at the conclusion of the discussion of each theory.

Personal Prejudice

This theory of discrimination as developed by Becker (1957) is the foundation for neoclassical economic analysis of both race and sex discrimination. It is assumed that individuals are prejudiced against women. This prejudice may be based on a "negative" or antifemale preference to avoid any contact with women in the labor market or to avoid only certain types of contact, such as a worker refusing to be supervised by a woman but being willing to supervise women. Alternatively, the prejudice may be based on a "positive" or promale preference to interact with men, such as a male college professor preferring to promote his colleagues with whom he likes to play poker, but he will only play poker with men. Discriminatory treatment of women can result from either "positive" or "negative" preferences. The labor market manifestations of these preferences depend on whether the prejudiced individuals are employers in, coworkers with, or customers of the establishment that employs women. We treat each of these separately. To simplify the discussion we also restrict our analysis to the case of equally productive men and women.

Employer Prejudice

Assume that neither consumers nor coworkers are prejudiced. An employer who is personally prejudiced against hiring women in at least some kinds of jobs behaves as if women are less productive than men in those jobs (even though they are, in fact, equally productive). The prejudiced employer who actually hires women must be compensated for "female presence" by getting additional or marginal revenues as a result of their hire that are greater than the marginal wages expended. Because a profit-maximizing employer would continue to hire women until the marginal revenue added is equal to the marginal wages

expended, the prejudiced employer who underhires women, while paying more for men employees, loses profits. Therefore, the personal prejudice theory of discrimination implies that prejudiced employers are less profitable than nonprejudiced employers.

The sex-wage differences observed in the labor market as a result of individual employer tastes for discrimination depend on the supply of female workers, the proportion of employers who are prejudiced, the depth of their prejudices, and the extent to which their prejudices differ by job.

If there are a sufficient number of nonprejudiced employers to employ women, then there are no sex-wage differences observed, even though there are prejudiced employers. The nonprejudiced employers hire women and men at equal salaries; the prejudiced employers do not hire any women for "inappropriate" jobs. These employers are not willing to pay women male wages; no woman will work for less than the male wage because she can get the male wage from nonprejudiced employers. In this case, the prejudiced employers do not lose profits because the preferred male workers cost them no more than female workers. The female workers are not hurt economically because there are sufficient numbers of nonprejudiced employers to hire them.

If there are not a sufficient number of jobs with nonprejudiced employers, then there is a sex-wage difference in those jobs in which prejudice occurs. Women earn the lower female wage with both prejudiced and nonprejudiced employers. They are paid less at the firms of prejudiced employers because these employers would not hire women unless the difference existed, and there are not sufficient job openings for women with nonprejudiced employers. Nonprejudiced employers hire only at the lower female wage. They do not hire men because, although they are indifferent between men and women, it costs more to hire men. Nonprejudiced employers are more profitable because they have lower wage bills.

The conclusion that discriminating employers would be less profitable creates a serious question for this model of discrimination. Over the long run, more profitable firms should expand relative to less profitable ones. Furthermore, because nonprejudiced management would make more profits from a given establishment than a prejudiced one, there is an economic incentive in the long run for nonprejudiced managers to buy out prejudiced ones. The persistence of the sex-wage differential in the labor market over time has prompted two alternative responses to the economic theory of discrimination:

(1) The theory is wrong. Therefore, we must turn to the other theories of discrimination discussed below.

(2) The theory is correct and the persistence of the sex-wage differential reflects the persistence of sex differences in productivity. This notion is reconciled with the empirical studies that cannot dismiss a persistent discriminatory differential by appeal to the role of the unmeasured productivity characteristics as mentioned above.

Consumer Prejudice

A consumer who is personally prejudiced against being served by women in any situation or only in situations involving more skilled jobs such as lawyers, professors, and consultants behaves as if women are less able to provide the services (even though they are in fact equally productive). Thus, for these consumers, if the prices for the goods or services produced by women and men are equal, only the goods and services produced by men will be purchased. Prejudiced consumers purchase from female workers only if they are compensated by paying a lower price. Firms who sell to prejudiced consumers get less revenue when they employ female workers. The profit-maximizing non-prejudiced employer hires female workers when their hire yields as much profit as the hiring of male workers. When female workers yield less sales revenue, female workers can be as profitable as male workers only if women accept sufficiently lower wages to compensate for the revenue loss. The greater is the prejudice among consumers, the greater would be the prices paid by consumers and the difference in male/female wages in consumer contact jobs.

Whether prejudiced consumers actually purchase a product or service from a female worker—that is, whether the market even yields a greater price for goods and services produced by men—depends on the total supply of female workers, female workers' preferences for consumer contact jobs, and the proportion of consumers who are prejudiced.

If consumer prejudice is sufficiently widespread to lower the wages of female workers in jobs that involve consumer contact, consumer prejudice encourages female workers to work in jobs that do not involve consumer contact. Therefore, consumer prejudice would promote job segregation of women. If, in fact, women workers are otherwise indifferent between jobs that involve contact with prejudiced consumers and those that do not, and there are sufficient numbers of noncontact jobs to employ female workers, consumer prejudice could only result in job segregation. Wage differences in consumer contact jobs can only occur if women either cannot or do not find appropriate employment elsewhere. The barriers to employment elsewhere, and not consumer discrimination, would cause a sex-wage differential.

Coworker Prejudice

An employee who is prejudiced against working with women in at least some kinds of jobs behaves as if his or her wage rate is less than its nominal level if his or her job involves working with women in those jobs. Thus prejudiced employees will not work for employers who hire women for the "wrong" kinds of jobs unless their wages are higher than in other firms in which women are not so hired. Employers can avoid the higher costs of hiring prejudiced coworkers if they can sex segregate jobs and/or establishments. However, such segregation is not feasible when there are wide ranges of skills required by the firm and when few female workers or male workers possess some of the necessary skills. For example, if male engineers are prejudiced against female engineers, it is easy to set up an engineering firm in which all engineering jobs are occupied by men. A similar firm employing only female engineers is more problematic because of the relative scarcity of female engineers. In this job market, female engineers would most likely have to seek employment in sexually integrated firms. If sexually integrated firms must hire prejudiced male workers (because there are insufficient numbers of female workers and nonprejudiced male workers to staff at an efficient size), men would earn more than women in those firms. The wage premium paid to men in these firms would be at the expense of female coworkers. There is no incentive for the employer to pay the premium from profits because the nonprejudiced employers would not accept a lower profit rate than that earned in an all-male firm. Female workers are willing to accept a wage rate lower than their productivity rate because they do not have an opportunity to be paid at their productivity rate elsewhere. Women cannot earn more elsewhere because, unless they work with prejudiced male workers, their productivity level is lower due, for example, to diminished efficiency in small firms (scale diseconomies). Nonprejudiced men work exclusively for sexually integrated firms because their wages are higher than in sexually segregated firms. The most prejudiced men work in sexually segregated firms at salaries that are equal to their productivity. This salary is lower than that earned by men in the integrated firms (who are compensated for working with women and earn more than their productivity) but higher than that earned by women (who pay for the compensation of prejudiced male coworkers by being paid less than their productivity).

In general, the theory concludes that coworker discrimination creates job segregation but not wage differentials. Coworker discrimination coupled with scale economies and relative scarcity of women create wage differentials.

Blau (1977) provides some empirical evidence on the effect of job segregation on wages. She finds that within occupations, men and women are segregated by establishment. She finds that sex-pay differentials within occupations are due to differences between (rather than within) firms. However, because she finds that men earn less when they work with women, coworker prejudice does not appear to explain the segregation or the wage differentials.

Devaluation of Women's Jobs

Assume, for the sake of discussion, a sex-segregated work force in which the job segregation is a given, that is, a possible result of sex differences in preferences and/or abilities, but not a direct result of discrimination. Could the personal prejudices of employers, consumers, or coworkers result in a systematic devaluation of jobs performed by women? To answer this question, it is necessary to specify the productive relationship between men's and women's occupations.

If men's jobs and women's jobs are perfectly substitutable in production, then the jobs are the same and only titles differ by sex. As job title defines the same phenomena as sex of worker, all the previous discussion of wage discrimination by sex applies to the relative devaluation of women's jobs.

If men's and women's jobs are not perfect substitutes in production—that is, if women's jobs are complementary with men's jobs—then men's productivity is lower with any firm in which prejudice interferes with employment decisions regarding women's jobs. When men's jobs and women's jobs are complements in production, the analysis and results are different from the case of wage discrimination against women.

If the employer has a prejudice against women's jobs or occupations, he or she devalues women's jobs independently of their marginal contribution to physical output (or profit). In other words, the prejudiced employer behaves as if jobs performed primarily by women contribute less to total product than jobs performed primarily by men, even though the marginal contribution is the same. In this case, prejudiced employers will always lose profits, regardless of the number of nonprejudiced employers. The reason is that the prejudiced employer's underhiring of workers in women's jobs results in lower productivity for workers in men's jobs and, hence, a lower total product. The (nonprejudiced) workers in men's jobs would not accept a lower wage with prejudiced employers, so the prejudiced employer must compensate for their lower productivity from profits.

As mentioned above, we reach the conclusion that employer prejudice that results in the devaluation of women's jobs would be unprofitable and, thus, not sustainable.

If the consumer has a prejudice such that the goods and services produced primarily by female workers are undervalued only because they are produced by women, prejudiced consumers purchase less of these goods and services. For example, nonprejudiced consumers who recognize the "true" value of services performed by women would demand more (in either quantity or quality) child care, nursing, and teaching services, and less of goods and services produced primarily by men such as professional sports, bartending, "doctoring," and so forth. When men's jobs and women's jobs are complementary in the production of a service (i.e., doctors and nurses producing medical care), the prejudiced consumer purchases from institutions that "overutilize" the male job in producing the service. Consumer devaluation of women's work would result in lower wages and fewer jobs in "women's" consumer contact occupations.

The concept of consumer prejudice against women's jobs is a problematic one for economists. Consumers select the bundle of goods and services that maximize their utility or well-being. The distinction between a taste for a particular good or service and a taste for the sex of the workers who *usually* produce a particular good or service is not an operationally useful one because there are no behavioral differences between consumers with either taste.

Because coworkers do not make work-force allocation decisions, it is difficult to imagine a way that a prejudice against jobs or occupations usually performed by women (as opposed to a prejudice against women coworkers) would affect their behavior as coworkers within a firm that operates in a competitive labor market.

Summary

The theory of discrimination motivated by personal prejudices in a competitive labor market cannot explain a continuing devaluation of jobs performed primarily by women. The theory is also unable to explain extensive and continuing wage discrimination against women. Job segregation by sex can be the result of consumer and/or coworker discrimination. Wage differentials could result from the job segregation within this theory only in industries or occupations with scale economies in production and a relative scarcity of female workers. This case is not likely to hold for a wide variety of jobs.

Statistical Discrimination

In the statistical theory of discrimination developed by Phelps (1972) and Aigner and Cain (1977), it is assumed that employers are not prejudiced against women. Rather, employers are interested in employing the most productive women and men, that is, those who would yield

the greatest profits for the company. The problem is that the employer cannot know with absolute certainty the productivity of each employee. Employers must guess this productivity using information that they believe is associated with productivity. Such information may include sex as well as the data typically collected on an application form (experience, skills, and education), results of tests of the applicant, and evaluation of references and/or supervisors. Clearly, these categories of information vary in both the extent of their correlation with actual productivity and the cost of acquiring the information.

The theory of statistical discrimination explores the effect of sex on wages and job placement within a labor market with imperfect information by (1) treating sex itself as an indicator of differences in average productivity; (2) allowing the reliability of more neutral indexes of productivity such as education or experience to vary by sex; and (3) examining the investment choices of women when signals of differential underlying productivity (i.e., diploma, license, etc.) may be acquired at a cost.

Sex as an Indicator of Productivity

The employer prefers to use the information that is simultaneously the least costly to acquire and the most correlated with actual productivity. Sex is undoubtedly among the least costly, if not the least costly worker characteristic, to observe. (Reports of education and experience, for example, must be solicited from the applicant and verified.) To the extent that sex is correlated in fact or in perception with productivity, employers will perceive a profit incentive to use sex as a criterion for employment decisions.

Is the sex-wage differential so generated discrimination? Aigner and Cain (1977, pp. 177-178) have argued that if employers pay men and women differently based on the average characteristics of each sex, then the resulting wage difference is not economic discrimination against women as a group (although it is discriminatory against some individuals). Women who experience job tenure that is longer than the average for their sex are underpaid (or "underpromoted"), but women who experience shorter than average job tenure are overpaid. Aigner and Cain conclude that, on average, the over- and underpayments balance out. Then, statistical discrimination cannot explain the sex differences reported in Table 3.1. Table 3.1 compares average wages paid to men and women, adjusted for the average characteristics of men and women.

This conclusion is correct if there are no feedback effects. If there are feedback effects such that women's rates of acquisition of the characteristic are responsive to the wages and/or job opportunities they generate, the underpayment of the characteristic for the most able will result in lower levels of the characteristic for women.

Reliability of Indexes of Worker Productivity Differ by Sex

If employers are risk-averse (Aigner & Cain, 1977), if an incorrect matching between workers' true productivity and their assigned job lowers output, and if the correlation between an observed worker characteristic and actual productivity varies by sex, employers would pay lower wages to workers for whom actual productivity is uncertain.

For example, consider an employer for whom word-of-mouth recruiting, the so-called old boy's network, yields the most appropriate applicant pool and the best information about the quality of individual applicants, but yields only males. The alternative is to use newspaper advertising that yields an applicant pool with much greater quality variation and less reliable information on quality, but significantly more women.

Therefore, the employers can more reliably select male workers and evaluation or search costs are lower when hiring men. A profit-maximizing employer would employ women only when compensated for higher search costs with lower wage costs, that is, only if women are paid less. In this case, women are paid less because it is harder to ascertain their actual productivity, and not because their actual productivity is lower. It would then be in the interest of both employers and women to find better means to reliably signal true productivity. Analyses of these possibilities are discussed next.

Investment in "Signals" of Productivity

There are two approaches to analyzing the decision to invest in an education or training credential in the presence of statistical discrimination. The first, developed by Spence (1973, 1974), Arrow (1972a, 1972b, 1973), and Starrett (1976), assumes in its simplest form that the acquisition of the credential does not itself increase productivity, but that the credential signals or sorts out the workers with greater innate productivity from the less innately productive. The second, developed by Lundberg & Startz (1983), assumes that the process of acquiring the credential does increase actual productivity, but that the true productivity effect varies randomly across individuals and cannot be known for any individual with certainty. For both approaches, there is a market failure with respect to investments in credentials because the effects of the investments on the income accruing to individuals diverge from the effects on the total productivity of the economy. This market failure makes discriminatory outcomes possible.

In the Spence model, workers invest in the credential if their costs are less than their wage gains. It costs more innately able workers less to acquire the credential. Therefore, more able workers acquire the credential and the less able do not. Employers correctly use the

credential as a signal of productivity and pay higher wages to those with the credential. The resulting level of investment in the credential is not socially optimal because the same level of social output could be achieved without the investment in credentials. From a social perspective, there is an overinvestment in the credential. Furthermore, as the level of the credential used to sort out ability is arbitrary over a certain range, several wage distribution possibilities are feasible, including ones that discriminate against women. For example, if employers believe that women need a higher level of the credential to be high-ability workers, and if equally able men and women face the same costs in acquiring the credential, equally able women will have to spend more on acquiring credentials and therefore will receive a lower wage net of education costs. Starrett (1976) analyzes a number of situations in which it is only necessary that women believe that they have a lower return on the credential for women to underinvest consistently in the acquisition of the credential.

As in the previous discussion, there is now a substantial incentive both for women and for employers to find a more efficient way for women to indicate their innate productivity. Either the failure of women and/or employers to find such a signal or the failure of such signals to reduce the sex-wage differential is difficult to explain. Starrett (1976) deals with this problem by suggesting that job credentials are very complicated. For example, an important requirement for being a manager may be the ability to "get along" with other managers, which means managers share common traits. If managers have historically been males and "get along" better with other males, it is very difficult for a firm to discover through experimentation that an all-female management team would perform as well.

In the Lundberg and Startz model, the market failure results in an underinvestment in the credential. As opposed to the Spence model, the credential actually increases productivity but now does not fully signal that increase for individuals with certainty. Therefore, employers discount the value of the credential and pay a lower wage to its bearers than they would if the credential were a totally reliable indicator. If employers view the credential as being a less reliable indicator for women, they pay lower wages to women with the credential. As a result of this lower return on the credential, women underinvest relative to men. In this case, market intervention is necessary to obtain equal treatment by sex. Government intervention would increase investment by women and would also increase total output in the economy.

Cain (1985) argues that the Lundberg and Startz results are contingent on their unrealistic specification of the cost function for obtaining the credential, which assumes no relationship between the costs of

attaining the credential and the ability of the worker. He contends that other reasonable specifications of the cost function result in no underinvestment by women and, thus, no sex-wage differential.

Devaluation of Women's Jobs

As before, we assume now that there is a sex-segregated work force resulting from sex differences in preferences and abilities. Could the employer's knowledge of group averages and lack of knowledge of individual productivity result in a systematic devaluation of jobs performed by women?

Within the context of statistical discrimination models, the devaluation of women's jobs would occur through the differential use or interpretation of information on men's jobs and women's jobs. Consider, for example, the case of high turnover in a particular job within a firm. If the job is "male," the employer attributes the turnover to the wage level; if the job is "female," the employer attributes the turnover to the sex of employees. In "male" jobs, the firm raises wages to reduce turnover costs. For "female" jobs with high turnover the firm redesigns the jobs so as to lower turnover cost (i.e., gives less training to job occupants). The firm determines the optimal number of employees in the "female" jobs from the contribution of the jobs to total product after subtracting any remaining cost of turnover. To the extent that this turnover cost reflects a low, nonoptimal wage rate, the firm hires too few individuals in the "female" job. As such a firm would be less profitable than a firm that hired more workers in the female job, there is a strong incentive for both firms and workers in "female" jobs to alter the arrangement.

Summary

The statistical theory of discrimination can explain some sex differences in the labor market. To the extent that it is more difficult for firms to place women of equal credentials with men in jobs either because search is more costly or because the quality of individual women is harder to determine and to the extent that there are no market signals that can decrease the costs of search or quality verification, equally qualified women could earn less than men. To the extent that these problems are greater in some jobs, women would have more problems in obtaining those jobs, so there would be job placement discrimination against women. To the extent that firms attribute the cause of worker behavior differences within male jobs to the conditions of employment and within female jobs to the sex of the workers, "female" jobs can be undervalued. However, there would be strong incentives for both firms and female workers to devise better search and testing methods. Once such methods were available, statistical theories

would no longer offer an explanation of wage and job placement differences by sex or of the devaluation of women's work.

Power and Imperfect Labor Markets

This approach to analyzing discrimination assumes that discrimination is not the result of isolated acts of prejudiced or misinformed individuals, but rather that discrimination is the result of institutionalized procedures and incentives that make discriminatory outcomes economically advantageous to decision makers. Discrimination in noncompetitive markets has been analyzed using both traditional neoclassical economic analysis and more interdisciplinary approaches.

Economic Models of Imperfect Competition

The analyses using traditional economic approaches for analyzing noncompetitive markets have focused on the wage effects of market power or control resting with employers in the labor market (i.e., monopsony models) or in the product market (i.e., monopoly models) and with coworkers (i.e., union or licensing models).

Monopsonistic models. A monopsony exists when there is only one employer or a collusive group of employers in the specific local area labor market for specific worker skills (such as electrical engineers, nurses, teachers, etc.). A monopsonistic market exists when there are few enough employers in the local labor market that the wage policies of an individual firm influence the supply of workers available to the other firms.

It is well-known (Robinson, 1933; Madden, 1973, 1977a, 1977b) that in such a situation, employers maximize profit by "exploiting" workers; that is, employers pay workers less than their productivity would warrant if the labor market was competitive. Employers are assumed to be profit-maximizers who hire workers up to the point at which the marginal cost of hiring an additional worker is equal to the additional worker's contribution to profit. The employer then pays the wage rate that is necessary to attract that number of workers. As the marginal cost of hiring an additional worker exceeds the wage rate (because the supply curve is upward sloping), workers are paid less than their marginal contribution to profit, or their productivity. In contrast to competitive labor markets, wages are determined by the responsiveness of labor supply to wages as well as by productivity.

The basic assumption necessary to the model is that employer monopsony power exists. Technically this means that individual employers (or collusive groups of employers) face an upwardly sloping (with respect to wages) supply curve for labor; that is, very few workers

are perfectly mobile between employers. In this case, individual firms must increase their wage levels when increasing the total number of employees.

The presence of monopsony power in the labor market results in discrimination against women when a wage change yields a smaller change in the number of female workers seeking employment than in the number of male workers, that is, when female labor supply to the firm is less wage elastic. In this case, profit-maximizing employers pay women less than equally productive men.

The persuasiveness of this model as an explanation of discriminatory pay differentials has been challenged with two arguments: (1) Labor markets are generally competitive, so that a monopsonistic analysis is irrelevant (Cain 1976, p. 1233); (2) Women workers are not less wage responsive than men; that is, the wage elasticity of labor supply for women is greater than men's. Therefore, even if labor markets were not competitive, wage discrimination against women would not result (Cain, 1985).

With respect to the first contention, there has been little empirical investigation of the extent of monopsony in the labor market. Perhaps this reflects a pervasive presumption by economists that labor markets are competitive. Also, because data on wages, employment, and worker characteristics are not available at the level of the individual firm, it is impossible to directly test the proposition that individual firms must raise wages to expand employment (that is, whether labor supply is positively sloped). Rather, the few studies that have examined labor market structure focus on indirect evidence.

Bunting (1962) finds that for most U.S. counties, employment is not concentrated in a few firms. This finding has been used to suggest that there is a sufficient number of employers in most labor markets to guarantee competition (Cain, 1976). However, as labor markets must also be defined with respect to specific skills, locations, work hours, and so forth, this study cannot dismiss monopsony. Nelson (1973) finds evidence of a positively sloped labor supply for specific industry and local area labor markets. Madden (1977a), using individual data on wages, hours worked, commuting distances, and other worker characteristics, also finds evidence of a positively sloped labor supply for firms. Madden (1977b) develops a theoretical model that demonstrates that spatial separation of work places within a local labor market can be a sufficient condition for individual firms to face a positively sloped labor supply.

The second contention is premised on empirical studies of the effect of wage changes on the willingness of men and women to enter the labor force (as opposed to willingness to accept employment at a particular

firm) that have uniformly found women to be more responsive than men (see, for example, Mincer, 1962; Cain, 1966; Bowen & Finegan, 1969). However, labor supply *to the firm* is the concern in the discriminatory monopsony model. Any introductory economics text distinguishes between the elasticity of demand and supply curves for the aggregate market and for individuals. There are two ways in which a wage inelastic (relative to women) supply of male workers to the total labor market may be a more wage elastic supply to the firm: Men may be unionized and/or there may be relatively more competition for male workers among employers in the labor market. In either case, the male labor supply to an individual firm is more elastic than the supply to the labor market.

Cardwell and Rosenzweig (1980) find that the sex-wage differential is significantly greater in local markets characterized by more union activity, a lower wage elasticity of labor market supply for women, and/or low levels of female participation in male occupations. They find evidence that monopsony power has no effect on the wage of male workers but that it lowers wages of women, especially in local labor markets characterized by high degrees of union activity and occupational segregation.

In the study discussed previously, Madden (1977a) also finds some evidence of a greater wage elasticity to the firm for male workers than for their employed wives. Madden (1977b) derives the conditions under which the wage elasticity of labor supply to the firm will be greater for married men than for married women. The likelihood of this result increases as families are less able to accept alternatives for wives' homemaking activities and as husbands and wives have stronger preferences about spending their leisure time together.

Product monopoly models. Because firms that hold a monopoly in their product market earn excess profits (i.e., greater profits than they would earn in a competitive product market), discriminating monopoly employers would not be driven out of business, although they would still lose profits from discrimination. However, if the monopoly power is transferable and if the discriminating employer loses nothing from the inability to discriminate (that is, the "taste" for discrimination reflects an aversion to employing women in some jobs rather than a "positive" desire to subjugate women), then the firm is worth more to a nondiscriminatory employer. Thus discriminatory employers would sell out to nondiscriminating employers and a monopoly in product markets would not explain the persistence of discrimination.

Comanor (1973, p. 372) and Ashenfelter and Hannon (1984, p. 8) develop another analytical approach, tying monopolization of product

markets to a sex-discriminatory wage differential. If discrimination is a "normal" good, that is, if rising income induces employers to discriminate more, monopolists will be more likely to discriminate because they earn greater profits and hence have higher incomes than owners of firms that operate in competitive markets.

Third, if the monopoly is regulated such that profits are constrained, there may be no profit penalty for discrimination. In this case, discrimination would not be driven out by the market.

Finally, if ownership and management of the monopoly are separated, it may be very difficult for owners to monitor the profits lost by the discriminatory actions of management (Ashenfelter & Hannon, 1984, pp. 11-13). If the discriminating management would not suffer income loss, discrimination would not be driven out by the market.

Three empirical studies (Luksetich, 1979; Oster, 1975; Ashenfelter & Hannon, 1984) have examined the effect of monopoly in the product market on the sex-wage differential. Oster (1975) examines the sex discriminatory effect of market power by correlating the ratio of female to male employees with the concentration ratio of firms by industry for several white-collar occupations. She finds that although women are less likely to be employed in industries in which firms have more market power (i.e., higher concentration ratios), the correlation is not statistically significant. The opposite conclusion is reached by Luksetich (1979), who finds a significant correlation between sex discrimination in white-collar jobs and the concentration ratio across industries.

Ashenfelter and Hannon (1984) criticize the approach used in prior work. The extent to which a concentration ratio measures market power varies by industry so that the absence or presence of a relationship between the concentration ratio and sex discrimination may result as much from industrial variation in the correlation between market power and the concentration ratio as from the correlation between market power and employment discrimination. Ashenfelter and Hannon address this problem by examining concentration ratios in local markets within the same industry, that is, banking. They report a strong correlation between market concentration and female employment in banking. Banks that have more competitors in the local market hire significantly more women, after controlling for numerous other factors such as total deposits, firm growth rate, total employment, local industrial mix, and ownership structure.

Union models. There are several ways in which the activities of labor unions could affect the pay differential by sex. Although it is not clear whether unions maximize their membership's welfare by maximizing

the wage level, total employment, total membership income (wage times total union employment), or something else, it is clearly to the advantage of any single union member to block the entry of other workers into his or her labor market. Although there are numerous ways to exclude competitive workers from the market (license requirements, entrance fees, prolonged apprenticeships), discrimination against any particular competitive group (such as females) can be a more efficient barrier to entry if there is emotional support from union members. Not only is sex discrimination an administratively easy form of exclusion, but it also provides psychic income to workers who would rather not associate with the excluded group at equal occupational levels anyway. However, as with employers, it is not always morally or legally appropriate to systematically exclude women from jobs. Unions may obtain the resulting exclusion of women by negotiating with employers to set up job requirements that effectively exclude women. Unions would, then, support and bargain for a wage structure tied to seniority, discrimination against part-time workers, or excluding women from jobs requiring weight lifting, night hours, overtime, and so forth.

Numerous empirical studies have demonstrated that unions do increase the wages of their members (Ashenfelter, 1973; Freeman & Medoff, 1984; Lewis, in press). To the extent that women are less likely to be employed in unionized jobs, unions increase the pay of men relative to women. Ashenfelter (1973, pp. 98-19, 109) finds that women in 1967 were one-third as likely as men to belong to unions and that the sex difference in unionization exists in virtually every occupation group, including white-collar occupations. More recent data (U.S. Bureau of the Census, 1982, pp. 376, 408; Ashenfelter, 1979), indicate that the probability of female workers belonging to a union has increased slightly relative to men, but that women are still less than half as likely to be union members.

Ashenfelter (1973, p. 105) concludes that unions have had a very small effect on the sex-pay differential. He estimates that unions have increased the overall male/female pay differential among whites by 1.9 percent and among blacks by 2.8 percent. Ashenfelter's estimate of the impact of unionism on the overall sex-wage differential is so small because most workers of both sexes are not unionized. Currently, less than 20 percent of the labor force are union members (U.S. Department of Labor, 1980, p. 412).

Ashenfelter's estimate of the effect of unions on women may underestimate the true effect of unions on the sex-wage differential. By structuring the statistical analysis so that unions only affect the wages of workers given their industry and occupation, Ashenfelter does not

consider the effect of union actions on the distribution of workers across occupations and industries. No one has conducted such a study.

Finally, the differential unionization rate by sex suggests an important reason why the male labor supply to an individual employer is more wage sensitive (elastic) than is the aggregate male supply curve. If male workers (occupations) have monopoly power of their own through unionization whereas female workers do not, male workers (unions) could be paid consistent with their productivity whereas female (i.e., nonunionized) workers would be paid a wage based partially on their willingness to work. So, even if the aggregate male labor supply to the labor market is more inelastic (i.e., less wage-responsive) than the aggregate female supply, the male labor supply to the firm is perfectly elastic because the union will guarantee no workers at any wage below the negotiated wage, but as many workers as necessary at the negotiated wage.

Devaluation of women's jobs. Again, a sex-segregated work force resulting from sex differences in preferences and/or abilities is assumed. If it is easier for firms or unions to exercise their market power to discriminate profitably by establishing wage differentials across jobs rather than across individuals within the same job, "women's" jobs will be paid less than "men's" jobs. It can be easier to set wages lower in "women's" jobs than to pay women less in all jobs either because there are laws against unequal pay for equal work or because workers or unions find these wage differentials more acceptable than wage differentials within jobs.

In a monopsonistic labor market, women's jobs would be paid less than comparable men's jobs if the supply of workers in "female" jobs to the firm is less wage elastic (as discussed above). To the extent that monopsonistic labor markets exist (see above), the devaluation of women's jobs is profitable. Therefore, discriminatory outcomes are not driven out by market forces, as long as the firm possesses monopsonistic power in the local labor market.

For a firm that has a monopoly in the product market, the incentive to devalue women's work is the same as that discussed above in the case of personal prejudice among employers in competitive markets. The difference in the case of a monopolist is that monopoly often protects the firm from the profit consequences of discriminatory actions (see above). To the extent that the employer has a prejudice against women's work or a prejudice against women but is constrained from offering women lower wages when employed in the same jobs as men, the monopolist will undervalue women's work.

To the extent that unions redistribute income toward their members and away from nonmembers, and unionize jobs or occupations rather than the entire work force of a firm, male domination of unions would increase wages in men's jobs at the expense of wages in women's jobs.

Interdisciplinary or Institutional Approaches

The institutional or interdisciplinary analyses of discrimination are not so much alternatives to economic models (which take tastes as given and assume either profit-maximizing behavior and/or a free market) as they are an expansion of the economic analysis to include sociological, historical, psychological, and political processes and interactions. The dominant approach taken in the economics literature is the segmented labor market theory.

Segmented labor market theories. Doeringer and Piore (1971) and Gordon (1972) argue that the labor market is divided into non-competing groups (also see Gordon, Edwards, & Reich, 1982; Edwards, Reich, & Gordon, 1975). The wage effects of this division vary depending on whether workers are in primary or secondary labor markets.

The so-called primary jobs are located in large firms and/or are protected by a strong union. Jobs in the primary market offer stable employment (i.e., lifetime jobs) and are better both in terms of pecuniary and nonpecuniary rewards. Within the primary market, wages and promotions are the result of internal (to the firm) labor markets that are relatively isolated from external competition. Doeringer and Piore (1971) argue that only entry-level positions are filled by workers from outside the firm; positions above entry level are mostly filled by promotion from within the firm. The isolation from external competition alters the rules under which wages, promotions, and training opportunities are allocated. Within the internal labor market, the optimal allocations are those that keep the workers in toto happy and, therefore, productive, as opposed to those that would match individual wages, training, and so forth to individual rates of productivity (Thurow, 1975, p. 179). Because the internal market is protected from the competition of the external market, there is no necessity to match individual "outside" offers, which would be based on an assessment of an individual's productivity, simply because such offers are rare. Individual productivity is, in fact, not observed. Only the productivity of a unit (a department, a plant, or an entire firm) that includes several persons is observed. Wages, promotion, training, and so forth are allocated within a unit, then, according to workers' concepts of equity. If workers believe that better educated and/or more experienced workers should be paid more or that whites and/or men should be paid more,

then those characteristics will be statistically correlated with pay. The reason for the correlation has nothing to do with physical productivity. Rather it is the result of worker attitudes, the bases of which are the provinces of sociologists and psychologists, and not economists. In the primary market, sex-discriminatory pay differentials (and other differentials) are the result of prejudices (attitudes) of coworkers and/or employers. (Starett, 1976, develops a formal model of this process.)

In the so-called secondary jobs that are located in small, nonunionized firms, employment is inherently more unstable. The supply of workers to these jobs is viewed as perfectly elastic. Employers can hire as many workers as they want at the going wage (often the legislated minimum wage) and can costlessly replace terminated workers. Secondary market workers are those who cannot get jobs in the primary sector.

The segmented labor market theory becomes a theory of discrimination both when it addresses the determinants of wages in the primary market (as discussed above) and when it analyzes the allocation of workers between primary and secondary sectors. Because jobs in the secondary sector are organized to encourage unstable employment, whereas worker instability in the primary sector is costly to both workers and employers (who have invested in worker training), the strength of a worker's job attachment is the logical means by which workers would be sorted into or out of the primary sector. Invoking the same notions of statistical discrimination discussed above, sex is viewed as an indicator of job attachment. As a result, women are disproportionately restricted to the secondary job market. Because the organization of secondary jobs (i.e., low wages, no promotions) encourages sporadic labor force attachment, workers trapped in the secondary market ultimately demonstrate sporadic labor force attachment. This learned sporadic attachment confirms the original employer expectations and perpetuates the secondary market status of women.

Therefore, this theory predicts that women would be underrepresented in the primary markets and that those women who did get jobs in the primary market would get lower wages due to sex discrimination. Blau (1977), Blau and Jusenius (1976), and Gordon et al. (1982) further elaborate the application of this model to the case of sex differentials in pay. They argue that within the internal market, wages are administratively attached to job titles or occupational categories. Within these categories, institutional and regulatory constraints require equal pay except for differences based on seniority and/or merit. If discriminatory preferences of workers or employers result in incentives to pay women less because they are women or because they are perceived to be either less deserving or less productive, the most efficient allocation over job

titles is one in which there is little overlap by sex. Thus the primary market designs "women's" jobs that fit the perceived characteristics of women and also lowers their wages. "Women's" jobs are devalued, then, solely because women perform them.

The persuasiveness of this model as an explanation of discriminatory pay differentials has been challenged by Cain (1976) and Wachter (1974), among others. They argue the following:

(1) Wages and job assignments in both primary and secondary markets are subject to the productivity tests of the marketplace. Mobility between jobs in the primary market indicates that the external labor market keeps the internal labor market "honest" (that is, paying only for true merit or productivity).

(2) It is clearly in the interest of secondary market workers to increase the stability of their labor force attachment. It is also in the interest of primary market employers to do so because this would increase the potential supply of primary workers and would permit a lowering of wages in the primary sector. Therefore, the discriminatory placement of women into such jobs cannot be an equilibrium situation.

Other approaches. Barbara Bergmann (1974) has developed an "overcrowding" analysis of discrimination that assumes the existence of a nonspecified institutional barrier to women entering male occupations. Bergmann then works through a standard neoclassical economic analysis in which workers in both men's and women's occupations are paid according to the marginal productivity of the last worker hired in the occupation. However, due to the entry barriers, there is a greater supply of workers in women's occupations, lowering the marginal product of the last worker hired and, thus, the equilibrium wage rate in the occupation.

This theory is subject to the same criticism we have now raised with respect to all the theories. Simply, the existence of barriers to women entering male occupations is an unstable situation. Any nondiscriminatory employer could profit by hiring equally able women at their lower wage level into male jobs. Therefore, in the long run, occupational segregation would disappear.

A POLICY EPILOGUE: SOMETHING FOR EVERY PARTISAN

It is disappointing to complete a review of such an extensive research literature and to realize that there is no consensus on the answers to the most important questions. The research literature truly contains something for every partisan, but no complete answers for the scholar.

I have support for the proposition that sex discrimination in the labor market is not a problem, making government intervention unnecessary. The failure of any theory to explain convincingly the basis for a persistent discriminatory sex differential in wages or in job placement or for a devaluation of women's work lends some credence to a belief that aggregate sex differentials are the result of aggregate sex differences in choices and in abilities.

On the other hand, the sheer magnitude and persistence of the observed sex-wage differential *after adjusting* for sex differences in credentials, including some questionable credentials (i.e., occupation, job tenure, etc.) that could be influenced more by differential opportunities than by different choices, make it impossible to dismiss the existence of extensive sex discrimination in the labor market. The empirical data on sex differentials in wages indicate that the inability of economic theory to explain satisfactorily the existence of discrimination points to the inadequacy of the theory itself and not to the nonexistence of discrimination.

The empirical research does reach some consensus on the sources of the sex-wage differential. Sex differences in occupations or job title account for significantly more of the sex-pay differential than do sex differences in pay for workers within the same job. There is less evidence on whether the concentration of women in low-paying jobs is the result of (1) sex barriers to entry in high paying jobs; (2) discriminatory devaluation of women's work that results in women's jobs paying less; or (3) occupational or job choices of women being relatively more constrained by family status. Given the assumptions required for theory to yield extensive devaluation of women's jobs, I find it hard to believe that such devaluation of women's jobs could be the most important reason why women are in low-paying jobs. The more important questions revolve around the other two possibilities.

When any sex differential in the labor market cannot be explained by observable credentials, two explanations are possible: Women face different opportunities to work and acquire skills or women make different choices about working and acquiring skills. We only observe the sex differences in outcomes, and those outcomes are most often consistent with either cause. Of course, both explanations can contribute to the differences. Given the current status of available data and research methodologies, less precise judgments (or prejudices?) based on more qualitative experiences in the labor market determine whether any scholar or policymaker weighs discrimination or choice more heavily. This weighting cannot solely be the result of quantitative analysis.

titles is one in which there is little overlap by sex. Thus the primary market designs "women's" jobs that fit the perceived characteristics of women and also lowers their wages. "Women's" jobs are devalued, then, solely because women perform them.

The persuasiveness of this model as an explanation of discriminatory pay differentials has been challenged by Cain (1976) and Wachter (1974), among others. They argue the following:

(1) Wages and job assignments in both primary and secondary markets are subject to the productivity tests of the marketplace. Mobility between jobs in the primary market indicates that the external labor market keeps the internal labor market "honest" (that is, paying only for true merit or productivity).

(2) It is clearly in the interest of secondary market workers to increase the stability of their labor force attachment. It is also in the interest of primary market employers to do so because this would increase the potential supply of primary workers and would permit a lowering of wages in the primary sector. Therefore, the discriminatory placement of women into such jobs cannot be an equilibrium situation.

Other approaches. Barbara Bergmann (1974) has developed an "overcrowding" analysis of discrimination that assumes the existence of a nonspecified institutional barrier to women entering male occupations. Bergmann then works through a standard neoclassical economic analysis in which workers in both men's and women's occupations are paid according to the marginal productivity of the last worker hired in the occupation. However, due to the entry barriers, there is a greater supply of workers in women's occupations, lowering the marginal product of the last worker hired and, thus, the equilibrium wage rate in the occupation.

This theory is subject to the same criticism we have now raised with respect to all the theories. Simply, the existence of barriers to women entering male occupations is an unstable situation. Any nondiscriminatory employer could profit by hiring equally able women at their lower wage level into male jobs. Therefore, in the long run, occupational segregation would disappear.

A POLICY EPILOGUE:
SOMETHING FOR EVERY PARTISAN

It is disappointing to complete a review of such an extensive research literature and to realize that there is no consensus on the answers to the most important questions. The research literature truly contains something for every partisan, but no complete answers for the scholar.

I have support for the proposition that sex discrimination in the labor market is not a problem, making government intervention unnecessary. The failure of any theory to explain convincingly the basis for a persistent discriminatory sex differential in wages or in job placement or for a devaluation of women's work lends some credence to a belief that aggregate sex differentials are the result of aggregate sex differences in choices and in abilities.

On the other hand, the sheer magnitude and persistence of the observed sex-wage differential *after adjusting* for sex differences in credentials, including some questionable credentials (i.e., occupation, job tenure, etc.) that could be influenced more by differential opportunities than by different choices, make it impossible to dismiss the existence of extensive sex discrimination in the labor market. The empirical data on sex differentials in wages indicate that the inability of economic theory to explain satisfactorily the existence of discrimination points to the inadequacy of the theory itself and not to the nonexistence of discrimination.

The empirical research does reach some consensus on the sources of the sex-wage differential. Sex differences in occupations or job title account for significantly more of the sex-pay differential than do sex differences in pay for workers within the same job. There is less evidence on whether the concentration of women in low-paying jobs is the result of (1) sex barriers to entry in high paying jobs; (2) discriminatory devaluation of women's work that results in women's jobs paying less; or (3) occupational or job choices of women being relatively more constrained by family status. Given the assumptions required for theory to yield extensive devaluation of women's jobs, I find it hard to believe that such devaluation of women's jobs could be the most important reason why women are in low-paying jobs. The more important questions revolve around the other two possibilities.

When any sex differential in the labor market cannot be explained by observable credentials, two explanations are possible: Women face different opportunities to work and acquire skills or women make different choices about working and acquiring skills. We only observe the sex differences in outcomes, and those outcomes are most often consistent with either cause. Of course, both explanations can contribute to the differences. Given the current status of available data and research methodologies, less precise judgments (or prejudices?) based on more qualitative experiences in the labor market determine whether any scholar or policymaker weighs discrimination or choice more heavily. This weighting cannot solely be the result of quantitative analysis.

NOTES

1. Several other authors have reviewed the labor economics literature with respect to race differentials only (Marshall, 1974), with respect to sex and race differentials (Cain, 1985), and with respect to sex differentials only (Blau, 1982, 1984; Blau & Jusenius, 1976; Kahne, 1975; Kohen, Breinich, & Shields, 1975). In addition, Cain's (1976) review of segmented labor market theory includes a discussion of the theory of discrimination.

2. Because the dependent variable is the natural logarithm of annual salary, each regression coefficient may be interpreted as the approximate percentage effect of the dependent variable of a unit change in the independent variable. However, the regression coefficient is only an approximate percentage. To get the actual percentage p, one must compute $p = e^{\beta} - 1$, where β is the coefficient.

REFERENCES

Aigner, D. J., & Cain, G. C. (1977). Statistical theories of discrimination in labor markets. *Industrial and Labor Relations Review, 30*, 175-187.

Arrow, K. (1972a). Models of job discrimination. In A. H. Pascal (Ed.), *Racial discrimination in economic life* (pp. 83-102). Lexington, MA: D. C. Heath.

Arrow, K. (1972b). Some mathematical models of race in the labor market. In A. H. Pascal (Ed.), *Racial discrimination in economic life* (pp. 187-204). Lexington, MA: D. C. Heath.

Arrow, K. (1973). The theory of discrimination. In O. Ashenfelter & A. Rees (Eds.), *Discrimination in labor markets* (pp. 3-33). Princeton, NJ: Princeton University Press.

Arrow, K. (1976). Economic dimensions of occupational segregation: Comment I. *Signs, 1*(2), 233-237.

Ashenfelter, O. (1973). Discrimination and trade unions. In O. Ashenfelter & A. Rees (Eds.), *Discrimination in labor markets* (pp. 88-112). Princeton: Princeton University Press.

Ashenfelter, O. (1979). Union relative wage effects: New evidence and a survey of their implications for wage inflation." In R. Stone & W. Peterson (Eds.), *Econometric contributions to public policy*. New York: St. Martins Press.

Ashenfelter, O., & Hannan, T. H. (1984, August). *Sex discrimination and market concentration: The case of the banking industry*. Working Paper No. 179, Princeton University.

Becker, G. (1957). *The economics of discrimination*. Chicago: University of Chicago Press.

Bergmann, B. R. (1974). Occupational segregation, wages and profits when employers discriminate by race or sex. *Eastern Economic Journal, 1*, 103-110.

Blau, F. D. (1977). *Equal pay in the office*. Lexington, MA: D. C. Heath.

Blau, F. D. (1982, November). *Occupational segregation and labor market discrimination: A critical review*. Report to the National Academy of Sciences Committee on Women's Employment and Related Issues, Washington, DC.

Blau, F. D. (1984). Discrimination against women: Theory and evidence. In W. Darity, Jr. (Ed.), *Labor economics: Modern views* (pp. 53-89). Boston: Kluwer-Nijhoff.

Blau, F. D., & Jusenius, C. L. (1976). Economists' approaches to sex segregation in the labor market: An appraisal. *Signs, 1*(2), 181-199.

Blau, F. D., & Kahn, L. M. (1981). Race and sex differences in quits by young workers. *Industrial and Labor Relations Review, 34*, 563-577.

Blinder, A. S. (1973). Wage discrimination: Reduced form and structural estimates. *Journal of Human Resources, 8*, 436-455.

Bowen, W., & Finegan, T. A. (1969). *The economics of labor force participation.* Princeton, NJ: Princeton University Press.

Bunting, R. (1962). *Employer concentration in local labor markets.* Chapel Hill, NC: University of North Carolina Press.

Butler, R. J. (1982). Estimating wage discrimination in the labor market. *Journal of Human Resources, 17*, 606-621.

Cain, G. (1966). *Married women in the labor force.* Chicago: University of Chicago Press.

Cain, G. (1976). The challenge of segmented labor market theories to orthodox theory: A survey. *Journal of Economic Literature, 14*, 1215-1257.

Cain, G. (1985). The economic analysis of labor market discrimination: A survey. In O. Ashenfelter & R. Layard (Eds.), *Handbook in labor economics.* New York: Elsevier.

Cain, G. & Dooley, M. D. (1976). Estimation of a model of labor supply, fertility and wages of married women. *Journal of Political Economy, 84.*

Cardwell, L. A., & Rosenzweig, M. R. (1980). Economic mobility, monopsonistic discrimination and sex differences in wages. *Southern Economic Journal, 46*, 1102-1117.

Cohen, M. S. (1971). Sex differences in compensation. *Journal of Human Resources, 6*, 434-447.

Comanor, W. S. (1973, November). Racial discrimination in American industry. *Economica*, 363-378.

Corcoran, M., & Duncan, G. J. (1979). Work history, labor force attachment, and earnings differences between the races and sexes. *Journal of Human Resources, 14*, 3-20.

Daymont, T. N., & Andrisani, P. J. (1984). Job preferences, college major and the gender gap in earnings." *Journal of Human Resources, 19*, 408-428.

Doeringer, P. B., & Piore, M. J. (1971). *Internal labor markets and manpower analysis.* Lexington, MA: D. C. Heath.

Edwards, R. C., Reich, M., & Gordon, D. M. (Eds.). (1975). *Labor market segmentation.* Lexington, MA: D. C. Heath.

Featherman, D. L., & Hauser, R. M. (1976). Sexual inequalities and socioeconomic achievement in the U.S., 1962-1973. *American Sociological Review, 41*, 462-483.

Filer, R. K. (1983). Sexual differences in earnings: The role of individual personalities and tastes. *Journal of Human Resources, 18*, 82-99.

Freeman, R. B., & Medoff, J. L. (1984). *What do unions do?* New York: Basic Books.

Fuchs, V. R. (1971). Differences in hourly earnings between men and women. *Monthly Labor Review, 94*, 9-15.

Goldberger, A. S. (1984). Reverse regression and salary discrimination. *Journal of Human Resources, 19*, 293-318.

Gordon, D. M. (1972). *Theories of poverty and underemployment.* Lexington, MA: D. C. Heath.

Gordon, D. M., Edwards, R., & Reich, M. (1982). *Segmented work, divided workers.* Cambridge, England: Cambridge University Press.

Gwartney, J. D., & Stroup, R. (1973). Measurement of employment discrimination according to sex. *Southern Economic Journal, 60*, 575-587.

Kahne, H. (1975). Economic perspectives of the roles of women in the American economy. *Journal of Economic Literature, 13*, 1249-1292.

Kamalich, R. A., & Polachek, S. W. (1982). Discrimination: Fact or fiction? An explanation using an alternative approach. *Southern Economic Journal, 49*, 450-461.

Kohen, A. I., Breinich, S. C., & Shields, P. (1975). *Women and the economy: A bibliography and a review of the literature on sex differentiation in the labor market.*

Unpublished manuscript, Center for Human Resource Research, College of Administrative Science, Ohio State University.

Kohen, A. I., & Roderick, R. (1975). *The effect of race and sex discrimination on early career earnings.* Unpublished paper, Center for Human Resource Research, Ohio State University, Columbia.

Lewis, H. G. (in press). *Union relative wage effects: A survey.*

Luksetich, W. A. (1979, November). Market power and sex discrimination in white-collar employment. *Review of Social Economy*, 211-224.

Lundberg, S. J., & Startz, R. (1983). Private discrimination and social intervention in competitive labor market. *American Economic Review, 73*, 340-347.

Madden, J. F. (1973). *The economics of sex discrimination.* Lexington, MA: D. C. Heath.

Madden, J. F. (1975). Discrimination and male market power. In C. B. Lloyd (Ed.), *Sex, discrimination and the division of labor* (pp. 146-174). New York: Columbia University Press.

Madden, J. F. (1976). Economic dimensions of occupational segregation: Comment III. *Signs,* 1(2), 245-250.

Madden, J. F. (1977a). An empirical analysis of the spatial elasticity of labor supply. *Papers, Regional Science Association, 39*, 157-171.

Madden, J. F. (1977b). A spatial theory of sex discrimination. *Journal of Regional Science, 17*, 369-380.

Madden, J. F. (1981, November). *A potpourri of current theoretical and empirical issues in measuring employment discrimination.* Paper presented to the Seventeenth North American Peace Science Conference, Philadelphia, PA.

Maranto, C. L., & Rodgers, R. C. (1984). Does work experience increase productivity? A test of the on-the-job training hypothesis. *Journal of Human Resources, 19*, 341-357.

Marshall, R. (1974). The economics of racial discrimination: A survey. *Journal of Economic Literature, 12*, 849-871.

Medoff, J. L., & Abraham, K. G. (1980). Experience, performance, and earnings. *Quarterly Journal of Economics, 94*, 703-736.

Medoff, J. L., & Abraham, K. G. (1981). Are those paid more really more productive? The case of experience. *Journal of Human Resources, 16*, 186-216.

Mincer, J. (1962). Labor force participation of married women: A study of labor supply. In National Bureau of Economic Research, *Aspects of labor economics.* Princeton, NJ: Princeton University Press.

Mincer, J. (1979). Wage differentials: Comment. In C. B. Lloyd, E. S. Andrews, & C. L. Gilroy (Eds.), *Women in the labor market* (pp. 278-285). New York: Columbia University Press.

Mincer, J., & Polachek, S. (1974). Family investments in human capital earnings of women. *Journal of Political Economy, 82*, S76-S108.

Nelson, P. (1973). The elasticity of supply to the individual firm. *Econometrica, 41*, 853-866.

Oaxaca, R. (1973a). Male-female wage differentials in urban labor markets. *International Economics Review, 14*, 693-709.

Oaxaca, R. (1973b). Sex discrimination in wages. In O. Ashenfelter & A. Rees (Eds.), *Discrimination in labor markets* (pp. 124-151). Princeton, NJ: Princeton University Press.

O'Neill, J. (1985). The trend in sex differential in wages. *Journal of Labor Economics, 3*, S91-S116.

Oster, S. M. (1975). Industry differences in discrimination against women. *Quarterly Journal of Economics, 89*, 215-229.

Phelps, E. S. (1972). The statistical theory of racism and sexism. *American Economic Review, 62,* 659-661.

Ragan, J. F., Jr., & Smith, S. P. (1981). The impact of differences in turnover rates on male/female pay differentials. *Journal of Human Resources, 16,* 343-365.

Roberts, H. V. (1980). Statistical biases in the measurement of employment discrimination. In E. R. Livernash (Ed.), *Comparable worth: Issues and alternatives* (pp. 173-195). Washington, DC: Equal Employment Advisory Council.

Robinson, J. (1933). *The economics of imperfect competition.* London: MacMillan.

Roos, P. A. (1981). Sex stratification in the workplace: Male/female differences in economic returns to occupations. *Social Science Research, 10,* 195-224.

Sanborn, H. (1964). Pay differences between men and women. *Industrial and Labor Relations Review, 17,* 534-550.

Sandell, S. H., & Shapiro, D. (1978). An exchange: Theory of human capital and the earnings of women: A reexamination of the evidence. *Journal of Human Resources, 13,* 103-117.

Sawhill, I. (1973). The economics of discrimination against women: Some new findings. *Journal of Human Resources, 8,* 383-396.

Spence, A. M. (1973). Job market signaling. *Quarterly Journal of Economics, 87,* 355-374.

Spence, A. M. (1974). *Market signaling.* Cambridge, MA: Harvard University Press.

Starrett, D. (1976). Social institutions, imperfect information, and the distribution of income. *The Quarterly Journal of Economics, 90,* 261-284.

Suter, L. E., & Miller, H. P. (1973). Income differences between men and career women. *American Journal of Sociology, 78,* 962-974.

Thurow, L. C. (1975). *Generating inequality.* New York: Basic Books.

Treiman, D. J., & Hartmann, H. I. (Eds.). (1981). *Women, work, and wages: Equal pay for jobs of equal value.* Washington, DC: National Academy Press.

Treiman, D. J., & Terrell, K. (1975). Sex and the process of status attainment: A comparison of working women and men. *American Sociological Review, 40,* 174-200.

U.S. Bureau of the Census (1982). *Statistical abstract of the United States, 1982-1983.* Washington, DC: Government Printing Office.

U.S. Department of Labor (1980). *Handbook of Labor Statistics.* Washington, DC: Government Printing Office.

Viscusi, W. K. (1980, October). Sex differences in worker quitting. *Review of Economics and Statistics,* 388-398.

Wachter, M. (1974). Primary and secondary labor markets: A critique of the dual approach. *Brookings Papers on Economic Activity, 3,* 637-694.

Waite, L. J., & Stolzenberg, R. M. (1976). Intended childbearing and labor force participation of young women: Insights from nonrecursive models. *American Sociological Review, 41.*

Zellner, H. (1975). The determinants of occupational segregation. In C. B. Lloyd (Ed.), *Sex, discrimination and the division of labor* (pp. 125-145). New York: Columbia University Press.

4

Persistence and Change in Pay Inequalities
IMPLICATIONS FOR JOB EVALUATION AND COMPARABLE WORTH

JAMES E. ROSENBAUM

This chapter reports the results of a study of pay practices in a large corporation over the period 1962-1975. In this period, this corporation, like many others, experienced growth and contraction, an affirmative action program, and the implementation of job evaluation for setting the pay level of jobs. This chapter describes persistent and changing aspects of the relationship between men's and women's pay. The study finds that even a very strong affirmative action program, which greatly benefits women as a class, may neglect some groups of women. Second, affirmative action may help many individuals while maintaining structural discrimination against female jobs. Third, job evaluation, even in the context of a strong affirmative action program, may not overcome salary disadvantages of female jobs and may inadvertently legitimize traditional values under the mask of scientific procedure.

Whereas neoclassical economic theory portrays pay practices in organizations as highly changeable, social-structural theories portray them as rigidly constrained by administrative rules and institutional customs (Doeringer & Piore, 1971). Although these theories have been useful for explaining persistence and change in economic institutions, it is obvious that the explanation of institutional change lies somewhere between these views. As Granovetter (1981) and Jencks (1981) have noted,

AUTHOR'S NOTE: This chapter is a revised version of a paper presented at the Seminar on Comparable Worth held by the Committee on Women's Employment and Related Social Issues. The author is indebted to Bill Bielby, Heidi Hartman, and Don Treiman for their suggestions on earlier versions of this chapter. The author also wishes to thank the editors and the reviewers of this volume for their suggestions. Preparation of this chapter was supported by the Center for Urban Affairs and Policy Research at Northwestern University and by the Russell Sage Foundation. Of course, the views presented here are those of the author.

advocates of social structural theory concede that social structures must eventually change in response to economic forces, just as neoclassical economists concede the existence of temporary disequilibria and imperfect markets that sometimes make earnings temporarily unresponsive to change. The important issues to be studied are, according to Granovetter and Jencks, more complex. Rather than asking whether or not change occurs, the real issues to investigate are what kinds of forces, over what periods of time, create what kinds of changes in economic and social inequalities.

This theoretical conflict has some very practical implications. In particular, this article examines how pay inequalities between women and men have changed in a corporation over periods of economic growth and contraction and after periods when affirmative action programs were implemented, and it examines in what respects structural mechanisms are responsible for the observed changes or lack of changes in attainments. If neoclassical economic theory is correct that pay patterns are highly malleable, then we might expect considerable change to occur in the pay patterns of men and women over these periods. In contrast, if social-structural theory is correct that organizational pay patterns are structural in origin and are consequently resistant to change, then employees in organizations may be somewhat insulated from external market changes and the apparent policy changes regarding affirmative action may not be fully implemented in practice.

Although the question of structural unresponsiveness might never arise if organizations paid employees solely on the basis of their worth in the larger labor market (as neoclassical economic theory assumes), the external labor market is only one consideration in determining pay. Organizations often employ many individuals with different characteristics in the same job, and they tend to pay individuals in terms of the worth of the jobs they occupy (Treiman, 1979).

The practice of paying for job worth has important implications for the pay inequalities between men and women. In a labor market in which men and women often hold entirely different jobs, the relative pay of individuals within the same jobs is likely to be a less important source of discrimination than the way different jobs are compensated across pay levels (Treiman & Hartmann, 1981). The issue of comparable worth poses the question of whether jobs held predominantly by women are undervalued, and thus undercompensated, relative to jobs of comparable worth that are held predominantly by men. Consequently, the study of pay equity must consider the ways that job compensation is determined.

Compensation systems in organizations often operate by a two-stage process in which the relative value of jobs is first determined, and then the relative pay of individuals within jobs is determined. The latter process involves the assessment of an individual's contribution compared with other individuals in the same job, and this assessment—usually by the person who supervises all these people—tends to operate in the way neoclassical economists customarily assume.

However, the former process, determining the value of jobs, is very different. It requires the evaluation of highly different job tasks and their classifications into a limited number of ranked levels. Traditional customs and beliefs were the original basis for allocating jobs into differential status rankings (Treiman, 1979). Some jobs were considered to have more status because they were believed to require more skill, talent, or persistence, and this status consensus was the basis for compensation differences.

In recent decades, these traditional status rankings came under increasing criticism, and, in response, formal job evaluation systems have been devised to make the process of assigning jobs to different hierarchical positions more objective, rational, and equitable. This change has raised the question of whether this shift from tradition to job evaluation has increased pay equality between jobs held predominantly by men and those held predominantly by women.

Although the origins of inequalities among jobs have long been of interest to social theorists (e.g., Davis & Moore, 1965), the administrative procedure for evaluating the worth of jobs has only recently been analyzed as a way of understanding pay equalities between women and men. The study reported here provides one of the first opportunities to examine this issue empirically.

This chapter describes the results of a study of these issues in a large corporation. The study investigates the ways that jobs are allocated to different status categories, the ways they are compensated, and the extent to which job statuses prevent a narrowing of the wage gap between men and women. Moreover, it investigates pay outcomes over a relatively long period, from 1962 to 1975; over the course of this period the corporation implemented an increasingly strong affirmative action program and shifted from a tradition-based job ranking system to one based on job evaluation. These changes might be expected to influence the ways men and women employees and predominantly male and female jobs were compensated. This report is based on results from a larger study (Rosenbaum, 1984). For the sake of simplicity, statistical results are not discussed in detail here.

SETTING AND DATA

This chapter is based on a study of employees' earnings and job attributes in a large corporation over a 13-year period from 1962 to 1975. The corporation employed between 10,000 and 15,000 employees in the period studied, making it slightly larger than the median corporation in *Fortune's* largest 500 corporations. The firm is a large, autonomous, and investor-owned firm, having offices in many cities and towns across a large geographic region.[1]

The study had use of the computerized personnel records of the corporation for the years 1962, 1965, 1969, 1972, and 1975, permitting analyses of changes over 3-year intervals for all but one period. Analyses reported here use two kinds of samples.

The first is based on analyses of independently drawn 25 percent random samples of all individuals in the firm in four periods (the 1962 data are excluded because they lack information on race). Regression analyses are used to explain individuals' earnings (in logs, adjusted to 1967 dollars) in terms of individual attributes (experience, education, entry age, sex, race, and the status ranking of colleges attended using the Astin [1965] scale) and by comparing their relative influences within and across job status levels.

The other set of analyses examine the determinants of the average pay that jobs offer. These analyses are based on a data set that aggregates information about all individuals in each job (i.e., a 100 percent sample) to describe jobs in terms of averages: Average tenure, average earnings, percentage college graduates, percentage female, and so forth. These analyses take jobs as the units of analysis in order to discover relationships among the attributes of jobs.

The availability of actual personnel records makes the present research distinct from most economic and sociological research in this area and offers two important advantages. First, these personnel records offer valid and precise information on employees' salaries, levels of attainment in the organizational hierarchy, education, college attended, age, and years of experience in the corporation (tenure). Most research has been based on employees' self-reports, and the possibilities of distortions or poor recollection are generally a cause of concern. In contrast, these personnel records are systematically kept by the corporation's personnel department for the organization's own use, and consequently, extensive data-checking procedures are implemented to ensure the accuracy of the information because mistakes would have important implications for company personnel practices.

Second, these personnel records represent the complete universe of employees in the corporation. Most studies of organizations have had to rely on employees' cooperation, and less than perfect cooperation leads to incomplete information or possibly biased samples. For instance, Grusky's (1966) 75 percent response rate (in the data Halaby [1979] used) is rather good as questionnaire response rates go; however, it does raise questions about the representativeness of the sample that cannot be completely settled. These data are drawn from the universe of all employees in the cohort studied here, and there is no missing information for any individual (except the above mentioned race information in 1962).

Of course, the use of personnel records does have its own limitations, primarily in that they do not include all the information that a researcher might like to consider. In particular, the records do not include information on marital status or actual years of education, which previous research has suggested to be worthy of consideration.

AFFIRMATIVE ACTION EFFECTS ON INDIVIDUALS

This corporation provides a notable example of an ostensibly successful affirmative action program. It implemented a serious affirmative action program in 1970 and an even stronger one in 1973, and these two programs had an impressive beneficial impact on women's earnings. In 1969, before these programs began, women received about 46 percent lower earnings than similar men at entry, and their disadvantage remained at about the same magnitude for those with greater seniority. The affirmative action programs increasingly reduced females' disadvantages: From 46 percent in 1969 to 39 percent in 1972 and 23 percent in 1975. Female college graduates gained even more, going from a 36 percent disadvantage for new entrants before affirmative action to only a 3 percent disadvantage by 1975.

However, senior women did not fully share in these gains. Although each year of seniority raised women's earnings at the same rate as it raised men's in 1969, by 1972 women's rate of earnings increase with seniority was 21 percent lower than that of men, and by 1975, it was 29 percent less. For example, while entering women in 1975 had a 23 percent earnings disadvantage relative to male peers, women with 10 years of seniority had a 31 percent disadvantage relative to their male peers.

This tenure discrepancy was true mostly for college-educated women, the group whose least senior members gained the most from affirmative

action. Obviously, the great gains for newly entering women were not being fully passed along to their more senior peers.

This outcome is particularly poignant because it was the senior women who had been most hurt by the previous decades of discrimination and whose experience had prompted the affirmative action program. Nonetheless, the affirmative action program was not providing reparation for the deprivations these women had experienced. Their deprivations continued even after the affirmative action program had accomplished great gains for others. Although the program had created substantial gains for the class of employees it aimed to help, the specific individuals who had been most hurt by previous discrimination were left with earnings similar to what they had always received.

ARE THESE REDUCED GAINS
DUE TO STRUCTURAL BARRIERS?

To what extent are these reduced gains for older college women mediated by job status (internal ranking)? To answer this question, regression analyses were run to separate the components of college women's earnings within job statuses from the components across job statuses. In a regression model with interactions for tenure and tenure squared, high tenure college women's diminished gains (relative to their less senior peers) could be discerned by a decline in the tenure coefficients after affirmative action began.

Although the full analysis is reported elsewhere (Rosenbaum, 1984, Chapter 7), only the coefficients for college women are relevant to the present concern. Table 4.1 presents separate models for college women's earnings within and across statuses in 1965 and 1975.[2] Because the dependent variable is the natural logarithm of earnings (adjusted for constant 1967 dollars), tenure coefficients indicate the percentage gain in earnings for additional years of tenure in the firm. The strong curvilinear component in these models (the tenure-squared term is large in three of the four models) makes it difficult to compare slopes by inspection. Consequently, these results are most easily compared by seeing their effects on sample values of tenure.

Table 4.2 shows college women's earnings gains within and across statuses in 1965 and 1975 for two sample values of tenure: 10 and 20 years. For instance, the first column in Table 4.2 indicates that college women with ten years of tenure had 35.5 percent greater earnings than entering college women within the same status and 41.2 percent greater earnings than entering college women across different statuses.

TABLE 4.1
Regression Coefficients for Ln (Earnings) Within and Across
Statuses for College-Educated Women in 1965 and 1975

	1965	1975
Within Statuses	$8.2541 + .0485T - .0013T^2$	$8.7488 + .0296T - .0006T^2$
Across Statuses	$.2676 + .0292T + .0012T^2$	$.4054 + .0063T + .0000T^2$

SOURCE: Adapted from Rosenbaum (1984).

TABLE 4.2
Percentage Increase in Earnings Within and Across Statuses
for 10 and 20 Years of Tenure

	10 Years Tenure		20 Years Tenure	
	1965	1975	1965	1975
Within Statuses	35.5%	23.6%	149.0%	83.2%
Across Statuses	41.2%	6.3%	106.4%	12.6%

SOURCE: Adapted from Rosenbaum (1984).
NOTE: Figures derived from models in Table 4.1.

The results indicate that while ten years of tenure confers only slightly less earnings gain within statuses in 1975 than it did in 1965 (declining from 35.5 percent to 23.6 percent), it confers much less earnings gain across statuses over that period (declining from 41.2 percent to 6.3 percent). The same is true at 20 years tenure, although the difference is less.

The results also indicate that college women with low tenure receive more of their affirmative action gains within statuses than across statuses. Comparing the constants in Table 4.1 (which represent the logarithm of earnings at tenure equals zero), we see a 50 percent gain within statuses (9.7488 − 8.2541 = .4947) but only a 14 percent gain across statuses (.4054 − .2675 = .1378).

Thus although most earnings variation in this corporation occurs across rather than within job statuses, job status gains account for less of the affirmative action earnings gains of newly entering college women than do earnings gains within job statuses. Furthermore, this difference is accentuated for more senior college women whose earnings gains are disproportionately more within, rather than across, job statuses. These results suggest that the job status structure may limit the earnings gains senior college women receive from affirmative action.[3]

Initial inquiry into the question of persistence and change reveals that the apparent changes indicated in women's average earnings conceal a substantial component of stability and even resistance to change. Moreover, as social-structural theories imply, this stability is largely mediated by the job status system. Consequently, subsequent analyses investigate how jobs and job composition may contribute to this process.

THE CREATION AND DISSOLUTION OF JOBS

Persistence depends on the endurance of a constant set of jobs in an organization. Large organizations are usually conceptualized as unchanging, almost physical structures—much like the concrete and steel structures that house them. Organizational charts of jobs in an organization are portrayed as if these diagrams represented something enduring about the organization.

Organizations sometimes change their organizational structures: jobs are created and disbanded. Technological and economic changes occur, requiring new kinds of jobs while making others obsolete. Political battles over authority and task responsibilities change jobs into entirely different jobs. Individual job occupants become proficient and take on so many additional tasks that they change the nature of a particular job. These dynamic processes seem entirely plausible, but we have no idea how often they occur. To the extent that they occur, they pose a serious challenge to the notion of a fixed organizational structure, for they suggest that old job duties or old ways of organizing duties into jobs disappear and new duties or new ways of organizing duties appear in the form of new jobs. If jobs and job statuses are as important as they seem to be in affecting earnings, this degree of change in the job structure will have important implications for any program to affect earnings and employment outcomes.

This study analyzed the set of job titles that are listed in the personnel records of this corporation for the years 1962, 1965, 1969, 1972, and 1975. Titles for the three lowest levels in the organization—nonmanagement, foreman, and lower management—are reported.

The main concern of the first analysis is the number of jobs that appear or disappear, that is, that go from having no occupants to having some occupants, and vice versa. However, because jobs with few occupants could mistakenly appear to have been eliminated when they temporarily have several vacancies, inferences are more ambiguous with these jobs. Consequently, the analysis distinguishes between small

TABLE 4.3
Number of Jobs Changing Job Size Between 1962 and 1965, 1969, 1972, and 1975 by Level

Job size in 1962	Nonmanagement				Foreman				Lower Management		
	0	1-4	5+	Total	0	1-4	5+	Total	0	1-4	5+
Number of Jobs in 1965 by Job Size											
0	0	31	19	50	0	26	10	36	0	43	5
1-4	2	82	11	95	14	89	8	111	10	59	4
5+	0	5	71	76	1	2	41	44	1	0	12
	2	118	101	221	15	117	59	191	11	102	21
Number of Jobs in 1969 by Job Size											
0	0	26	14	40	0	20	12	32	0	28	9
1-4	26	60	9	95	49	55	7	111	34	35	4
5+	4	10	62	76	5	5	34	44	1	2	10
	30	96	85	211	54	80	53	187	35	65	23
Number of Jobs in 1972 by Job Size											
0	0	20	17	37	0	18	13	31	0	21	4
1-4	42	42	11	95	63	38	10	111	49	20	4
5+	11	12	53	76	12	5	27	44	5	2	6
	53	74	81	208	75	61	50	186	54	43	14
Number of Jobs in 1975 by Job Size											
0	0	16	16	32	0	9	16	25	0	15	5
1-4	46	36	13	95	61	41	9	111	58	11	4
5+	17	10	49	76	12	5	27	44	5	0	8
	63	62	78	203	73	55	52	180	63	26	17

SOURCE: Adapted from Rosenbaum (1984).

NOTE: Job sizes are divided into three categories: Vacant (0), small (1-4 occupants), and large (5 or more occupants).

123

jobs (having one to four occupants) and large jobs (having five or more). We can be more confident in inferring that jobs have been eliminated when jobs with five or more occupants subsequently have no occupants.[4]

Table 4.3 shows the pattern of changes in job occupancy. The entries in the tables are the number of jobs of various sizes in the years portrayed for the three different levels considered here. For instance, the upper-left corner of the table shows that in nonmanagement, two small jobs (with one to four occupants) in 1962 had become empty three years later, but no large jobs (with five or more occupants) in 1962 had become empty three years later. However, between 1962 and 1969, 26 of the small jobs and 4 of the large jobs had become empty. On the other hand, this also indicates that even more new jobs were created over these time intervals. Between 1962 and 1965, 31 small nonmanagement jobs and 19 large jobs were created.

The patterns for other levels show even greater amounts of job disappearance and job creation. Whereas 76 percent of the non-management jobs existing in either 1962 or 1965 existed in both years, 73 percent of the foreman level jobs and only 56 percent of the lower-management jobs were similarly enduring. For the 13-year interval between 1962 and 1975, the comparable figures are much lower for all levels and the differences among levels is even greater: 53 percent for nonmanagement, 46 percent for the foreman level, and 22 percent for the lower-management level. For all three levels, most jobs existing in these years were abolished or newly created over the period. Persistence is more the exception than the rule.

In considering the possible generalizability of these findings, what is most striking is that this company has not undergone enormous outwardly visible changes. It continued to conduct the same activities over the entire period. Nor have there been any mergers with other companies or divestitures of subsidiaries. To all outward appearance, it is the same organization housed in most of the same buildings doing largely the same activities over the entire decade. Nor has it had any new leadership or organizational shake-ups that would explain these changes. As large corporations go, it is probably more stable and less changed than most over the period considered.

Of course, affirmative action, job evaluation, organizational contraction, and organizational growth were important changes over these periods, but they are not sufficient to explain the findings of these analyses. In particular, the 1962-1969 period is largely unexplained by the affirmative action program or the shift to job evaluation as they

occurred after this period. Organizational growth is the main feature of the period, and, although growth might explain job creation, it does not explain why more jobs were disbanded than were created over the period. The disappearance and creation of jobs found here are indicative of small changes that gradually evolved from a multitude of particular decisions in various parts of the organization. Although no other evidence is available on this specific point, it is reminiscent of Granovetter's finding that 35 percent of the job placements in his study were jobs that had not existed previously (Granovetter, 1974, p. 14).

These results have important implications for job evaluation programs. Although a jobs-based policy may be necessary for realizing our goals for affirmative action and is essential in developing a comparable worth strategy, a lasting solution will not result from a one-time effort. With jobs continually being disbanded and created, any reform effort requires the formulation of an entirely new system and a continuing commitment to its implementation. This analysis also clearly indicates that our customary image of a fixed organizational hierarchy is seriously misleading. Jobs appear and disappear at a surprisingly high rate. White's (1970) procedure for analyzing mobility in terms of vacancy chains would clearly not apply here, even over the short period from 1962-1969. Although the assumptions of vacancy analysis seemed to apply rather well to the hierarchy of the Episcopal Church that White studied, in the corporation studied here, any vacancy that occurred could go unfilled forever while new jobs were being created and filled that had never before been occupied.

DO JOBS OFFER STABLE COMPENSATION?

To what extent do jobs change in the relative compensation they offer over periods of changing economic circumstances? The importance of jobs and job statuses to earnings will be especially great if it is found that jobs provide stable relative earnings over time.

We commonly assume that jobs retain the same value over time, so that compensation would not be very responsive to changes in economic circumstances. However, these hypotheses are put to a severe test in studying the periods included in these data, for they were times of economic and social change. The successive periods in these data were times of modest growth (1962-1965) followed by booming growth (1965-1969). We would expect such changes to be accompanied by changes in priorities among types of jobs. Furthermore, the organization shifted

TABLE 4.4
Stability of Job Salaries by Level (Pearson Correlations)

	Nonmanagement Level				Foreman Level			
	1962	*1965*	*1969*	*1972*	*1962*	*1965*	*1969*	*1972*
1965	.977				.965			
1969	.968	.980			.944	.952		
1972	.958	.966	.968		.876	.881	.920	
1975	.958	.954	.948	.954	.842	.868	.869	.898

SOURCE: Adapted from Rosenbaum (1984).

from a traditional job status system to a job evaluation system during this period (in 1972). In addition, an affirmative action program begun in 1970 was made even stronger in 1973, developments that we would expect to change the relative standing of jobs filled with large proportions of women and minorities. In the face of these great changes, to what extent did jobs change in the compensation they offered?

The job titles data file was created from the complete personnel records on all employees in the firm. These data on individuals were aggregated by job titles, so that jobs became the units of analysis and the variables for these units were the average salary of all occupants in each job, the average tenure of job occupants, the percentage of job occupants with a college degree, the percentage of job occupants who were female, and so forth.

This section reports the analysis of the compensation offered by a job. This is indicated by the average earnings of all individuals who occupy the job at a particular time and is called job salary or simply salary. There is a large range of job salaries in this organization, even within a single level of the organizational hierarchy.[5] To what extent are these job salaries stable properties of jobs over these periods of great economic changes?

The analysis finds only minimal change in salaries. Job salaries in nonmanagement levels remained extremely stable between 1962 and 1975 (Table 4.4). All correlations are large: The correlations of 1962 job salaries with those in later years show negligible decline (.98, .97, .96, .96). The comparable correlations at the foreman level start at the same magnitude, but the correlations of 1962 job salaries with those in later years show some decline, particularly between 1969 and 1972 (.96, .94, .88, .84).[6]

TABLE 4.5
Jobs at Each Level by Percentage Female, 1962-1975
(for jobs with five or more employees)

	1962	1965	1969	1972	1975
Nonmanagement Level					
0 percent	47	55	42	34	19
1-99 percent	3	6	7	13	25
100 percent	23	37	34	31	31
Total	73	98	83	78	75
Foreman Level					
0-percent	18	25	20	17	17
1-99 percent	2	7	7	13	14
100 percent	24	27	25	18	20
Total	44	59	52	48	51
Lower-Management Level					
0 percent	13	21	18	9	8
1-99 percent	0	0	5	4	8
100 percent	0	0	0	1	1
Total	13	21	23	14	17

SOURCE: Adapted from Rosenbaum (1984).

Despite considerable changes in economic circumstances and organizational practices over these periods, job salaries remained extremely stable for nonmanagement and foreman levels. This stability is particularly striking, for it occurred despite an explicit effort to reform the traditional job status system by implementing job evaluation at foreman levels and above. This effort was implemented in 1972 and was probably responsible for the declining earnings correlation between 1969 and 1972 at the foreman level. However, the decline in the earnings correlation is surprisingly minor, given the extensiveness of the reform. This stability suggests that the job evaluation effort had little effect on the average earnings in jobs.

THE SEX COMPOSITION OF
JOBS AND WOMEN'S EARNINGS

Having seen that jobs offered highly stable salaries over this period, our analysis of the effects on women's earnings must turn to an analysis of the composition of jobs to understand how women are allocated among jobs and how this affects their earnings. We begin by describing the sex composition of jobs and how it was affected by affirmative action.

The affirmative action program had an increasingly strong effect in integrating jobs. Of the 100 nonmanagement jobs with 5 or more individuals in 1965, only 6 contained both men and women (Table 4.5). Almost 40 were all-female jobs and 55 were all-male jobs. The numbers remained similar in the following period, but by 1972 the modest affirmative action program had doubled the number of sex-integrated jobs (to 13), and the number doubled again by 1975 (to 25). Similar changes occurred in the foreman and lower-management levels. The affirmative action program seems to have had great success in increasing the number of integrated jobs.

However, despite these gains, most jobs were unaffected. By 1975, even with a generous definition of integration as the broadest possible range (1-99 percent women), only one-third of nonmanagement jobs fit into this range, and only 27 percent of foreman jobs did so. Clearly, the vast majority of jobs were still segregated by sex.

Moreover, the sex-segregated jobs offered considerably different salaries. All-female jobs paid an average salary that was about three-quarters of the salary paid by all-male jobs, and this ratio applies both to nonmanagement and foreman levels in most years (Table 4.6). There is a general trend toward slightly greater equality over these years, but the trend is modest (and it shows an unexplainable reversal at the nonmanagement level in 1975). Female jobs clearly showed much less gain than individual women experienced over this period.

Of course, the simple association between female composition and average salary may be highly misleading because jobs may differ in other respects and the apparent effects of female composition may actually be due to other factors. For instance, jobs may differ in terms of education and training they require, and economists might suggest that the human capital composition of jobs may account for the apparent effects of female composition. Regressions were run to study the effects of female and minority composition on job salaries, controlling for the percentage of college graduates in the job and the average tenure in the job (Table 4.7). As economists would predict, the two human capital factors affect job salaries. Indeed, it is intriguing to note the stability of the effects of college graduate percentage on job salaries in all years within each level.[7] However, female percentage and minority percentage in jobs also have significant effects on job salaries, independent of their human capital composition.

Percentage female had a strong significant negative relationship with job salaries in all years, even after controlling for human capital composition. At the nonmanagement level in 1965, jobs were paid $21 less for each additional female percentage unit, so that the regression

TABLE 4.6
Average Salary for Jobs by Percentage Female in Jobs, 1962-1975
(for jobs with five or more employees)

	1962	1965	1969	1972	1975
Nonmanagement Level					
0 percent	$ 6,268	$ 6,988	$ 7,894	$10,009	$14,679
100 percent	4,530	4,854	5,850	7,590	10,632
Foreman Level					
0 percent	$ 8,863	$10,050	$12,345	$15,297	$19,713
100 percent	6,849	7,440	9,104	11,569	15,722
Lower-Management Level					
0 percent	$11,160	$12,440	$14,617	$19,368	$22,600
100 percent	–	–	–	18,333	21,985

SOURCE: Adapted from Rosenbaum (1984).

estimates that jobs with 100 percent females were paid $2,100 less than all-male jobs, a figure very close to the real difference between the job salaries of all-male and all-female jobs. Although this difference declined over the periods of increasingly strong affirmative action, even in 1975 it retained a strong significant negative effect. At the foreman level the decline was less, and it was more erratic (perhaps because of the large influx of women promoted into foreman-level female jobs in 1972). But even in 1975, female composition still had a strong negative association with job salaries. Although human capital composition accounts for some of the earnings differences among jobs (particularly at the foreman level), even after controlling for this, jobs with a higher percentage of females offered lower salaries.[8]

Moreover, further analysis indicates that the job status system was involved in mediating much of the effect of female percentage. Adding job status to this regression reduces the net effect of percentage female a great deal (Table 4.8). For instance, although each additional unit of female percentage reduces job salaries in nonmanagement level by $19.87 in 1969, each female percentage unit subtracts only $1.68 after controlling for job status. This indicates that nearly all of the effect of female percentage on job salaries is due to the lower statuses of these jobs. What is most noteworthy is that this remains true even after the organization shifted from a status system based on tradition to a system based on job evaluation. In 1972, after job evaluation was implemented, each female percentage unit subtracts almost $15, but after controlling for job status, each female percentage unit subtracts less than $3. Job evaluation created a status hierarchy that continues to mediate much of the effect of female composition on earnings in the same way that the

TABLE 4.7
Human Capital, Sex, and Race Effects on Job Salaries over Four Periods

	1965	1969	1972	1975
Nonmanagement Level				
Percentage college graduates	27.814*	22.313*	25.821*	26.522*
	(5.175)	(5.173)	(6.012)	(6.842)
Tenure	−.319*	−.387*	.898*	.586*
	(.099)	(.097)	(.227)	(259)
Percentage minority	−38.045*	−22.667*	−14.207	−24.159*
	(14.112)	(7.453)	(7.898)	(8.749)
Percentage female	−20.759*	−19.868*	−14.946*	−12.310*
	(4.383)	(5.192)	(5.170)	(5.031)
Constant	75.423*	81.330*	66.212*	75.710*
	(2.874)	(3.290)	(3.640)	(4.473)
Variance Explained (R^2)	43.1%	39.3%	40.3%	37.3%
Standardized Coefficients				
Percentage college graduates	.416	.401	.390	.370
Tenure	−.248	−.376	.382	.231
Percentage minority	−.209	−.276	−.172	−.278
Percentage female	−.369	−.339	−.258	−.231
Foreman Level				
Percentage college graduate	7.116*	10.718*	12.783*	11.022*
	(1.906)	(3.550)	(3.907)	(3.495)
Tenure	.256*	.046	.512*	.460*
	(.103)	(.120)	(.192)	(.195)
Percentage minority	−2.623	−84.099*	−9.941	−1.147
	(13.479)	(22.241)	(6.320)	(5.737)
Percentage female	−10.259*	−8.108*	−10.200*	−8.192*
	(1.122)	(1.011)	(1.417)	(1.460)
Constant	95.278*	103.558*	103.885*	104.559*
	(2.519)	(2.966)	(4.538)	(4.841)
Variance Explained (R^2)	40.0%	46.7%	41.5%	32.4%
Standardized Coefficients				
Percentage college graduates	.224	.203	.262	.283
Tenure	.150	.025	.219	.212
Percentage minority	−.011	−.246	−.121	−.017
Percentage female	−.560	−.534	−.541	−.472

SOURCE: Adapted from Rosenbaum (1984).
*Coefficients significant at .05 level.

traditional status system did. Job evaluation, even in the context of a strong affirmative action program, maintains and possibly reinforces much of the earnings differences among male and female jobs.

PROMOTION CHANCES ASSOCIATED WITH JOBS

This analysis turns to another issue that is sometimes ignored in the discussion of job rewards. Jobs differ in the promotion opportunities they offer. Human capital economists might attribute this to the differential training offered by jobs, whereas structural sociologists would explain this in terms of opportunity structures. But, regardless of cause, these data show that the percentage of individuals who are promoted from a given job tends to be highly stable. The percentage of employees promoted from 1962 jobs in the next three years is highly correlated with the percentage promoted from the same jobs a decade later (r = .807 at the foreman level, .735 at the nonmanagement level).

Moreover, jobs have lasting effects on individuals' careers. The 1975 attainments of the cohort of employees who entered this organization between 1960 and 1962 were analyzed (Rosenbaum, 1984, Chap. 6). Using separate (dummy) variables for each job, the longitudinal analysis indicates that individuals' 1962 jobs had a very large effect on their attainments 13 years later, even after controlling for sex, race, age, education, and a rough proxy measure of ability (see the Astin [1965] scale of college quality). As an indication of unmeasured components of human capital, 1962 earnings were also introduced into the regression. In all analyses, early jobs continued to have a strong and significant effect on attainment 13 years later.

Moreover, this effect does more than simply advance an individual to a higher job in the following period. Even controlling for intervening attainments (in 1965), early jobs had a significant enduring effect on individuals' subsequent careers. Even employees who do not advance in their first few years still benefitted from early placements in higher jobs. According to the Horatio Alger stories that are often cited in this organization, individuals who overcome initial low origins are offered advancements to the higher echelons. In the cohort that entered the firm in the years 1960-1962, some Horatio Alger-like individuals did indeed overcome low origins by 1965 to attain the same jobs as "elites" who had been in these higher-status jobs from the outset. When their attainments 10 years later (1975) were compared, however, the Horatio Alger types ended up much lower than the elites who had been initially favored with better jobs. Early jobs have an enduring effect that even subsequent attainments do not eradicate.[9]

Moreover, most of the effect of individual jobs was due to the way jobs are ranked in the job status system. When these analysis were repeated, replacing the job dummy variables by the single job status variable, the results remained quite similar. Early job status explained nearly as much variation in later job status (or later earnings) as did dummy variables for all the individual jobs. Clearly, the job status system in this company has an important impact on employees' careers.

Given the great importance of jobs and job statuses in determining employees' careers, it is noteworthy that the promotions associated with jobs are often ignored as job effects. The reason is clear; it is not easy to determine the effects of jobs on future promotions in short-run analyses.

The data on this firm permit an analysis of this relationship. Taking as the dependent variable the percentage of employees promoted from a job in the next three (or four) years, regression analyses were run using the same model as was used to explain job salaries. Controlling for percentage of college graduates and average tenure, the regressions found that the female concentration of a job was negatively related to the promotion chances of a job during the 1960s (Table 4.8). However, the affirmative action program had a strong effect on this result. Over the two periods in the 1970s, the negative influence of percentage female continually decreased at the nonmanagement level, and at the foreman level its influence vanished in the 1969-1972 period and actually became significantly positive in the final period. Moreover, when job status was added to this regression, the effect of percentage female on 1969-1972 promotions declined slightly and had no effect at all on 1972-1975 promotions (Table 4.9). In spite of the high stability of promotion rates offered by jobs, the stability is not total, and jobs with high proportions of women experienced a large reduction in their disadvantage.

These results may be interpreted as reassuring in some respects. Although percentage female and job status remained serious obstacles to earnings parity, they did not limit women's promotions after the affirmative action program began. Jobs with high proportions of women had as high or higher promotion rates as jobs with high proportions of men.

However, although these specific results are gratifying, some caution is required. The high rates of female promotions that were demanded by the organization's affirmative action program are unlikely to be maintained after the organization reaches its initial targets and the impetus for the affirmative action program subsides.

TABLE 4.8
Human Capital, Sex, Race, and Status Effects on Job Salaries
Over Four Periods

Foreman Level	1965	1969	1972	1975
Percentage college graduates	−2.559*	−2.781	.509	−1.689
	(.571)	(1.529)	(2.236)	(1.381)
Tenure	.111*	−.079	.437*	.175*
	(.029)	(.049)	(.103)	(.073)
Percentage minority	−7.646*	−26.520*	−2.172	.053
	(3.749)	(9.269)	(3.435)	(2.115)
Percentage female	−.778*	−1.681*	−2.870*	−.250
	(.376)	(.480)	(.887)	(.621)
Job status	3.169*	2.989*	9.164*	9.502*
	(.070)	(.117)	(.567)	(.373)
Constant	61.949*	72.561*	69.731*	73.949*
	(1.017)	(1.704)	(3.230)	(2.151)
Variance Explained (R^2)	95.4%	91.4%	83.2%	90.9%
Standardized Coefficients				
Percentage college graduates	−.081	−.053	.010	−.043
Tenure	.065	.043	.186	.081
Percentage minority	−.035	−.078	−.026	.001
Percentage female	−.042	.111	−.152	−.014
Job status	.973	.894	.813	.949
n =	44	59	53	52

Partitioning of Variance from Tables 4.5 and 4.8
Variance (%)

	1965		1969		1972		1975	
	Unique	Total	Unique	Total	Unique	Total	Unique	Total
Demographic variables	1.5	40.0	2.1	46.7	5.2	41.5	1.2	32.4
Status	55.4	93.9	44.7	89.3	41.7	78.0	58.5	89.7
Shared	38.5		44.6		36.3		31.2	
Total	95.4		91.4		83.2		90.9	

SOURCE: Adapted from Rosenbaum (1984).
*Coefficient significant at .05 level.

CONCLUSION

This chapter investigated persistence and change in pay inequalities between men and women in a large corporation. The specific aim was to discover to what extent and in what ways jobs and job statuses affected

TABLE 4.9
Human Capital, Sex, and Race Effects on the
Promotion Chances of Jobs

	1962-1965	1965-1969	1969-1972	1972-1975
Nonmanagement Level				
Percentage college graduates	.688* (.095)	1.167* (.223)	.584* (.171)	.697* (.091)
Tenure	.005 (.005)	−.002 (.004)	−.004 (.003)	−.001 (.003)
Percentage minority		.823 (.606)	.172 (.247)	−.096 (.122)
Percentage female	−.108 (.169)	−.321 (.218)	−.140 (.184)	−.114 (.084)
Constant	.141 (.078)	.380* (.123)	.351* (.109)	.114* (.056)
Variance Explained (R^2)	42.7%	24.7%	12.9%	45.3%
Standardized Coefficients				
Percentage college graduates	.655	.466	.382	.665
Tenure	.083	−.050	−.132	−.036
Percentage minority	−	.121	.075	−.073
Percentage female	−.057	−.131	−.081	−.117
n =	76	101	85	81
Foreman Level				
Percentage college graduates	.439* (.105)	.491* (.079)	.369* (.104)	.473* (.034)
Tenure	.001 (.003)	.001 (.004)	.000 (.003)	−.004 (.003)
Percentage minority	−	−1.368 (1.401)	−.419 (.314)	−.432* (.185)
Percentage female	−.085 (.071)	−.136 (.082)	.010 (.065)	.069* (.032)
Constant	.029 (.086)	.129 (.096)	.065 (.067)	.084 (.056)
Variance Explained (R^2)	39.0%	50.6%	35.6%	86.1%
Standardized Coefficients				
Percentage college graduates	.591	.650	.556	.888
Tenure	.023	.015	.010	−.095
Percentage minority	−	−.095	−.158	−.143
Percentage female	−.154	−.165	.019	.120

SOURCE: Adapted from Rosenbaum (1984).
*Coefficient significant at .05 level.

TABLE 4.10
Human Capital, Sex, and Race Effects on the Promotion Chances of Jobs

Foreman Level	1962-1965	1965-1969	1969-1972	1972-1975
Percentage college graduates	.332*	.347*	.280*	.456*
	(.109)	(.081)	(.105)	(.039)
Tenure	.002	−.001	.000	−.004
	(.003)	(.004)	(.003)	(.003)
Percentage minority		−.894	.049	−.362
		(1.271)	(.352)	(.199)
Percentage female	−.005	−.027	.092	.077*
	(.074)	(.080)	(.070)	(.033)
Job status	.014*	.021*	.014*	.008
	(.006)	(.006)	(.006)	(.009)
Constant	−.053	−.039	−.095	.054
	(.088)	(.100)	(.090)	(.064)
Variance Explained (R^2)	47.1%	60.8%	43.2%	86.4%
Standardized Coefficients				
Percentage college graduates	.444	.460	.422	.857
Tenure	−.077	−.032	−.009	−.100
Percentage minority	−	−.063	.019	−.120
Percentage female	−.009	.032	.166	.136
Job status	.344	.401	.391	.064
n =	43	59	53	50

SOURCE: Adapted from Rosenbaum (1984).
*Coefficient significant at .05 level.

women's earnings relative to men's during periods of growth, contraction, and affirmative action.

The initial analyses found that job status determined which women benefit and which do not benefit from the strong affirmative action program. In particular, the job status system prevented women with more seniority from gaining as much from the affirmative action programs as did their peers with less seniority.

In order to get another perspective on job effects, the properties of jobs were investigated. The continual appearance of new jobs clearly

suggests that lasting reforms will not result from one-time efforts. Reforms must be embodied in coherent systems, like job evaluation systems, which can continue to handle the many new jobs that are created.

The findings also indicate the need for revaluing the worth of jobs. In the 1960s, the female composition of jobs had a strong negative influence on job salaries. Although previous research has shown such a relationship for occupational groups (Sanborn, 1964; Fuchs, 1971; Oaxaca, 1973; Sommers, 1974; Treiman & Terrell, 1975; Featherman & Hauser, 1976, Blau, 1977; Treiman, Hartman, & Ross, 1984; Roos, 1981), this issue has been difficult to investigate for jobs within firms. The present finding of female job composition effects on job salaries is particularly noteworthy because these analyses control not only for human capital composition but also for level in the authority hierarchy. Moreover, we find that the job status hierarchy mediates most of the effect of female composition on job salaries. Clearly some revision of the job status system is necessary if women's jobs are to be better paid.

However, job evaluation does not necessarily contribute to gains for women. Even in the context of a strong affirmative action program, job evaluation does not diminish the relationship between female composition and job salary very much. Indeed, in this corporation, the new job status system—based on job evaluation—continued to mediate this relationship.

Two cautions need to be borne in mind in evaluating these findings. First, as in most research of this sort, the evidence is not sufficient to identify unambiguously whether the effect is biased. That requires far more detailed data than this research, like most analyses, encompasses. However, the discrepancy between the gains of some individual women and the lack of gains for other women and for female jobs suggests that structural barriers may be operating, although other interpretations are possible.

Second, because this is only a case study of a single corporation, it is difficult to assess the generalizability of most of these findings. The initial finding of this study, that job status mediates most of the female earnings disadvantage, has been shown in studies of other organizations (Malkiel & Malkiel, 1973; Halaby, 1979), but its effect in preventing senior women from gaining from affirmative action and in mediating the influence of female job composition are new findings and, as such, require further replication. Similarly, the effect of female composition on salaries has previously been shown for occupations, but not for jobs, and it has not been possible to relate it to job evaluation status categories so clearly before.

However, regardless of generalizability, the primary value of these findings is in suggesting some issues to consider in assessing the effectiveness of affirmative action programs. Three central conclusions are stressed. First, even a very strong affirmative action program that leads to very great benefits for some women may neglect other groups of women. In particular, aiding women as a class may not lead to reparation for those most hurt by past discrimination.

Second, to the extent that these programs are based on helping individual women, as most such programs are, they are likely to have the problem seen here, that is, helping some individual women while maintaining structural discrimination against female jobs. Not only does this prevent the individuals in these jobs from receiving the full benefit of the affirmative action program; but also more seriously, it remains a structural component of the organization so that when the impetus of the affirmative action program ends, the structure may again tend to recreate the old patterns.

Third, job evaluation, even in the context of a strong affirmative action program, may not overcome the salary disadvantages of female jobs. The conclusion to the interim report of the National Research Council's Committee on Occupational Classification and Analysis warned that job evaluation procedures use several procedures that raise questions about whether they can be effective in fairly assessing sex-segregated jobs (Treiman, 1979, p. 48). In particular, their reliance on market wage rates and subjective judgments raise serious risks that job evaluation will reinstate the same biases as traditional status systems. Unfortunately, the present findings provide empirical support for this warning. This job evaluation system, which to all appearances was a sincere reform effort and that was implemented concurrently with a strong and generally effective affirmative action program, nonetheless had the effect of preserving sex bias in job salaries (though not in promotions).

What is particularly disturbing about this is that the presumed objectivity and rationality of job evaluation may serve to confer legitimacy to these outcomes under the mask of scientific procedure. Job evaluation programs tend to be implemented with great fanfare about their "scientific" basis, and a considerable amount of meticulous work goes into the development of job descriptions and quantitative ratings. Nonetheless, the judgmental process is likely to include a strong subjective component (Treiman, 1979), and few efforts have been made to reduce the sex biases that might enter at this stage.

Presumably, subjective job assessments and market-based factor weightings of the job evaluation procedure had important influence on

these findings, and these may be the best targets for policy change. We currently lack sufficient evidence on how these procedures operate. However, the present findings suggest that the mechanisms underlying job evaluation need to be scrutinized to discover whether these inequalities are inequitable, and, if so, how job evaluation could be done in other ways to lead to more equitable results.

In the absence of data for analyzing the job evaluation process in detail, this study offers empirical support to the warning of the National Research Council report:

> Jobs and job evaluation programs, even in the context of very serious and effective affirmative action programs, may partially undermine the goals of affirmative action and legitimize traditional inequalities. The mantle of scientific procedure and the cloak of proprietary rights [by consultants] have been used to shelter job evaluation programs from scrutiny. (Treiman, 1979)

Having shown that job evaluation programs may be a serious obstacle to advancing women's earnings parity, these findings indicate the need for more detailed research into the inner workings of job evaluation programs. And they also suggest caution in relying on "unreformed" job evaluation plans in comparable worth strategies. Those seeking a realignment of the wage rates of women's jobs should attempt to ensure that the job evaluation instrument used is not unfairly biased towards maintaining the status quo.

NOTES

1. Because of the sensitive nature of the files, I had to promise to preserve the anonymity of the firm, so I cannot elaborate this description in greater detail. I regret the difficulty this imposes for generalization and comparison. The possibility of conducting further research on private organizations requires that our confidentiality promises be credible.

2. These coefficients are computed from Table 7.4 in Rosenbaum (1984) by summing all coefficients pertaining to college women, that is, adding the coefficients for male B.A.s, females, and college-females to the base coefficients for the residual category of noncollege males.

3. Rosenbaum (1984, Chap. 7) for further evidence on this point and Note 9 below.

4. The job title identifications for higher levels were removed from the data to protect the anonymity of employees because these jobs tend to have few occupants. Of course, their small size also makes them unsuitable for these analyses.

5. In the year 1962, the job salaries of nonmanagement jobs ranged from $3354 to $8684, with a mean of $5462 and a standard deviation of $1336 for the 171 jobs at that level. Foreman jobs offered job salaries in the range of $4810 to $10,061, with a mean of $8031 and a standard deviation of $1511 for the 155 jobs, and lower-management job

salaries were between $9222 and $12,203, with a mean of $11,422 and a standard deviation of $729 for the 86 jobs.

6. In this and subsequent analyses, lower-management level is not analyzed because too few jobs persist over these periods. Note that correlations are reported for jobs existing in all periods.

7. The range of standardized coefficients in the nonmanagement level is .370-.416 and .203-.283 in the foreman level.

8. The large unexplained changes in the influence of minority percentage may be due to the small numbers of minorities in most jobs.

9. This early job effect may be responsible for the lack of earnings and status gains for older females. Having gotten off to the wrong start in the wrong jobs, the organization may have given up on them. For more detailed discussion of these analyses, see Rosenbaum (1984, Chap. 6).

REFERENCES

Astin, A. (1965). *Predicting academic performance in college*. New York: Free Press.

Blau, F. D. (1977). *Equal pay in the office*. Lexington, MA: Lexington Books.

Davis, K., & Moore, W. E. (1945). Some principles of stratification. *American Sociological Review, 10*, 242-249.

Doeringer, P., & Piore, M. (1971). *Internal labor markets and manpower analysis*. Lexington, MA: Lexington Books.

Featherman, D. L., & Hauser, R. M. (1976). Sexual inequalities and socioeconomic achievement in the U.S., 1962-1973. *American Sociological Review, 41*, 462-483.

Fuchs, V. (1971). Differences in hourly earnings between men and women. *Monthly Labor Review, 94*, 9-15.

Granovetter, M. (1974). *Getting a job: A study of contacts and careers*. Cambridge, MA: Harvard University Press.

Granovetter, M. (1981). Toward a sociological theory of income differences. In I. Berg (Ed.), *Sociological perspectives on labor markets* (pp. 11-48). New York: Academic Press.

Grusky, O. (1966). Career mobility and organizational commitment. *Administrative Science Quarterly, 10*, 489-502.

Halaby, C. N. (1979). Sexual inequality in the workplace: An employer-specific analysis of pay differences. *Social Science Research, 8*, 79-104.

Jencks, C. (1980). Structural versus individual explanations of inequality: Where do we go from here? *Contemporary Sociology, 9*, 762-767.

Malkiel, B. B., & Malkiel, J. A. (1973). Male-female differentials in professional employment. *American Economic Review, 63*, 693-705.

Oaxaca, R. (1973). Sex discrimination in wages. In O. Ashenfelter & A. Rees (Eds.), *Discrimination in labor markets* (pp. 124-151). Princeton, NJ: Princeton University Press.

Roos, P. A. (1981). Sex stratification in the workplace: Male-female differences in economic returns to occupation. *Social Science Research 10*(3).

Rosenbaum, J. E. (1984). *Career mobility in a corporate hierarchy*. New York: Academic Press.

Sanborn, H. (1964). Pay differences between men and women. *Industrial and Labor Relations Review, 17*, 534-550.

Sommers, D. (1974). Occupational rankings for men and women by earnings. *Monthly Labor Review, 97*, 34-51.

Treiman, D. J. (1979). *Job evaluation: An analytic review.* Interim Report of the Committee on Occupational Classification and Analysis to the Equal Employment Opportunity Commission. Washington, DC: National Research Council.

Treiman, D. J., & Hartman, H. I. (Eds.). (1981). *Women, work and wages: Equal pay for jobs of equal value.* Washington, DC: National Academy Press.

Treiman, D. J., Hartman, H. I., & Roos, P. A. (Eds.). (1984). Assessing pay discrimination using national data. In H. Remick (Ed.), *Comparable worth and wage discrimination: Technical possibilities and political realities.* Philadelphia, PA: Temple University Press.

Treiman, D. J., & Terrell, K. (1975). Women, work, and wages—trends in the female occupational structure since 1940. In K. C. Land & S. Spilerman (Eds.), *Social indicator models* (pp. 157-200). New York: Russell Sage.

White, H. C. (1970). *Chains of opportunity.* Cambridge, MA: Harvard University Press.

5

The Debate Over Equality for Women in the Work Place

RECOGNIZING DIFFERENCES

ALICE KESSLER-HARRIS

This chapter investigates women's continuing position in relatively disadvantaged places in the labor force. It argues that the failure of earlier strategies to alter this position derives, in part, from our failure to come to terms with whether in fact men and women are "different." It seeks to explore how dominant perceptions about women's nature have conditioned past and present strategies. Finally, it argues that for a variety of historical reasons, a strategy that accepts women as different might enhance the speed with which they can move toward equality.

What constitutes a "special" group in the work force? Why is it that after all these years of striving for equality, we still refer to women workers as "special?" The familiar statistics belie any such categorization. Fifty-three percent of all women work for a living—more than seventy percent of them full time. Whereas the proportion of white women working for wages has expanded recently, black women have worked at these rates for most of this century. Currently more than four of every ten workers is female. And women have demonstrated that they no longer fit the old stereotypes. Relatively fewer women than in the past quit when they have babies; their absenteeism and turnover rates are no higher than those of men holding the same kinds of jobs; and they are not more temperamental on the job.

What is it then that makes this large group of workers "special?" That separates them from male workers? That enables most of us without a

AUTHOR'S NOTE: Permission to reprint this article must be obtained from both the publisher and the author. Please address such requests to Alice Kessler-Harris, Department of History, Hofstra University, Hempstead, NY 11550. An earlier version of this chapter was delivered at the Eleanor Roosevelt Centennial Conference, Vassar College, October 15, 1984. My thanks to Louise Tilly and Marilyn Blatt Young for suggestions as to revisions.

second thought to cast them into an apologetic place in relation to work? This chapter argues that women's continuing "special" position derives in part from our historical failure to come to terms with whether in fact women are different from men. It seeks to explore how dominant perceptions about women's nature have conditioned past and present strategies for achieving equality in the labor force. Finally, it argues that for a variety of historical reasons, a strategy that accepts women as different might enhance the speed with which they can move toward equality.

At the core of the consensus that has shaped women's labor market position is the family. To most historians it seemed self-evident that women's relationship to their families accounted for their unique labor force position. Whatever our own predilections and lifestyles, historians of women understood that most women bore children, were responsible at some level for rearing them, and that they perpetuated the value systems of their communities in the home. Beyond this, the sheer physical demands of these tasks, as well as the special abilities developed to do them well, mitigated against successful labor force roles. Given the realities of work in the home and the nurturing and self-sacrificing qualities most people believed were required to sustain a household, women could not be expected to perform effectively in the labor force. For when they entered it, they brought with them not the competitive and achievement-oriented attitudes required for success in that sphere, but the more cooperative and relational spirit said to be cultivated in the home (Gilligan, 1982; Welter, 1966; Kessler-Harris, 1975).[1] The attribution of family-related goals and norms to women thus constituted problematic, or even negative, features in the labor force.

To say that women have historically remained a "special" group, then, is to say that in the past, by and large, they did not act like male workers, choose the same responsibilities, make the same commitments, compete as effectively, or expect the same rewards. In the words of one recent historian of women and the family, "Women are still the primary child rearers, even when they work, and the purpose of their work in the main is to support and advance the family, not to realize themselves as individuals" (Degler, 1980, pp. 452-453). If this can be said to be true of men also an important distinction remains. The popular mind saw women as primarily responsible for the family's emotional and physical well-being—a function that conflicted with that of success in the work place. For men, in contrast, responsibility for the family's financial needs fostered a search for more options in the labor force, and this, in turn, enhanced the possibility of individual fulfillment.

Economists, too, have tended to rely on some notion of women's social place to explain their currently disadvantaged places in the labor

force. Traditional or neoclassical economists argue that women's decisions as to when and how to enter wage-work are based on their present or anticipated responsibilities for household care and child rearing. They argue further that investment in human capital determines how far and how quickly workers will be upwardly mobile and conclude that women occupy low-paying jobs because their family orientations and responsibilities discourage them from investing in their own skills or in human capital. And those who resort to the notion that employers simply have a "taste for discrimination" believe that, rightly or wrongly, people in charge of hiring attribute certain qualities to women that have emerged from their natural or culturally assigned roles.

The more radical perspective of labor market segmentation theory seems to suggest at first that inequality is a function of the job and not the home. And yet segmentation theorists argue that income and rewards (especially in the lower primary sector) come largely from job training and socialization. To cite Michael Piore, "a good deal of what is required to perform effectively on the job and is involved in the improvement of productivity during the 'training' period is the under-standing of the norms of the group and of the requirements of the various roles which are played within it and conformity to the generalized norms and to the specialized requirements of the particular role or roles to which one is assigned" (Piore, 1979, p. 135). But if learning on the job is a process in which custom and skill are handed down, it is also one that reinforces old roles: The more skilled teach the newcomers and men tend to resist learning from women. Female workers cannot therefore be advanced beyond the point at which they are accepted by coworkers. The traditional values of the home are reinforced, in this schema, by the demands of production.

For feminists attempting to develop a theory of labor force patterns that both explains women's historically disadvantaged position and offers some hope for future equality, the notion that women derive their identity, self-esteem, and work-place personas primarily in families has constituted a central and precarious dilemma. Short of challenging the structure of work itself, and by implication the individualistic nature of work in the United States, it places women in the awkward position of either defending or rejecting the family in order to enter work on an equal footing with men. Some have insisted that the search for equality requires women to abandon traditional notions in regard to their family roles and to adopt the competitive and achievement-oriented hierarchy of the work sphere (Sokoloff, 1980; Epstein, 1971; Kanter, 1977). But, assuming that work lives remain demanding, that path also requires women to give up many of the comforting values associated with home and child care. Resistance to this direction is familiar, visible, for

example, in the current concern for the family and its value. And troubling questions about the nature and scope of parenting remain even for those of us who accept these new work force roles.

An alternative is to adopt what philosopher Iris Young calls a "gynocentric" or woman-centered view of feminism—a view that accepts women's differences from men and argues that women bring to the work place something of their traditional, socially and culturally inculcated behavior patterns (Young, in press). This position, however, seems to return women to the beliefs of an earlier period when acknowledging family roles placed them in the position of perpetual outsiders in a labor force that bowed to their special needs only under legislative duress. And it carries with it the danger that insisting on recognition of such qualities as cooperation or sharing above competition, and on such legitimate needs as child care, flexitime, extended parental leave, personal days and so on, assigns to women the sometimes unspoken designation of "special" with all of its potentially discriminatory consequences. Either way, equality for women becomes a distant goal.

Can women move toward equality without either negating family roles or reifying them? One way, of course, is to revalue these roles. If men did them too, they would no longer be negative attributes in the work force, but simply part of the baggage all workers brought with them to the work place. And there would then be a greater likelihood that jobs would alter to accommodate family roles. Is this plausible? I want to suggest in this chapter that it becomes more likely if we rethink social policy in regard to women wage earners anew, recognizing some of the lessons of history. The apparent lesson of the past was that paying attention to the characteristics of one group of workers can overemphasize their special needs and result in discrimination. A second, and now overlooked lesson is that ignoring difference tends to perpetuate existing inequalities. The bridge between these two lessons first conceptualizes difference as a broadly social phenomenon—one that touches all workers at some point—and, based on this understanding, proposes a pluralistic solution to broadly address difference. Second, it insists on sharing some of the social costs of family and child rearing that historically have been borne by women and have made them "special." We can more easily understand how such a strategy might work if we look back at the history, the assumptions, and the legacies of an earlier search for equality.

We must begin, if only briefly, with a sympathetic understanding of the plight of most working women in the late nineteenth and early twentieth centuries. Limited by widely accepted practice to relatively few occupations and paid little because it was assumed that they had

homes in which husbands or fathers were the primary breadwinners, women's real or imagined attachment to home and family led to their widespread abuse as workers. While wage-earning women struggled to organize in order to combat the resulting problems of unemployment, overwork, malnutrition, and inadequate care for children, reformers and feminists developed two alternative and sometimes competing theories to inform social policy.

The first theory, which, following Iris Young, I have labeled "humanist," traces its roots back to the early campaigns for women's rights and beyond. It derives from the belief that women, by virtue of their common humanity with men, are entitled to all the same rights and privileges. They share with men, the theory argues, a set of human rights that transcend biological/gender differences (Wollstonecraft, 1967; Fuller, 1971). This tradition spawned Alice Paul's militant battle for suffrage in the early twentieth century and continued into the National Women's Party in the 1920s. Governed by a belief that women were more like men than different from them, members of the NWP believed that dropping barriers to work for women would yield eventual workforce equality. They shared with other groups the slogan, "Give a woman a man's chance—industrially." And they sponsored the first Equal Rights Amendment, introduced into Congress in 1923. Its friends called it the Lucy Stone amendment after the nineteenth-century women's rights advocate, and its enemies labeled it simply the "blanket amendment" because, they said, it covered such an enormous variety of sins. The key phrase of that very first ERA stated simply, "Men and women should have equal rights throughout the United States and every place subject to its jurisdiction" (Woloch, 1984, p. 383). The language has changed since then, but the assumption that human rights transcended any biological difference remains much the same. Current arguments from this humanist feminism assert women's capacity to participate in the work force as equals, demanding only that barriers to fair competition be dropped.

In sharp contrast, the second or "women-centered" position emerged from the belief that women were inherently different from men. In the nineteenth century, such differences were commonly seen as spiritual or moral, and, in the interpretation of today's historians, provided women with the strength and influence from which they could look after community welfare (Ryan, 1983; Smith-Rosenberg, 1971). Doing good works, an extension of women's duty to guard national virtue, became a springboard for women's civic clubs and charitable and welfare acts, as well as for legislative lobbying and municipal reform. The same kind of argument—that women had special insights and special needs whose representation in the polity would uplift public debate—is widely

credited for convincing a largely male electorate to give women the vote in 1919.

The goal of this group of women's rights advocates was not so much equality as a place in the public sphere for their own form of moral influence. Their position achieved public support partly because it did not explicitly violate commonly held views of men's and women's separate spheres and partly because it seemed to offer some moderate and sensible solutions to the social and economic problems produced by women's increasing wage-earning roles. But a position that contained the potential for obtaining equity for women in the political sphere proved to be more constraining when it came to economic issues. Those who believed in women's special attachment to the home and her more refined spiritual sensibilities deplored the idea of paid work for women as depriving the home of her guidance.

Applied to the work place, difference arguments insisted that women required special protection. Their natural sensibilities, their greater delicacy, as well as the morality and spirituality they were destined to uphold, were incompatible with the coarseness and competitiveness of the marketplace. And more realistically, excessive and poorly paid work might lead to fatigue, ill health, inadequate housekeeping, and neglected children. Faced with the need to work like men, so the argument went, women would be crushed, their capacity for uplift drained, their virtue tempted, and their bodies so weakened as to incapacitate them for healthy future motherhood. This argument, supported by social and scientific findings, researched by Josephine Goldmark of the National Consumers League, was incorporated in the 1908 Brandeis brief. It persuaded the U.S. Supreme Court to sanction special labor legislation for female workers on the grounds that the State had a legitimate interest in protecting the mothers of the race. The principle adopted mirrored the Supreme Court's rationale for denying protection to male workers. The Court would not sanction labor legislation that protected workers per se, but it could and did sustain laws that regulated working conditions for those whose safety or good health could be construed as in the public interest (Baker, 1969). In the case of women, the public or state interest involved what the Court understood as a permanent or biological difference—women's childbearing capacity and its concomitant child-rearing function.

Given the Court's repeated and consistent refusals to sustain labor legislation on other grounds, most female activists, working- and middle-class alike, accepted this difference argument and agreed that women ought indeed to constitute a special group or "class" in the work force. They took this position, as one proponent argued, not "because we want to get anything for women which we do not desire for

men, but since protective legislation for men has been declared unconstitutional, the best means of aiding both men and women is to secure laws for women" (Shuler, 1923, p. 12).

The legislation that emerged from this widely shared understanding took a variety of forms. It limited the hours per day and days per week during which women could work, regulated night work, prohibited women from lifting heavy weights, and outlawed their employment in certain jobs altogether. Despite the attempts of 15 states to establish minimum wages for women or to create a minimum wage commission, protagonists of special legislation never succeeded in compensating for reduced hours through an adequate floor under women's wages. Efforts to do so were effectively stymied until the New Deal by a 1923 Supreme Court decision that invalidated a Washington, D.C., minimum wage law for women, calling it a "wage-fixing law, pure and simple."

Most historians now agree that, whatever the short-term benefits, the consequences of protective labor legislation were in the long run negative for women, rigidifying separate niches in the labor market and depriving women of opportunities they might otherwise have had. Reading back into the past, they argue that the critical mistake of early social feminists was to accept, as the basis of legislation, the assumption that women's work force roles rested on their biological differences from men (Baker, 1964; Baer, 1978; Hill, 1979; Kessler-Harris, 1982). But it is important to remember that in the teens and the early 1920s, hard-fought battles for special legislation were treated as important victories by wage-earning women and reformers alike. So widely accepted was the notion that women occupied a separate sphere that the idea that they could win protection for their differences seemed like triumph indeed. And in the same years, other groups from railroad workers to government employees eagerly sought protected status. Advocates of protection urged the few working women who suffered from new laws to sacrifice their own interests to what the Women's Bureau concluded in 1926 was the well-being of the vast majority. Drawing a distinction between industrial equality and legal equality, Mary Anderson, head of the newly created Women's Bureau of the Department of Labor, defended her position in favor of special legislation by arguing, "I consider myself a good feminist, but I believe I am a practical one" (Anderson, 1925, p. 4).

The debate over strategy ushered in by this early twentieth-century conflict has continued in one form or another up until the present. Those who advocated social legislation to ameliorate women's family and work roles, usually called social feminists, have shared the notion of women's differences. Eleanor Roosevelt is a useful example. From the early 1920s, as her membership in such groups as the National Women's

Trade Union League (NWTUL) and the League of Women Voters indicates, she supported the notion that women were in fact different from men. Like other social feminists who belonged to these groups, she vigorously opposed the Equal Rights Amendment, fearing that its passage would eliminate all special protection for female workers. In doing so, she rejected the arguments of what was then the more radical wing of the women's movement, the National Women's Party, which believed in women's rights as a matter of justice and humanity. To Eleanor Roosevelt and the social feminists, career and job satisfaction were as important as to the Women's Party. But the notion that a married woman could value individual achievement and personal aspiration above the welfare of her family was inconceivable. "I never like to think of this subject of a woman's career and a woman's home as being a controversy," she wrote in 1933. "It seems to me perfectly obvious that if a woman falls in love and marries, of course her first interest and her first duty is to her home, but her duty to her home does not of necessity preclude her having another occupation" (Roosevelt, 1933, p. 145).

In the 1920s, short of women placing jobs first (that is, short of rejecting differences), possibilities for improving the working conditions and opportunities of even well-educated women seemed negligible. Even the trade unions conceded that among poor women improved conditions depended on legislation, a lesson learned from the unenviable position of most black women whose work in domestic service and in agriculture all but excluded them from protection.

The depression proved to be a watershed in which opinions began to change. It challenged an array of assumptions about women's difference, shaking the assurance that had surrounded three decades of mostly successful work for protective labor legislation and extending its benefits to many more workers (Kessler-Harris, 1982, Chap. 8; Milkman, 1976). As in the war that followed, New Deal policymakers introduced solutions to labor problems that undermined earlier certainties about the importance of difference. Together, depression and war, and the social policies they spawned, revealed that male and female workers shared more than they realized. Despite their differences, they could be equally protected.

To begin with, widespread economic privation destroyed the always tenuous illusion that families could be securely supported by a single male breadwinner. Among broader sectors of the population than had ever been true before, economic collapse meant that wives, as well as grown children, needed to earn wages and that more and more families were dividing the task of sustaining themselves among their members. As wives became more frequent and sometimes more permanent wage

workers they raised questions as to whether some of work's rewards could not also be theirs. Did personal aspiration in fact conflict with family values? "Was work," as some asked, "an exclusive prerogative of the male portion of humanity." or was it "a fundamental right of every human being?" These questions were to reemerge in the 1950s. Despite desperate attempts to drive them out of the work force, married women worked in ever-larger numbers, accounting for 35 percent of all women workers by 1940. And though they were abused in the public press and attacked by unmarried women, these new workers stood their ground. Some, like the San Antonio woman whose wages were deeply cut, did so because her job provided free meals, relieving her family of the need to feed her (Blackwelder, 1983, Chaps. 4-5). Others simply found work gratifying. Male and female workers experienced other commonalities. Unemployment and homelessness, for example, crossed gender lines.

The solutions of the New Deal summed up the similarities among workers. The same National Recovery Administration (NRA) codes that discriminated against women acknowledged that male workers needed protection too, and extended the arms of the state to them. Eleanor Roosevelt, Frances Perkins, and other social feminists fought consistently to defend the right of married women to work, to ensure equal pay for equal work, and to provide equal treatment for women on work relief. Partly as a result of this, public policy that at first treated women as if they always had somewhere to go was altered and the New Deal made some crude attempts to find jobs and relief for women. Finally, the Supreme Court opened the possibility of general labor legislation. After decades of rejecting the idea that the State had any interest in the hours and wages of most male workers, the Supreme Court upheld the 1938 Fair Labor Standards Act, which for the first time legislated a minimum wage for many workers and successfully gave to men the kinds of legal protections against excessive hours from which women had benefited. Only 12 short years before, Mary Anderson had mocked what she called the "ultrafeminist" position for holding that such laws could be extended beyond women (Anderson, 1925).

Perhaps most importantly, notions of sturdy individualism suffered a severe blow as even the best competitive energies of male workers could not alter the bleak prospect of unemployment. A trade union movement that had been at best ambivalent about recruiting women revitalized itself by relying at least in part on the energies of female workers as well as on the wives of male workers to sustain its expansion. Willingly or not, male unionists evoked the values of community, the virtues of cooperation, and family at its best as women turned their tradition and experience into mechanisms for survival. In significant ways, the depression experience meant reduced differences. New laws or regula-

tions extended the protections of women to working men and in everyday life demonstrated the unforgettable lesson that family survival and wage-work were an inseparable whole.

By the end of the decade these changes had revitalized the movement for an equal rights amendment and reduced opposition to it among some women's groups. To many, equality now seemed a plausible as well as desirable goal (Becker, 1981). The notion of difference, which in the 1920s had been largely reduced to biology as two groups of feminists adopted competing positions, was now broadened to include some notion of socially defined roles. Its champions responded to the challenge of women's new stature by drawing up what they called a Women's Charter. Conceived in 1936 by social feminists led by the Women's Bureau's Mary Anderson, the charter claimed to offer an alternative to constitutional amendment by declaring the desirability of equality while acknowledging the need for protective labor legislation. Differences that earlier had been asserted as a means for women to achieve a place in public life were now claimed not to inhibit the goal of equality. But the difference argument itself was not abandoned. The argument put its proponents in the unwieldly position of asking for equal treatment and pay on the one hand and protected status on the other. One protagonist commented that it asked for "full responsibility and special privilege" at one and the same time (Becker, 1981, p. 180). But though the issue tore the group apart, social feminists were not yet ready to assert equality if it meant abandoning their notion of womanhood. As one businesswoman put it, "There are hundreds and thousands of the group I represent who are muddled by the whole thing" (Becker, 1981, p. 179).

Like other social feminists, Eleanor Roosevelt found herself changing. Her concern and that of others increased during World War II as challenges against notions of difference multiplied. During the war years, women demonstrated their capacity to work at the same jobs and as effectively as men. To support needed female workers, industry and government adopted new and imaginative policies for housing women and for feeding and caring for their children. What reasons now could be adduced for treating women as outsiders? For arguing that their positions as "mothers of the race" demanded special treatment? Toward the end of the war, Eleanor Roosevelt, although still opposed to the ERA, thought that the new circumstances warranted some compromise. "We must do a lot more than just be opposed to an amendment," she wrote to her friend Rose Schneiderman. "I believe we should initiate through the Labor Department a complete survey of the laws that discriminate against women and the laws that are protective; that we should then go to work in every state in the Union to get rid of the

discriminatory ones and to strengthen the protective ones; and if the time has come when some of them are obsolete, we should get rid of them even though they were once needed as protective (Roosevelt, 1944).

Mrs. Roosevelt had touched a historical nerve ending. She understood that the notion of difference, having emerged from a particular historical context, had taken on a shape appropriate to its time. As circumstances changed, the idea that men and women were different appeared to be undermining the equal opportunity that had been its goal. Further change was hidden below the placid surface of the 1950s. Public education expanded dramatically, offering new opportunities to men and women, and though women gave birth to more children, soon the need to educate them and to provide them with the benefits of a consumer society led mothers back into the work force. Tempting possibilities of upward mobility in an expanding economy fostered a meritocratic ethic posing a challenge to which women were not immune. Ideas of personal progress on the basis of individual merit nestled into an egalitarian framework. It was not only that some would make it; if ideology were to be believed, everyone who tried would do so. A decade of relative prosperity, shorter hours for everyone, and reasonable working conditions provided unusual optimism about the present and future possibilities of work. Although most activists still clung to the belief that women were not like men, pressures for equality mounted.

For women, new job-related opportunities still competed with notions that kept them tied to the family. Married women entered the work force in unprecedented numbers. Although most would have argued that wage-work was only a means to some other family end, the pressures of opportunity and mobility exercised their own influence. Old defenders of protection for women began to see it as no longer necessary. As Alice Hamilton wrote to one critic of her new position, "I have seen so great a change in the position of women workers in the last fifteen years or so that it seemed to me there was no longer any need to oppose the formal granting of equality" (Hamilton, 1953).

But arguments from difference were rooted not merely in an understanding of women's historical exploitation in the labor force. They had come as well out of a set of shared understandings about women's relationship to the home. And they persisted in the 1950s, despite new protections for all workers, because to abandon them was to leave questions about home and family unanswered. Short of arguing for an abstract equality or a humanist feminist position that most men and women in the 1950s did not support, solutions to women's disadvantaged labor force position lay in addressing particular issues. In 1951, for example, the heirs of social feminism tried for three years to

pass a "Women's Status Bill" that would have declared in national legislation that there be "NO DISTINCTION on the basis of sex, except such as are reasonably justified by differences in physical structure, or by maternal function" (Reasons for opposing the Equal Rights Amendment," n.d.). The draft bill also recommended a presidential commission to review discrimination against women. Without confronting the fundamental problem of family-care responsibilities, the bill, like earlier demands for equal pay, simply insisted that women be treated equally in the labor force. But equal treatment for different people seemed hard to achieve as a staff writer for the labor movement's *American Federationist* discovered in 1957. Vehemently opposed to the "misnamed Equal Rights Amendment," she argued that "an intelligent approach to women workers takes into account differences between men and women workers. On the other hand, these social differences in employment patterns should not be used to rationalize wage discrimination where women are doing the same job as men" (Pratt, 1957, p. 8). The author did not explain how if differences were taken into account, women could obtain the "same jobs as men."

Very much weakened, the old idea that women required special protection because they were different suffered its mortal wound at the hands of President Kennedy's Commission on the Status of Women. The commission, which Eleanor Roosevelt headed until her death in 1962, was recommended to Kennedy by, among others, Esther Peterson, then head of the Women's Bureau. It took an ambiguous stance calling for more attention to preparing young women for motherhood at the same time as it explored job-related issues like training, selection, advancement, and equal pay in women's jobs. At the same time, the commission issued the first quasi-official public calls for "necessary supportive services by private or public agencies" to women in gainful employment. Here, at last, was a peacetime statement of social policy that acknowledged the double-sided nature of the dilemma of difference. Could women ask for equality at work without compromising their family roles? If they asserted a claim to motherhood, how, then, could they justify demands for equal opportunity in the work place?

In the context of the 1960s, the fight to acknowledge women's difference, still tarnished by biological notions and those of the centrality of motherhood, took on a defensive posture. The idea that women had family lives in need of protection had seemed a great and humane breakthrough in 1920 and 1930. By 1940 and 1950, women who wanted to advance in the sphere of work were willing to assign the issue of family lives to the private sphere. By 1960, to argue that women were different from men was tantamount to believing that little could be done

to allow full work lives and quickly became a position largely held by those who preferred dependent roles. The old belief system was held responsible for limiting personal aspiration and for creating discrimination by fostering among employers the notion that women were not genuinely committed to wage-work.

Simultaneously, the competing notion that women, not merely as equals to men, but like them, could and should be permitted to function as individuals at work—which had seemed to many in the 1920s at best as an invitation to exploitation and at worst as a threat to the separation of the sexes—had become by the 1950s more attractive to millions of women who now saw family lives as parallel to paid work. By the 1960s, the argument for equality seemed to those concerned with women's labor force roles the only viable way to create job options for women and had certainly replaced notions of difference as the operative factor in the wage labor force.

By the end of the 1960s, attempts to achieve special treatment for women in the work force had come to an end. Most feminists, seeing what they took to be the consequences of "special protection," rejected the assumption that women were somehow different from men and argued instead that as far as the workforce was concerned they were more like them than not. This humanist feminism insisted that it was because women had been treated as a special group that they continued to be disadvantaged. From their perspective, if women were to achieve equal status, they would have to give up the traditional attributes of their gender as well as the special treatments that were attached to them. Only by adopting the competitive and achievement-oriented values of the work sphere could women achieve equality. Informed by a new faith in more egalitarian household relationships that were thought to make possible job-related aspirations for women at work, new feminists believed that separating women's two roles would enable the married as well as the single to compete effectively for wages, promotions, and new opportunities. The result, as we know, was the spate of legislation that started with the Equal Pay Act of 1963, continued with Title VII of the Civil Rights Act of 1964, ran through Title IX of the Higher Education Act of 1972, and culminated the same year in the passage by Congress of an Equal Rights Amendment. Each of these bills attempted to remove some barriers to equality. And yet together they have had little discernible impact for women as a whole.[2]

The current movement has relied heavily on a strategy of dropping barriers to work and encouraging women, their opportunities purportedly equal, to fend for themselves. Even the addition of affirmative action has not brought anticipated gains.[3] Real advances have occurred for a few women in such professional and business areas as pharmacy,

law, medicine, personnel management, banking, and accounting. And real alternatives have been created among women in intact two-income professional families—families that can afford to replace the services of the homemaker and child rearer—as well as among some who postponed childbearing or marriage until their thirties. In blue-collar jobs, women have made modest gains as bus drivers and repair persons, but in general equality has floundered. Fearful that demands for modified working conditions and benefits will be seen by male coworkers as coming out of their pockets and will leave them wondering whether such essentials as maternity leaves, day care, and flexitime will be used by employers as excuses to lay off women or reduce their chances for promotion, women have only reluctantly asked for them. Nor have trade unions actively pushed such issues. Instead, employers have taken advantage of women's assertion of equality to treat them more like men than as people with different needs. Since the early 1970s, we have seen a relative increase in the amount of female poverty, little reduction of unemployment in poorly paid work force sectors, a rather small narrowing in the wage-gap (the ratio of female to male pay), and only selective relief from occupational segregation.[4]

In short, for all its euphoric and insistent tone, the notion of dropping barriers to equality for women at work has not prevented women from becoming poorer and has only marginally increased opportunities for genuine mobility. Nor have affirmative action programs brought about any deep transformation of women's position in the work force. Clerical jobs, always female-dominated in the modern period, have become even more so. And clerical jobs continue to be those held by the largest number of women. Women remain a disadvantaged group.

How then should we integrate this group into the work force? At least one current strategy holds some promise. It revolves around two areas, each of which has, to some degree, abandoned the notion that women should adapt to male structures and returned to the idea that their differences require accommodation. Both represent what we have earlier called woman-centered or gynocentric feminism in that they recall the assumptions, if not the strategies, of the social feminists.

The first is best illustrated by the current strategy of the Women's Rights Project of the American Civil Liberties Union (ACLU). In a July, 1984, amicus brief, the ACLU opposed the constitutionality of Montana's Maternity Leave Act—an act that entitled pregnant women to extended unpaid leave before and for several weeks after the birth of a child. Arguing that the effect of such a law would be to place women in a "special" category and citing the history of past discrimination that had "perpetuated destructive stereotypes about women's proper roles and operated to deny them benefits enjoyed by men," the ACLU proposed

that the law be extended to permit health-connected unpaid leaves for all workers. The discriminatory effects of the act would be mitigated, the brief argued, and its "ultimate goals and purposes" supported if the court tied the act to Title VII of the Civil Rights Act of 1964, which forbade distinctions on the basis of gender. The effect of such a link would be to extend leaves to all workers unable to work for reasons of health.

Here the ACLU argues that the law, while acknowledging gender-based differences, can encompass them instead of isolating or ignoring them. By extending rights granted to some workers to all, invidious discrimination is turned into a potential gain for everyone. The pluralism of the work force is given its due, and each group of workers has access to the special treatment it needs.

A second example of current strategy emerges from the issue of comparable worth. The proponents of this effort to equalize pay acknowledge the existence of occupational segregation on the basis both of prior discrimination and of structural barriers. They insist, however, that the social roles that account for women's segmentation not be penalized. Instead, they demand that some objective scale be devised to evaluate the education, training, responsibility, and initiative required for a range of jobs within firms and that pay be granted accordingly. Such a strategy promises to protect women's social needs even when they emerge as job preferences because it avoids the assumption that equality can be achieved only by dropping barriers, challenges the notion of the market as the fairest determinant of the value of work, and substitutes instead the idea that women's goals are as legitimate as those of men and deserve equal rewards.

Such strategies emerge from an understanding of differences that acknowledges the social importance of familial roles and insists on the necessity of integrating them into a demand for equality. Insofar as these roles are traditionally preferred by women, sharing their immediate and opportunity costs by encouraging work place compromises to accommodate them reduces the penalty women pay for engaging in them. At the same time, the work place that accommodates family roles will exact fewer sacrifices from those who choose to emphasize the less individualistic elements of personality and thus it may encourage men to become less competitive as well.

As in the humanist feminist tradition, the basis of inequality in the work place in this approach is understood to lie in the privatization and separation of household and child-rearing functions. Such privatization, as many scholars have noted, perpetuates the inequality of women in the household, is characterized by dependence on male support, and is upheld by the value placed on femininity (Sokoloff, 1980). But these

inequalities in the home are rooted in contributions and values that some women, as well as men, do not choose to give up. For all that they have been manipulated and abused, notions of nurturance, sharing, and the kinds of relational and affectional qualities of which Gilligan (1982) speaks are nevertheless valued by large numbers of people. Maintaining them has in the past required women to ignore inequality in the work place and men to consciously foster it. A strategy that revalues these different qualities can create conditions that will enhance equality at home by making some of the real costs of family life and child rearing a social responsibility rather than a private one. This in turn will serve to increase the demand for equality.

I am here not suggesting a new strategy so much as I am urging that we not retreat from an insight that has had mixed results in the past. Yet, the attempt to deny differences has been equally mixed. A series of utopian communities in the nineteenth and early twentieth centuries attempted to confront and resolve the issues of child rearing and family care by fostering cooperation to share the burden. All were problematic. Charlotte Perkins Gilman proposed in her pathbreaking essay, *Women and Economics*, that these tasks be removed from the household. Several attempts to set up cooperative kitchens and community laundries provided no continuing model. We must at least consider the notion that such proposals have had little popular appeal because they have ignored what many women have felt was most satisfying about their lives, namely, their relationships to family. More successful have been those few attempts to accommodate the work place to family. Wartime experiments in housing women with families demonstrated the dramatic increase in productivity and family well-being that resulted from offering well-planned housing with easy supervision of children and on-site day-care, laundry and banking facilities, as well as prepared hot meals (Hayden, 1981, 1984). This success offers a sharp contrast to the extension of female poverty that has resulted from the systematic decrease in the already minimal community and social services offered to poor women today. And it suggests that an earlier generation of feminists who asserted women's difference deserves a new look. For them, difference meant limiting or regulating the sphere of work for women—a strategy that, as we have seen, in the end undermined equality for women. But within the context of the service economy of the 1980s, difference could mean adapting work place patterns for all workers to suit family lives.

In contrast to earlier notions of social or woman-centered feminism, the new understanding of difference proudly accepts the attributes associated with women's historically assigned roles, declaring itself antithetical to such male values as competition and achievement for

their own sakes. It lacks the moralistic assumption that women's culturally or socially ascribed roles are in any sense more valuable while insisting that such qualities belong in the world and not in a separate sphere. Thus it argues that women bear responsibility for family lives but insists that they do not bear it alone. This perspective opens the possibility of placing what have previously been private issues onto the public stage. In doing so, it takes assumptions of difference that in Eleanor Roosevelt's time were rooted in biology and therefore isolated women as a group and turns them into a sociocultural form that holds the possibility of genuine equality.

These new arguments from difference suggest that a woman's sense of morality and responsibility, and her behavioral codes (including those that derive from her sense of family and her childbearing capacity) are as much a public as a private resource and they insist as a matter of social policy that the work force recognize and make room for these alternative approaches to human relationships. Far from believing that women can act like men at work, this position asserts women's differences proudly, insisting that the work place accommodate to women's biology as well as to society's need for those less individualistic qualities of personality and relationship that are her strength. At its most optimistic, this approach is nothing less than a belief that gender equality will be achieved only when the values of the home (which have previously been assumed to keep women out of the work place or to assign them to inferior places within it) are brought to the work place where they can transform work itself. It opens the possibility that an ethic of compassion or tolerance, a sense of group responsibility to the world at large (instead of to self), might in fact penetrate the work place.[5]

It differs sharply from the implications of a neohumanist feminism that argues that women can respond to the work place like men and that assumes at heart that women can and will play the game the way men play it. In this form of feminism, personal aspiration and individual achievement measure progress toward the goal of equality. The problem is that this theory makes room in the work force primarily for those who wish to place nurturing roles in a secondary category and/or to acquiesce to the ethic of competition. It relegates to second place those who wish to function by their own more clearly female lights. In contrast, those who assert the validity of difference challenge the rules by which the game has been played, leaving room to extend protections won by women to men (as in the ACLU example) and opening up the opportunity to share the costs of childbearing and child rearing. Because this position accepts domestic life as a necessary part of the wage-work process, it encourages innovative thought in regard to housing programs, transportation systems, child care, and the allocation of

community resources. On the other hand, it insists on the need for compromises in the work situation that fully integrate women's orientations to work. At their most extreme, the two positions juxtapose the power of individualism against the force of some notion of collective good.

But lest it appear that one perspective is more radical than another, let me add that both hold the possibility of major social transformation, and it is for this reason that I suggest what looks like a utopian possibility. Given the numbers of women entering the labor force for perfectly valid demographic, ideological, and economic reasons, and given their pressures to share in the American dream of success, some change in either the family or the work force seems inevitable. If women are to function at work in competitive and achievement-oriented ways, they can and should fulfill all their drives for personal achievement. That goal offers a vision of a world without gender domination in the same breath as it implies the necessity for maintaining some form of hierarchy. It directly threatens the family in its patriarchal form and challenges traditional familial values. It begs the question of how the services normally offered in the home are to be provided in most families. In the end, it threatens the breakup of the family altogether.

The second direction, in insisting that women's orientation be publicly espoused, turns the attention of the state, the community, and extended friendship and kin networks to modifying both work place and the home. As in our comparable worth example, it places the market in second place behind an ethos of responsibility and fairness. Yet in insisting on shared values, this view challenges individualism, competition, and the profit system.

Both directions hold the possibility of conservative responses. The same group of people who argue that women can and should accept the rules as men have defined them implicitly accept the premises of individualism, namely, that people are by nature competitive, that some will not survive the struggle, and that although no one need starve, self-help is the key to eventual equality. Those who believe that difference should be honored, however, could respond positively to the New Right position that social order rests on reinforcing distinctions, not on accommodating them. The logic of that argument is that women really belong at home.

If women's values become a force in creating and influencing work culture, if women can resist efforts to use their understandings to enforce old roles, then exciting possibilities could confront us in terms of cooperation and shared goals in the work place and in family lives. As the material and other costs of rearing children and running households are shared or socialized, then no woman need fear an Equal Rights

Amendment. Once women's values are fully integrated into social relations, women will no longer constitute a "special group."

NOTES

1. Long before Gilligan (1982) articulated the differences between men and women in terms of their moral stance, historians spoke of a socialization process that yielded differentiated male and female stances toward the world. See, for example, Welter's classic "The Cult of True Womanhood: 1820-1860" (1966). For a discussion of the uses of these different relationships in the work force, see Kessler-Harris (1975). Gilligan's work sustains these earlier notions but is not necessary to it.

2. Evidence on this point is ambiguous. In her concluding remarks to the most recent survey and evaluation of occupational segregation to date, Blau notes rather pessimistically that "sex segregation in employment remains a pervasive feature of the labor market and a major cause of women's lower earnings" (1984, p. 313). She reaches this conclusion despite the relatively optimistic account of Beller and Rosenfeld in the same volume and in view of research findings by Bielby and Bowen also in the same volume. Note also comments of Pamela Stone Cain on this issue. Thanks to Louise Tilly for drawing this volume to my attention. Blau and Ferber suggest in this volume that a modest decline in the rate of occupational segregation in the seventies may be due to the shifting priorities of younger women vis à vis paid work and home work. If this is so, then some way of narrowing the separation between home and work becomes ever more crucial as this generation confronts conflicts between home and work in the future.

3. Marcia Greenberger (1980) cites lack of federal enforcement as well as the inadequacy of some of the laws themselves as responsible for slow progress.

4. For unemployment figures see the U.S. Department of Labor, Bureau of Labor Statistics (1983). Despite the generally higher ratio of female unemployment to male, during the recession of the early 1980s, women's level of unemployment dropped below that of men, indicating their persistence in occupationally segregated areas that were less vulnerable in this downturn. For female earnings and the level of poverty among wage-earning women, see report number 663 (1981), which indicates that the median earnings of female household heads were less than half those of male household heads.

5. Contrast this with the New Right position that, still wedded to the old notion of difference, reasserts the importance of the work/family dichotomy by implying that women will be returned to the home. See Ruddick (1980).

REFERENCES

Anderson, M. (1925, September). Should there be labor laws for women? Yes. *Good Housekeeping*, p. 4.

Baer, J. A. (1978). *The chains of protection: The judicial response to women's labor legislation*. Westport, CT: Greenwood.

Baker, E. F. (1964). *Technology and women's work*. New York: Columbia University Press.

Baker, E. F. (1969). *Protective labor legislation: With special reference to women in the state of New York*. New York: AMS Press.

Becker, S. D. (1981). *The origins of the Equal Rights Amendment: American feminism between the wars*. Westport CT: Greenwood.

Blackwelder, J. K. (1983). *Women of the Depression: Caste and culture in San Antonio, 1929-1939.* College Station: Texas A & M University Press.

Blau, F. (1984). Concluding remarks. In B. Reskin (Ed.), *Sex segregation in the work place: Trends explanations, and remedies.* Washington, DC: National Academies Press.

Degler, C. (1980). *At odds: Women and the family in America from the Revolution to the present.* New York: Oxford University Press.

Epstein, C. F. (1971). *Woman's place: Options and limits in professional careers.* Berkeley: University of California Press.

Fuller, M. (1977). *Woman in the nineteenth century.* New York: W. W. Norton.

Gilligan, C. (1982). *In a different voice: Psychological theory and women's development.* Cambridge, MA: Harvard University Press.

Gilman, C. P. (1898). *Women and economics.* Boston: Small and Maynard.

Greenberger, M. (1980). The effectiveness of federal laws prohibiting sex discrimination in employment in the United States. In A. S. Ratner (Ed.), *Equal employment policy for women: Strategies for implementation in the United States, Canada, and Western Europe* (pp. 108-127). Philadelphia: Temple University Press.

Hamilton, A. (1953, May 15). Personal communication to Miss Magee. Detroit, MI: Wayne State Archives in Labor History and Urban Affairs.

Hayden, D. (1981). *The grand domestic revolution: A history of feminist designs for American homes, neighborhoods, and cities.* Cambridge, MA: MIT Press.

Hayden, D. (1984). *Redesigning the American dream: The future of housing, work, and family life.* New York. W. W. Norton.

Hill, A. C. (1979). Protection of women workers and the courts: A legal case history. *Feminist Studies, 5,* 271.

Kanter, R. M. (1977). *Men and women of the corporation.* New York: Basic Books.

Kessler-Harris, A. (1975). Stratifying by sex: Notes on the history of working women. In R. Edwards et al. (Eds.), *Labor market segmentation* (pp. 217-242). Lexington, MA: Lexington Books.

Kessler-Harris, A. (1982). *Out to work: A history of wage-earning women in the United States.* New York: Oxford University Press.

Milkman, R. (1976). Women's work and the economic crisis: Some lessons from the Great Depression. *Review of Radical Political Economics, 8,* 73-97.

Piore, M. (1979). Fragments of a "sociological" theory of wages. In M. Piore (Ed.), *Unemployment and inflation: Institutionalist and structuralist views.* White Plains, NY: M. E. Sharpe.

Pratt, N. (1957). When women work. *American Federationist, 64,* 7-9, 25.

Roosevelt, E. (1933). *It's up to women.* New York: Franklin A. Stokes.

Roosevelt, E. (1944). Personal communication to Rose Schneiderman. Hyde Park, New York: Eleanor Roosevelt Collection, Franklin Delano Roosevelt Library.

Reasons for opposing the Equal Rights Amendment (n.d.). Detroit, MI: Wayne State Archives in Labor History and Urban Affairs.

Ruddick, S. (1980). Maternal Thinking. *Feminist Studies, 6,* 342-367.

Ryan, M. (1983). *Womanhood in America: From colonial times to the present.* New York: Franklin Watts.

Shuler, M. (1923, January 27). Industrial women confer. *The Woman Citizen,* p. 12.

Smith-Rosenberg, C. (1971). Beauty, the beast, and the militant woman: A case study in sex roles and social stress in Jacksonian America. *American Quarterly, 23,* 562-584.

Thibert, M. (1933). The economic depression and the employment of women: II. *International Labor Review, 27.*

U.S. Department of Labor, Bureau of Labor Statistics. (1983). Washington, DC: Government Printing Office.

Welter, B. (1966). The cult of true womanhood: 1820-1860. *American Quarterly, 17*, 151-174.

Woloch, N. (1984). *Women and the American experience.* New York: Alfred A. Knopf.

Young, I. (in press). Humanism, gynocentrism and feminist politics. *Hypatia: A Journal of Feminist Philosophy.*

6

Work and Family Linkages

VERONICA F. NIEVA

In recent years the previously separate worlds of work and family have become increasingly interconnected due to demographic changes in the work force and changing notions of work and careers. This chapter provides a review of the developing literature on work and family linkages. It includes discussions of the impact of work on family functioning and its converse: the impact of the family on work and careers. In addition, the chapter discusses the various modes by which individuals and institutions cope with the competing demands of work and family. Finally, the chapter presents suggestions for research needed for further understanding the ways in which work and family institutions affect each other.

The current rise of interest in the interpenetration of work and family issues accompanies recent major shifts in the nature of work and the definitions of families. Perhaps the most significant among these shifts is the growth of female participation in the labor force, particularly among married women with children. In 1975, about 55 percent of the women aged 25 to 50 were in the labor force; by 1990, projections estimate a 63 percent participation rate—an increase of about 12 million (Smith, 1979). The composition of the increasing female labor force has important implications for the work and family arenas. Over the past three decades, the number of wives in the labor force has more than tripled (U.S. Department of Labor, Bureau of Labor Statistics, 1980), reaching about 56% of the female labor force. Further, the numbers of working women who have children under 18 years has also tripled over the same period. Another significant change in the work and family scene is the increase in the number of families headed by single women. In 1977, more than 73 percent of divorced and 55 percent of separated women were working, and the numbers are rising (Grossman, 1975). Still another significant development is the increase in the number of dual-career couples, for whom the pursuit of both careers is important.

AUTHOR'S NOTE: I would like to thank the anonymous reviewers who made helpful suggestions on an earlier draft of this chapter.

These demographic changes have made it necessary to reexamine the linkages between work and family. Traditionally, work and family were viewed as separate worlds, with males occupying the work world and females responsible for the family. The Parsonian discussion of a split between instrumental (male) and expressive (female) roles (Parsons & Bales, 1955), reinforced by later research differentiating task leadership from socioemotional leadership (Bales & Slater, 1955), underlined the traditionally dichotomous world view. Thus although the world was seen as divided into working, instrumental males and homemaking, socioemotional females, there was little impetus to study the inter-dependence between spheres (Nieva & Gutek, 1981; Gutek, Nakamura, & Nieva, 1980). The separation was supported further by the split in academic disciplines that "owned" each sphere; that is, industrial psychologists, economists, and occupational sociologists tended to study work behavior, where family behaviors tended to be studied by child and marriage specialists.

Another shift that has stimulated the new focus on work and family linkages is the creation of the New Breed worker (Yankelovich, 1979; Bailyn & Schein, 1976; Gartner & Riessman, 1974). For this emerging group, the meaning and priority of work has changed, alongside other priorities. The New Breed worker places high value on opportunities for self-expression, and work takes its place alongside other life goals and interests. Some of the male New Breed workers are divorced or single parents, who are newly struggling with the challenge of balancing priorities between work and family responsibilities.

These recent changes in societal structures have eroded some of the separation that traditionally existed between the worlds of work and family.[1] This chapter will provide an overview of research on the impact of work on family, the impact of family on work, and individual and institutional mechanisms for handling work and family inter-dependencies. It ends with a discussion of future research needed to advance our understanding of the interacting worlds of work and family.

EFFECTS OF WORK ON FAMILY

Employment Status of Women

Because of the traditional sex linkage of work and family roles, the questions asked about work influences on family differ greatly depend-ing on whether the focal population is female or male. An extensive and early stream of research focused on the effects of women's employment status on their families. Underlying many of these early studies was the

hypothesis of maternal employment as deviance, resulting in harm to their children and their marriages. However, the expectations that maternal employment would result in delinquent and nonachieving children and general marital discord have not found consistent support. Later research and reviews of this extensive literature (e.g., Nye & Hoffman, 1963; Hoffman, 1974, 1979; Cochran & Bronfenbrener, 1979; Hofferth & Moore, 1979) have shown that early simplistic problem formulations ignored important factors that have to be taken into account such as forced versus chosen employment, kinds of child-care arrangements made, type of work, and the husband's attitude toward his wife's employment.

Married women's employment status, however, appears to have consistent effects on women's status and influence on family decision making. The independent financial base provided by employment provides women with an increased sense of competence, gives women more power within the marriage, and increases her influence in decision making (e.g., Blood & Wolfe, 1960; Blood, 1965; Safilios-Rothschild, & Dijkens, 1978). Couples in which both husband and wife work are more likely to share decisions about major purchases and child rearing. In addition, the financial resources brought by the wife's job enhances the family's living standards and social class position (Scanzoni, 1978).

Although they gain power and contribute to family status, working wives do not obtain significantly more help in household work from their husbands than do nonworking wives (Hofferth & Moore, 1979). Rather, women tend to add on the employment work load to their household work, although they also tend to reduce the amount of time spent on household chores by half (Vanek, 1974). Research shows that working wives and husbands do not share household activities (Berk, 1976; Bryson et al., 1976; Pleck, 1977; Berk & Berk, 1978, 1979, Hoffman & Nye, 1974; Lopata, Barnewolt, & Norr, 1980). Any change occurring in the distribution of household work is slight. Recent data show a very slight increase in husband's household work time (Pleck & Rustad, 1980), but these time budget analyses show that employed women still do twice as much homework (23.6 hours per week) as their unemployed husbands (11.4 hours per week). In an intensive study of organization of the household day among a cross section of urban families, Berk and Berk (1979) found that when the wife is present, she tends to handle the child care and household tasks; husbands do household work only when the wife is unavailable.

The slow rate of behavioral change in the distribution of family work may be due as much to female reluctance to share the home role as it is to male resistance to taking on new responsibilities at home. A recent study of professional women (Yogev, 1981) showed that these women, who

felt equal to their husbands in terms of ability and intelligence, still perceived housework and child care as their own responsibilities and spent much more time at these tasks than did their husbands. Most were relatively satisfied with the division of labor, suggesting that the traditional division may persist because, at least in part, the wives need to maintain their feeling as the "mother in the family." Yogev suggests that the combination of egalitarian self-concepts with unequal division of labor may be a temporary compromise in the process of role redefinition for both spouses.

Employment Status of Men

Given societal expectations of the male breadwinner role, employment of husbands has been viewed with a different perspective in comparison to employment of wives. Husband employment is viewed positively, whereas nonworking husbands are considered deviant. Consequently, research has focused on the familial effect of male *unemployment* rather than employment. Studies dating from the Depression showed that unemployment led to devastating effects on men, leading to a variety of negative emotional states, including lowered morale, depression, and anxiety (see Eisenberg & Lazarsfeld, 1938, for a summary of the literature). Later research has tended to support and extend these findings (e.g., Kasl & Cobb, 1970; Braginsky & Braginsky, 1975).

It is not surprising that these negative individual effects were also found to be mirrored in families of unemployed men. Men who became unemployed lost respect and power in the family (Cavan, 1959). Family instability among low-income families has frequently been attributed to the low earning capacity of men. A man's job was linked to his power over his wife and children (Angell, 1936; Komarovsky, 1940; Aldous, 1969). All of these reports support Scanzoni's (1970) exchange model of family dynamics, which states that the husband's socioeconomic success was rewarded by the wife's supportiveness and marital satisfaction, and overall marital stability.

However, changes in external support systems available to the unemployed, shifts in the psychological centrality of work, and changing sex roles may modify the negative relationships between male unemployment and family functioning (Thomas, McCabe, & Berry, 1980). Little (1976) suggests that the unemployed role has become more socially acceptable for *some* individuals, who often do not blame themselves for their job loss; these individuals therefore do not suffer in the same ways as others do. It is difficult to predict what the effects of employed spouses might be. One could expect, for example, that the

negative effects of male unemployment may be somewhat minimized in families with working wives, whereas families depending on a single male wage earner may undergo major difficulties. On the other hand, if the unemployed partner is male, his "failure" at the traditional male breadwinner role may cause greater psychological problems within the family.

In addition, relationships different from those that would be predicted by Scanzoni's (1970) exchange model have also been demonstrated. Studies, for example, by Blood and Wolfe (1960) and Dizard (1968) show curvilinear relationships—lower marital satisfaction at both the high and low ends of occupational success. The findings of dissatisfaction for highly successful husbands required the development of an alternative "success constraint model" (Aldous, Osmond, & Hicks, 1979). This model suggests that excessive success lowers the husband's marital involvement and participation, and ultimately threatens marital stability. A study of police and their families (Hageman, 1978) provides a variant on the "success constraint" model. His study showed that high job satisfaction among officers was correlated with lower levels of marital satisfaction of both husband and wife. Thus the critical factor may not be so much "success" as it is the occupational involvement that diverts all energy to the job and away from the family.

More complexities in the relationships among occupational success, involvement, and family functioning have yet to surface in research on working wives. Anecdotal evidence suggests that dual-career women successful in the occupational sphere face additional challenges of implied competition with their partners. At the same time, reports are also increasing regarding successful women linking themselves to younger or nonprofessional men who perform the support function traditionally assigned to wives. If these journalistic reports are indeed reflections of a developing societal trend, critical changes in status and power allocation within couples—and perhaps even in society at large—might be anticipated. In this arena, research has yet to catch up with the dynamic developments that create new combinations of occupational and family statuses.

Time and Schedules

Recent research has begun to move from a focus on the global status of employment and unemployment to more specific aspects of work that affect families. An analysis of a national survey of workers (Pleck, Staines, & Long, 1978) revealed that time and scheduling problems were major aspects of work-family conflicts. These time factors included amount of time required by the job and work-family schedule incom-

patibility. In this survey, problems due to excessive work time were more often reported by men, whereas schedule incompatibility was reported by women, particularly employed single mothers.

In a very basic way, the amount of time spent at or on work limits the amount of time available for the home (Meissner, Humphreys, Meis, & Schein, 1975; Robinson, 1977; Staines & Pleck, 1983). The effect is more directly seen among men than among women. Among husbands, negative relationships have been found between hours worked and hours devoted to household tasks (e.g., marketing, laundry, and gardening), although work hours have been found to be unrelated to time spent with children (Robinson, 1977). Wives, as noted earlier, do reduce their household work when they are employed (Vanek, 1974) but still maintain primary responsibility and spend twice as much time as their husbands on work at home (Pleck & Rustad, 1980).

The number of hours worked and the extent to which work is brought home varies greatly across occupations. A small study of male professionals (Gertsl, 1961) found that dentists worked 40 hour weeks and never brought work home. In contrast, professors, who worked 56-to 60-hour weeks, brought work home and did no household chores. Long work hours can create family strain. For example, a recent survey of professional men (Mortimer, 1980) found that 59 percent of the men considered their long job hours to be disruptive of family life. An analysis of a national sample (Staines & Pleck, 1983) also found that the number of hours worked was related to work-family conflict. Keith and Shafer (1980) report an interesting crossover effect: An increase in the husband's work hours was associated with wife strain but not the reverse. Other studies, such as that by Staines and Pleck (1983), show little or no such crossover effects.

Shifts create other types of work-family conflicts. Mott et al. (1965) reported husband and wife problems for night shift workers and problems with the father role for afternoon shifts. Staines and Pleck (1983) found that nonday shifts were associated with scheduling problems within the family, as the time shift workers have available do not mesh with schedules of other family members. Lein et al. (1974) note that special issues occur when the man is home during the day or away in the evening, deviating from regular schedules. The father with young children with such a schedule has more time than other fathers with the children, as well as more time to take on housekeeping duties. His absence in the evenings, however, means that the wife is alone and their social life is severely curtailed. Recreation and community activities, usually scheduled in the evenings, are often missed. Shift workers often develop their own cliques to provide the contact that their families, geared to day schedules, do not provide (Aldous, 1969).

Problems are exacerbated for rotating shifts when constant adjustments of family rhythms are required. Staines and Pleck (1983) found that variable work days create scheduling conflicts and various difficulties in the workers' family lives. Rotating shifts were reported as interfering with various aspects of the marital role, for example, sexual relations and decision making (Mott et al., 1965). Interviews in our ongoing study of police and their families, for example, reveal problems in defining what meals are (is this breakfast or dinner?), inability to plan ahead for social and family events, and problems in timing sexual activities.

Other aspects of work time and schedules have also been investigated, although less extensively. The four-day, 40-hour work week requires longer workdays in exchange for working fewer days. Maklan's (1977) study of blue-collar workers in the Midwest noted that four-day workers spent more time with their children and on traditionally male household chores compared to five-day workers. Flextime is another increasingly popular type of work time innovation in which variations in the start and end of the workday are allowed. A moderate amount of data support the many anecdotal tales of family benefits due to flextime. A quasi-experiment in two government agencies (Winnett, Neale, & Williams, 1982) showed significant increases in the amount of evening time spent with spouses and children. Bohen and Viveros-Long (1981), in contrast, show that flextime increases time spent on housework but not on child care. In general, flextime makes it easier to coordinate work schedule with time for the family and household chores.

Many other work-time factors remain to be examined for their family impact, for example, the seasonal cycle of some types of work. Lein et al. (1974) describe families in which the employee's looser schedule in either the summer or winter allows greater participation in family work. This is an aspect of the work time that has generally received little attention. Yet another is the phenomenon of second jobs, where the impact of two job schedules have to be handled. A different type of factor is the on-call nature of some jobs (e.g., doctors, therapists, and police) where there is no clear end to work time. These, among other work-time factors, can be expected to have major effects on family functioning.

Separation and Travel

Although work-related family separation is common in many occupations, by and large, the phenomenon has not yet been subject to much empirical scrutiny. Most of the research on the subject appears in the military context, in which deployment and war-induced separations

have stimulated inquiry into effects on the military families left behind. Early on, Isay (1968) identified the "Submariners' Wives Syndrome"— depression and other psychiatric problems that characterized many wives shortly before or after their husbands' sea duty, which lasted anywhere from three months to nine months. Similar studies of emotional difficulties suffered by wives during family separations described feelings of loneliness, social isolation, and sexual frustration (e.g., Pearlman, 1970; McCubbin, Dahl, & Hunter, 1975; Montalvo, 1976; Decker, 1978). The effects of such separations on children seem unclear (Croan et al., 1980) and appear to be heavily mediated by the impact of the separation on the mothers.

The Prisoner of War (POW) studies conducted in the 1970s focus on an extreme case of separation due to work. These studies showed a general increase in independent functioning and a decrease in marital satisfaction among wives over time (Hunter, 1977). To adjust, the wives adapted a variety of coping mechanisms that may apply as well in less extreme situations, for example, seeking opportunity to express their feelings; establishing autonomy while maintaining family ties; engaging in activities geared toward self-development; and depending on religion (McCubbin, Dahl, Lester, & Ross, 1975).

The issue of dependence and independence seemed to be particularly problematic for these separated families. Ironically, the extent to which families adjusted successfully to separation appears to be inversely related to the ease with which they accommodate to the return (Boynton & Pearce, 1978; McCubbin, Dahl, & Hunter, 1975). Thus to the extent they cope successfully with separation by becoming independent, problems in marital adjustment occurred when the families were reunited.

Travel-induced separations also occur among civilians, notably salespersons and business executives. Less research has been conducted in the civilian sphere compared to the military, but similar indications of difficult family consequences have been found. Renshaw's (1976) study of male managers in a multinational corporation revealed increased responsibility, worry, and fear for the wives, and disconnected social relations, fatigue, and guilt for the husband-employees. The gap between the lives of the husbands and wives and difficult reentry periods have also been mentioned (Levinson, 1964; Seidenberg 1973).

Relocation

Over 100,000 employees and their families are transferred by corporations in one year (Employee Relocation Council, 1981), and

many more are transferred by the military or move themselves. Although popular mythology suggests negative consequences of mobility, recent work (Brett, 1982) finds no difference between "mobile" and "stable" people in general well-being, that is, life, family, and marital satisfaction. The main differences between the "mobile" and "stable" populations appeared to be lower "mobile" satisfaction with various aspects of social relationships, for example, friends at work, neighbors, and community.

Many questions remain about the impact of job relocation, particularly relocation that is involuntary (e.g., in the military or when entire departments relocate), occurring over larger distances (e.g., overseas), or in dual-career situations in which geographic choices must be made that can result in relative advantages to one spouse.

Job Demands and Gratifications

Job-induced tensions or preoccupations result in the intrusion of work into the home. Pleck et al. (1978) label such work-induced exhaustion, irritability, and preoccupation "work spillover," resulting from jobs that require hard work, fast work, or continued attention after-hours. Analysis of our ongoing study of police officers and their families (Johnson, 1984) shows that strains resulting from the job are related to family disturbances, separations, and divorces. The familiar effects of job burnout appeared to be stronger among black officers than white officers, although the reasons for this difference are not yet clear. A survey of professional men (Mortimer, 1980) showed that work spillover was common in this population; that is, professionals had difficulties detaching themselves from the irritations and problems at work after work hours. Ridley's (1973) finding that job involvement is negatively related to marital satisfaction may be a reflection of this negative spillover effect. Aldous (1969) and Rapaport and Rapaport (1969) have raised similar questions about the impact of job salience on family roles.

Piotrowski's (1981) in-depth analysis of several families presents a detailed picture of the ways in which the job spills over both positively and negatively into the family life. Her case studies show that intrinsic gratifications (e.g., meaningful work, control over work pace) create conditions for favorable marital interactions and satisfactions. It appears that the concept of job involvement, as it may affect families, needs further refinement. Distinctions, for example, between involvement that is energizing—and therefore beneficial to the family—and involvement that is all-absorbing might be made. More attention is

needed on the occurrence of positive spillover and ways in which work life can be structured so as to allow employers to have fulfilling family lives.

THE EFFECTS OF FAMILY ON WORK

Much more is known about family accommodations to work demands than the reverse: Work accommodations to family. In many ways, the myth of the "good worker" prescribes that work should not be affected by extraneous matters, including the family. For most workers, work-family conflicts imply the interference of work on the family (Pleck, Staines, & Long, 1978) rather than the reverse. The influence of family on work has been largely a matter of concern for three groups: Women with families (because women's primary responsibility for the home suggests that work for her should give way), dual-career families, and the military (because the institution is so totally absorptive of its members' families).

Women's Labor Force Attachment

Early in life, young women face the question of placing priorities on a career versus family (Angrist & Almquist, 1975). Although the choices are becoming less absolute, and different possibilities of integrating both spheres are opening up, women are aware early on of what some trade-offs might be. Weingarten and Daniels (1978) found that parenthood had different occupational consequences for women and men in line with traditional assignment of family and work to women and men, respectively. The effect of parenthood on men was to push them further in their work activity and commitment. In contrast, women made major adjustments in their work lives to accommodate their family needs. Because women still tend to retain major responsibilities for the home whether they are employed or not, it is inevitable that home and family factors affect whether women decide to work, the jobs women take, the satisfaction they receive from working, their salary, and a host of other job-related behaviors and attitudes (Pearce, 1978).

Nieva and Gutek (1981) review various factors affecting whether a married woman decides to take a job. This decision is heavily influenced by her husband's attitudes (Winter, Stewart, & McClelland, 1977; Farmer & Bohn, 1970; Weil, 1961), the family's economic needs (Finegan, 1975; Dickinson, 1974; Mahoney, 1961), and the number and ages of children (Molm, 1978; Stolzenberg & Waite, 1977; Waite, 1976; Finegan, 1975). Women's identification with the family role also appears to influence the nature of jobs traditionally available to them.

Many "women's jobs" can be characterized as having the same service components as the wife and mother roles, and have been seen as extensions of women's primary home roles of providing nurture and support.

Women's family roles have also significantly affected their labor force attachment, many exhibiting an intermittent work style. Various researchers (e.g., Young, 1978; Corcoran, 1978; Bernard, 1971; Cooper, 1963; Super, 1957) have identified career patterns involving career interruptions and combinations of work and family cycles. The intermittent work style has been blamed for women's lack of parity with men in work status (Inderlied, 1979; Shea et al., 1970), although Corcoran's work (1978) on the 5000 American Family Study tends to undercut this proposition. Corcoran's (1978) finding that the differences in men's and women's work patterns do not account for the 40 percent difference in their earnings is supported by others who found no support for the negative effects of women's work discontinuities (Sandell & Shapiro, 1976; Sawhill, 1973).

The age of marriage and childbearing influences women's labor force attachment over time; early marriage or childbearing has been found to increase the likelihood of limited work experience and later dependence on welfare (Moore, Hofferth, Caldwell, & Waite, 1980; Barrett, 1979). The preference for part-time work among many women has been heavily influenced by women's family roles. In the past decade, there has been a dramatic increase of part-time workers among women, especially married mothers. Nearly half of all women who worked part-time gave "taking care of home" as the reason for not working full-time (Barrett, 1979). In contrast, only 1 percent of the men gave this as their major reason for part-time work. Men tended to cite school attendance and job loss as reasons for less than full-time work.

Dual-Career Couples

Dual-career couples comprise a group attracting attention in the study of family effects on work. At issue is the impact of dual-career considerations on career development and productivity. Job-seeking and transfers become more complicated in dual-career families. Holmstrom (1971) showed that the professional careers of both spouses were mutually interdependent; both husbands' and wives' choice of decisions on locations were affected by the spouse. However, wives tend to make greater accommodations to their husband's career needs. For example, Bryson and Bryson (1978) found that a majority of wives would accept jobs in another town only if their husbands also received satisfactory offers, whereas the reverse was not true. Wallston, Foster,

and Berger (1978) found that although egalitarian decision rules were espoused by recent Ph.D.'s, females gave the lead to the males when forced to make hard choices.

Other work-related advantages of the male half of the dual-career couple were described in a study of dual-career psychologist couples (Bryson & Bryson, 1980). Within couples, more husbands tended to have higher degrees, hold academic jobs, publish more, and have higher salaries compared to their male and female counterparts, especially compared to their wives. Notably, the income differential between husband and wife was inversely related to the amount of household responsibility he accepted.

A variety of work innovations are gaining momentum in large part among dual-career couples in search of alternative work styles that can coordinate both careers. Butler and Paisley (1980) suggest four forms of dual-career coordination: The alter ego model (in which couples coordinate both specialities and institutions, collaborating side by side on the same tasks); institutional coordination (working in the same institutions in which no antinepotism rules hold); specialty coordination (working on similar tasks in different institutions); and complementary coordination (emphasizing the contribution of each career to the other, regardless of specialty of institution). Job sharing is another related form of couple coordination. Difficulties in maximizing both careers simultaneously may lead to other forms of work accommodation such as taking turns in moving for each partner's career opportunities and alternating working in several year cycles (Moore et al., 1980). Also, geographic constraints on the availability of optimal employment for both parties may lead to temporary separation or commuting arrangements (Butler & Paisley, 1980; Farris, 1978). Clearly, dual-career couples will force changes from the traditional linear definitions of careers that currently exist.

Military Families

Implicit in much of military lore and practice is the notion that the military institution is responsible for the families of its members. In comparison to most work organizations, the military—perhaps because it is a relatively enclosed institution and because its special demands have such visible effects on members' families—sees much less of a separation between the institutional and the private spheres. For example, although spouses of service members are not themselves enlisted in the institution, they are very much subject to the service's formal policies and procedures as well as to the very strong informal norms on appropriate behaviors. The recognition of the military as a

total institution has resulted in the development of support services not often considered to be within the organization's primary responsibility in the civilian world (e.g., child abuse programs, family mediation, and child care) and in various assessments of the needs of military families (see Croan, Katz, Fischer, & Smith-Osborne, 1980).

In the past two decades, the military's interest in its families has risen, alongside the dramatic increase in the number of married service members. Although some of this concern can be traced to the military's ethic that "the military takes care of its own," much of the focus is pragmatic. The military has become aware that the family can be a powerful influence on the service member's interest in remaining in the service and on his or her performance on the job.

Studies show strong consensus that family factors significantly affect the decision to stay in or leave the service (Nieva, Hernandez, Waksberg, & Goodstadt, 1982). Satisfaction with family-related benefits (e.g., housing and recreation facilities) and with military practices that involve the family (e.g., frequent moves) were found to be highly related to retention intentions (Strumph, 1978; Woelfel & Savell, 1978). The influence of service wives on the decision to remain with the military has also been well-documented. Various studies (e.g., Stalaff et. al., 1972; Grace, Holoter, Provenzano, Copes, & Steiner, 1976; Thomas & Durning, 1980; Szoc, 1982) found that Navy wives thought of themselves as an important influence on their husband's reenlistment decisions. Other data from the Air Force (Orthner, 1980) showed that, although a number of factors were related to retention decisions— including pay satisfaction, job security, and satisfaction with supervision—the most important factor in deciding on a long-term Air Force career was spousal support. The importance of spousal support to retention was supported by a recent large-scale Navy study (Szoc, 1982).

The relationship between family factors and job performance, however, has been less studied, and the results, although not conclusive, tend to show no linkages. For example, Woelfel and Savell (1978) showed no relationships between marital and job satisfaction among Army enlisted men. A study of Navy personnel (Nieva, 1979) also showed that, although work-family conflict was related to satisfaction and intention to stay, it was not related to job motivation. It remains to be seen whether these null relationships will be formed if other measures of job performance (e.g., promotions and absenteeism) are used.

Family Supports for Work

On the positive side of family influence on work, attention has been paid to the support that family members, particularly wives, give to the worker. Early focus on the corporate wife of the "Organization Man"

(Whyte, 1956) recognized the auxiliary functions provided for the worker (e.g., entertaining colleagues and clients, maintaining community relations, doing secretarial work, and providing psychological nurturing).

Many jobs are designed to be filled by a family man who has a wife to manage the household, allowing his full attention to be given to the job. Kanter's (1977a) inclusion of wives as corporation members recognizes that the male employees' productivity level is only possible because of the support services provided by his wife. Papanek (1973) described the "two-person single career" in which the wife (of chaplains, military husbands, foreign service employees, corporate executives) plays the role of supporter, home maintainer, and child-raiser. These wives participate vicariously in the husband's job achievements and respond to institutional expectations for employee wives. Among professional men, wives provide support to their occupational roles by providing entertainment to colleagues attending company parties, discussing work with them, providing direct assistance such as office work, and making contacts in the community that help business (Mortimer, 1980; Gutek & Stevens, 1979).

Women, however, frequently do not have such support. A study of Chicago women (Lopata et al., 1980) showed that the women felt they gave more help to their husbands than they received. For most working women, their husbands' influence is psychological, rather than instrumental; that is, their approval and support are important to the women's careers (Rapaport & Rapaport, 1971; Farmer & Bohn, 1970). Further, a supportive husband is an effective mediator of role conflict and strain (Burke & Weir, 1977).

JUGGLING WORK AND FAMILY

As work and family roles, previously compartmentalized by gender, become increasingly connected, both men and women are beginning to learn how to redefine role responsibilities and to handle the strains resulting from overload and spillover. At the same time the institutions within which work and family activities are carried out are starting to address the needs of their changing work force. This section discusses coping mechanisms for handling work and family concerns at the individual and organizational levels.

The Individual Jugglers

At this stage, problems of integrating work and family lives still fall more heavily on women than men. Women have added work role

demands to their traditional family role responsibilities, but, as noted earlier, most men have not been too quick to add new family tasks to their traditional work responsibilities.

Pleck (1977) suggests the presence of asymetrically permeable boundaries between work and family for the two sexes. For women, the family role is allowed to intrude upon work; for example, she has to leave work to take care of sick children or attend school functions. In contrast dinner may be delayed or activities cancelled because of the man's work activities. Hall (1972) hypothesized that women have two *simultaneous* roles, whereas men are allowed to have *sequential* roles. Men, therefore, can defer their family roles to the evening after work, whereas women's family responsibilities continue throughout their workday. Given the same number of roles, it can be expected that women would experience more conflict and overload compared to men.

This situation has led many women to eliminate roles and to make choices not traditionally required of men. Some women have chosen to remain childless to reduce role conflict, especially in demanding careers. Rebecca (1978) has suggested voluntary childlessness as a conflict-reducing mechanism. Early studies show that marital role has also been sacrificed. Various studies (Rossi, 1965; Epstein, 1971) found that the majority of the professional women studied who had risen to the top of their professions remained unmarried. Herman and Gyllstrom (1977) also found that twice as many women as men in their sample of university staff were unmarried.

The timing of role adoption, rather than complete abnegation, is another form of coping with the demands of multiple roles. About 20 percent of the respondents in the national General Mills Survey (1981) reported that work affected their decisions about the timing of children. Conversely, women who are able to choose the timing of their entry or reentry into the paid labor force consider their readiness in relation to their children's stages of development (Weingarten & Daniels, 1978). Studies have found that employed women adopt different strategies for relating childbearing and work: To bear children early and resume work, and to establish the career first and then have a family (Rapaport & Rapaport, 1971; Hennig & Jardim, 1977).

However, more and more women are in the work force even when they have small children (Smith, 1979). This choice of the "double tracking" rather than the "sequential" approach to childbearing and employment implies that satisfactory solutions have been developed to handle work-family conflict problems or that the satisfaction derived from role accumulation may overide the conflicts.

A variety of solutions to role conflict have been identified. Whereas unemployed women have increased their time spent on housework since

1920, working women decreased housework time by half (Vanek, 1974). Role standards may be lowered; for example, the house need not be meticulously clean at all times. Compartmentalization—not allowing concerns from other roles to disturb the salient role—is the solution currently used by many men and has been found effective for women except in emergency situations (Poloma, 1972). A solution much touted by the media, though difficult for most mortals, is the "Superwoman" solution—becoming better organized and more efficient at all roles (Hall, 1972).

Recently, there is increasing emphasis on the perspective that multiple roles can provide positive, rather than stressful experiences. Crosby (1984) suggests that multiple roles can provide people with psychological protection: The happiness at home with children can block disappointments at work; or conversely, people can use the job to distract themselves from a discordant or empty personal life. Empirical support for the notion of the beneficial effects of multiple roles are beginning to emerge. For example, a study of the roles of women in their middle-years—wife, mother, and paid worker—found that feelings of well-being were highest among women with three roles and least among women with only one (Barnett, Baruch, & Rivers, 1982). Further, they found no differences in roles conflict among women with one, two, or three roles. Various other benefits have also been reported among individuals—both men and women—who combine several roles. For example, married women who work report greater self-esteem and well-being (Bernard, 1972) and greater marital satisfaction (Safilios-Rothschild, 1970) than do unemployed women. Husbands of wives who choose to work have also reported happier marriages and better physical and mental health than the husbands of housewives (Booth, 1976, 1979). Clearly, multiple roles create both new conflict and satisfaction. The contingencies around the development of conflict and stress, on the one hand, and greater fulfillment and happiness, on the other, as a result of role accumulation have yet to be examined.

Institutional Responses to Work-Family Issues

A variety of institutional adjustments can help maintain balance between the work-family spheres. In recent years, employers have become increasingly concerned with providing various forms of assistance and support for their employees' family concerns. For example, employee benefits—for example, paid personal days to attend to child and family responsibilities, part-time work with full-time benefits, reimbursement for or direct provision of child-care services, and flexibility in selecting benefits for one's family—can be structured to

facilitate employee balancing acts (General Mills, 1981). The current availability of these types of benefit structures varies greatly across companies. Personnel policy change could also be designed to help employees balance their work and family responsibilities. The General Mills Survey (1981) identified the following policies that employees would consider particularly helpful:

- the right to resume work at the same pay and seniority after a personal leave of absence;
- the right to refuse a relocation without career penalty; and
- the choice between a 7 to 3, 8 to 4, or 9 to 5 workday.

These policies have been adopted by 60 percent, 48 percent, and 28 percent, respectively, of the companies in this survey.

Dual-career couples require special attention in terms of personnel policies, such as spouse assistance in relocation and antinepotism rules. Although antinepotism policies have officially been declared as discriminatory, underlying antinepotism attitudes may remain (Butler, Paisley, & Hawkins, 1978). The rise of dual-job couples, coupled with high rates of unemployment, may give rise to new interest in an old idea: The part-time job. Reduction in work time, if made legitimate and detached from the traditional definition of part-time jobs as jobs requiring low skills and having low potential for upward mobility, would enable both men and women to handle work and family requirements. The current status differentials between part-time jobs, often held by women, and full-time jobs, held by men, make it difficult to elevate the status of part-time jobs. Variations in time arrangements that are not allocated by sex would be necessary to eliminate the stigma attached to less than full-time work.

A related innovation, found in a limited way in some companies, is the concept of shared jobs. This idea remains controversial. About one-third of the human resources officers surveyed by General Mills (1981), for example, thought that shared jobs would help employee families, and 70 percent thought it likely that their companies would adopt this practice. However, less than 20 percent of the labor leaders held this view. Job sharing is most likely to succeed in institutions whose policies allow for permanent, upgraded part-time employment and that do not have nepotism rules (Arkin & Dubrofsky, 1979).

FUTURE RESEARCH

More Understanding of Work-Family Connections

Research leaves much to be discovered about work-family linkages. Because research reflects—and often lags behind—the dynamic realities

of a changing world, the questions that have been asked may have the intellectual and emotional blinders of the times. For example, the early search for harmful effects of women's employment on their children and their marriages did not succeed under the simplistic cause and effect problem formulation that characterized that early work. Many intervening factors have been found to affect the relationships between female employment and family factors. In addition, data may no longer be true by the time they are published. Care should be taken, for example, in assuming that time budget data collected in the 1970s reflect reality a decade later.

New questions are constantly emerging. Thus where research has examined the impact of specific work factors—for example, schedules, relocation, separation, and job demands on the family—among working men, the same issues must be investigated for women. Disruptions in family life have been found when men work too long or are too consumed by the job to have energy left for the family. Much more research is needed, on both male and female employees, to understand the characteristics of jobs that "absorb" individuals and what work absorptiveness means for employees and their roles as spouses, parents, and household workers in the family. In contrast, research is also needed on what job aspects "energize" their incumbents and leave them better able to execute their family roles.

Much more research is needed to examine the effects of family factors on work behaviors. The implicit rules in many organizations tend to make the examination of this relationship difficult because organizations tend to operate under the assumption of separate work and family worlds. Many questions beg for answers, however. For example, how does the family affect job satisfaction? Do family factors affect performance and turnover? Very little is empirically known in these regards for individuals outside the military.

The positive effects of each sphere on the other also needs examination. Much of the research on work and family has tended to focus only on the potential for disruption and to overlook the possibilities of positive spillover. In addition to the traditional model of the corporate wife, new models of support might be identified given changing family forms. It may also be possible to identify supports from the work place—for example, the job structure, support from coworkers and supervisors—that help the individual carry out family duties. Within the individual, the rewards of multiple roles deserve further examination. The opportunity for shifting gears between work and family, for example, may alleviate rather than create stress. Roles may reinforce rather than disrupt each other.

In general, more attention is needed on the processes by which individuals perceive and handle their multiple roles either in the short run (day-to-day) or over the life cycle. Although there has been somewhat more focus on the negative aspects of multiple roles (e.g., overload and spillover) than on its positive aspects, many areas remain unexplored. The role adjustment mechanisms that have received the attention thus far have tended to be intraindividual ones, mostly on the part of females. Examination of role adjustments among males will become more necessary as they become more involved in the home. In addition, role adjustments occurring among members of the family role set (i.e., "outside" the individual) must be given more attention.

Research on work-family interdependencies can be organized into the cells illustrated in Table 6.1, which represents the possible areas of mutual impact between the work and family sphere. Because present realities still differ markedly for men and women, it is important to examine the work-family relationships for each group. In addition, it is advisable to further delineate the family roles into at least three major components—the marital, parental, and household roles—because there may be very different influences operating in each sphere.

In each cell, the flow of effect can occur in either direction, that is, from work to family and family to work. The flow can be positive or negative in direction. In addition, the effect flow can be examined within the individual (e.g., the amount of work time and time spent on chores by the same person) or in crossover fashion across the role set (e.g., from husband's work to wife's work, from wife's work to children, from husband's work to wife's household duties). For each action in each sphere, the types of variables to be examined can be arrayed and the interrelationships—within and across individuals—explored. For example, important types of variables in future investigations should include

- chronic work and family characteristics (e.g., global and specific job and family characteristics and requirements);
- special events and decisions in work and family arenas (e.g., marriage, divorce, entry into labor force, work termination);
- affect (e.g., satisfactions, commitments, priorities); and
- performance at work and at home.

Changing Work-Family Sequences

Over the life course, coping could take the form of alternative work-family patterns. Such alternate patterns would require definitions of careers and families different from the traditional continuous stage models. Family sociologists have developed a variety of stage models to

TABLE 6.1
Work-Family Interdependencies

			Family Role			
	Female			*Male*		
Marital	*Parental*	*Household*		*Marital*	*Parental*	*Household*
Work Role						
Female						
Male						

identify the major transition points in the life course. Duvall's (1977) eight-stage paradigm, which is based largely on children's ages and parental responsibilities in a long-standing marital relationship, is probably the most extensively used. This traditional perspective has required recent expansion in recognition of new patterns, for example, out-of-wedlock births, delayed marriages, separations, divorces, and remarriage (Glick, 1984; Norton, 1983; Murphy & Staples, 1979).

In parallel fashion, work careers have been defined in various ways. Bailyn and Schein (1976) identify six stages that challenge a person's entry into, full participation in, and exit from a series of related jobs. Again, these traditional notions of one linear career progression must be revised to consider factors such as interruptions and career changes.

A survey conducted on the West Coast (Best, 1978) suggests a strong desire for alternative life scheduling patterns that differ from the currently prevalent "linear life plan," that is, from school to work to retirement. Women, and married men with working wives, as well as single men, favored plans to which work and nonwork periods are more intertwined. Flexibility was seen as especially desirable by respondents who believed in sex role flexibility in terms of job holding and housekeeping. By the year 2000, Best (1981) suggests that a work-life cycle might resemble the following:

Single and nonoffspring years	Long work weeks (45-50 hours) with annual vacation of 8-14 weeks and some sabbaticals
Early child-rearing years	Shorter work weeks (25-40 hours) with 2-4 week vacations
Late and postchild years	Moderate work weeks (40-45 hours) with long annual vacations (5-8 weeks) and extended sabbaticals
Old age	Short work weeks (25-40 hours) with long vacations and sabbaticals

Thus it would be instructive to examine in closer detail special junctures and time periods along the career line. One such transition point, at this time experienced mostly by women, is the decision to reenter the labor force after a period of interruption. Another transition point would be the decision to leave an existing work situation to accommodate family needs, whether this be for a temporary recess from formal employment or a shift to a very different kind of employment. Information on the motivations behind career interruptions or changes may be useful to organizational efforts to keep valued employees. Given the high cost of breaking in and training new employees, it is to the organization's advantage to be able to design mechanisms to meet some of the needs that motivate interrupting employment in the organization.

In general, one might expect the pattern of interrupted work patterns to rise with the increase of dual-worker and dual-career couples. With the burden of producing income taken on by both husband and wife, there is increased freedom for men to develop alternate uses of time, to take a break from formal employment, or to take time to change to a more attractive field of endeavor. Breaks in labor force attachment (without a necessary break in career attachment) may be necessary at certain points in time if desirable opportunities are not available simultaneously for both partners. Thus far, most of the interruptions and accommodations have affected wives rather than husbands in dual-career couples, but this too may change with increases in egalitarian values for couples.

Research should look into the feasibility of alternative policies around planned interruptions. For example, can seniority policies be designed so that employees can pick up where they left off, if the interruption does not exceed a certain length of time? Can organizational policies be designed to enable the individual and the organization to maintain contact, if desired by either party, so that skills are maintained and reentry difficulties are minimized? This is presently done informally, but institutionalized procedures may help maintain women and dual-career men in the work force.

The possibility of interruption in one's formal connections to the labor force necessitates new definitions of career commitment and labor force attachment. Traditional measures of work commitment should incorporate the notion of voluntary interruptions of formal employment without a necessary interruption of career commitment. The assumption of a continuous involvement in a line of work for which one received formal training early on is already outdated, given the realities of fast-changing technology. It becomes even more outdated when one considers seriously the changes implied by having two income producers in the family, particularly if the income gap between the partners becomes narrower with more equity in the work place.

Special Populations

In previous work (Nieva & Gutek, 1981; Gutek, Nakamura, & Nieva, 1980) we suggested that in-depth understanding of the work-family interface will only come about by dealing with specific work situations (e.g., professional versus blue-collar workers) and specific family situations (e.g., single parents, dual-career couples).

Family-work issues have received some attention in recent research on dual-career couples. For example, Epstein (1971) looked at the division of labor at work and at home among lawyer couples; Poloma (1972) and Garland (1972) examined role conflicts and resolutions for both husbands and wives in dual-career couples; and Bryson et al. (1976) have examined the professional productivity of dual-career couples.

However, many issues remain untouched. For example, without a traditional "nurturer," how do dual-career couples handle simultaneous job pressures or demands? How does one define the "best solution" in situations of conflict—in terms of an "average good," "least harm," or some other definition? What support mechanisms can they develop to substitute for the lack of a full-time nurturer and child caretaker? How do job demands of one affect the job performance of the other partner? Are there differences in work or family processes depending on the couple's stage in the family life cycle and in the career stage of each person?

From an institutional point of view, it also becomes increasingly important to consider the needs of dual-career couples and to consider optimal institutional responses to their needs. Work organizations need basic information to guide their actions. How do dual-career couples differ from others in their responses to institutional demands, particularly demands for mobility and travel? What kinds of benefits would be appropriate to these couples? As the dual-career pattern becomes more prevalent, particularly in certain professions, work institutions may be faced with new concerns. Is it a good strategy to employ both partners, or under what condition would such an arrangement be advantageous? Do innovations such as "shared jobs" for couples benefit company interests? Companies may also be faced with new dilemmas. How does one reconcile, for example, the need to be responsive to dual-career "packages" in which employment for both husband and wife is desired with requirements for open job advertising and selection purely on qualifications?

A second group of interest is single parents, most (but not all) of whom are women. Some research is starting to accumulate on this ever-increasing segment of the population (Campbell, Converse, & Rodgers, 1978; Ross & Sawhill, 1975; Brandwein, Brown, & Fox, 1974). Women who are single parents are underprivileged in every sense of the

word; they are overburdened with responsibilities, have little security and scarce resources; only one-third feel confident that they can meet their expenses (Campbell et al., 1978). At least half of women heads of families had median incomes below the poverty level.

It is obvious that the family-work problems that single parents face are very different from those confronted by dual-career couples. Problems of single parents are often economic (e.g., inadequate incomes to provide for the family, see Corcoran & Duncan, 1979) and psychological (e.g., inadequate social support to handle all the problems of work and parent roles, see Giele, 1978). What support systems are available to them and what coping mechanisms can they develop? Single parents do not prepare for their roles in the way dual-career couples do because most people do not aspire to become single parents. Often acquiring the status by unforeseen circumstances, single parents tend to be ill-prepared to assume the roles of solo parent and solo worker. Does their lack of preparedness and economic insecurity make them more vulnerable to exploitation or harassment at work?

The dual-career and single-parent situations are only two of the possible population segments that should be given separate scrutiny in thinking about work-family issues. Much of the existing literature in this area focuses on middle-class or professional populations, and hardly any research has focused on racial groups other than whites. Although there are commonalities across various types of individuals in terms of the ways that the work and family worlds intersect, the situations that different groups face can vary substantially. Thus examination of these differences is needed to comprehend the different links between the increasingly overlapping spheres of work and family.

NOTE

1. "Family" in this chapter is limited to spouse and children and does not include family of origin (i.e., parents).

REFERENCES

Aldous, J. (1969). Occupational characteristics and males role performance in the family. *Journal of Marriage and the Family, 31,* 707-712.

Aldous, J., Osmond, M., & Hicks (1979). Men's work and men's families. In W. Burr, R. Hill, T. Reiss, & F. I. Nye (Eds.), *Contemporary theories about the family.* New York: Free Press.

Angell, R. (1936). *The family encounters the depression.* New York: Scribners.

Angrist, S. S., & Almquist, E. M. (1975). *Careers and contingencies.* New York: Dunellen.

Arkin, W., & Dubrofsky, L. (1979). Job sharing couples. In K. W. Feinstein (Ed.), *Working women and families.* Beverly Hills, CA: Sage.

Bailyn, L., & Schein, E. H. (1976). Life/career conditions as indicators of quality of employment. In A. D. Biderman & T. F. Drury (Eds.), *Measuring work quality for social reporting*. Beverly Hills, CA: Sage.

Bales, R. F., & Slater, P. (1955). Role differentiation in decision-making groups. In T. Parsons & R. F. Bales (Eds.), *Family socialization and interaction process*. New York: Free Press.

Barnett, R. C., Baruch, G. K., & Rivers, C. (1982). *Lifespring: New patterns of love and work for today's women*. New York: McGraw-Hill.

Barrett, N. S. (1979). Women in the job market: Occupations, earnings and career opportunities. In R. E. Smith (Ed.), *The subtle revolution*. Washington, DC: The Urban Institute.

Berk, S. F. (1976). *The division of household labor: Patterns and determinants*. Unpublished doctoral dissertation, Northwestern University.

Berk, R. A., & Berk, S. F. (1978). A simultaneous equation model for the division of household labor. *Sociological Methods and Research, 6*, 431-468.

Berk, R. A., & Berk, S. F. (1979). *Labor and leisure at home: Content and organization of the household day*. Beverly Hills, CA: Sage.

Bernard, J. (1971). Changing lifestyles: One role, two roles, shared roles. *Issues in Industrial Society, 2*, 21-28.

Bernard, J. (1972). *The future of marriage*. New York: World.

Best, F. (1978). Preferences on worklife scheduling and work-leisure tradeoffs. *Monthly Labor Review, 101*(6), 31-37.

Best, F. (1981). Changing sex roles and worklife flexibility. *Psychology of Women Quarterly, 6*, 55-78.

Blood, R. O., Jr. (1965). Long-range causes and consequences of the employment of married women. *Journal of Marriage and the Family, 27*(1), 43-47.

Blood, R. O., & Wolfe, D. M. (1960). *Husbands and wives: The dynamics of married living*. Glencoe, IL: The Free Press.

Bohen, H. H., & Viveros-Long, A. (1981). *Balancing jobs and family life: Do flexible work schedules help?* Philadelphia: Temple University Press.

Booth, A. (1976). A wife's employment and husband's stress: A replication and refutation. *Journal of Marriage and the Family, 39*, 645-650.

Booth, A. (1979). Does wives' employment cause stress for husbands? *Family Co-ordinator, 4*, 445-449.

Boynton, K. R., & Pearce, W. B. (1978). Personal transactions and interpersonal communication: A study of Navy wives. In E. J. Hunter & D. S. Nice (Eds.), *Military families: Adaptation to change*. New York: Praeger.

Braginski, D. D., & Braginski, B. M. (1975). Surplus people: Their lost faith and self. *Psychology Today, 9*, 69-72.

Brandewein, R. A., Brown, C. A., & Fox, E. M. (1974). Women and children last: The social situation of divorced women and their families. *Journal of Marriage and the Family, 36*, 498-515.

Brett, J. (1982). Job transfer and well-being. *Journal of Applied Psychology, 67*, 450-463.

Bryson, J. B., & Bryson, R. B. (Eds.). (1978). Dual career couples. *Special Issue of Psychology of Women Quarterly, 3*, 5-120.

Bryson, J. B., & Bryson, R. B. (1980). Salary and job performance differences in dual career couples. In F. Rockwell (Ed.), *Dual career couples*. Beverly Hills, CA: Sage.

Bryson, R. B., Bryson, J. B., Licht, M. H., & Licht, B. G. (1976). The professional pair: Husband and wife psychologists. *American Psychologist, 31*, 10-16.

Bumpess, L., & Westoff, C. F. (1970). *The later years of childbearing*. Princeton, NJ: Princeton University Press.

Burke, R. J., & Weir, T. J. (1977). Marital helping relationships: The mediators between stress and well being. *Journal of Psychology, 95*, 121-130.

Butler, M., & Paisley, W. (1977). Status of professional couples in psychology. *Psychology of Women Quarterly, 1*, 307-318.

Butler, M., & Paisley, W. (1980). Coordinated-career couples: Convergence and divergence. In F. P. Rockwell (Ed.), *Dual career couples.* Beverly Hills, CA: Sage.

Campbell, A., Converse, P. E., & Rodgers, W. L. (1978). *The quality of American life.* New York: Russell Sage.

Cavan, R. (1959). Unemployment: Crisis of the common man. *Marriage and Family Living, 21*, 139-146.

Cochran, M. M., & Bronfenbrener, N. (1979). Child rearing, parenthood, and the world of work. In C. Kerr & J. Rosow (Eds.), *Work in America: The decade ahead.* New York: Van Nostrand Reinhold.

Cooper, S. (1963). Career patterns of women. *Vocational Rehabilitation and Education Quarterly, 13-14*, 21-28.

Corcoran, M. (1978). Work experience, work interruption and wages. In G. J. Duncan & J. N. Morgan (Eds.), *Five thousand American families: Patterns of economic progress.* Ann Arbor, MI: University Michigan.

Corcoran, M., & Duncan, G. J. (1979). Work history, labor force attachment and earnings: Differences between races and sexes. *Journal of Human Resources, 14*, 3-20.

Croan, G., Katz, R., Fischer, N., & Smith-Osborne, A. (1980). *Roadmap for navy family research.* Final Report submitted to the Office of Naval Research (Contract No. N00014-79-C-0929). Columbia, MD: Westinghouse Public Applied Systems Division.

Crosby, F. (1984). Job satisfaction and domestic life. In M. D. Lee & R. Kanungo (Eds.), *Management of work and personal life.* New York: Praeger.

Decker, K. B. (1978). Coping with sea duty: Problems encountered and resources utilized during periods of family separation. In E. J. Hunter & D. S. Nice (Eds.), *Military families: Adaptation to change.* New York: Praeger.

Dickinson, J. (1974). Labor supply of family members. In *Five thousand American families: Patterns of economic progress* (Vol. 1). Ann Arbor, MI: University of Michigan.

Dizard, J. (1968). *Social change in the family.* Chicago: University of Chicago Press.

Duvall, E. M. (1977). *Family development.* Philadelphia: J. P. Lippincott.

Eisenbert P., & Lazarsfield, P. F. (1938). The psychological effects of unemployment. *Psychological Bulletin, 35*, 358-391.

Employee Relocation Council. (1981). *Relocation trends survey: 1981.* Washington, DC: Employee Relocation Council.

Epstein, C. F. (1971). Law partners and marital partners: Strains and solutions in the dual career family enterprise. *Human Relations, 24*, 549-564.

Farmer, H. S., & Bohn, M. J., Jr. (1970). Home-career conflict reduction and the level of career interest in women. *Journal of Counseling, 17*(3), 228-230.

Farris, A. (1978). Community. In R. Rapaport & R. N. Rapaport (Eds.), *Working Couples.* New York: Harper & Row.

Finegan, T. A. (1975). Participation of married women in the labor force. In C. B. Lloyd (Ed.), *Sex, discrimination and the division of labor.* New York: Columbia University Press.

Garland, T. N. (1972). The better half? The male in the dual profession family. In C. Safilios-Rothschild (Ed.), *Toward a sociology of women.* Lexington, MA: Xerox College Publishing.

Gartner, A., & Riessman, F. (1974). Is there a new work ethic? *American Journal of Orthopsychiatry, 44*, 563-619.

General Mills Survey. (1981). *Families at work: The General Mills American family report*. Minneapolis, MN.

Gertsl, J. E. (1961). Leisure, taste and occupational milieu. *Social Problems, 9*, 56-68.

Giele, J. (1978). *Women and the future*. New York: The Free Press.

Glick, P. C. (1984). Marriage, divorce and living arrangements. *Journal of Family Issues, 5*, 7-26.

Goode, W. J. (1956). *After divorce*. New York: The Free Press.

Grace, G., Holoter, H., Provenzano, R., Copes, J., & Steiner, M. (1976). *Navy career counseling research: Phase III summary and recommendations*. Systems Development Corporation. (TM-5031/008/00).

Grossman, A. S. (1975). Women in the labor years: The early years. *Monthly Labor Review, 98*, 3-9.

Gutek, B. A., Nakamura, C. Y., & Nieva, V. F. (1980). The interdependence of work and family roles. *Journal of Occupational Behavior, 2*, 1-16.

Gutek, B. A., & Stevens, D. A. (1979). Effect of sex of subject, sex of stimulus cue and androgyny level of evaluation in work situations which evoke sex role stereotypes. *Journal of Vocational Behavior, 14*, 23-32.

Hageman, M.J.C. (1978). Occupational stress and marital relationships. *Journal of Police Science and Administration, 6*, 402-412.

Hall, D. T. (1972). A model of coping with role conflict: The role behavior of college education women. *Administrative Science Quarterly, 17*, 471-486.

Hennig, M., & Jardin, A. (1977). *The managerial woman*. New York: Doubleday.

Herman, J. B., & Gyllstrom, K. K. (1977). Working men and women: Inter- and intra-role conflict. *Psychology of Women Quarterly*, 1, 319-333.

Hofferth, S. L., & Moore, K. A. (1979). Women's employment and marriage. In R. E. Smith (Ed.), *The subtle revolution*. Washington, DC: The Urban Institute.

Hoffman, L. W. (1974). The effects of maternal employment on the child: A review of the research. *Developmental Psychology, 10*(2), 204-228.

Hoffman, L. W. (1979). Maternal employment: 1979. *American Psychologist, 34*, 859-865.

Hoffman, L. W., & Nye, F. I. (1974). *Working mothers*. San Francisco: Jossey-Bass.

Holmstrom, L. (1971). Career patterns of married couples. In A. Theodore (Ed.), *The professional woman*. Cambridge, MA: Schenkman.

Hunter, E. J. (Ed.). (1977). *Prolonged separation: The prisoner of war and his family*. San Diego, CA: Center for POW Studies, Naval Health Research Center.

Inderlied, S. (1979). Goal setting and career development of women. In B. A. Gutek (Ed.), *New directions for education, work and career: Enhancing women's career development*. San Francisco: Jossey-Bass.

Isay, R. (1968). The submariners' wives syndrome. *Psychiatric Quarterly, 42*, 647-652.

Johnson, L. B. (1984). *Police families: Family-work stress, coping and support*. Paper presented at the annual conference of the National Council of Family Relations, San Francisco, CA.

Kanter, R. M. (1977a). *Men and women of the corporation*. New York: Basic Books.

Kanter, R. M. (1977b). *Work and family in the United States: A clinical review and agenda for research*. New York: Russell Sage.

Kasl, S. V., & Cobb, S. (1970). Blood pressure changes in men undergoing job loss. A preliminary report. *Psychosomatic Medicine, 32*, 1938.

Keith, P. M., & Shafer, R. B. (1980). Role strain and depression in two job families. *Family Relations, 29*, 483-488.

Komarovsky, M. (1940). *The unemployed man and his family*. New York: Dryden.

Lein, L., et al. (1974). *Work and family life*. Final Report to the National Institute of Education, 1974. Cambridge, MA: Center for the Study of Public Policy.

Levinson, H. (1964). *Emotional problems in the world of work.* New York: Harper & Row.

Little, C. B. (1976). Technical-professional unemployed middle class adaptibility to personal crisis. *Sociological Quarterly, 17,* 262-275.

Lopata, S., Barnewolt, D., & Norr, K. (1980). Spouse's contributions to each other's roles. In F. P. Rockwell (Ed.), *Dual career couples.* Beverly Hills, CA: Sage.

Mahoney, T. A. (1961). Factors determining labor force participation of married women. *Industrial and Labor Relations Review, 14,* 563-577.

Maklan, D. M. (1977). *The four-day work week, blue-collar adjustment to a non-conventional arrangement of work and leisure time.* New York: Praeger.

Marks, S. (1978). Multiple roles and role strain. *American Sociological Review, 42,* 921-936.

McCubbin, H. I., Dahl, B., & Hunter, E. J. (1975). *Research on the military family: An assessment* (NTIS AD-A016 057). San Diego: Naval Health Research Center.

McCubbin, H. I., Dahl, B. B., Lester, G. R., & Ross, B. A. (1975). The returned prisoner of war: Factors in family reintegration. *Journal of Marriage and the Family, 37,* 471-478.

Meissner, M., Humphreys, E. W., Meis, S. M., & Scheu, W. J. (1975). No exit for wives: Sexual division of labor and the cumulation of household demands. *Canadian Review of Sociology & Anthropology, 12,* 424-439.

Molm, L. D. (1978). Sex role attitudes and the employment of married women: The direction of causality. *The Sociological Quarterly, 19,* 522-533.

Montalvo, F. F. (1976). Family separation in the army: A study of the problems encountered and the correlating resources used by career army families undergoing military separation. In E. J. Hunter, H. I. McCubbin, & B. Dahl (Eds.), *Families in the military system.* Beverly Hills, CA: Sage.

Moore, K. A., Hofferth, S. L., Caldwell, S. B., & Waite, L. J. (1980). *Teenage motherhood: Social and economic consequences.* Washington, DC: The Urban Institute.

Mortimer, J. T. (1980). Occupation-family linkages as perceived by men in the early stages of professional and managerial careers. In *Research in the interweave of social roles: Women and men* (Vol. 1, pp. 99-117). Greenwich, CT: JAI Press.

Mott, P., et al. (1965). *Shift work: The social, psychological and physical consequences.* Ann Arbor, MI: University of Michigan Press.

Murphy, P. E., & Staples, W. A. (1979). A modernized family life cycle. *The Journal of Consumer Research, 6,* 12-22.

Nieva, V. F. (1979). *The family's impact on job-related attitudes of women and men: Report of work in progress.* Paper presented at the annual convention of the American Psychological Association, New York.

Nieva, V. F., & Gutek, B. A. (1981). *Women and work: A psychological perspective.* New York: Praeger.

Nieva, V. F., Hernandez, E., Waksberg, M., & Goodstadt, B. (1982). *NCO retention.* Final Report to the U.S. Army Research Institute (Contract No. MDA 903-81-C-0227). Rockville, MD: Westat, Inc.

Norton, A. J. (1983). Family life cycle: 1980. *Journal of Marriage and the Family, 45,* 267-275.

Nye, F. I., & Hoffman, L. W. (1963). *The employed mother in America.* Chicago: Rand McNally.

Orthner, D. K. (1980). Families in blue: A study of married and single parent families in the air force. Washington, DC: Department of the Air Force.

Papanek, H. (1973). Men, women and work: Reflections on the two person career. *American Journal of Sociology, 78,* 852-870.

Parsons, T., & Bales, R. F. (1955). *Family socialization and interaction process.* New York: Free Press.

Pearlman, C. A. (1970). Separation reactions of married women. *American Journal of Psychiatry, 126,* 946-950.

Peck, J. (1978). The work-family role system. *Social Problems, 24,* 417-442.

Pingree, S., Butler, M., Paisley, W., & Hawkins, R. (1978). Anti-nepotism's ghost: Attitudes of administration toward hiring professional couples. In J. B. Bryson & R. Bryson (Eds.), *Dual career couples* (pp. 22-29). New York: Human Sciences Press.

Piotrowski, C. (1981). *Work and the family system.* New York: The Free Press.

Pleck, J. (1977). The work-family role system. *Social Problems, 24,* 417-427.

Pleck, J. (1979). Married men: Work & Family In *Families today: A research sampler on families and Children* (Vol. 1). Washington, DC: Government Printing Office.

Pleck, J., & Rustad, M. (1980). *Husbands' and wives' time in family work and unpaid work in the 1975-1976 study of time use.* Wellsley, MA: Wellesley College Center for Research on Women.

Pleck, J., Staines, G., & Long, L. (1978). *Work and family life: First reports on work-family interferences and workers' formal child care arrangements from the 1977 quality of employment survey.* Ann Arbor, MI: University of Michigan.

Poloma, M. M. (1972). Role conflict and the married professional woman. In C. Safilios-Rothschild (Ed.), *Toward a sociology of women.* Lexington, MA: Xerox College Publishing.

Rapoport, R., & Rapoport, R. N. (1969). The dual career family: A variant pattern and social change. *Human Relations, 22*(1), 3-30.

Rebeca, M. (1978). *Voluntary childlessness as a conflict reducing mechanism.* Paper presented at the Association of Women in Psychology Annual Meeting, Pittsburgh, PA.

Renshaw, J. R. (1976). An exploration of the dynamics of the overlapping worlds of work and family. *Family Process, 15,* 143-165.

Ridley, C. (1973). Exploring the impact of work satisfaction and involvement on marital interaction when both partners are employed. *Journal of Marriage and the Family, 35,* 229-237.

Robinson, J. P. (1977). *How Americans use time: A social psychological analysis of everyday behavior.* New York: Praeger.

Ross, H. L., & Sawhill, I. V. (1975). *Time of transition.* Washington, DC: The Urban Institute.

Rossi, A. (1965). Women in Science: Why so few? *Science, 148,* 1196-1202.

Safilios-Rothschild, C. (1970). The influence of the wife's degree of work commitment upon some aspects of family organization and dynamics. *Journal of Marriage and the Family, 32,* 681-691.

Safilios-Rothschild, C., & Dijkers, M. (1978). Handling unconventional asymmetries. In R. Rapoport & R. Rapoport (Eds.), *Working couples.* New York: Harper & Row.

Sandell, S. H., & Shapiro, D. (1976). *The theory of human capital and the earnings of women: A reexamination of the evidence.* Columbus, OH: Ohio State University, Center for Human Resources Research.

Sawhill, I. V. (1973). The economics of discrimination against women: Some new findings. *Journal of Human Resources, 8,* 383-395.

Scanzoni, J. (1970). *Opportunity and the family: A study of the conjugal family in relation to the economic opportunity structure.* New York: The Free Press.

Scanzoni, J. (1978). *Sex roles, women's work and marital conflicts: A study of family change.* Lexington, MA: D. C. Heath.

Schein, E. H. (1978). *Career dynamics: Matching individual and organizational needs.* Reading, MA: Addison-Wesley.

Seidenberg, R. (1973). *Corporation wives: Corporate casualties*. New York: Amalom.

Shea, R. J., et al. (1970). *Dual careers: A longitudinal study of labor market experience of women* (Vol. 1). Columbus: Ohio State University, Columbus Center for Human Resources Research.

Smith, R. E. (1979). *Women in the labor force in 1990*. An Urban Institute Working Paper, UI-1156-1. Washington, DC: The Urban Institute.

Staines, G. L., & Pleck, J. H. (1983). *The impact of work schedule on family life*. Ann Arbor, MI: The Institute for Social Research.

Stoloff, P., Lockman, R., Allbritton, A., & McKinley, H. (1972). *An analysis of first term reenlistment intentions*. Center for Naval Analysis.

Stolzenberg, R. M., & Waite, L. J. (1977). Fertility expectations and employment plans. *American Sociological Review, 42*, 769-783.

Stumpf, S. (1978). Military family attitudes towards housing, benefits, and the quality of military life. In E. Hunter & D. Nice (Eds.), *Military families: Adaption to change*. New York: Praeger.

Super, D. (1957). *The psychology of careers*. New York: Harper & Row.

Szoc, R. (1982). *Family factors critical to the retention of naval personnel*. Final Report to the Navy Personnel Research and Development Center. Columbia, MD: Westinghouse Public Applied Systems.

Thomas, L. E., McCabe, E., & Berry, J. (1980). Unemployment and family stress: A reassessment. *Family Relations, 29*, 514-524.

Thomas, P. J., & Durning, K. P. (1980, January). Role affiliation and attitudes of navy wives. Technical Report 80-10. San Diego: Navy Personnel Research and Development Center.

U.S. Dept. of Labor, Bureau of Labor Statistics. (1980, October). *Perspectives on working women: A databook*. Washington, DC: Government Printing Office.

Vanek, J. (1974, November). Time spent in housework. *Scientific American*, pp. 116-120.

Waite, L. J. (1976). Working wives: 1940-1960. *American Sociological Review, 41*, 65-80.

Walker, K. E. (1970). Time spent by husbands in household work. *Family Economics Review, 4*, 8-11.

Whyte, W. (1956). *The organization man*. New York: Simon & Schuster.

Wallston, B. S., Foster, M. A., & Berger, M. (1978). I will follow him: Myth, reality or forced choice? Job seeking experiences of dual career couples. *Psychology of Women Quarterly, 3*, 9-21.

Weil, M. W. (1961). An analysis of the factors influencing married women's actual or planned work participation. *American Sociological Review, 26*, 91-96.

Weingarten, K., & Daniels, P. (1978, August). *Family/career transitions in women's lives: Report of research in progress*. Annual Conference of the American Psychological Association, Toronto, Canada.

Winnett, R., Neale, M., & William, K. (1982). The effect of flexible work schedule on urban families with young children: Quasi-experimental ecological studies. *American Journal of Community Psychology, 80*, 49-64.

Winter, D., Stewart, A., & McClelland, D. (1977). Husband's motivations and wife's career level. *Journal of Personality and Social Psychology, 35*, 159-166.

Woelfel, J. C., & Savell, J. M. (1978). Marital satisfaction, job satisfaction and retention in the army. In E. Hunter & D. Nice (Eds.), *Military families: Adaptation to change*. New York: Praeger.

Yankelovich, D. (1979). Work, values and the "New Breed." In C. Kerr & J. Rosow (Eds.), *Work in America: The decade ahead*. New York: Van Nostrand Reinhold.

Yogev, S. (1981). Do professional women have egotistical marital relationships? *Journal of Marriage and the Family*, 865-871.

Young, C. M. (1978). Work sequences of women during the family life cycle. *Journal of Marriage and the Family, 40*(2), 401-411.

7

Sex Segregation in American Higher Education

JERRY A. JACOBS

This chapter examines trends in sex segregation among fields of study for recipients of associate, bachelor's, master's, professional, and doctoral degrees between 1948 and 1980. Two indices of segregation are employed: the index of dissimilarity (Duncan's D) and the probability of intergroup contact (Lieberson's P^*). The former is viewed as an aggregate measure of segregation, whereas a version of the latter (the intragroup probability of contact) is viewed as an indicator of the extent of potential support networks. The analysis focuses on the timing and direction of change, as well as the extent of sex segregation at different levels of higher education. As expected, the data indicate that sex segregation by specialty declined among associate, bachelor's, and master's and professional degree recipients. Throughout the period examined, sex segregation was highest among associate degree recipients and lowest among doctoral degrees. Among the surprising findings are the stability of sex segregation among doctoral degree recipients and the asymmetry in the experience of change by men and women. Men at all levels of higher education were more likely to find women majoring in the same subjects, whereas women experienced a much smaller increase in contact with men. Explanations for these trends include the important effect of occupational segregation on educational choices, the influence of the women's movement and a variety of specific factors affecting each level of higher education differently.

Higher education in America has undergone striking changes in the post-World War II period. Overall enrollments, the proportion of degrees granted in junior colleges, and the proportion of students enrolled in coeducational settings all have soared, transforming the college and university system.

The 1964 Civil Rights Act, the burgeoning Women's Movement, and the 1972 Title IX provisions of the Higher Education Acts all pointed to increased opportunities for women in higher education. By one measure of opportunity, enrollment, women have made dramatic strides in recent years. Women now receive more than one-half of all associate

AUTHOR'S NOTE: The comments of Paul Allison, Fred Block, Michelle Fine, Doug Massey, Sam Preston, and the editors of this volume are greatly appreciated.

degrees (two-year degrees typically granted by community colleges), one-half of all bachelor's degrees, one-third of doctoral degrees, and one-quarter of professional degrees. In 1950, women received only one-third of bachelor's degrees and less than one of ten doctoral and professional degrees. Female enrollments have grown at all levels of higher education.

Another indicator of opportunities is the fields of study women pursue. Men and women have always been concentrated in separate majors. Business, chemistry, and physics have traditionally been male bastions, while foreign languages, fine arts, and psychology have enrolled disproportionately high numbers of women. Although all specialties are formally open to men and women, informal social processes work to channel men and women into separate specializations (Hearn & Olzak, 1981). The educational arena is a particularly interesting setting in which to study patterns of segregation by sex because of the substantial role of informal social controls in maintaining a highly stable structure of segregation.

Table 7.1 presents data collected by the National Center for Educational Statistics on the size and sex composition of fields of study for bachelor's, master's, professional, and Ph.D. degree recipients. Bachelor's degree fields range in sex composition from home economics and library science, which graduated over 95 percent women in 1980, to engineering and military science, which graduated 9.3 and 3.9 percent women, respectively. At the master's and professional degree level, women comprise over 70 percent of teachers but only 13 percent of dentists. Ph.D. programs enroll fewer women, but there is still a great range in concentration: 57.4 percent of foreign language Ph.D.s are women compared to 14.4 in the physical sciences.

This chapter will focus on trends in the specializations pursued by women and men throughout higher education. How have the changes in higher education since the 1940s affected the fields men and women pursue? This question parallels in the educational area a line of studies that has examined changes in occupational segregation by sex in the U.S. labor force (England, 1981; Beller, 1984a; Jacobs, 1983). This research has documented the remarkable resilience of sex segregation over the course of the century. This chapter will investigate whether the educational realm is as resistant to change as the occupational structure.

In addition to the central focus on change over time, this chapter will ask a number of subsidiary questions. First, how do different levels of higher education compare in the level of sex segregation they exhibit? Second, how have men and women experienced these changes? That is, have men and women experienced a great increase in the probability of sharing academic specializations with members of the opposite sex? In

TABLE 7.1
Degrees Received in 1980 by Field of Study for
Bachelor's, Master's, and Ph.D. Degrees

	Bachelors		Masters		Ph.D.	
	n	%f	n	%f	n	%f
Agriculture	22,802	29.6	3,976	22.5	991	11.3
Architecture	9,132	27.8	3,139	28.4	79	16.5
Biology	46,370	42.1	6,510	37.1	3,636	26.0
Business	186,683	33.6	55,148	22.3	796	14.4
Education	118,102	73.8	103,453	70.2	7,940	44.3
Engineering	68,893	9.3	16,243	7.0	2,507	3.8
Fine Arts	40,892	63.2	8,708	53.3	655	36.9
Foreign Languages	11,133	75.5	2,236	70.2	549	57.4
Health Professions	63,920	82.2	18,982	62.7	786	44.7
Home Economics	18,411	95.3	2,690	91.3	192	76.0
Law	683	45.5	37,464	29.6	40	10.0
Letters	69,249	56.4	11,591	57.8	2,068	40.6
Library Science	398	95.0	5,374	81.3	73	52.1
Mathematics	11,378	42.3	2,860	36.1	724	13.8
Military Science	251	3.9	46	0.0		
Physical Sciences	23,410	23.7	5,219	18.6	3,089	12.4
Psychology	41,962	63.3	7,806	56.8	2,768	42.1
Social Sciences	143,914	46.9	33,040	46.0	3,762	28.2
Theology	6,207	25.5	11,037	19.9	1,319	5.8
Interdisciplinary	45,627	45.3	8,599	33.2	641	22.6
Dentistry			5,258	13.3		
Medicine			14,902	23.4		
Optometry			1,085	15.7		
Osteopathy			1,011	15.7		
Podiatry			580	12.6		
Veterinary Medicine			1,235	32.8		

SOURCE: The National Center for Educational Statistics (1948-1980).

answering this question the multifaceted nature of segregation will be examined. Third, what accounts for the patterns of change that are found?

The field of study students pursue is an important aspect of their experience of higher education. A substantial proportion of undergraduate course work is directed to fulfilling requirements for the student's major; this has been true throughout the postwar period (Dressell & Delisle, 1969). The college major or professional specialization affects subsequent occupational and earnings possibilities as well as a range of experiences during matriculation (Angle & Wissman, 1981; Jacobs, in press). Consequently, a number of studies have focused on the differences in fields pursued by men and women in higher

education (Beller, 1984b; Lyson, 1981; Thomas, 1980; Lloyd & Niemi, 1979; Polachek, 1978). The present investigation broadens these efforts by considering a broader sweep of time; by comparing trends in sex segregation at different levels of higher education; and by using two complementary indicators of segregation.

DATA AND METHODS

The National Center for Educational Statistics publishes statistics on degrees received annually. These statistics are published in a series, *Earned Degrees Conferred in Higher Education*, and are also reprinted in the annual *Digest of Educational Statistics*. The data series is continuous from 1948 to 1980, the most recently published year. Associate degree data dates from 1966. The data is based on complete or virtually complete reports from all colleges and universities throughout the United States.

Two measures of segregation are employed. The standard measure of segregation, Duncan's index of dissimilarity (D), is supplemented with Lieberson's P*. D is interpreted as measuring the proportion of men or women who would have to change majors in order to produce an even distribution in all specialities (Duncan & Duncan, 1955). P* measures the probability of intergroup contact. In recent research on residential segregation, this statistic has been employed to provide new insights into the structure of segregation (Lieberson & Carter, 1982; Massey & Mullan, 1984). P* has two important properties that should be recognized: It depends on the relative size of different groups and it is asymmetric, that is, the probability of men's contact with women will differ from women's probability of contact with men. For example, if men comprise 80 percent of a group, and men and women are moderately segregated, men may have a 15 percent chance of contact with women in a given encounter, while women may have a 60 percent chance of contact with men. In the case of the analysis of two groups, the probability of intragroup contact and intergroup contact sum to 1. Consequently, in the above example, if men's possibility of contact with women is .15, their probability of contact with men in .85.

This statistic supplements the overall index of segregation by revealing the way a social situation is experienced by each group. Two different settings with equal levels of segregation (D) but different proportions of women will have different probabilities of contact, a feature of segregation revealed by P*. In the educational setting, the probability of intragroup contact may be viewed as providing the potential context for peer support networks. The degree to which women have other women for academic support may be important to

their chances for academic success (Alexander & Thoits, 1983). Likewise, the frequency of men's contact with women in academic settings may be an important factor influencing their views of women's capabilities (Kanter, 1977). The P* statistic taps this important dimension of segregation in a way that the index of dissimilarity does not.

Segregation is a double-edged sword. High segregation has the positive effect of increasing intragroup contact. This facilitates communication among group members and enhances the opportunities for networking, sharing information, and political mobilization. Yet segregation has negative consequences as well. Segregation results in the restriction of access to desirable opportunities. The utilization of two separate indices helps to shed light on these different aspects of segregation.

It should be noted that the P* statistics presented here refer to contact between men and women in classes, not in other settings. More specifically, the figures measure the likelihood of sharing the same major for men and women. One must also note that these figures represent national averages. The sex composition in a given school may differ substantially from these national averages, with single-sex colleges being the extreme case. In that instance, the statistic refers to the likelihood that a random individual specializing in one's field of study is a man or a woman, not the direct probability of contact with a classmate at one's college or university.

COMPARABLE MEASURES OVER TIME

A central methodological issue is the selection of appropriate categories across which segregation can be measured. All indices of segregation are sensitive to the categories employed. The number of educational specialties reported in the NCES data often changes. For example, in 1948 there were 67 specialties for bachelors degree recipients; in 1980 over 300 categories were listed. This poses a problem for analysis of trends over time because one cannot tell how much change is due to the reclassification of specialties. The approach to handling this problem here was the use of major categories as the units of analysis. For bachelor's, master's, and doctoral degree programs, 20 categories were essentially constant throughout the period considered. These categories, along with the professional categories employed, are listed in Table 7.1.

Two potential problems with relying on major categories were considered. The first is that the degree of segregation may be severely underestimated as a result of using these major categories. Within broad

specialties, women and men are not evenly distributed. Consequently, the higher the level of aggregation, the smaller the proportion of actual segregation captured by one's measure. The second problem is that gross units of analysis may misrepresent trends over time. The major categories may capture an increasingly small proportion of overall segregation as specializations proliferate. England has emphasized this point in studies of trends in occupational segregation by sex (1981). The reliance on standardized categories may be deceptive, in that the underlying phenomenon may become increasingly remote from the measures employed.

Given these potential difficulties, it is important to examine whether major fields constitute an appropriate unit of analysis. Table 7.2 presents indices of segregation (D) for the major categories and for the most detailed available categories for 1952, 1960, 1970, and 1980 for bachelor's, master's, and doctoral degrees.[1] Three striking results in Table 7.2 are quite reassuring. The major categories consistently capture between 80 and 90 percent of the index of dissimilarity revealed by the detailed categories. The number of categories generally has even smaller effects on P*.

Second, the major categories appear as robust in 1980 as in 1952. There is no apparent secular decline in the proportion of segregation captured by the major categories. In spite of increasing specialization, the major categories employed here are reliable indicators both of the level and of the trend in specialization of educational majors. Third, major categories capture comparable proportions of total segregation for each level of higher education examined. Thus comparisons between bachelor's, master's, and doctoral degrees will not be biased as a result of the reliance on major categories.

In addition to paving the way for the subsequent analysis, these results offer a provocative substantive interpretation: students chose major fields first and then detailed specializations within these fields. That may be why the dramatic proliferation of specializations within certain fields has not increased the overall level of segregation. Sex-role socialization channels men and women into different majors; specialization within these fields is a subsequent process with a constant incremental effect on overall sex segregation. Table 7.2 thus not only provides a convenient empirical finding but is also suggestive of the process by which specialties become segregated by sex.

A final issue regarding categories is the problematic nature of professional degrees. Before 1961, professional degrees such as law, medicine, and theology were grouped with bachelor's degree statistics. Professional degree recipients were removed in calculating segregation statistics for bachelor's degrees during this period.[2]

TABLE 7.2

Comparison of Indices of Segregation for Major and Detailed
Categories for Bachelor's, Master's, and Ph.D. Degrees

Year	Date	D	P*WW	P*WM	P*MM	P*MW	Major D/ Detailed D
Bachelor's Degrees							
Major	1952	46.6	.49	.51	.75	.25	85.1
Detailed		53.6	.49	.51	.76	.24	
Major	1960	51.4	.56	.44	.76	.24	81.7
Detailed		62.9	.67	.33	.82	.18	
Major	1970	47.1	.60	.40	.70	.30	86.4
Detailed		54.5	.66	.34	.74	.26	
Major	1980	35.2	.52	.48	.60	.40	84.8
Detailed		41.5	.62	.38	.63	.37	
Master's Degrees							
Major	1952	31.5	.40	.60	.73	.27	79.1
Detailed		39.8	.44	.56	.74	.26	
Major	1960	39.5	.43	.57	.74	.26	88.2
Detailed		44.8	.51	.49	.77	.23	
Major	1970	40.2	.47	.53	.69	.31	81.7
Detailed		49.2	.41	.59	.73	.27	
Major	1980	41.3	.40	.60	.61	.39	87.3
Detailed		47.3	.36	.64	.65	.35	
Ph.D. Degrees							
Major	1952	32.1	.14	.86	.91	.09	86.8
Detailed		37.0	.16	.84	.91	.09	
Major	1960	34.7	.18	.82	.90	.10	81.2
Detailed		39.5	.21	.79	.91	.09	
Major	1970	32.4	.20	.80	.88	.12	87.8
Detailed		39.9	.23	.77	.88	.12	
Major	1980	32.2	.38	.62	.74	.26	88.5
Detailed		36.4	.40	.60	.75	.25	

SOURCE: The National Center for Education Statistics (1948-1980).

After 1961, data on professional degrees are published separately.
The problem is that the distinction between masters' and professional
degrees in published statistics is an arbitrary one. The professional
degrees in the NCES data are all male-dominated fields, including
medical specialties, law, and theology. Masters in business administra-
tion, as well as degrees in such female-dominated professions as
education and social work, are classified as masters' degrees, not as
professional degrees. This distinction, which I feel is artificial, results in

TABLE 7.3
Bachelor's Degree Segregation, 1948-1980

Year	Percentage Female	D	P*WW	P*WM	P*MM	P*MW
1948	24.0	45.2	.47	.53	.84	.16
1952	33.8	46.6	.51	.49	.75	.25
1956	38.3	52.7	.58	.42	.74	.26
1960	37.5	53.7	.55	.45	.75	.25
1964	42.9	52.7	.62	.38	.72	.28
1968	43.4	48.5	.60	.40	.70	.30
1972	43.6	45.7	.59	.41	.68	.32
1976	45.5	39.7	.57	.43	.64	.36
1980	49.0	35.2	.58	.42	.60	.40

SOURCE: The National Center for Education Statistics (1948-1980).

peculiar indices of segregation, particularly for professional degrees. The appropriate grouping for measures of segregation is a combination of master's and professional degrees.

RESULTS

The results section will be divided into two parts. A description of the patterns of change for each level of higher education will be presented, followed by a comparison of these trends.

Bachelor's Degrees

Table 7.3 presents data on bachelor's degrees from 1948 to 1980. In this and subsequent tables, the year, the percentage female, the index of segregation (D), and the probabilities of intra- and intergroup contact are presented. There are four different probabilities of contact, with P*WW indicating the probability of contact with women for women; P*WM, the probability of contact with men for women; P*MM, the probability of contact with men for men; and P*MW, the probability of contact with women for men. These figures represent national averages. They can be interpreted as indicating the probability that a random comajor is a man or a woman. Indices were calculated for each year; every fourth year is presented in the tables.

For bachelor's degrees, the index of segregation rose from 45 to 54 between 1948 and 1961, and then declined slowly and steadily from 1961 to 1980. The 1980 level of segregation was 35.2, indicating that over 35 percent of women would have had to change majors to be distributed in the same manner as men. To give an indication of how this figure

compares to others, the degree of occupational segregation by sex in 1981 in the U.S. labor force was over 60; the degree of occupational segregation between white and black men in 1981 was just over 35. Thus the degree of segregation between men and women in bachelor's degree programs was quite similar to that of the racial segregation of occupations but was much lower than the sex segregation of occupations.

The probability of intragroup contact for women (P*WW) increased from 47 in 1948 to 58 in 1980. This figure indicates that women bachelor's degree recipients on the whole have not found themselves an isolated minority. As a result of substantial enrollments and significant segregation, women bachelor's degree candidates on the average have had approximately an equal chance of having men and women classmates for much of the postwar period. Men, on the other hand, have historically been much less likely to come into contact with women as comajors. The probability of contact with women for men (P*MW) has grown from .16 in 1948 to .40 in 1980. This asymmetry reflects the fact that men have until recently exceeded women in enrollment and have been segregated from women in the majors they pursue. The probability figures in Table 7.3 exemplify the asymmetric nature of intergroup contact: Women, a sizable minority group in this case, have had roughly equal chances of having men and women as classmates, whereas men, the majority, were much less likely to encounter women in classes.

The trends in intergroup contact reflect trends in enrollments and segregation. Between 1948 and 1970, both men and women experienced increased chances of having women as classmates, as the increases in women's enrollments exerted the dominant influence on P*s. After 1970, however, women's chances of having women as classmates stabilized and then declined slightly, whereas men's probability of having women classmates increased sharply. In the 1970s women's enrollments continued to increase, but the decline in segregation between the sexes had the dominant effect. As women moved into more male-dominated fields, their probability of encountering male classmates increased and their probability of encountering female classmates declined.

Master's and Professional Degrees

As Table 7.4 indicates, master's and professional degree sex segregation has largely followed the pattern found for bachelor's degrees. From 1948 to 1960, the level of segregation in master's and professional degrees rose from the low 40s until the low 50s. The index of segregation fell below 50 in 1965, and continued to fall slowly through 1980, when it

TABLE 7.4
Professional and Master's Degree Segregation,
1948-1980

Year	Percentage Female	D	P*WW	P*WM	P*MM	P*MW
1948	23.3	48.0	.41	.59	.82	.18
1952	22.2	47.7	.38	.62	.82	.18
1956	24.8	52.4	.43	.57	.81	.19
1960	24.1	52.5	.42	.58	.81	.19
1964	26.0	50.3	.43	.57	.80	.20
1968	30.7	47.8	.48	.52	.77	.23
1972	35.5	49.5	.53	.47	.74	.26
1976	41.2	45.9	.55	.45	.69	.31
1980	44.7	42.9	.56	.44	.65	.35

SOURCE: The National Center for Education Statistics (1948-1980).

TABLE 7.5
Ph.D. Degree Segregation, 1948-1980

Year	Percentage Female	D	P*WW	P*WM	P*MM	P*MW
1948	12.0	34.3	.20	.80	.89	.11
1952	9.3	32.1	.14	.86	.91	.09
1956	9.9	30.2	.16	.84	.91	.09
1960	10.5	34.7	.18	.82	.90	.10
1964	10.6	34.8	.17	.83	.90	.10
1968	12.6	34.0	.19	.81	.88	.12
1970	13.3	32.4	.20	.80	.88	.12
1972	15.8	31.4	.22	.78	.85	.15
1976	22.8	30.5	.30	.70	.79	.21
1980	29.7	32.2	.38	.62	.73	.27

SOURCE: The National Center for Education Statistics (1948-1980).

reached 42.9. This level was higher than that of bachelor's degrees, with the gap widening during the 1970s.

The probability of intergroup contact reveals similarities with the bachelor's degree pattern. Trends in intragroup contact for female master's and professional degrees rose from just over 40 in 1948 to 56 in 1980. Men's probability of contact with women rose from .18 to .35 over this period.

Doctoral Degrees

Doctoral degrees exhibited remarkable stability in sex segregation over the period examined, as indicated in Table 7.5. The index of segregation hovered in the low 30s throughout the postwar period. In 1948, the index of dissimilarity was 34.3; in 1980 it remained at 32.2. At

no time did it rise above 37 or fall below 30, with most changes apparently reflecting annual variations rather than a secular trend. Although degrees received by women have risen from under 10 percent to over 30 percent of all Ph.D.s awarded in 1980, the degree to which men and women have remained segregated stayed quite constant throughout this period.

The probability of intergroup contact reveals an interesting pattern of isolation of female doctoral candidates. Female doctoral candidates have had relatively low chances of having female classmates until very recently, when women's enrollments skyrocketed. Females' probability of having a random classmate be female tended to be about 20 percent until 1972, when it began to steadily increase toward 40 percent. Male doctoral candidates have had little contact with their female counterparts, with the probability of a classmate being female at or below 10 percent until nearly 1970.

Associate Degrees

Data on associate degrees covering the period 1966 to 1980 are presented on Table 7.6. NCES data classify associate degrees into 75 categories that have been quite stable since 1971. The figures presented in Table 7.6 for prior years are estimated levels of segregation, assuming the same categorization of fields of study employed in subsequent years.[3] The level of segregation by sex was highest for associate degrees.[4] The lowest figure for 1980 was substantially higher than the highest year for any other level of higher education. At the peak level of segregation, in the early 1970s, nearly 75 percent of men or women would have had to change fields in order to be equally distributed. After a decade of sharp declines, the index of segregation remained above 60 in 1980.

Associate degrees have had the highest representation of women of any level of higher education. Women had become a majority of degree recipients by 1980. Given the high representation of women and the high degree of segregation, it is not surprising that women associate degree candidates have had high probabilities of intragroup contact. During the 1970s the probability of intragroup contact stabilized and then declined, as the effect of decreasing segregation outweighed the effect of increasing proportions of female enrollment. Throughout this period women had nearly an 80 percent chance of having a random classmate be female. Male associate degree candidates experienced a sharp increase in contact with their female counterparts due to the combination of increased enrollment of women and declining segregation. Men's chances of encountering a female classmate increased from 18 percent to 30 percent.

TABLE 7.6
Associate Degree Segregation, 1966-1980

Year	Percentage Female	D	P*WW	P*WM	P*MM	P*MW
1966	45.0	71.8	.80	.20	.82	.18
1967	46.7	64.6	.79	.21	.81	.19
1968	47.2	76.8	.82	.18	.83	.17
1969	46.9	76.0	.82	.18	.83	.17
1970	47.1	76.2	.81	.19	.83	.17
1971	45.7	74.2	.80	.20	.84	.16
1972	46.6	73.9	.80	.20	.83	.17
1973	47.2	70.0	.77	.23	.80	.20
1974	48.3	69.5	.77	.23	.79	.21
1975	49.7	71.5	.79	.21	.80	.20
1976	48.8	68.7	.77	.23	.79	.21
1977	49.7	66.5	.77	.23	.77	.23
1978	51.5	65.3	.76	.24	.75	.25
1979	53.3	62.5	.76	.24	.73	.27
1980	55.1	59.8	.76	.24	.70	.30

SOURCE: The National Center for Education Statistics (1948-1980).

Comparison of Trends

Graphic depictions of trends in segregation in higher education by level of degree are presented in Figures 7.1, 7.2, and 7.3. Figure 7.1 presents trends in D, the index of dissimilarity for degrees garnered at each level of higher education. Figure 7.2 presents trends in intragroup contact probabilities for women for all degree levels. Figure 7.3 presents trends in intragroup contact probabilities for men.

Bachelor's and combined master's and professional degree indices of segregation (as shown in Figure 7.1) increased in the 1950s and declined subsequently. Master's and professional degree segregation was slightly higher than bachelor's degree segregation, and the gap widened during the 1970s. Associate degree segregation declined after increases in the late 1960s. Indices of segregation at the doctoral level, the lowest of the group, were also the most stable, with no downward trend.

The probabilities of intragroup contact for women, shown in Figure 7.2, rose for master's, professional, and doctoral degrees as female enrollment increased. P*WW stabilized and declined for bachelor's and associate degrees during the 1970s, as the declines in segregation counterbalanced the increase in female enrollments.

The probabilities of intragroup contact for men, shown in Figure 7.3, declined dramatically at all levels of higher education. Increased enrollment of women and declining or stable segregation produced

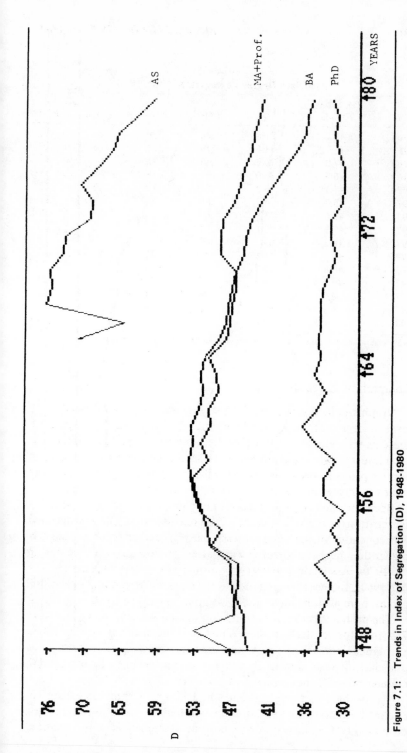

Figure 7.1: Trends in Index of Segregation (D), 1948-1980

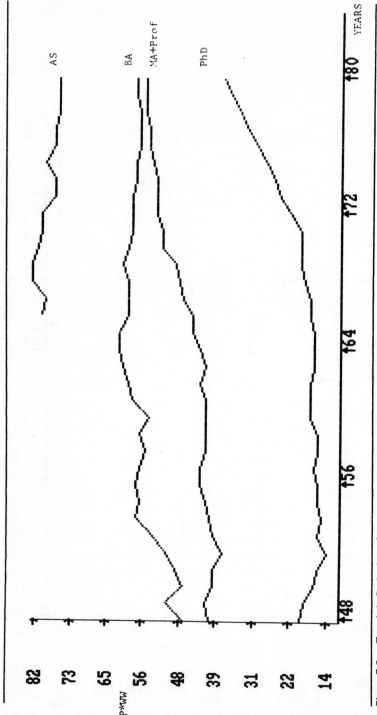

Figure 7.2: Trends in Probation of Intragroup Contact for Women, 1948-1980

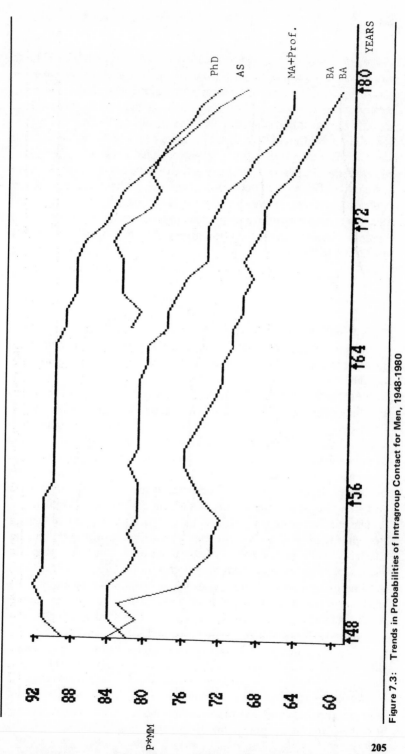

Figure 7.3: Trends in Probabilities of Intragroup Contact for Men, 1948-1980

205

sharp reductions in men's contact with other men. At all levels of higher education, however, men have been more likely to encounter each other than to encounter women. The comparison of Figures 7.2 and 7.3 clearly demonstrates the asymmetric effects of the change on men and women.

With the exception of master's, professional, and bachelor's degrees, the relative position of the different degrees has remained constant over time. Associate degrees by far have had the highest degree of segregation by sex; Ph.D. degrees have consistently had the lowest level of segregation. For most of the period examined, bachelor's, master's, and professional degrees have had very similar levels of segregation. In the 1970s, sex segregation among bachelor's degree recipients declined precipitously, leaving master's and professional degrees with the higher level of segregation.

DISCUSSION

Explanations for the two salient features of these patterns will now be considered: First, the relative degree of sex segregation evident at different levels of higher education; and second, the different patterns of change.

What factors account for the high degree of sex segregation among associate degrees, the low level found among Ph.D. recipients, and the faster decline among bachelor's degree recipients than among master's and professional degree recipients? One factor may be the relationship of educational programs to subsequent occupational opportunities. Students pursue educational programs in part to further career objectives. Educational and career choices are often studied together and seen as part of a unified process (Astin, 1977; Davis, 1965).

The selection of educational specialties reflects occupational segregation prevalent at the time students make their educational choices. Students make choices to pursue educational areas that they can reasonably expect will lead to a job and perhaps a career upon graduation. Among the considerations involved in a realistic choice is the current sex composition of an occupation. If women are exceptions in an occupation at present, choosing a field of study leading to that occupation is somewhat less realistic than it would otherwise be.

This process helps to explain the relative degree of sex segregation at different levels of higher education because the educational level of workers varies directly with occupational segregation by sex. The professions, which include workers with bachelor's, master's, and doctoral degrees as well as professional degrees, are less segregated by sex than are other occupations. Further analysis of occupational

segregation by sex links this differentiation directly to eductional level. Men and women with more than 17 years of education are less segregated by occupation than bachelor's degree recipients and those with fewer than 16 years of education (Jacobs, 1983). Women with these educational credentials are still underrepresented in the labor force, but among men and women at the highest levels of educational attainment, sex segregation is less prevalent.

The pattern of sex segregation in higher education, therefore, in part mirrors occupational differentiation by sex. Workers in professional occupations are less segregated by sex, and the educational system that tracks such workers into careers reflect this fact. The high degree of sex segregation in associate degree programs may be due to the relatively high levels of sex segregation found in the occupations that associate degree graduates can expect to enter.

I am suggesting a reciprocal relationship between educational and occupational segregation. The sex segregation found in the educational system to some extent helps to perpetuate occupational segregation (Polachek, 1978). But the reverse direction of causality is being emphasized here because it is rarely considered. The patterns of educational segregation by sex in part reflect the contours of sex segregation in the labor market.

It is also interesting to note that historical trends in occupational sex segregation broadly parallel the patterns found here. Occupational segregation by sex rose in the 1950s and declined subsequently, as did sex segregation in higher education. The same connection might explain the stability of segregation at the Ph.D. level. The academy has been slow to admit women, in part due to the restricted opportunities in American universities in the 1970s. Thus the stability of sex segregation in academic specialties may be a factor in the continued sex segregation of Ph.D. candidates. Thus the cross-sectional and temporal dimensions of sex segregation in higher education match those of occupational segregation by sex.

Another possible explanation of this pattern is that sex segregation is reduced when the time for choice is extended. Associate degree candidates typically have to choose their specialties before entering. The opportunities to change specialization after socialization in a college setting are minimal. Students bring with them stereotypical notions of appropriate choices for young men and women, and these attitudes directly translate into choices of educational specialties.

At higher levels of the educational system, choices are delayed, and students are subjected to a greater diversity of students and ideas before they are required to choose majors. There is some evidence to suggest that the socialization afforded by college reduces the sex segregation of

majors. Longitudinal analysis of choices of majors by bachelor's degree candidates reveals that the degree of sex segregation declines between freshman year and senior year (Jacobs, 1985; Bressler & Wendell, 1980). Master's, professional, and Ph.D. degree candidates had four years of college to mull over the choice of specialty in pursuing further education. I am suggesting that the socialization afforded by the college environment serves to reduce the sex segregation of choices, at least during periods of changes in sex-role attitudes. The more exposure to this environment, the less differentiated choices become.

These suggestions point to lower levels of sex segregation at higher levels of the educational system. But why do master's and professional degrees exceed bachelor's degrees in the level of sex segregation in recent years? The explanations so far discussed would point in the opposite direction. To answer this question we need to consider trends over time. The explanation will have to do with factors that speeded the decline in sex segregation at the bachelor's degree level but slowed it at the master's and professional degree levels.

The decline in sex segregation described here began during the 1960s, as the Women's Movement started to emerge as a significant force in American life. The call for greater opportunities for women in higher education was among the leading issues of the Women's Movement from the earliest days of the current revival of feminism. Betty Friedan's *Feminine Mystique*, often cited as marking the beginning of the new wave of feminist activism, emphasized the exclusion of women from professional education. Friedan (1963, p. 152) wrote critically of "feminine" higher education, which defines sociology, anthropology, and psychology as acceptable for women but excludes "pure science (since abstract theory and quantitative thinking are unfeminine)." The higher education of women has consistently been a focal concern of the Women's Movement.

The Women's Movement also directly affected the sex segregation of American higher education by pressuring institutions of higher education to change their recruitment and admissions procedures. The increased attendance of women in professional and master's degree recipients, was in no small measure the result of pressure to eliminate enrollment quotas and other practices restricting admission for women (Rossi & Calderwood, 1973; Westervelt, 1975). This pressure culminated in the 1972 Title IX Amendents to the Higher Education Act, which proscribed sex discrimination in higher education. Subsequent programs, developed at all levels of higher education including the associate degree level, have been introduced to attempt to reduce inequities related to sex.

Associate degree sex segregation was so high that significant political pressure resulted in a sharp decline, although sex segregation remains at high levels. The 1976 Title II provisions specified a number of measures to provide sex equity in vocationally oriented programs. It is not unreasonable to infer that these measures may well have contributed to the decline in sex segregation among associate degree recipients.

Two factors are particularly important in the rapid decline in sex segregation among bachelor's degree recipients. First, the rapid growth of coeducation in the 1960s and 1970s may have contributed to a decline in sex segregation in the choice of majors. Between 1960 and 1980, the proportion of colleges and universities with coeducational enrollments rose from 76 percent in 1960 to 92 percent in 1980 (data from National Center for Educational Statistics, 1960-1980). Coeducational settings may facilitate a decline in sex segregation by giving students access to a wider range of courses and curricula and by enabling students to mimic the choices of students of the opposite sex.

A second important factor at the bachelor's degree level was the rapid decline in enrollment of women in teaching. In 1959 over 47 percent of women bachelor's degree recipients received their degrees in teaching; by 1980 the proportion had declined to 19 percent. This single female-dominated specialty included such a large proportion of women that its contraction single-handedly produced a large decline in sex segregation at the bachelor's level. These two factors combined to produce the largest decline in sex segregation at the bachelor's degree level, over and above the secular decline found throughout higher education.

One might have expected a steeper decline in sex segregation among master's and professional degree recipients as a result of the dramatic rise in enrollments of women in professional programs previously overwhelmingly attended by men. The reason for a more modest decline has to do with the paradoxical effects of the growth of extreme cases on measures of segregation.

If all else remains equal, the growth of an extremely segregated field of study will clearly increase the degree of segregation. If this field is growing in numbers while slowly becoming more integrated, it may still contribute to overall segregation. If the growth in one field is more segregated than the average field, overall segregation will continue to increase, even though the particular specialty is becoming more integrated.

The growth in enrollment in certain professional schools is an instance of this pattern. Although dramatically more integrated than professional education had previously been, the growth of enrollment in professional schools such as law, medicine, and business did not

substantially exceed the average integration in master's and professional programs. In sum, despite the rapid growth and rapid integration of women into the professions, these fields contributed only moderately to a decline in sex segregation.

The curious exception to the general pattern of decline in sex segregation is the case of the Ph.D. degree. In this case more women are obtaining the degree than ever before, but the segregation of women and men by specialties has continued at the same (relatively low) level as before.

There are several possible explanations for the persistence of this pattern. As indicated above, the limited progress in bringing women into academia may be a factor in slowing the growth of women in male-dominated Ph.D. programs. There is a Catch-22 quality to this situation: Without more women, fields will remain male-dominated; as long as fields remain male-dominated, the impetus for women to pursue these fields is inhibited. Strong signals of opportunities for women need to be sent out in order to break this cycle.

Another important consideration is the dramatic increase in women in Ph.D. programs, which has the paradoxical effect of limiting the potential decline in sex segregation. The proportion of female Ph.D. recipients has tripled in the last 25 years. This means that the proportion of women entering male-dominated specialties must more than triple to cause a decline in sex segregation. As the pool of female Ph.D. candidates increased, the pool may have become more heterogeneous, with large numbers of women eager to become "pioneers" in male-dominated fields, but far larger numbers joining traditionally female specialties. Consequently, in the large group of new female Ph.D. candidates, although the number of pioneers has increased significantly, the proportion of pioneers has not grown. Clearly, there is a point at which growth of enrollments is so fast that it overwhelms the growth of "pioneering" women. Similar reasoning may be linked to the slow change in the level of occupational segregation by sex.

Another factor is the scarcity of women with undergraduate degrees from male-dominated fields. Because so many male-dominated technical fields are difficult if not impossible to enter without prior specialization in such areas, the proportion of women majoring in male-dominated specialties as undergraduates effectively serves as an upper bound on the proportion in Ph.D. programs. It is easier for a woman with an undergraduate degree in English to go to law school or business school than it is for her to enter a Ph.D. program in physics or economics. Thus male-dominated Ph.D. programs are not likely to benefit from women switching in at a late date and must await increased

numbers of women with technical specializations as undergraduates. With a several year lag required to obtain a degree taken into account, the large increase in women with B.A.s in math and science in the 1970s may well be about to produce a significant increase in women Ph.D. recipients in these male-dominated fields.

Other hypotheses put forth to characterize the relative segregation between field seem less plausible. Beller (1984b) has suggested that the degree of sex segregation is directly related to the proportion of women enrolled. This suggestion fits neither the trends over time nor the relative levels of higher education. Master's and professional degrees have a higher level of segregation and a smaller proportion of women than do bachelor's degrees. Doctoral degrees experienced an increase in the proportion of women without changing the degree of sex segregation. For bachelor's and associate degrees, the growing representation of women is coincident with a decline in sex segregation. The hypothesis of a direct relation between sex segregation and the proportion of women is not borne out in these data.

The trends described here also should not be viewed simply as paralleling other postwar demographic patterns for women. Changes in sex segregation in higher education do not closely follow increases in women's labor force participation, for example, because sex segregation in education increased during the 1950s while women's labor force participation increased. The evidence suggests specific links to the occupational prospects for women and the political context of higher education.

CONCLUSION

This chapter has examined trends in sex segregation among fields of study for recipients of associate, bachelor's, master's, professional, and doctoral degrees between 1948 and 1980. Sex segregation by specialty declined among associate, bachelor's, master's, and professional degree recipients, whereas sex segregation remained roughly constant among doctoral degree recipients. These changes commenced in the 1960s and continued through the 1970s. Throughout the period examined, sex segregation was highest among associate degree recipients and lowest among those with doctoral degrees.

The two most striking findings were the stability of sex segregation for Ph.D. recipients and the asymmetry in the experience of change by men and women. Men experienced a sharp increase in academic contact with women at all levels of higher education, in part due to the declines in segregation and in part due to increased enrollments of women. For

women, these two developments tend to counteract each other: Declining segregation results in increased contact with men, which tends to be offset by increasing enrollments of women.

Sex segregation was highest among associate degree recipients and lowest among Ph.D. recipients because of the corresponding segregation in the labor force and because the socialization experience afforded by college results in lower sex segregation for those pursuing higher degrees. The declines over time are due to the influence of the Women's Movement, not simply changes in women's labor force participation, and a variety of particular factors affecting each level of higher education differently. These data depict a complicated picture of trends in this period of time. No single factor completely characterizes the relative levels and trends observed.

This chapter has focused on comparisons between different levels of higher education. The data represent national averages. Clearly, interesting variations among institutions were pushed to the background in this analysis. Institutional variation remains an important area for the extension of this line of inquiry.

The evidence underscores the importance of longitudinal investigation of sex segregation in higher education. All too often research conducted in one college at one point in time is taken as characterizing important social or psychological generalities. Important as the contributions of this type of research can be, the dramatic changes of the past few decades in the fields pursued by men and women caution against generalizing from data from one college at one point in time.

These data can also help to provide a context for research that is not longitudinal in nature. By providing baseline data for sex segregation as well as outlining the predominant trends, the analysis presented here can enable researchers to put their results and those presented in the literature in the context of the overall patterns of sex segregation in higher education.

The data suggest that our nation's colleges and universities have experienced a much greater decline in sex segregation than has the American occupational structure. Whereas occupational segregation by sex has been quite slow to change over the course of the century, higher education has experienced substantial changes since the 1940s. Higher education appears far more susceptible to the influence of governmental decree and organized pressure groups than do private employers. Yet the formal equality of higher education continues to coexist with substantial segregation in the studies men and women pursue.

NOTES

1. 1952 is the first year detailed categories were grouped into major categories.
2. A small number of students receive undergraduate law degrees. Bachelor's degree data prior to 1961 do not distinguish between L.L.D. degrees and undergraduate law degrees. All were excluded from the pre-1961 data. This adjustment has a very small effect on the results.
3. When one groups 1971 data into the same categories as are available for 1966 data, the index of segregation declines a certain amount. The pre-1971 results were inflated by this amount to adjust for the change in categories.
4. In this volume see Sharon Harlan's chapter on nondegree job training programs, also characterized by a high degree of sex segregation.

REFERENCES

Alexander, V., & Thoits, P. A. (1983). *Token achievement: An examination of Kanter's theory of proportional representation.* Unpublished manuscript, Princeton University, Department of Sociology.

Angle, J., & Wissman, D. A. (1981). Gender, college major, and earnings. *Sociology of Education, 54,* 25-33.

Astin, A. W. (1977). *Four critical years.* San Francisco: Jossey-Bass.

Baruch, G. K., & Nagy, J. (1977). *Females and males in the potential scientist pool: A study of the early college years.* Hanover, NH: Dartmouth College.

Beller, A. H. (1984a). Trends in occupational segregation by sex and race, 1960-1981. In B. Reskin (Ed.), *Sex segregation in the workplace* (pp. 11-26). Washington, DC: National Academy Press.

Beller, A. H. (1984b). *Higher education fields of study and professional employment: Trends in sex segregation during the 1970s.* Unpublished manuscript, University of Illinois at Urbana-Champaign.

Bressler, M., & Wendell, P. (1980). The sex composition of selective colleges and gender differences in career aspirations. *Journal of Higher Education, 51*(6), 651-666.

Davis, J. A. (1965). *Undergraduate career decisions.* Chicago: Aldine.

Dressel, P. L., & Delisle, F. H. (1969). *Undergraduate curriculum trends.* Washington, DC: American Council on Education.

Duncan, O. D., & Duncan, B. D. (1955). A methodological analysis of segregation indexes. *American Sociological Review, 20,* 210-217.

England, P. (1981). Assessing trends in occupational sex-segregation, 1900-1976. In I. Berg (Ed.), *Sociological perspectives on labor markets.* New York: Academic Press.

Friedan, B. (1963). *The feminine mystique.* New York: Dell.

Gross, E. (1968). Plus ca change? The sexual structure of occupations over time. *Social Problems, 16,* 198-208.

Hearn, J. C., & Olzak, S. (1981). The role of college major departments in the reproduction of sexual inequality. *Sociology of Education, 54,* 195-205.

Jacobs, J. A. (1983). *The sex-segregation of occupations and the career patterns of women.* Ph.D. dissertation, Department of Sociology, Harvard University.

Jacobs, J. A. (in press). Trends in sex segregation during the college years. *Journal of Higher Education.*

Jacobs, J. A., & Powell, B. (1984). Gender differences in the evaluation of prestige. *Sociological Quarterly, 25*(2), 173-190.

Kanter, R. M. (1977). *Men and women of the corporation.* New York: Basic Books.

Karabel, J. (1972). Community colleges and social stratification. *Harvard Educational Review, 42*(4), 521-562.

Lieberson, S., & Carter, D. K. (1982). Temporal changes and urban differences in residential segregation: A reconsideration. *American Journal of Sociology, 88* (September), 296-310.

Lloyd, C., & Niemi, B. (1979). *The economics of sex differentials.* New York: Columbia University Press.

Lyson, T. A. (1981). The changing sex-composition of college curricula: A shift- share approach. *American Educational Research Journal, 18*(4), 503-511.

Massey, D. S., & Mullan, B. (1984). Processes of Hispanic and Black spacial assimilation. *American Journal of Sociology, 89*(4), 874-888.

National Center for Educational Statistics. (1962-1980). *Digest of educational statistics.* Washington, DC: Government Printing Office.

National Center for Educational Statistics. (1948-1980). *Earned degrees conferred in higher education.* Washington, DC: Government Printing Office.

Peng, S. S. & Jaffe, J. (1979). Women who enter male-dominated fields of study in higher education. *American Educational Research Journal, 16*(3), 289-293.

Pincus, F. (1980). The false promises of community colleges. *Harvard Educational Review, 50*(3), 332-361.

Polachek, S. (1978). Sex differences in college major. *Industrial and Labor Relations Review, 31*, 498-508.

Powell, B., & Jacobs, J. A. (1984). The prestige gap: Differential evaluations of male and female workers. *Work and Occupations, 11*, 283-308.

Rossi, A. S., & Calderwood, A. (Eds.). (1973). *Academic women on the move.* New York: Russell Sage.

Strange, C. C., & Rea, J. S. (1983). Career choice considerations and sex role self-concept of male and female undergraduates in nontraditional majors. *Journal of Vocational Behavior, 23*, 219-226.

Thomas, G. E. (1980). Race and sex group equity in higher education: Institutional and major field enrollment statuses. *American Educational Research Journal, 17*(2), 171-181.

Westervelt, E. M. (1975). *Barriers to women's participation in post-secondary education.* Washington, DC: National Center for Educational Statistics.

8

Discriminating Between Attitudes and Discriminatory Behaviors
CHANGE AND STASIS

WILLIAM A. KAHN
FAYE CROSBY

Presuming that attitudes and behaviors are related, one would assume that attitudes toward working women are intimately connected to women's status in the labor market. The task of supporting this assumption with empirical research yields a paradox both puzzling and frustrating. Research exploring attitudes toward women in the workplace suggests that both women and men are expressing increasingly more egalitarian views concerning women and employment. Occupational segregation continues with little change, and even when women penetrate the traditional male bastions, they are less well compensated than are men. Women are also far more likely to face personal discrimination and harassment in the work place than are men. This chapter documents changes in attitudes concerning gender in the paid labor force and continuities in sex discrimination. It then accounts for the discrepancy between decreasing prejudice and persisting discrimination.

Antifemale prejudice and sex discrimination have been features of the economic scene at least since World War II and probably since the country was founded. If attitude surveys are to be believed, prejudice has greatly diminished and Americans have steadily (if slowly) changed their attitudes toward employed women. But while prejudiced attitudes have been constantly changing, actual discrimination has remained relatively constant and pervasive.

In this chapter we first document the discrepancy between attitudinal change and behavioral stasis. We then seek to account for the discrepancy. Are thousands of Americans currently lying to survey researchers? We think not. Can we explain the discrepancy by assuming

AUTHORS' NOTE: We would like to thank the editors and reviewers, and Nancy Goodban for their thoughtful comments on an earlier draft of this chapter.

that while pollsters speak to the egalitarian masses the misogynist elites perpetuate discrimination? Again, the answer seems negative.

Is the paradox then an artifact of an analysis in which we speak, at the same time, of events at an individual level (opinions and attitude statements) and events at a social level (labor market behavior)? Certainly levels of analysis are important to any argument about discrimination, but the paradox does not disappear by appealing simply to levels of analysis. Group phenomena are inherently functions of individuals engaged in their own particular behaviors. We are left with the puzzling picture of individuals who, in the aggregate, profess their dislike of discrimination while performing behaviors that—in the present context—serve to perpetuate gender inequities. We point out how these behaviors may be unthinkingly performed, to the extent that their discriminatory consequences remain unclear to individuals in given social contexts. We thus account for persistent sex discrimination in terms of structural factors that inhibit progress, or more specifically, inhibit systemic change in spite of individual change.

ATTITUDE CHANGE

Opinion surveys conducted during the past few decades indicate widespread trends toward the expression of egalitarian views concerning women in the work force. These trends are indicated by a variety of surveys conducted in diverse settings, ranging from national polls to experimental questionnaires. What these surveys share, aside from a form designed to elicit articulable (and thus consciously held) general attitudes, is a focus on working women and the various issues surrounding their employment.

Findings

Many surveys show increasing acceptance of working women and a growing awareness of their contributions to the economy and the factors that often work to undermine that potential. Some attitudes, like attitudes toward women's participation in the paid labor force, reflect directly the degree of gender prejudice central to issues of women and work. Others, like attitudes toward day care, are more peripheral but equally important. Attitude surveys document changes in both.

Women's participation. A number of studies have traced the increasing acceptability of the notion that women may desire work, consider jobs in terms of careers, compete for all types of jobs, and

manage the dual demands imposed by work and family (Converse, Dotson, Hoag, & McGee, 1980; Duncan & Duncan, 1978; Erskine, 1971; Kaley, 1971; Parelius, 1975a, 1975b; Roper, 1980; Spitze & Huber, 1980; Thornton & Freedman, 1979; Yarburg & Arafat, 1975). Spitze and Huber (1980), for example, cite data from national Gallup polls assessing general support for women's employment since the late 1930s. In 1938 20 percent of the men and 26 percent of the women surveyed supported the idea of women's employment; in the latest data provided, 76 percent of the men and 78 percent of the women surveyed supported women's employment in 1978. Duncan and Duncan (1978), using a cross section of men and women, found increasing support for the idea that there are no types of work that women should not have; 20 percent approved of this statement in 1956, 33 percent approved it 15 years later. Further, 80 percent of the men and 90 percent of the women in Yarburg and Arafat's (1975) sample of 1048 metropolitan residents advocated women's dual role in the home and the economy in 1975, as opposed to the 12 percent men and 18 percent women who, in a 1936 national Roper poll, advocated that married women should have full-time jobs (Erskine, 1971).

Surveys have also traced the increasing acceptability of women being paid for their participation in the labor force, regardless of their financial needs (Bowman, Worthy, & Greyser, 1965; Cherlin & Walters, 1981; deBoer, 1977; Erskine, 1971; Gallup, 1972, 1978; Parnes, Jusenius, Blau, Nestel, Shortlidge, & Sandell, 1975; Roper, 1974; Smith, 1980). The classic Gallup poll question, asked of large samples of respondents between 1936 and 1976, asks "Do you approve of a married woman earning money in business or industry if she has a husband capable of supporting her?" In 1936, 18 percent approved, 72 percent disapproved, and 10 percent expressed no opinion (Gallup, 1972). In 1969, 55 percent approved, 40 percent disapproved, and 20 percent expressed no opinion. The progression continued in 1976, when 68 percent approved, 29 percent disapproved, and 3 percent expressed no opinion (Gallup, 1978).

Equal pay. Studies also indicate an increasing awareness that women should be paid the same wages as men for comparable work (Agassi, 1982; Erskine, 1971; Gallup, 1972; Mason, Czajka, & Arber, 1976; Harris & Associates, 1970). One national Gallup poll, asking whether women should receive the same rate of pay as men for the same work, received 76 percent approval in 1945 and 87 percent in 1954—indicating a potential ceiling effect. Data provided by Mason, Czajka, and Arber (1976), employing a collection of sample surveys using high school and college students, also indicated a ceiling effect: 95 percent of respon-

dents in 1970 and 98 percent of respondents in 1973 agreed that men and women should be paid the same money if they do the same work. Apparently, respondents across various surveys and years are agreeing with the notion of equal pay as one might agree that there ought to be justice; that is, respondents are simply expressing a widely shared value. Nevertheless, that expression is seemingly reflecting greater egalitarianism with respect to equal pay.

Women as workers. In terms of the more peripheral attitudes surrounding working women, a number of studies have traced the decline of the widespread belief in stereotypic gender differences concerning the abilities of women as workers and leaders (Agassi, 1982; Bass, Krussell, & Alexander, 1971; Bowman, Worthy, & Greyser, 1965; deBoer, 1977; Erskine, 1971; Ferber, Huber, & Spitze, 1979; Gallup, 1972; Parelius, 1975a; Roper, 1980). In 1946 a series of Roper and Gallup polls (Erskine, 1971) documented traditional beliefs about gender differences in creativity, decision making, acceptance of new ideas, handling of people, and so forth. A typical response pattern was that to creativity: 62 percent of the men and 48 percent of the women believed that women are less creative. Forty percent of the entire sample considered men to be more intelligent, 48 percent thought men were more level-headed, and 34 percent believed men had more common sense than women (30 percent thought the opposite). A 1975 national Harris poll (deBoer, 1977) showed changes in such stereotypic beliefs; 53 percent of the women and 35 percent of the men disagreed with the statement that women will always be more emotional and less logical than men. Agassi (1982) found that 94 percent of 760 women and 95 percent of 180 men in her cross-sectional sample noted that women could do mathematics just as well as men. The gradual shift away from stereotypic beliefs is reflected in attitudes toward female leadership. A 1970 Gallup poll (Gallup, 1972) found that 45 percent of the men and 55 percent of the women thought that women could run most businesses as well as men. In Agassi's (1982) sample, 91 percent of the men and 92 percent of the women believed that women can manage or supervise just as well as men.

Discrimination. Research also points to the increasing acceptance of the idea that women should have the same opportunities as men in the work place and to a growing awareness of the discrimination undermining those opportunities (Agassi, 1982; Bowman et al., 1965; Erskine, 1971; Gallup, 1978; Mason et al., 1976; Roper, 1980; Yarburg & Arafat, 1975). Mason et al. (1976) provide data indicating that 66 percent of their respondents supported equal job opportunities for women in 1970—77 percent of their respondents did so in 1973. The trend continued in 1975. Yarburg and Arafat (1975) noted that 84 percent of

the men and 91 percent of the women in their sample of a metropolitan city supported equal opportunities for women's access to executive jobs, again indicating a potential ceiling effect as respondents increasingly expressed their shared value for equality. Yet they are also expressing increasing awareness of the reality of discrimination. A 1970 Harris poll indicated that 50 percent of the women and 47 percent of the men in the national sample believed that women were discriminated against in obtaining executive positions in business—as compared to 57 percent of women and 48 percent men in 1980 (Roper, 1980). The same polls indicated growth in perceptions of discrimination against women in obtaining top jobs in the professions (a change of 12 percent for women, 7 percent for men) and skilled-labor jobs (a change of 8 percent for women, 2 percent for men); slightly less discrimination was perceived toward women obtaining jobs in the arts and white-collar, clerical positions.

Day care. Finally, various studies have traced the increasing decline in the stereotypic belief that full-time labor drastically alters the quality of child care and the increasing recognition of the need for more day-care centers (Agassi, 1982; deBoer, 1977; Harris & Associates, 1970; Kaley, 1971; Mason et al., 1976; Roper, 1980). Mason et al. (1976), for example, provide data showing that across their collection of sample surveys, 54 percent of respondents in 1964 agreed that working mothers can establish as equally warm and secure relationships with their children as can nonworking mothers, as opposed to 69 percent in 1970. A 1980 Roper poll (Roper, 1980) found that 47 percent agreed (and 16 percent disagreed) with the sentiment that paid employment does not affect the quality of mothering. With these changes has come an awareness of the need for institutional day care. A 1970 Harris poll (Harris & Associates, 1970) found that 63 percent of women and 49 percent of men favored the establishment of day-care, as opposed to 75 percent of women and 66 percent of men in 1980 (Roper, 1980). And in Agassi's (1982) sample, 84 percent of 760 women and 71 percent of 180 men agreed that the state should provide good day care and school supervision so both parents could work.

Wording

Simply calculating the differences in respondent agreement with various items ignores the evolving ways in which the issues themselves have been framed and says little about the assumptions in which questions and surveys have been embedded. Even a cursory examination of the survey instruments reveals dramatic changes in how questions are asked. A 1936 Gallup poll, for example, asked respon-

dents whether a married women should earn money if she has a man capable of supporting her (82 percent answered "no"), clearly assuming the traditional roles of male as breadwinner and female as housewife and mother (29 percent disapproved in 1976). Similar assumptions pervaded a 1952 Gallup poll asking whether working mothers should be allowed to receive income tax breaks for paying household help and babysitters. Although the question does grant the possibility of working mothers, the 1952 poll also blithely asked what kind of job or occupation offers a young woman the best chances of finding a husband (32 percent responded "office job").

A 1942 Gallup poll—to take another example—asked "If women replace men in industry should they be paid the same wages as men?" (78 percent responded "yes"). The 1954 Gallup version asked "Do you approve or disapprove of paying women the same salaries as men if they are doing the same work?" (87 percent approved). Each question was directed toward the issue of equal pay for women, yet they obviously implied different assumptions about the actual status of women in the work place. The word "replace" in the 1942 poll, especially offensive in today's attitudinal climate, certainly reflected (and possibly reinforced) the cultural assumptions of the 1940s. Clearly, successive generations of different questions illustrate changing assumptions about the place of women in the paid labor market.

LABOR MARKET STATUS

Has women's status in the labor market changed as much as attitudes (at least as measured by opinion polls) have changed? To be sure, there has been some behavioral change: Women are entering the work force in record numbers and represent an increasingly large proportion of that work force (Blau & Ferber, this volume; Serrin, 1984; Trafford et al., 1984). Further, a greater variety of women (e.g., married women) are working in a greater variety of jobs once considered exclusively in the male domain. Yet women's share of rewards remains disproportionately low. Different studies report various manifestations of the same phenomenon: Persistent sex discrimination in the labor force.

Unemployment

Perhaps the most fundamental issue of sex discrimination concerns unemployment. Women continue to have substantially higher unemployment rates than men (Barnes & Jones, 1975; Barrett & Morgenstern, 1974; Niemi, 1975). Statistically controlling for factors such as occupational distribution, job search time, geographic mobility, and movement

into and out of the labor market, researchers conclude that discrimination has been an important determinant of women's higher unemployment rate (Ferber & Lowry, 1976). Women continue to be denied access to appropriate jobs, either explicitly or through subtle mechanisms such as being offered lower starting salaries than men (cf. Terborg & Ilgen, 1975). Although the absolute numbers of employed women have risen in recent years, women continue to have high unemployment (and underemployment) rates relative to men—in spite of generally expressed attitudes supporting equal work opportunities for women.

Segregation

When women do manage to enter the paid labor force, they are generally greeted with occupational segregation. The majority of women in the work force are in stereotypically female jobs (Barrett, 1979) characterized by "cheapness plus availability" or "cheapness plus skill" (Oppenheimer, 1968). These jobs typically involve white-collar clerical and service positions rather than blue-collar work or white-collar managerial, technical, and professional positions (Nieva & Gutek, 1981). Blau (1978) notes that 40 percent of working women are secretaries, household workers, bookkeepers, elementary school teachers, waitresses, typists, cashiers, nurses, or seamstresses.

Some, but not all, measures of sex segregation signal improvement in the condition of women. Women are entering the graduate and professional schools in increasing numbers and are penetrating the professions. Trafford et al. (1984) note that women have made significant gains in male-dominated fields between 1973 and 1983; women account for 5.8 percent of engineers (1.3 percent in 1973), 15.3 percent of lawyers (5.8 percent in 1973), 15.8 percent of physicians (12.2 percent in 1973), and 32.4 percent of managers and administrators (18.4 percent in 1973). But the diminution of sex segregation in the paid labor force may in fact be less rapid than it appears at first glance (Gornick, 1983). Using an adaptation of the Duncan's Index of Segregation, Gross (1968) demonstrated that the apparent increase in sexual integration between 1900 and 1960 was illusory and that there was actually little change in that 60-year period. More recently, Fox and Hesse-Biber (1984) have reiterated the message. They note that in 1900, 60 percent of working women were in occupations in which at least half of their coworkers were also female; in 1980, the percentage increased to 75 percent (Smith, 1979; Treiman & Terrell, 1975).

Unequal Compensation

Typically lower status than male occupations, the female occupations have traditionally commanded less financial benefits than recognizably

equal work in stereotypically male occupations (Blaxall & Reagan, 1976) and have slow and truncated promotional structures relative to male occupations (Rotella, 1980). Persistent sex segregation of the labor market helps one understand the remarkably stable gap between male and female earnings. With very slight fluctuations over the past three decades, the average female worker earns 60 cents on the average male worker's dollar (Treiman & Hartmann, 1981; Trieman & Roos, 1983; Waite, 1981).

Occupational segregation does not entirely account for the disparity in male and female incomes. Over the years numerous studies controlling for variables such as occupation, occupation level, experience, and education have indicated that women are simply paid less than men for doing similar work in the same jobs (Blau, 1978; Suter & Miller, 1973; Treiman & Roos, 1983). Although there are a number of analytical problems involved in assessing the degree to which sex differences in pay are discriminatory, it has not been ruled out by a number of economic studies (see Madden, this volume). What is especially disturbing is that the most recent studies show wage discrimination as clearly as did the older studies. In an in-depth study of employed women and men in a Boston suburb conducted in 1978 and 1979, Crosby (1982) sampled among narrow bands of high-status and low-status full-time employed women and men. The modified random sample procedure yielded samples of employed women and men who were exactly equal, on average, in all job-related attitudes (e.g., job commitment) assessed in the study and all job-relevant characteristics (e.g., occupational prestige, education, years of training) measured. Yet the men in the study earned approximately $8000 a year more than the women they matched.

Crosby's findings are not isolated. In a 1979 job audit of male and female administrative personnel in a large university, researchers found sex differentials in salaries (Siegelman, Milward, & Shepard, 1982). Level of responsibility was—as it ought to have been—the single most important predictor of salary, but at every level men earned more than women. The gender differential remained, furthermore, after one corrected statistically for factors like years on the job, which covaried with gender and helped to determine salary.

A massive study of wage and salary structures in nine nations, including the United States, has produced perhaps the most compelling findings. Using data collected between 1975 and 1980, Treiman and Roos (1983) show that in all nine countries women earn less than men. They then consider three explanations for the observed differences. First, they test the human capital theory that states that males tend to be better paid because they tend to accumulate more human capital, like education, than do females. Equations that take into account the male

superiority fail to eliminate sex differences in earnings, however, and Treiman and Roos therefore discard the human capital argument. Statistical tests also lead the researchers to discard the dual-career explanation showing, in essence, that family responsibilities of women do not adequately account for the severe restriction of their salaries. Nor, according to a third set of statistical tests, does sex segregation of the work force. Concluding that none of the explanations "receives much support in any country," Treiman and Roos propose in a masterful understatement that their findings leave "open the possibility that the earning differences are due to deeply entrenched institutional arrangements that limit women's opportunities and achievements" (p. 612).

Sexual Harassment

The social status of women in the work place itself has changed as little as that of their occupational and economic status. Women continue to face the possibility of sexual harassment as a common, everyday occurrence (Farley, 1978; Gutek & Morasch, 1982). Sexual harassment may be defined as "any unwanted pressure for sexual activity," including an array of behaviors ranging from suggestive comments and gestures to unwanted physical contact, rape, and attempted rape (Bularzik, 1978, p. 25); typically, harassment occurs in the context of relationships of unequal power (MacKinnon, 1979). Research indicates that sexual harassment is widespread and continues to intrude into the work life of many female workers regardless of age, marital status, occupation, or ethnic background (Neugarten & Shafritz, 1980). Sexual harassment symbolizes the continued domination of men over women on a variety of work dimensions: Economic benefits, occupational prestige, and personal control.

EXPLANATIONS

How does one account for the persistence of sex discrimination in the face of widely expressed changing attitudes? We can think of six ways to reconcile the apparently discrepant findings in attitudinal change and behavioral stasis. Two explanations focus on the nature of the attitudinal measures, and one explanation on the nature of the various samples of respondents. The other three explanations are less methodological and are more substantive.

Response Bias

Attitudes toward working women and their treatment in the labor force may be inconsistent because of the (typically unrecognized) desire

of survey respondents to answer attitude statements in a socially desirable way. Attitude items often have strong social desirability components. This is particularly true in recent years for items expressing nonsexist attitudes, and perhaps more true for public opinion polls than for instruments that probe people's attitudes in depth. Often a respondent will now disagree with the statement "Women cannot adapt to the working world as well as men" simply because to agree would be inappropriately discordant with the socially desirable attitude. People's desires to respond in socially desirable ways do not necessarily involve a conscious process of impression management. More likely people react to the unconscious wish to appear to oneself as a progressive, socially correct person. Following this reasoning, attitudes toward working women and women's treatment in the labor force diverge because survey respondents are reacting to the social implications of the attitudinal items while, in practice, such rhetoric gives way to practical demands (Trafford et al., 1984).

The response bias explanation fails to resolve adequately the attitude-behavior paradox. Even if the changes in survey respondents' stated attitudes merely reflect changing norms (presumably widely shared), one is left with the same basic conundrum: How can societal norms have changed so much without equally widespread changes in behavior?

Inappropriate Questions

The link between the attitudes elicited in the general surveys and women's treatment in the labor market may be blurred because of a second form of measurement error, one that is related to response bias. It is conceivable that the survey items were simply unreliable, couched in language so general and vague that respondents agreed with the egalitarian items as a function of not being pinned down to specific, nonegalitarian attitudes. Agreeing with the general public opinion statement "Women should be paid the same as men for equal work" is psychologically simpler than answering specific questions about pay scales in the respondent's own work place. Yet reliability may be sacrificed for this simplicity.

As Ajzen and Fishbein (1977) note, behavioral measures may be defined in terms of four facets or elements: The action involved, the target at which the action is directed, the context in which it occurs, and the time of its occurrence. The closer the attitudinal measure is able to approximate behavioral measures in terms of these elements, the more likely that the attitudes and behaviors will show logical consistency. According to this reasoning, attitudes toward working women and their

overall treatment are inconsistent because the wrong questions are being asked in the opinion polls. More telling questions would focus on specific ways of treating women in the work place, assessing attitudes accordingly.

Although this explanation is appealing, it too does not fully account for the attitude-behavior paradox. Attitudinal measures using items directly questioning specific behaviors indicate as much change as measures consisting of more or less general platitudes. For example, various studies, cited above in the documentation of changing attitudes toward women's competence at work, have employed attitude items differing in levels of specificity but not in results. Although some surveys ask general questions such as "Can women do most jobs as well as men?" (Agassi, 1982; Duncan & Duncan, 1978; Parelius, 1975a), others such as the 1976 Gallup poll and 1980 Roper poll probe for specific attitudes about particular occupations (e.g., "Would you have more confidence in a man or woman doctor treating you for a serious injury in a hospital emergency room"; see Roper, 1980). In each case, results indicate that attitudes toward the competence of female workers have changed to a degree that their status in labor force has not.

Inappropriate Samples

Another type of measurement error is concerned with sample bias. It may be that respondents to the various polls, surveys, and experimental questionnaires represented a skewed sample of the general population, thus producing expressions of attitudes not widely shared in that population. Alternatively, the survey population may not have been representative of the decision makers who possess control over the fate of women in the work force. That is, people expressing attitudes about working women on the one hand and people whose behaviors most directly affect those women on the other hand may represent unrelated segments of the larger population.

The relative impact of the third type of measurement error (and its ability to determine the attitude-behavior paradox) is limited due to the unusually diverse number of studies using large numbers of respondents. Within that diversity are studies employing actual samples of managers as respondents—studies that mirror the changes in attitudes documented for the larger culture. A 1965 survey of approximately 2000 executives, including males and females, indicated that 35 percent of men and 48 percent of women had a strongly favorable or mildly favorable attitude toward women in management—as opposed to 41 percent of men and 18 percent of women who expressed a mildly or strongly unfavorable attitude (Bowman et al., 1965). More recent

surveys of managers, using the Women as Managers scale (Peters, Terborg, & Taynor, 1974), document the increasing acceptability of women into management (Crino, White, & DeSanctis, 1981; Terborg, Peters, Ilgen, & Smith, 1977; Tsui & Gutek, 1984).

Many Attitudes

There is a theoretical component to the methodological argument that attitude statements need to refer as specifically as possible to potential behaviors. Rather than presuming that people hold one and only one attitude toward women, it seems reasonable to expect people to hold a number of attitudes toward women. Certainly, individuals possess any number of competing attitudes about particular objects and persons (Davidson & Morrison, 1983) and rarely conform to the "true believer" conception underlying traditional attitude theories (Schuman, 1972). Typically, individuals have a number of attitudes about an object depending on their own purposes and the situations in which they encounter the objects. Among attitude objects likely to elicit complex clusters of beliefs, a special place no doubt belongs to the category "women" (Dinnerstein, 1971; Horney, 1932).

The idea of competing attitudes is especially compelling in light of the extent to which society enables the maintenance of traditional stereotypic beliefs about women and their roles. The treatment of women in the work place may be a function of ingrained beliefs about their "place" and typical characteristics rather than expressed attitudes about them as workers per se. To a large extent, society still reinforces the role of homemaker as the woman's domain (deBoer, 1977) and the role of breadwinner as the man's domain. There are a variety of stereotypic beliefs that, on a cultural level, serve to maintain and legitimate the basic gender-based division of responsibilities. Some of these beliefs operate to place the blame for women's relatively low status in the labor force on the nature of women themselves (for example, "blaming the victim"). In spite of the expression of changing attitudes, the traditional sex stereotypes of women as relatively dependent, passive, gentle, and warm remain (Broverman, Vagel, Broverman, Clarkson, & Rosenkrantz, 1972; Ruble, Cohen, & Ruble, 1984). Although organizational members, both men and women, possess attitudes that contradict these beliefs, they often behave as if the traditional sex-role stereotypes were accurate, for example, by assuming that women would not make as effective, "strong" leaders as would men.[1]

The other competing beliefs derive from the widespread sex-typing of the work settings themselves. Prevailing beliefs about what jobs are appropriate for men and what jobs are appropriate for women establish

strong normative pressures for both women and men entering the labor market. Research indicates that men and women are in fairly close agreement about the appropriateness of particular jobs for each sex (Shepard & Hess, 1975), beliefs learned quite early and constantly reinforced by toys, school textbooks, and career counseling (Wirtenberg & Nakamura, 1976). This consensus implicitly limits occupational choices. Normative assumptions about what jobs are "appropriate" for women and for men affect the decision process, influencing both what jobs people seek and what jobs they are given. These expectations also determine the treatment of those who violate the norms. Research indicates that women violating sex-role expectations in job selection are awarded less social standing (Nilson, 1976) and judged less likeable (Suchner & More, 1975) than those conforming to such expectations.

Behaviors to Attitudes

Perhaps there does exist a link between currently measured attitudes toward working women and their labor market status, but the standard attitude-behavior model does not provide a complete conceptual framework with which to understand that link. The traditional attitude-behavior model simply assumes that individuals will behave toward objects in a manner consistent with the attitudes they expressed about those objects.

A problem with this attitude-behavior model is that, like most psychological models, it is ahistorical. We have not explicitly considered the possibility that the tremendous increase in women's labor force participation (especially by married women) occurring in the 1950s and 1960s itself was a change in behavior that began to alter previously held attitudes. The implication is that the paradox we have discussed may be a product of the "cultural lag" between revolutionary social change and individual adaptation to (and rationalization of) such change. Yet psychologists interested in individual behavior are not particularly well-equipped to conduct inquiries into social history.

This is not to deny the possibility, noted by many psychologists, that attitudes may follow, or derive from, behaviors. Explanations that posit a behavior to attitude causal path are of two general types: Self-perception explanations posit a "top of the head" process (Bem, 1972; Chaiken & Baldwin, 1981) in which persons who cannot discern situational determinants of their behavior will infer that those behaviors accurately reflect typically corresponding attitudes; dissonance theory explanations (Festinger, 1957; Brehm, 1960) suggest that dissonance attaches to attitude-discrepant behaviors and that it motivates people to change their attitudes in accordance with their behaviors.

The general thrust of this account is that attitudes toward working women should follow from, rather than determine, their treatment in the work place. Of course, the inconsistency between expressed attitudes and behavioral manifestations remains—only the causal relationship of the paradox is now reversed. Social psychologists employ this reversal to understand unexpected attitude-behavior relations, usually those that are puzzlingly consistent. Given this perspective, it may be that attitudes toward working women are expressed on the basis of behaviors—selectively remembered and interpreted. Individual respondents, faced with questions implicitly asking for socially desirable egalitarian responses, may ask themselves if they have felt any hostility toward working women or if they have acted in a misogynist fashion. If they decide that they have neither felt nor acted in ways hostile to working women, the respondents would perceive themselves as egalitarian (to the degree socially desirable at the time of the survey).

Even if all of the respondents were unbiased in their recollections, the result would be that most surveys would show respondents clustering around socially appropriate levels of egalitarianism (with the appropriate levels shifting according to changing fashions and norms) because, in fact, most people do not make it a point to exclude or oppress working women. People may, at the same time, continue in their work-force behaviors to favor this man or that in one situation or another (see Nieva & Gutek, 1980, for a review of research indicating that the cumulation of individual decisions favoring men constitutes "discriminatory" behavior). Many discrete individual actions, each perpetuating a seemingly insignificant male advantage in one place or another, accumulate and the aggregate effect becomes one of keeping women severely at a disadvantage.

How can people in the work force, both men and women, favor men without realizing the implications of their actions? The answer to this question brings us to our last explanation of the paradox of attitude-behavior discrepancy.

Context

The key to understanding the nature of the relation between the changing attitudes and static behaviors rests in realizing that behaviors occur within institutional contexts. Because the vast majority of the labor force, men and women, work within relatively complex formal organizations (Hall, 1982), our discussion will focus on the salient characteristics of organizations that reinforce discriminatory behaviors. In some ways, organizational contexts are microcosms of the wider culture (Martin, Harrison, & Dinitto, 1983). Within organizations a

norm exists, similar to that in the larger culture, supporting egalitarianism. This norm accounts, say, for the apparently widespread verbal support of women as managers and supervisors. Competing normative expectations within the organizational culture, however, reinforce the traditional beliefs about women in the work place. Some organizational decision makers, primarily men, may, for example, continue to believe (consciously or unconsciously) that women are less committed to work than are men (Martin et al., 1983). These individuals and others may respond negatively to the underrewarded and impotent women not because of their gender but because of their organizationally based powerlessness. Responses to woman leaders, for example, may be a function of features of work units, task design and structure, and the relative power of the leader rather than of the leader's sex per se (Fox & Hesse-Biber, 1984; Kanter, 1977).

In other words, individuals generally behave as a function of their location in organizational structures. Discriminatory practices are more often than not responses by individuals to system pressures, particularly those connected with the uncertainties of legitimacy, evaluation, communication, and loyalty (Kanter, 1976, 1977). Understanding these system pressures enables us to realize that, within organizations, discriminatory behaviors are often unintentional rather than deliberate. Madden (this volume) notes that the personal prejudices of employers, consumers, or coworkers cannot explain, in terms of economic theory, a continuing devaluation of women's jobs.

Kanter's (1977) classic study of a large corporation provides some clues to the pressures surrounding individual actors in a variety of social systems. She notes that bureaucratic organizations, which theoretically maximize predictability, are subject to variable contingencies within the organizations themselves and in their surrounding environments. The desire to reduce that uncertainty pervades the organization and assumes a variety of individual- and group- level forms. Individuals reduce the uncertainty of their own jobs by assuming circumscribed roles tightly defined in relation to other roles. To the extent that organizational roles within complex bureaucracies reflect historical gender asymmetries of the larger cultural context, the simple desire to reduce uncertainty perpetuates sex discrimination.

Take, as Kanter does, the example of secretaries. Secretaries are implicitly expected to "understand" their bosses (usually male), responding to moods, needs, whims, and personal quirks much in the way that wives stereotypically act toward their husbands (McNally, 1979). If managers then commit what Nisbett and Ross (1980) call the "fundamental attribution error"—and who does not?—they assume that the nurturant and submissive behaviors of secretaries result from

personality characteristics of the secretaries and not from the role requirements imposed by the situation. As a result, the typical manager may not, for instance, think of his or her secretary as a strong candidate for promotion into the managerial ranks. Or, the manager may assume that secretary submissiveness connotes less work commitment, thus creating the foundation for self-fulfilling prophecies. Employers expecting turnover provide little training or challenging work, which leads to boredom, frustration, and eventual turnover (McNally, 1979). Individual employers feel little impetus to step out of their formal roles and explore how their own role behaviors affect the women's behavior—particularly because the use of temporary worker agencies relieves the pressure of observing one's own complicity (McNally, 1979).

Certainly, many organizational members may believe strongly in egalitarian, nonsexist attitudes. How can they behave in sexist ways and yet experience no cognitive dissonance? The anxiety that individuals might experience when behaving incongruently with expressed attitudes are partially mitigated by the protection of having a strictly defined role, which by definition implies behaviors appropriate to the system. Any discriminatory behaviors are thus legitimated and rationalized by the role pressures. Indeed, most people in most organizations never have to scrutinize their behaviors, and most people do not recognize (and may not intend) the discriminating by-products of their own attempts to function on the job.[2]

IMPLICATIONS

Our analysis suggests a number of implications for those interested in charting, and perhaps speeding, the movement toward the equal treatment of women in the paid labor force. We outline these implications by proposing three models by which behaviors toward working women will change in accordance with the increasingly egalitarian attitudes about those women. Attached to these models are related courses of individual, organizational, and societal actions.

The first model suggests that attitude changes reflect underlying changes in values; agreeing with statements about women's equality may simply indicate a value for that equality. Thus the surveys reflect the ideal rather than the actual; the ideal may also be represented by what attitudes are socially desirable to express. The individual expression of shared ideals may be viewed from a group-level analysis. From this perspective, the attitude shifts toward egalitarianism express some aspect of group life, such as changing sex-role expectations. The egalitarianism trend is thus a weathervane, showing "which way the

wind is blowing," and supported (if not driven) by the increasing changes in the actual sex-role behaviors of women and men.

This implies that women's treatment in the labor force will follow in the egalitarian footsteps of attitudinal change. It is an optimistic, even evolutionary perspective, built on the observation that "the imposition of the new does not necessarily automatically and immediately wash out the old" (Leavitt, 1976, p. 79). The traditional sex-role equilibrium supported by the legal, economic, social, and cultural institutions has been jolted (Strober, 1976); the paradox discussed here reflects a society searching for a new equilibrium.

This model also implies that the attitude-behavior paradox is not as puzzling as first thought. Conceptualizing the attitude changes as an expression of group life enables us to see that paradoxical individual attitude-behavior relations may make sense on the group and inter-group levels of analysis. Individually expressed attitudes are subject to group influences in the form of social desirability, that is, what is appropriate to value or express. Similarly, norms governing individual behaviors and organizational roles should be understood as group phenomena: the means by which groups regulate member behaviors and maintain group boundaries. The organizationally and culturally reinforced role behaviors reflect those aspects of social life in which people are more concerned with or more able to conserve traditional modes of behavior. For the dominant group to recognize that con-servation of some values is bought at the expense of women will require time. But, according to the first model, once the realization of injustice occurs, behavioral change will follow.

Our second model assumes that systemic change, such as the movement toward the equal treatment of women in the paid labor force, is partly a function of the aggregate of individuals' experiences and changes. As people increasingly come into contact with evidence testifying against the traditional sex-role ideology, their attitudes change. But general attitudes may not at first seem relevant to people's day-to-day lives. Only after a while do contradictions become apparent. Personal experience with the wealth of data contradicting traditional beliefs embedded in one's organizational role may provoke a good deal of anxiety—similar to the dissonance experienced when one behaves inconsistently with one's values.

As psychologists, we suggest that the process by which system change occurs is hastened by the extent to which individuals are able to keep the anxiety aroused by their own contranormative experiences alive. This is in spite of the individual tendency to seek closure and certainty in face of psychologically uncomfortable anxiety and societal and organizational pressures toward accepting the certainty and safety afforded by

acceptance of the status quo. These individual and contextual pressures serve as defenses against personal experiences contradicting embedded, outdated values and enable us to repress the anxiety that always seems to accompany paradoxical behavior. It is by coming to terms with their anxiety that individuals change and develop; it is by coming to terms with group anxieties, such as those inevitably characterizing class struggles, that social systems change.

This model implies that movement toward the equal treatment of working women is not an inevitable evolutionary process but is dependent on efforts to make individuals realize the disparity between their own expressed values and their behaviors. The point is to heighten one's awareness of unwitting complicity in discriminatory behavior, thus heightening one's anxiety about being "forced" to act inconsistently with one's own (socially desirable) values. Theoretically, as more individuals experience the anxiety, change will be accelerated. Consider in this context the striking worker: Individuals forced to cross picket lines of coworkers will experience the anxiety and personal disruption that leads to systemic disruption and change. The primary objective is to make explicit the paradox of egalitarian attitudes and discriminating behaviors, and, further, to convince people that responsibility for the paradox lies with individuals—groups and organizations of individuals, to be sure, but people nevertheless. Taking, rather than diffusing, the responsibility for one's own discriminating behaviors and perceiving the intimate relationships between familial sex roles, women's labor rights, and nonfamilial institutions (Martin et al., 1983; Mason & Bumpass, 1975) will guide us toward a nonsexist paid labor market. Again, this is an optimistic analysis, but one trusting to individual rather than systemic forces.

Modification of institutional structures, not individual change, lies at the heart of the final model. Institutions can be modified through laws and through practice. The legislation of affirmative action and equal opportunity policies—and, most important, the evaluation and enforcement of those policies—may lay the groundwork for change. As Kanter (1977) suggests, organizations must devise and execute policies explicitly designed to empower women and enhance their opportunities. Such policies include creating bridges between job ladders, flexible working hours, job redesignation and rotation, decentralization, autonomous work teams, and opening channels of communication, as well as the batch hiring, training, and clustering of women workers. Unlike the other models, this model of change asserts that simply and directly implementing structural changes is the most effective means of achieving parity for working women. The reasoning is that if the

egalitarian treatment of women is mandated by the organizational hierarchy, the members will behave accordingly as a function of their value for the smooth maintenance of the organization and the norm discouraging the questioning of authority. If egalitarianism becomes embedded in one's organizational role expectations, unintentional sex discrimination will be mitigated.

Although deceptively simple, this model is more intrusive than the two outlined above. It does not assume that systems naturally evolve over time; nor does it count on the experience of personal anxiety to evoke system change. Rather, this model asserts that systems change as a result of direct structural intervention and, further, that people will eventually adapt to structural change as a necessary by-product of reducing the dissonance of incongruent thoughts and behaviors. Such adaptation takes time, however, and people are likely to feel uncomfortable as they deal with the ambivalence of changing basic values while maintaining some sense of certainty. It is this ambivalence that characterizes the changing of attitudes toward, and labor force stasis of, working women—an ambivalence not likely to dissipate within the current generation. As Leavitt (1976) notes:

> Maybe what we are doing is offering up a sacrificial generation—a generation of people who will have to absorb the conflicts until a new generation swings itself ponderously into place.

That we are in some sense caught in the midst of social change underlies each of the three models we have described. Although the models differ in terms of implications for individual action, none suggest that individuals should sit passively by and await the new generation of social behavior. Individuals create structural, institutional, and societal change. Such change necessitates political behavior occurring in a variety of individual situations, organizational contexts, and explicitly political arenas. Employers can hire and promote more women, paying close attention to how the standards they use for hiring and promotion may bias the system in favor of those whose backgrounds conform to the standard mold. Working women themselves can, as Crosby (1984) suggests, complain, compare, and question. Recognizing and pointing out organizational practices that have the potential to discriminate against women is, at this point, the way in which women alert both one another and the men in their systems to the paradox of expressed egalitarianism and behavioral discrimination. It is the gaining of insight into the individual and structural forces maintaining that paradox that will eventually enable its resolution.

NOTES

1. One way of understanding these widespread stereotypic beliefs about women is that they serve mutually reinforcing dual purposes: To enhance performance in traditional sex roles (O'Leary, 1974) and to rationalize the position of women in the labor force. If the stereotypes are accurate (the reasoning goes), women *should* be primarily concerned with household and child raising duties rather than spending time in work settings for which they are clearly ill-suited. At one stroke this argument legitimizes women's primary responsibility for the family and rationalizes their lower status in the work place. In spite of the changing nature of the family and the work place, this argument has maintained its force in our culture by its grounding in traditional assumptions about men, women, and their actual behaviors that have now achieved the status of common misconceptions (Laws, 1976). These assumptions represent unquestioned, deeply ingrained beliefs learned and reinforced since childhood. They also represent the building blocks of the sex-role stereotypes and, as such, form the nucleus of a cognitive classification system (of overgeneralizations) more immune to correction than are attitudes (Adams, Lawrence, & Cook, 1979; Petro & Putnam, 1979; Ruble, 1983).

2. The maintenance of these inequalities in the experience of women seems incongruent with the model of the rational, bureaucratically efficient organization. Miller, Labovitz, and Fry (1975) note that this apparent organizational "schizophrenia" does not necessarily undermine organizational efficiency; they argue that not all discrimination is costly, organizationally, if the basic rationality of the system (that technically qualified people are in control) is intact. The authors also note that this basic rationality becomes compartmentalized throughout the system—presumably as a way of avoiding the anxiety surrounding the incongruency of discrimination in a system maximizing efficiency. Organizations manage to survive, and thrive, while supporting systematic discrimination. Those who suffer are primarily the working women themselves. Besides the economic and organizational rewards they are denied, women suffer psychologically: Working women typically devalue their own achievements relative to men (Deaux, 1979), developing self-images to match their situations (Kanter, 1977). These self-images, and the lowered aspirations they engender, tend to reinforce the traditional sex roles embedded in the organizational context.

REFERENCES

Adams, J. R., Lawrence, F. P., & Cook, S. J. (1979). Analyzing stereotypes of women in the work force. *Sex Roles, 5*, 581-594.

Agassi, J. B. (1982). *Comparing the work attitudes of women and men.* Lexington, MA: Lexington Books.

Ajzen, I., & Fishbein, M. (1977). Attitude-behavior relations: A theoretical analysis and review of empirical research. *Psychological Bulletin, 84*, 888-918.

Barnes, W. F., & Jones, E. B. (1975). Women's increasing unemployment: A cyclical interpretation. *The Quarterly Review of Economics and Business, 15*, 61-69.

Barrett, N. S. (1979). Women in the job market: Occupations, earnings, and career opportunities. In R. E. Smith (Ed.), *The subtle revolution.* Washington, D.C.: The Urban Institute.

Barrett, N. S., & Morgenstern, R. D. (1974). Why do blacks and women have high unemployment rates? *Journal of Human Resources, 9*, 452-464.

Bass, B. M., Krusell, J., & Alexander, R. A. (1971). Male managers' attitudes toward working women. *American Behavioral Scientist, 15*, 221-236.

Bem, D. J. (1972). Self-perception theory. In L. Berkowitz (Ed.), *Advances in experimental social psychology* (Vol. 6). New York: Academic Press.

Blau, F. D. (1978). The data on women workers, past, present and future. In A. H. Stromberg & S. Harkness (Eds.), *Women working*. New York: Mayfield.

Blaxall, M. & Reagan, B. (Eds.). (1976). *Women and the workplace: The implications of occupational segregation*. Chicago: University of Chicago Press.

Bowman, G. W., Worthy, N. B., & Greyser, S. A. (1965). Are women executives people? *Harvard Business Review, 43*, 14-28, 164-178.

Brehm, J. W. (1960). A dissonance analysis of attitude-discrepant behavior. In M. J. Rosenberg, C. I. Hovland, W. J. McGuire, R. P. Abelson, & J. W. Brehm (Eds.), *Attitude organization and change*. New Haven: Yale University Press.

Broverman, I. K., Vogel, S. R., Broverman, D. M., Clarkson, F. E., & Rosenkrantz, P. S. (1972). Sex-role stereotypes: A current appraisal. *Journal of Social Issues, 28*, 59-78.

Bularzik, M. (1978). Sexual harassment at the workplace: Historical notes. *Radical America, 12*, 25-43.

Chaiken, S., & Baldwin, M. W. (1981). Affective-cognitive consistency and the effect of salient behavioral information on the self-perception of attitudes. *Journal of Personality and Social Psychology, 41*, 1-12.

Cherlin, A., & Walters, P. B. (1981). Trends in United States men's and women's sex role attitudes: 1972-1978. *American Sociological Review, 46*, 453-460.

Chusmir, L. H. (1982). Job commitment and the organizational woman. *Academy of Management Review, 7*, 595-602.

Converse, P. E., Dotson, J. D., Hoag, W. J., & McGee, W. H., III. (1980). *American social attitudes data sourcebook 1947-1978*. Cambridge, MA: Harvard University Press.

Crino, M. D., White, M. C., & DeSanctis, G. L. (1981). A comment on the dimensionality and reliability of the women as managers scale (WAMS). *Academy of Management Journal, 24*, 866-876.

Crosby, F. (1982). *Relative deprivation and working women*. New York: Oxford University Press.

Crosby, F. (1984). The denial of personal discrimination. *American Behavioral Scientist, 27*, 371-386.

Davidson, A. R., & Morrison, D. M. (1983). Predicting contraceptive behavior from attitudes: A comparison of within- versus across-subjects procedures. *Journal of Personality and Social Psychology, 45*, 997-1009.

Deaux, K. (1979). Self-evaluations of male and female managers. *Sex Roles, 5*, 571-580.

deBoer, C. (1977). The polls: Women at work. *Public Opinion Quarterly, 41*, 268-277.

Dinnerstein, D. (1971). *The mermaid and the minotaur: Sexual arrangements and human malaise*. New York: Harper, Coliphon.

Duncan, B., & Duncan, O. D. (1978). *Sex typing and social roles: A research report*. New York: Academic Press.

Erskine, H. (1971). The polls: Women's role. *Public Opinion Quarterly, 35*, 275-290.

Farley, L. (1978). *Sexual shakedown: The sexaul harassment of women on the job*. New York: McGraw-Hill.

Ferber, M., Huber, J., & Spitze, G. (1979). Preference for men as bosses and professionals. *Social Forces, 58*, 466-476.

Ferber, M., & Lowry, H. M. (1976). Women: The new reserve army of the underemployed. In M. Blaxall & B. Reagan (Eds.), *Women and the workplace: The implications of occupational segregation*. Chicago: University of Chicago Press.

Festinger, L. (1957). *A theory of cognitive dissonance*. Evanston, IL: Row, Peterson.

Fox, M. F., & Hesse-Biber, S. (1984). *Women at work*. New York: Mayfield.

Gallup, G. H. (1972). *The Gallup poll: Public opinion 1935-1971.* New York: Random House.

Gallup, G. H. (1978). *The Gallup poll: Public opinion 1972-1977.* Wilmington, DE: Scholarly Resources, Inc.

Gornick, V. (1983). *Women in science: Portraits from a world in transition.* New York: Simon & Shuster.

Gross, E. (1968). Plus ca change? The sexual structure of occupations over time. *Social Problems, 16,* 198-208.

Gutek, B. A., & Morasch, B. (1982). Sex-ratios, sex-role spillover, and sexual harassment of women at work. *Journal of Social Issues, 38,* 55-74.

Hall, R. H. (1982). *Organizations: Structure and process.* Englewood Cliffs, NJ: Prentice-Hall.

Harris, L., & Associates. (1970). *The Virginia Slims American Women's Opinion Poll.* New York: Louis Harris and Associates, Inc.

Horney, K. (1932). The dread of women. *International Journal of Psychoanalysis, 13,* 348-360.

Kaley, M. M. (1971). Attitudes toward the dual role of the married professional woman. *American Psychologist, 26,* 301-306.

Kanter, R. M. (1976). The policy issues. In M. Blaxall & B. Reagan (Eds.), *Women and the workplace: The implications of occupational segregation.* Chicago: University of Chicago Press.

Kanter, R. M. (1977). *Men and women of the corporation.* New York: Basic Books.

Laws, J. L. (1976). Work aspirations of women: False leads and new starts. In M. Blaxall & B. Reagan (Eds.), *Women and the workplace: The implications of occupational segregation.* Chicago: University of Chicago Press.

Leavitt, H. J. (1976). The social institutions of occupational segregation. In M. Blaxall & B. Reagan (Eds.), *Women and the workplace: The implications of occupational segregation.* Chicago: University of Chicago Press.

MacKinnon, C. A. (1979). *Sexual harassment of working women.* New Haven, CT: Yale University Press.

Martin, P. Y., Harrison, D., & Dinitto, D. (1983). Advancement for women in hierarchical organizations: A multilevel analysis of problems and prospects. *The Journal of Applied Behavioral Science, 19,* 19-33.

Mason, K. O., & Bumpass, L. L. (1975). U.S. women's sex-role ideology, 1970. *American Journal of Sociology, 80,* 1212-1219.

Mason, K. O., Czajka, J. L., & Arber, S. (1976). Change in U.S. women's sex-role attitudes, 1964-1974. *American Sociological Review, 41,* 573-596.

McNally, F. (1979). *Women for hire: A study of the female office woker.* New York: St. Martin's Press.

Miller, J., Labovitz, S., & Fry, L. (1975). Inequities in the organizational experiences of women and men. *Social Forces, 54,* 365-381.

Neugarten, D. A., & Shafritz, J. M. (Eds.). (1980). *Sexuality in organizations: Romantic and coercive behaviors at work.* Oak Park, IL: Moore.

Niemi, B. (1975). Geographic immobility and labor force mobility: A study of female unemployment. In C. B. Lloyd (Ed.), *Sex, discrimination and the division of labor.* New York: Columbia University Press.

Nieva, V. F., & Gutek, B. A. (1980). Sex effects on evaluation. *Academy of Management Review, 5,* 267-276.

Nieva, V. F., & Gutek, B. A. (1981). *Women and work: A psychological perspective.* New York: Praeger.

Nilson, L. B. (1976). The occupational and sex-related components of social standing. *Sociology and Social Research, 60,* 328-336.

Nisbett, R. E., & Ross, L. (1980). *Human inference: Strategies and shortcomings of social judgment.* Englewood Cliffs, NJ: Prentice-Hall.

O'Leary, V. E. (1974). Some attitudinal barriers to occupational aspirations in women. *Psychological Bulletin, 81,* 809-826.

Oppenheimer, V. (1968). The sex-labeling of jobs. *Industrial Relations, 7,* 219-234.

Parelius, A. P. (1975a). Change and stability in college women's orientations toward education, family, and work. *Social Problems, 22,* 420-431.

Parelius, A. P. (1975b). Emerging sex-role attitudes, expectations, and strains among college women. *Journal of Marriage and the Family, 37,* 146-153.

Parnes, H. S., Jusenius, C. L., Blau, F., Nestel, G., Shortlidge, R., Jr., & Sandell, S. (1975). *Dual careers: A longitudinal analysis of the labor market experience of women* (Vol. 4). Columbus, OH: Center for Human Resource Research.

Peters, L. H., Terborg, J. R., & Taynor, J. (1974). Women as managers scale: A measure of attitudes toward women in management positions. *JSAS Catalog of Selected Documents in Psychology, 4,* 27.

Petro, C. S., & Putnam, B. A. (1979). Sex-role stereotypes: Issues of attitudinal changes. *Sex Roles, 5,* 29-39.

Reagan, B., & Blaxall, M. (1976). Introduction: Occupational segregation in international women's year. In M. Blaxall & B. Reagan (Eds.), *Women and the workplace: The implications of occupational segregation.* Chicago: University of Chicago Press.

Roper Organization. (1974). *The Virginia Slims American Women's Opinion Poll* (Vol. III). Storrs, CT: Roper Center, University of Connecticut.

Roper Orgnization. (1980). *The 1980 Virginia Slims American Women's Opinion Poll.* Storrs, CT: Roper Center, University of Connecticut.

Rotella, E. J. (1980). Women's roles in economic life. In S. Ruth (Ed.), *Issues and feminism: A first course in women's studies.* Boston: Houghton Mifflin.

Ruble, T. L. (1983). Sex stereotypes: Issues of change in the 1970s. *Sex Roles, 9,* 397-402.

Ruble, T. L., Cohen, R., & Ruble, D. N. (1984). Sex stereotypes: Occupational barriers for women. *American Behavioral Scientist, 27,* 339-356.

Ryan, W. (1971). *Blaming the victim.* New York: Pantheon Books.

Schuman, H. (1972). Attitudes vs. actions versus attitudes vs. attitudes. *Public Opinion Quarterly, 36,* 347-354.

Serrin, W. (1984, July 31). Shifts in work put white men in the minority. *The New York Times,* p. 133.

Shepard, W. O., & Hess, D. T. (1975). Attitudes in four age groups toward sex role division in adult occupations and activities. *Journal of Vocational Behavior, 6,* 27-39.

Siegelman, L., Milward, H. B., & Shepard, J. M. (1982). The salary differential between male and female administrators: Equal pay for equal work? *Academy of Management Journal, 25,* 664-671.

Smith, C. B. (1979). Influence of internal opportunity structure and sex of worker on turnover patterns. *Administrative Science Quarterly, 24,* 362-381.

Smith, T. W. (1980). *A compendium of trends on General Social Survey questions.* NORC Report No. 129. Chicago: National Opinion Research Center.

Spitze, G., & Huber, J. (1980). Changing attitudes toward women's nonfamily roles: 1938 to 1978. *Sociology of Work and Occupations, 7,* 317-335.

Strober, M. H. (1976). Toward dimorphics: A summary statement to the conference on occupational segregation. In M. Blaxall & B. Reagan (Eds.), *Women and the workplace: The implications of occupational segregation.* Chicago: University of Chicago Press.

Suchner, R. W., & More, D. M. (1975). Stereotypes of males and females in two occupations. *Journal of Vocational Behavior, 6*, 1-8.

Suter, L. E., & Miller, H. P. (1973). Income differences between men and career women. *American Journal of Sociology, 78*, 962-974.

Terborg, J. R., & Ilgen, D. R. (1975). A theoretical approach to sex discrimination in traditionally masculine occupations. *Organizational Behavior and Human Performance, 13*, 352-376.

Terborg, J. R., Peters, L. H., Ilgen, D. R., & Smith, F. (1977). Organizational and personal correlates of attitudes toward women as managers. *Academy of Management Journal, 20*, 89-100.

Thornton, A., & Freedman, D. (1979). Changes in the sex-role attitudes of women, 1962-1977: Evidence from a panel study. *American Sociological Review, 44*, 832-842.

Trafford, A., Avery, P. A., Thornton, J., Carey, J., Galloway, J. L., & Sanoff, A. P. (1984). She's come a long way: Or has she? *U.S. News and World Report 97*, 44-51.

Treiman, D. J., & Hartmann, H. I. (1981). *Women, work and wages: Equal pay for jobs of equal value.* Washington, DC: National Academy Press.

Treiman, D. J., & Roos, P. A. (1983). Sex and earnings in industrial society: A nine-nation comparison. *American Journal of Sociology, 89*, 612-650.

Treiman, D. J., & Terrell, K. (1975). Women, work and wages: Trends in the female occupational structure since 1940. In K. C. Land & S. Spilerman (Eds.), *Social indicator models.* New York: Russell Sage.

Tsui, A. S., & Gutek, B. A. (1984). A role set analysis of gender differences in performance, affective relationships, and career success of industrial middle managers. *Academy of Management Journal, 27*, 619-635.

Waite, L. J. (1981). U.S. women at work. *Population Bulletin, 36*(2). Washington, DC: Population Reference Bureau.

Wirtenberg, T. J., & Nakamura, C. (1976). Education: Barrier or boon to changing occupational roles of women? *Journal of Social Issues, 32*, 165-180.

Yarburg, B., & Arafat, I. (1975). Current sex role conceptions and conflict. *Sex Roles, 1*, 135-146.

9

Women and the Exercise of Power in Organizations

FROM ASCRIBED TO ACHIEVED STATUS

CAROLYN R. DEXTER

Work in modern life is conducted largely in bureaucratic organizations. Although women play a major role in the labor force, they are underrepresented in managerial positions. This chapter analyzes some mechanisms that either facilitate or prevent women from becoming managers. It develops a perspective that integrates women's primary family socialization to ascribed status with the achieved status demands of managers in large organizations. Although many women now aspire to and train for professional positions, they often carry with them to their new careers some attitudes and interpersonal skills learned in family settings that are inappropriate for managerial positions in large organizations. Behaviors associated with the exercise of power, the structure of interpersonal relationships, and culture in bureaucratic organizations differ from those women learn as a result of their primary socialization. These differences demand that women undergo a two-stage socialization process, first to ascribed and then to achieved status, to reach managerial positions. This two-stage process consists of different mechanisms for women's access to the labor force than for their promotion to managerial positions.

In 1983, 53 percent of the women aged 20 years and over were in the labor force compared to 79 percent of men (U.S. Department of Labor, 1984, p. 65). Bartos (1982, p. 104) reports that an additional 25 percent of all women are nonworking housewives planning to reenter the labor market. The traditional role of full-time housewife is becoming less common as the number of two-income families continues to increase (New York Times, April 5, 1984, p. C-7).

Several studies indicate that women have been more successful in gaining access to the labor force than in receiving equitable rewards for their contributions (Alexander & Sapery, 1972; Wertheimer & Nelson, 1975; Lloyd & Niemi, 1979; Epstein, 1980; Beck & Powers, 1984). Employed women are relegated primarily to gender-defined occupations or to the lower ranks of traditionally male occupations (Darling, 1975, p. 57; Federal Civilian Work Force Statistics, 1981; Mellor, 1984).

Regardless of the type of work or the type of organization involved, women's employment is characterized by limited power over their own and others' activities, few economic or symbolic rewards, and low prestige (Powell & Jacobs, 1984a, 1984b; Fullerton & Tschetter, 1983; Bose & Rossi, 1983; Spitze & Huber, 1980; Rosenfeld, 1979; Kanter, 1977). The phenomenon occurs across all types of organizations and regardless of institution. Women are low-status participants in religious, cultural, educational, political, and economic organizations, both in the United States and overseas (Welch, 1982; Izraeli, 1979; Sorentino, 1984; Darling, 1975).

There are exceptions. A few women have achieved notable positions and their names appear in the public press. It is not uncommon for these women to attribute their success to individual ability and to be unaware of the structural determinants that facilitated their achievements (Lee, 1937; Epstein, 1980). Even in these exceptional cases, it is not always clear if the women occupy positions of actual organizational decision-making or how they achieved their positions.

A central question raised in this chapter is: Why have women in general not been more successful in achieving managerial positions in large organizations? These organizations play a dominant role in the economy, and the failure of capable women to attain and occupy managerial positions places severe limits both on their potential for personal reward and on their ability to affect the direction of society.

Explanations of social mobility in the United States have dealt almost exclusively with intergenerational mobility. Social class, usually measured by father's occupation, along with son's education and first job, were useful in predicting the experience of white male sons (Bendix & Lipset, 1966; Blau & Duncan, 1967). These models focused on individual status attainment and ignored the structurally determined availability of managerial employment. Europeans, in contrast, were concerned with relationships between classes that controlled the allocation of available positions and limited the opportunity for upward mobility (Goldthorpe, 1980; Kerckhoff, 1984).

With the advent of the Civil Rights Movement of the 1960s, the limitations of both of these models became evident. It became clear that gender and race were in fact the primary determinants of occupational mobility. For example, Alexander and Sapery (1972, p. 40) found the chances of achieving managerial positions were 1 in 3 for white men, 1 in 12 for black men, 1 in 17 for white women, and 1 in 48 for black women. These data indicate that ascribed statuses played the dominant role in promotions to managerial positions. Ascribed statuses are those determined at birth and based on unchangeable characteristics such as race and gender (Linton, 1936; Parsons, 1951). However, recent research

suggests that at least for middle-class blacks, achievement, or learned abilities, has replaced race as primary determinant of managerial status (Hout, 1984; Featherman & Hauser, 1976). These findings raise the question of the nature of the transition from ascribed to achieved status. Under what conditions does admission to managerial status change from ascription to achievement? And in particular what are the implications of female ascriptive characteristics for achieving managerial positions?

Research on sex roles has documented the differences between the male and female occupational experience. These studies describe differences in women's learned attitudes and skills that channel them early into educational and occupational choices limiting their mobility to managerial positions (Lyson, 1984; Gomez-Mejia, 1983). Other scholars have observed differences in the labor markets in which women and men are employed that result in women's marginal occupational status (Hall, 1983; Rosenfeld, 1979). These studies have indicated the need to take into account the interface of three levels of analysis: Individual socialization, labor market structure, and the organization of the firm (Montagna, 1977; Rosenfeld, 1979; Hall, 1983).

In this chapter I explore the notion of power as a variable that may explain gender differences in promotions to managerial positions in large organizations. By power I mean the "probability that one actor within a social relationship will be in a position to carry out his own will despite resistance, regardless of the basis on which the probability rests" (Weber 1947, p. 152). Power is viewed as a mechanism that links girls' primary socialization to ascribed status with the achieved status requirements of successful organizational managers.

Second, the character of managerial interpersonal relationships and the culture of bureaucratic organizations are described. These managerial skills are then discussed as learned skills that girls growing up in family settings are less likely to learn than boys. Finally, the interplay of ascribed characteristics and the organizational structure of work are analyzed. Family socialization is found to support women's access to professional occupations but to conflict with the demands of managerial status. Models developed by Nicholson (1984) and Quinn, Tabor, and Gordon (1968) are used to determine those organizational arrangements affecting access to large organizations and promotion to managerial positions.

POWER AS A MANAGERIAL SKILL

The exercise of power in hierarchical relationships distinguishes bureaucratic organizations from other types of social affiliation (Weber,

1947; Kotter, 1979; Pfeffer, 1981). As a result, social relationships in organizations differ from those in families, for example, in a number of ways (Weber, 1947; Parsons, 1951; Zetterberg, 1962). The number of personal activities subject to organizational control are fewer than those subject to family control. One's boss can demand only specific types of on-the-job activities. Parents can demand a limitless range of compliance, from what one studies to whom one marries.

Second, the character of organizational social relationships differs from family relationships. In Parsons's (1951) terms, organizational and social relationships are universalistic rather than particularistic. By these terms he means that in organizations the expectation is that all individuals occupying similar statuses should be treated in a similar fashion. However, in families the norm is that members of one's own family should be treated preferentially compared to members of other families. In organizations one's interaction with other members is expected to be determined by their officially defined rights and responsibilities.

The exercise of power in organizational relationships also varies from that in family relationships. Two types of power have been identified: Formal power based on the status one occupies and informal power based on the results of interaction with others (Etzioni, 1975).

Managers and chief executive officers (CEOs) are charged with the tasks of coordinating the activities of other organizational members and negotiating with members of external organizations to provide resources and markets. Persons who occupy these positions, which are nominally high in status and well rewarded, are simultaneously dependent on others for information required to make decisions and to assess the performance of the organization as a whole. Because of the scale and complexity of modern organizations this dependency ranges across all organizational levels, including persons in positions with which management normally has little or no interaction.

An example of the managers of bureaucratic organizations' needs to cope with dependence is provided by Kotter and Lawrence's (1974) study of mayors. Equal in their formal power, successful mayors differed from unsuccessful mayors in their ability to maintain a large network of relationships with subgroups both inside and outside of city government whose support was required to achieve city goals. The quality of their performance, and their jobs, depended on their ability to recruit the contributions of others over whom they had no formal control.

Coping with organizational dependence, then, is central to successful maintenance of managerial positions. Managers are unable to rely solely on the formal power of their positions, but must exercise informal

power to comply successfully with the demands of their jobs. The mechanisms for acquiring and exercising power are numerous, vary, and require continual effort (Kotter, 1979; Pfeffer, 1981). Kotter (1979, p. 37) proposes a model of managerial behavior and the acquisition of power in which managers' interpersonal and analytical skills, knowledge, and energy level increase or decrease their power through control of important resources by establishing favorable relationships with other organizational members. These favorable relationships may be based on a sense of obligation, professional reputation, identification of others with the manager, and perceived dependence. Moreover, this type of power may increase or decrease depending on managers' skill in maintaining their relationships with others. Resources expended in gaining compliance of one organization member need to be replaced to maintain the compliance of others. Managers must actively control their relationships with other organizational members to counter their organizational dependence and to provide the leadership expected of their positions.

Implicit in the exercise of this type of power is the maintenance of multiple relationships. Seiber (1974) argues that a wide network of relationships increases both the information and the rewards available for status enhancement. Resources obtained from one relationship may be used to motivate compliance in another.

Finally, organizations, though nominally controlled by rules, are complex (Weber, 1947). Rapid market fluctuations in a global economy demand more flexible forms of organizational control. Etzioni (1975) identified the importance of organizational culture as a mechanism for coordinating organizational members' activities. Culture is a shared set of beliefs, values, and norms (Parsons, 1951; Zetterberg, 1961). A common culture among organizational members permits coordination of widely dispersed and loosely coupled subgroups. Deal and Kennedy (1982) found that organizational cultures varied depending on the degree of risk and the speed of feedback in an organization's relations with its environment. The extent to which members share the organizational culture will enhance their acceptability in managerial positions.

A cultural norm important for the exercise of power is the "norm of reciprocity" (Gouldner, 1960). This is a process whereby granting unearned rewards earns later compliance on the part of grantees. However, it is only available to those who have accumulated sufficient resources with which to trade. Although not identifying women specifically, he mentions children as being among those whose social position precludes them from accumulating control over discretionary resources.

In summary, successful management candidates are those who are motivated to understand, acquire, and exercise organizational power;

feel comfortable operating in a complexity of multiple, narrow, "universalistic" relationships; and share the cultural values of their organizational coworkers. If women are rarely found in upper management positions we suggest examining the mechanisms that limit their motivation and ability to acquire and exercise organizational power.

POWER AS LEARNED BEHAVIOR

In developed countries work life and family life are organized along different and, in the case of women, often conflicting lines. Some behaviors and norms learned in one setting are inappropriate and detrimental to successul performance in the other. The critical difference in the socialization of men and women is that, despite recent advances, women are socialized primarily to occupy a family role, an ascribed status (Linton, 1936, Spitze & Waite, 1980). Men, on the other hand, learn both economic and family roles, or achieved as well as ascribed statuses (Linton, 1936). In the case of men, their ascribed status as head of household is the dominant family role. Their achieved status in the economy as breadwinner is learned in the company of males and includes acquiring and exercising bureaucratic power. For women, gender socialization emphasizes an ascribed status in which they are subordinate to men: First to their fathers, then to their husbands. Moreover, these are the only two relationships they are encouraged to maintain with men. Unfortunately, the opportunity for women's upward organizational mobility is limited by the socialization of both men and women to the norm that women should occupy primarily ascribed statuses that are subordinate to men. Peer socialization for women is predominately in the company of females and in nonbureaucratic settings, I propose that although women increasingly aspire to professional careers, these goals are not accompanied by motivation or opportunities to learn the exercise of power appropriate for managerial positions in bureaucratic organizations.

In a study of power motivation McClelland (1975) noted that both men and women exhibited high power needs but that they expressed those needs differently. According to McClelland's data, power is learned differently by boys and girls. Those of each gender high on power motivation expressed their need by exaggerating gender stereotypes: Work and family roles for men and family roles for women. Power-motivated men were assertive and emotional. Power-motivated women were concerned about being a resource to others rather than asserting their own demands. Ascribed status is comparable to formal organization power in which the incumbent need not be concerned with the acquisition and maintenance of power to hold his or her position. In

achieved status an incumbent's or organization manager's position is based on the exercise of informal power through interaction with others. The difference between socialization to ascribed and achieved status results in different experiences in the exercise of power. For women, primary socialization to ascribed status of wife or mother fails to provide them with the knowledge that successful performance in achieved managerial roles requires acquiring, maintaining, and exercising power over other organizational members.

In addition to power orientation, the type of interaction skills learned in families also differs from those used in organizations. In families, as previously noted, relationships are few, broad in scope, encompassing a range of activities; status is particularistic and subordinate to men. When a woman moves from her family into an organization, her interactional skills learned and functional in the home conflict with the expectation of other organizational members, particularly with those of men and those in high positions. Learned compliance and experience as a subordinate in relationships with others is dysfunctional for those aspiring to managerial positions. Finally the difference in gender culture (Hennig & Jardim, 1977) means women are generally omitted from informal relationships with other managers who are predominately men. It is primarily through these relationships that power is acquired and exercised.

We can expect that a woman's occupational choice will be based on her primary socialization. Moreover, the primary socialization of the men with whom she must interact predisposes them to perceive women in ascribed rather than achieved status. There are few opportunities currently available for women to learn bureaucratic norms, or for boys and girls to interact with each other in bureaucratically organized activities. As a result, a woman's achievement-oriented managerial socialization most often occurs after obtaining first employment (Gomez-Mejia, 1983). Although some women learn bureaucratic skills in volunteer organizations, these are most likely to be gender-segregated organizations in which the norms of family relationships penetrate the structure of the organization to a greater extent than is true in work organizations dominated by men. For most women, achieving a managerial position requires a *two-stage* process of transition from ascribed to achieved status involving different mechanisms for access and promotion. Today's managerial women either have never been traditionally socialized (Symons, 1984) or have learned two different types of expected behavior—a difficult, time-consuming, and costly process. For women, managerial achievement is radical and deviant behavior.

OCCUPATIONAL ACCESS

The impact of gender socialization is observed in the fact that women seek, and are most accepted in, managerial roles consonant with the gender socialization of both men and women. They most often enter the labor force in low-ranked positions such as sales and clerical workers (Tsuchigane & Dodge, 1974; Mellor, 1984). Women who do become managers are most likely to do so in positions that require interaction with persons occupying positions outside the established societal power structure: Children, the poor, sick, disabled, or mentally ill. Even in specialized organizations, such as high schools and nursing organizations, those high-status positions that interact with prestigious members of society generally are occupied by men. Given the differences and the extent of gender occupational segregation, it is not surprising that prospective male employers perceive women in terms of their ascribed rather than their achieved characteristics. Their gender is not only more visible; it is a position in which they are socially defined regardless of individual desires and abilities. An example is provided by Etzioni (1975) in a study of semiprofessions, including nursing and social work. The semiprofessions are those whose members interact in a service capacity and depend on others for their authority. The services provided by these "helping professions" are similar to those assigned to women in their family roles. We propose that it is not accidental that semiprofessionals are predominantly women. The problem for prospective women managers is not only successfully *doing the job,* but also *gaining access* to the higher organizational positions.

Nicholson (1984) presents a model that links preoccupational socialization with organizational job requirements. His model predicts incumbents' adaptation to new roles based on the fit between current and prior positions in respect to demands for discretion and novelty. New positions that are low on both discretion and novelty permit *replication* of prior knowledge. Those low on discretion and high on novelty result in incumbents being *absorbed* by new role demands. Those high on discretion and low on novelty permit personal development of incumbents through their ability to *determine* the nature of the role. And finally those high on both discretion and novelty allow *exploration* providing for both personal and role development.

Applying these notions to women entering the labor force from ascribed family positions, we would expect they would be most likely to seek and be seen as qualified by others for positions that replicate their prior ascribed positions, positions low on discretion and novelty. These

TABLE 9.1
Modes of Role Transition

| | Novelty | |
	High	Low
Discretion		
High	Exploration	Determination
Low	Absorption	Replication

are positions most clearly identified with gender norms, in which the leap from ascribed to achieved position requires the least change and effort on the part of incumbents or their supervisors. Macke (1981) reports in a study of token men and women that role partners, persons with whom one interacts, devalue occupational competence compared to gender identification in opposite-sex dominated occupations. Although full-time housewives and mothers may individually exercise discretion and novelty in fulfilling their role prescription, societal norms place them outside the economy in the status of unpaid and occasional labor and as subordinate to the male head-of-household. They are excluded from exercising managerial power over others in bureaucratic organizations and therefore have no need to develop skills in its acquisition or exercise. They deal with the economic world as surrogates for their family's status. (Nieva & Gutek, 1981). A colleague relates a story that aptly illustrates this referent exercise of power. A diminutive daughter of a wealthy citizen was addressed, "My, what a little thing you are." She responded, "Not when I stand on my daddy's money bags, I'm not."

For women, managerial occupations are positions that require discretion or novelty—perceived as new prescriptions compared to their prior ascribed status. Successfully bridging the social distance from ascribed to achieved status would require conditions on the part of work organizations that would render prior gender socialization on the part of employer and employee ineffective.

I propose that entry criteria based on credentials, labor markets in which the supply of candidates is limited in relation to demand, and large organizational size are three characteristics of the organization of work that affect positively women's ability to enter managerial positions.

In seeking to enhance their employment status women have prepared themselves in increasing numbers for the professions of higher education, medicine, and law. More recently accounting and business have been professions selected by women. Admission to all programs but business are by examination, and in business the M.B.A. is the common-

ly accepted admissions credential (The Chronicle of Higher Education, 1984; National Center for Educational Statistics, 1979-1980). In addition, accounting and business have exhibited recent increases in the number of women entrants as they provide professional employment with a minimal educational investment. Burke (1982) observed in a historical analysis of American higher education that prospective students based decisions to enter college on a cost/benefit analysis of the relationships between the prospective income and the cost of education and lost wages while attending school.

Women began entering law and medicine when the labor supply in those professions was short. As the market situation changed, the pattern of choices moved to business and accounting. Now that medicine and law are becoming saturated, we would expect market pressures to affect the employment of women regardless of skill or knowledge (Szafran, 1984).

In considering the employment of women, we would expect to find women employed in managerial positions in large firms, first, because large organization demands "universalistic" rules that diminish the opportunity for prejudice in the employment of women and, second, because the cost of noncompliance with legal affirmative action prescriptions and the likelihood of being identified as a target for legal challenge is greatest in these firms. In 1976, Wallace reported on AT&T's experience as a result of court-ordered desegregation. This firm was required to desegregate gender-defined occupations. The cost was substantial as a large number of women had been relegated to the position of telephone operator. More recently, United Airlines was ordered to pay 37.9 million dollars in back wages to stewardesses fired in the 1960s as a result of the airlines' "no-marriage" rule (New York Times, April 5, 1984, p. C-7). These possibilities deter employers' propensity to discriminate in the employment of women.

Women have two other options for occupational entry, which in Nicholson's terms provide a close fit between ascribed and achieved status transitions. First, they may enter a family business that legitimizes ascribed characteristics. Traditionally this was the only way in which women were admitted to economic positions (Symons, 1984; Beech, 1983; Yoshihashi, 1984). A current variation is for women to establish their own firms, thus avoiding the problem of organizational limits in either entry or mobility due to gender discrimination (Goffee & Scase, 1983).

In summary, in the past decade and a half, as women have entered the labor market in increasing numbers they are most frequently employed in gender-stereotyped occupations and low prestige or low-paying positions. Few have been promoted to managerial levels. The present analy-

sis explains this phenomenon in terms of discrepancies in the fit between ascribed and achieved role prescriptions that preclude women from developing attitudes and skills appropriate for managerial roles in bureaucratic organizations and male decision makers from perceiving women as qualified to be managers.

OCCUPATIONAL MOBILITY AS A DIVERGENT PROCESS

Women have been more successful in gaining access to organizations than in achieving managerial status from entry-level positions. We would expect successful women managers to achieve their positions as a result of individual power-oriented behavior exhibited in conjunction with organizational conditions that preclude male decision makers from expressing personal prejudice in promotion decisions.

Quinn and his colleagues (Quinn et al., 1968) studied discrimination in promotion of Jewish men in industrial organizations. Their model is useful for organizing research findings on discrimination against women (Dexter, 1979). Quinn et al. (1968) studied the importance managers placed on *nonability* as opposed to *ability* criteria in promoting subordinates to supervisory positions. These characteristics are similar to ascribed and achieved status. *Nonability* was defined as non-work-related attributes such as race, ethnicity, marital status, age, and lifestyle. The study found that the probability of a manager's discriminating against Jewish subordinates in promotions depended on the interaction of three variables: (1) Personal attitudes toward the importance of nonability criteria; (2) the structure of interpersonal relationships on the job; and (3) global organizational characteristics. Global characteristics are attributes such as policies that are not derived from data on individual members (Barton, 1961). Regardless of attitudes, managers were less likely to discriminate if doing so diverged from both clearly written and enforced company policies *and* the expectations of others in *significant* third-party relationships such as customer, subordinate, or superior. Global organizational characteristics combined with the nature and structure of interpersonal work relationships could prevent managers from expressing personal discriminatory attitudes in making promotion decisions, in this case promotion from engineer to manager.

With the addition of a fourth variable—organizational context, the nature of the larger social units in which the organization is located (Barton 1961)—this model is useful in predicting promotion of women to managerial status because it links organizational conditions with the condition of the labor market.

The Structure of Work Relationships

In Quinn et al.'s (1968) study, managers were most likely to discriminate in promoting people to supervisory positions requiring interaction with others who are *perceived* as objecting to dealing with a member of a minority group. The greatest discrimination was observed in promotions to positions that required interaction with subordinates. Managers were least likely to discriminate in promotions that required interaction with superiors.

Personal attitudes alone did not determine promotion decisions. Equally important in determining their decisions was the organizational position of the other person in the relationship and managers' judgment of these third parties' reaction to dealing with a member of a minority group. Discrimination was most common in promotion to positions in which the social distance, the frequency of interaction between themselves and the relevant third party, produced the greatest ignorance of these persons' attitudes. Lacking data for accurate predictions, managers made conservative promotion decisions, reducing the risk to the organization resulting from errors in judgment. For example, promotions of minorities to managerial positions in sales was less common than in administration. Customers were important to the company and their reactions to minorities were less well known than those of administrators with whom they had daily contact.

Applying Quinn et al.'s (1968) notions of third-party pressure to the promotion of women managers, I expect women to be found most frequently in staff positions that require little interaction with important role partners. Alexander and Sapery (1972), in a study of women and minorities in banking, report that although banking had the highest rate of employment of women managers of any U.S. industry (12 percent), women were located predominantly in branch management, personnel, and retail lending positions in which interaction was restricted to clerks or small depositors and borrowers. Women were excluded from managerial positions in commercial lending departments, which require interaction with officers of other companies (mostly men) on whose business banks depend for their profits. Chase Manhattan, the only bank to recruit at a women's college at that time, had no women in commercial lending. Not surprisingly, commercial lending experience is the key avenue to top administrative posts in financial institutions (Alexander & Sapery, 1972).

More recently Epstein (1980) has reported the difficulty women have in achieving partnerships in law firms. The same phenomenon can be observed in the "Big-Eight" accounting firms. The problem is one of third-party relationships. Partners' primary assignment is to bring

business into the firm. Incumbents do so by maintaining wide networks of interpersonal relationships with community and business elites through formal and informal organizations. As most businesses are headed by men and the social organizations to which they belong limit membership to men, the opportunity for women to contact other business leaders is restricted. As a result, promoting women to partnership status is viewed as a risk to the firm's profitability.

As mentioned above, Quinn et al. (1968) reportedly found relatively little discrimination in promotion to positions involving interaction with superiors. In the case of women, this parallels Nicholson's notion of the fit between prior and current role prescriptions. Hiring women for low-ranked positions is consistent with male managers' perceptions of women's ascribed status. The popularity of mentorship (Kram, 1983; Klemesrud, 1983) as a mechanism for upward organizational mobility, particularly for women, also is in keeping with perceptions of ascriptive status. It allows promotion only on the basis of the male superior's endorsement. It should be noted that this mechanism limits the opportunity of subordinates in two ways. First, there are fewer available sponsors than prospective protégés. Second, the protégé is dependent on mentors' selection. The popularity of this notion might be explained by the fact that it also serves as a mechanism of social control, limiting access to higher organizational positions to all but approved candidates.

In Quinn et al.'s (1968) study minority managers were thought to be unacceptable to their subordinates. Nicholson's (1984) notion of role congruence explains the observation that women managers most frequently appear as managers of female departments. The dependence implicit in the managerial role requires shared norms on the part of superiors and subordinates. Katz and Lazarsfeld (1964), in a classic study of the role of personal relationships in communication, found that the number and type of male relationships providing women with information were limited. Among male role partners who influenced women's public affairs decisions, 59 percent of the single women identified fathers as important sources of information while 66 percent of the married women cited husbands as influential rather than male friends or coworkers.

At present the broad differences in gender socialization within and beyond work roles means women incumbents of managerial positions need to devote substantial time and energy to legitimize their roles among male role partners as well as to rely more heavily on formal mechanisms of control.

Quinn and his colleagues did not investigate the impact of peer relationships on discrimination, yet there is evidence that this is a hypothesis worth further investigation in the case of women. Hennig and Jardim (1977) suggest that lack of team sports experience limits wo-

men's ability to be effective on management teams. It is plausible to think that experience with team sports might develop bureaucratic skills, as both activities require reciprocity in multiple, narrow, and interdependent relationships. Kanter (1977) observed the difference in women's performance depending on whether they are minority, majority, or token group members. More importantly, if the acquisition and exercise of power are learned, then peer occupational socialization is an important mechanism whereby women may be resocialized for achievement in higher-level positions. They must discard attitudes and behaviors acquired in childhood that are inappropriate for achieving their occupational aspirations and learn ones needed to fulfill managerial roles.

Gomez-Mejia (1983) found that gender differences in occupational socialization change with the length of job tenure. After several years of experience, women's attitudes more closely resembled their male colleagues in all occupational categories and organizational levels. However, his conclusion that the importance of preoccupational socialization is overemphasized if work provides effective learning experiences fails to recognize the additional eleven years or more that women require to achieve occupational parity with men.

This discussion has suggested that the problem of socialization is a two-way street in which both men and women are required to change their views if women are to achieve upward mobility. South, Bonjean, Markham, and Coder, (1983), in a test of Kanter's (1977) notion of the importance of the relative proportion of women in a group to the relationships between men and women, find support for this hypothesis. Their study of federal workers reports that the more equitable the distribution of men and women, the less gender solidarity among men and the more likely they were to receive support from women.

Global Organizational Characteristics

Studies of discrimination in the employment of women seldom take into account the impact of global organizational characteristics, attributes of the organization as a whole (Barton, 1961; Wallace, 1976; Wertheimer & Nelson, 1975). Yet Quinn et al. (1968) found that organizational attributes were important predictors of discrimination. In their study managers were least likely to discriminate in promotion decisions in organizations with antidiscrimination policies distributed to company personnel in writing and enforced by top management's actions rather than by lip service. The most visible organizational characteristic affecting the proportion of women managers is the type of business in which it is engaged. Dexter (1975) found a systematic difference in the

career routes for women presidents of different types of firms. Presidents of firms built on traditional feminine skills or service to female clients founded their own firms. In cases in which women were presidents of businesses providing products and services outside the realm of traditional female concerns, they had inherited their companies.

Lyle and Ross (1973) studied 246 business firms in the United States with the goal of looking for organizational characteristics that aided the employment of women in nontraditional positions. They defined nontraditional employment more broadly than management and included jobs at any level that are not occupied predominately by women; but as these are jobs that lead to managerial positions, the data are of interest. These investigators found that the determinants of discrimination in industrial firms differed from those in nonindustrial firms. Global organizational characteristics were more important predictors of discrimination in industrial firms. Contextual variables relating to the firm's environment played a greater role in accounting for discrimination in nonindustrial firms. In industrial firms such as automobile, chemical, steel, food and beverage processors, oil, and electrical companies, men and women were occupationally distributed most equitably. There was least discrimination in firms with (1) relatively small numbers of females in the total labor force; (2) few women in white-collar occupations; and (3) firms whose major output was in the heavy manufacturing sector. In nonindustrial firms only one organizational characteristic was associated with low levels of discrimination against women. Men and women were most equitably employed in firms characterized by a high degree of product diversification. Clearly, the type of product as well as type of customers provide different pressures on organizations affecting their relationships with personnel and in particular attitudes toward promotion of women.

Size of organization is another variable that has been observed to affect equitable employment of women. Bowman et al. (1965) found that size affected both men's and women's perceptions of opportunities for women to obtain managerial positions. Women were considered more likely to reach top management positions in small companies but to have a greater opportunity to reach middle management positions in large companies. These authors do not explain their findings, but our earlier discussion on the types of interpersonal relationships that foster discrimination suggests some hypotheses for further research. These are that various forms of business organization, technology, and labor force composition help to structure interpersonal relationships in such a way as to increase or decrease opportunities for discrimination. Support for this explanation is found in Quinn et al.'s study (1968) in which rates of discrimination varied by functional department. Discrimination in pro-

motions was more common in sales and production departments, in which the dominant relationships are with customers and subordinates, respectively, than in engineering and administration, in which relationships are with superiors.

Type of work also affects the probability of discrimination. Dicesare (1975) reported that the high-ranked occupations and professions with the greatest rate of increase in female employment during the period from 1960 to 1970 were accountants, computer specialists, engineers, university professors, and wholesale sales representatives. These are all types of work in which the criteria for admission, or the criteria for performance evaluation, or both, are clear and unambiguous and leave little room for discrepancies in judgment between identical performances by men and women.

Organizational Contexts

Organizational context is the final dimension that plays a role in the opportunity structure for women managers. Rosenfeld (1982) is one among those who have identified the economic market sector as an important determinant of women's work roles. Lyle and Ross (1973) found that environmental factors were particularly important in predicting discrimination in nonindustrial firms. Discrimination was least in firms with (1) plants in suburbs or small towns rather than in urban areas; (2) government contracts with nondefense agencies; and (3) little or no civil rights or labor litigation. In industrial firms only one environmental factor was associated with low discrimination, and that was the existence of extensive international markets.

In a study of the impact of organizational context on employee attitudes Dexter (1967) found that, regardless of community size, women were most optimistic about their career opportunities in plants located in high growth rate communities. These findings are not explained, but they suggest that structural determinants of occupational discrimination result from complex interactions between the internal structure of an organization and its environment. This interdependence is perhaps most volatile in business organizations whose requirement to produce profits makes them particularly susceptible to environmental pressure, but nonprofit organizations and governments as well can vary in their degree of dependence on external forces.

IMPLICATIONS

The implications of the research summarized in this chapter are critical for women on a number of dimensions. First, failure to achieve

occupational mobility relegates women as a group to jobs with few rewards with which to maintain their economic livelihood. This alone is important in a world in which divorce is common and marriage does not provide an economic guarantee. Second, low-status jobs suffer a greater rate of unemployment than technical and managerial positions (Beck & Powers, 1984). Finally, the experience of occupying low-status positions, particularly in single-gender occupations, seldom provides the opportunity for learning managerial skills necessary for achieving higher managerial positions.

In industrial societies much of work is carried on in large organizations. If women are to achieve occupational mobility in these organizations through promotions to managerial positions, they need an understanding of the type of interpersonal attitudes and skills required to gain and maintain these positions. More importantly, and perhaps more painful to learn, are the negative consequences of maintaining some attitudes learned as a result of primary socialization that are dysfunctional for achieving occupational aspirations. It is necessary for women to develop an awareness that these are not immutable attributes but are in fact variables that were once learned and can be modified.

In this chapter we have explored the notion of power as a critical skill for attaining organizational management positions. The exercise of power, along with the maintenance of multiple, narrow, universalistic relationships and the norm of reciprocity, have been viewed as learned in the process of primary socialization currently provided primarily to boys. The ascribed socialization of girls means that those who do learn managerial skills rely for their training primarily on adult socialization and must undergo a two-stage socialization process: First to feminine norms and then to managerial norms to reach their occupational goals. It therefore becomes essential for women's career guidance and for managers who are seriously concerned with implementing affirmative action in their organizations to understand the organizational-structural conditions that facilitate resocialization of women to achieved statuses and also impede organizational decision makers from expressing personal discriminatory attitudes in making promotion decisions. The critical role that organizational structure plays in women's opportunities means that in addition to care taken in the selection of occupations and professions, women need to devote equal care in the selection of the organizations in which they intend to practice their skills.

REFERENCES

Alexander, R., & Sapery, E. (1972). *The shortchanged: Minorities and women in banking.* New York: Dunnellen.

Barton, A. (1961). *Organizational measurement and its bearing on the study of college environments.* New York: College Entrance Examination Board.

Bartos, R. (1982). *Moving target.* New York: The Free Press.

Beck, E. H., & Powers, N. (1984, February). Employment and unemployment improvements widespread in 1983. *Monthly Labor Review,* p. 12.

Beech, B. (1983). Charlotte Guillard: A sixteenth-century business woman. *Renaissance Quarterly, 36*(3), 345-367.

Bendix, R., & Lipset, S. M. (Eds.). (1966). *Class, status, and power: Social stratification in comparative perspective.* New York: The Free Press.

Blau, P. M., & Duncan, O. D. (1967). *The American occupational structure.* New York: John Wiley.

Bose, C. E., & Rossi, P. H. (1983). Prestige standings of occupations as affected by gender. *American Sociological Review, 48,* 316-330.

Bowman, G. W., Worthy, N. B., & Grayser, S. (1965). Are women executives people? *Harvard Business Review, 43,* 14-28, 164-178.

Burke, C. B. (1982). *American collegiate populations: A test of the traditional view.* New York: New York University Press.

Darling, M. (1975). *The role of women in the economy.* Washington, DC. Organization for Economic Co-operation and Development.

Deal, T. E., & Kennedy, A. A. (1982). *Corporate cultures: The rites and rituals of corporate life.* Reading, MA: Addison-Wesley.

Dexter, C. R. (1967). *Organizational structure and climates of change.* Unpublished Ph.D. dissertation, Columbia University.

Dexter, C. R. (1975, June 16-22). *On achieving economic power: The case of the female executive.* Paper presented at the International Workshop on Changing Sex Roles in Family and Society. Dubrovnik, Yugoslavia.

Dexter, C. R. (1979). Organizational determinants of occupational discrimination: Women managers in business. In R. C. Huseman (Ed.), *Academy of management proceedings* (pp. 386-390).

Dicesare, C. B. (1975, March). Changes in the occupational structure of U.S. jobs. *Monthly Labor Review.*

Epstein, C. (1980). The new women and the old establishment: Wall Street lawyers in the 1970s. *Sociology of Work and Occupations, 7,* 291-316.

Etzioni, A. (1975). *A comparative analysis of complex organizations.* New York: The Free Press.

Featherman, D. L. & Hauser, R. M. (1976). Changes in the socioeconomic stratification of the races, 1962-1973. *American Journal of Sociology, 82,* 621-1973.

Federal Civilian Work Force Statistics. (1981). *Occupations of Federal White-Collar and Blue-Collar Workers,* October 31.

Fullerton, H. N., Jr., & Tschetter, J. (1983, November). The 1995 labor force: A second look. *Monthly Labor Review,* pp. 3-10.

Gomez-Mejia, L. R. (1983). Sex differences during occupational socialization. *American Management Journal, 26,* 492-499.

Goffee, R., & Scase R. (1983). Business ownership and women's subordination: A preliminary study of female proprietors. *Sociological Review, 31,* 625-649.

Goldthorpe, J. H. (1980). *Social mobility and class structure in modern Britain.* Oxford: Clarendon.

Gouldner, A. W. (1960). Norm of reciprocity: A preliminary statement. *American Sociological Review, 25,* 161-178.

Hall, R. H. (1983). Theoretical trends in the sociology of occupations. *Sociological Quarterly, 24,* 5-23.

Hennig, M., & Jardim, A. (1977). *Managerial Women.* New York: Anchor/Doubleday.

Hout, M. (1984). Occupational mobility of black men: 1962-1973. *American Sociological Review, 49,* 308-322.

Izraeli, D. (1979). Sex structuring of occupations: The Israeli experience. *Sociology of Work and Occupations, 6,* 404-429.

Kanter, R. M. (1977). *Men and women of the corporation.* New York: Basic Books.

Katz, E., & Lazarsfeld, P. F. (1964). *Personal influence.* New York: The Free Press.

Kerckhoff, A. (1984). The current state of social mobility research. *Sociological Quarterly, 25,* 139-154.

Klemesrud, J. (1983, April 11). Special relationship of women and their mentors. *New York Times,* p. A-22.

Kotter, J. P. (1979). *Power in management: How to understand, acquire, and use it.* New York: AMACOM.

Kotter, J. P., & Lawrence, P. R. (1974). *Mayors in action: Five approaches to urban governance.* New York: John Wiley.

Kram, K. E. (1983). Phases of the mentor relationship. *Academy of Management Journal, 26,* 608-625.

Lee, E. B. (1937). *Eminent women: A cultural study.* Ph.D. dissertation, Yale University Library, New Haven, CT.

Linton, R. (1936). *The study of man.* Englewood Cliffs, NJ: Prentice-Hall.

Lloyd, C. B., & Niemi, B. T. (1979). *Economics of sex differentials.* New York: Columbia University Press.

Lyle, J., & Ross, J. L. (1973). *Women in industry: Employment patterns of women in corporate America.* Lexington, MA: D. C. Heath.

Lyson, T. A. (1984). Sex differences in choice of a male and female occupation: An analysis of background characteristics and work values. *Work and Occupations, 11,* 131-146.

Macke, A. S. (1981). Token men and women: A note on the salience of sex and occupation among professionals and semi-professionals. *Work and Occupations, 8,* 25-38.

McClelland, D. C. (1975). *Power: The inner experience.* New York: Irvington.

Mellor, E. F. (1984). Investigating the differences in weekly earnings of women and men. *Monthly Labor Review, 107*(6), 17-28.

Montagna, P. D. (1977). *Occupations and society.* New York: John Wiley.

National Center for Educational Statistics, 1979-1980. (1982, January). *Data on earned degrees confered by institutions of higher education by race, ethnicity, and sex: Academic year 1979-1980.* Washington, DC: Government Printing Office.

Nicholson, N. (1984). A theory of role transitions. *Administrative Science Quarterly, 29,* 172-191.

Nieva, V. F., & Gutek, B. A. (1981). *Women and work: A psychological perspective.* New York: Praeger.

Parsons, T. (1951). *The social system.* New York: The Free Press.

Pfeffer, J. (1981). *Power in organizations.* Marshfield, MA: Pitman.

Powell, B., & Jacobs, J. (1984a). Gender differences in evaluation of prestige. *Sociological Quarterly, 25,* 173-190.

Powell, B., & Jacobs, J. (1984b). The prestige gap: Differential evaluations of male and female workers. *Work and Occupations, 11,* 283-308.

Quinn, R. P., Tabor, J. M., & Gordon, L. K. (1968). *The decision to discriminate.* Ann Arbor: Institute for Social Research, The University of Michigan.

Rosenfeld, R. (1979). Women's occupational careers: Individual and structural explanations. *Work and Occupations, 6,* 283-311.

Rosenfeld, R. (1982). Sex segregation and sectors. *American Sociological Review, 48,* 637-655.

Seiber, S. C. (1974). Toward a theory of role accumulation. *American Sociological Review, 39,* 567-578.

Sorentino, C. (1984, February). International comparisons of labor force participation, 1960-1981. *Monthly Labor Review,* pp. 23-36.

South, S. J., Bonjean, C. M., Markham, W. T., & Coder, J. (1984). Female labor force participation and the organizational experience of male workers. *Sociological Quarterly, 24,* 367-380.

Spitze, G. D., & Huber, J. (1980). Changing attitudes toward women's non-family roles: 1938-1978. *Sociology of Work and Occupations, 7,* 317-336.

Spitze, G. D., & Waite, L. J. (1980). Labor force and attitudes: Young women's early experiences. *Work and Occupations, 7,* 3-32.

Symons, G. L. (1984). Career lives of women in Canada: The case of managerial women. *Work and Occupations, 11,* 331-352.

Szafran, R.F. (1984). Female and minority employment in banks. *Work and Occupations, 11,* 55-76.

The Chronicle of Higher Education. (1984, September 12). *A profile of 1982-1983 recipients of doctorates,* p. 20.

Tsuchigane, R. & Dodge, N. (1974). *Economic discrimination against women in the United States.* Lexington, MA: Lexington Books.

Two-income families on the rise, U.S. says. (1984, April 5). *New York Times,* p. C-7.

U.S. Department of Labor, Bureau of Labor Statistics. (1984, May). *Monthly Labor Review,* p. 65.

Wallace, P.A. (1976). *Equal employment opportunity and the AT & T case.* Cambridge, MA: MIT Press.

Weber, M. (1947). *The theory of social and economic organization.* T. Parsons (trans). Glencoe, IL: The Free Press.

Welch, M. R. (1982). Female exclusion from religious roles: A cross-cultural test of competing explanations. *Social Forces, 61,* 79-98.

Wertheimer, B. M., & Nelson, A. H. (1975). *Trade union women: A study of their participation in New York City locals.* New York: Praeger.

Yoshihashi, P. (1984, December 16). A daughter's quick rise to the top. *New York Times,* p. F-6.

Zetterberg, H. (1962). *Social theory and social practice.* Bedminster, NJ: The Bedminster Press.

10

Women in Toxic Work Environments

A CASE STUDY AND EXAMINATION OF POLICY IMPACT

DONNA M. RANDALL

In 1975, the Bunker Hill Company of Kellogg, Idaho, instituted an "exclusionary policy" in which all fertile female employees of the mining company were refused jobs involving lead exposure unless they were sterilized. The company adopted the policy in order to protect the fetus from reproductive harm and the company from legal liability for such damage. The use of such policies raises a series of complex and interrelated social, political, technological, medical and economic issues. Federal regulatory agencies have not been able to agree upon an appropriate response to exclusionary policies, and federal courts have only recently recognized such corporate practices as discriminatory. The growing reliance on such policies by the chemical and manufacturing industries over the last decade has serious implications for the role of women in organizations and the reproductive health of both male and female employees.

One of the most troubling issues facing some industries today is how to ensure the reproductive health of their employees. This chapter explores the origins of a highly controversial corporate practice—exclusion of fertile women from toxic work environments—designed to minimize reproductive risks of female employees. After the development of the policy has been traced and a case study illustrating its impact has been presented, the analysis moves to a broader context and explores key issues raised by the use of such policies. The federal response to the corporate practice is discussed, followed by suggestions for a more effective federal policy. Finally, implications of the use of exclusionary policies for employers in the future are set forth.

AUTHOR'S NOTE: The author is indebted to the National Institute of Mental Health for the award of a predoctoral fellowship that supported the early stages of this research. The author is also grateful to the editors of this volume and anonymous reviewers for their comments on an earlier draft of this chapter.

DEVELOPMENT OF EXCLUSIONARY POLICIES

Toxic work environments are those settings with occupational hazards that are likely to be detrimental to the health of workers. Commonly recognized hazards include lead, methyl mercury, phosphorus, beryllium, cotton dust, coal dust, and ionizing radiation. Of the 50,000 chemicals sold commercially, the Environmental Protection Agency (EPA) classifies 35,000 of these chemicals as potentially or definitely hazardous to human health ("The Poisoning," 1980).

Lead is among the oldest and most dangerous occupational health hazards. Lead poisoning occurs in a slow-acting and cumulative manner primarily through the inhalation of lead fumes and fine dust particles and consumption of food and drink contaminated with lead. At present, approximately 800,000 workers in 120 occupations are exposed to lead ("Equal Lead Safeguards," 1980).

In addition to the health hazards for workers, lead has long been suspected of being harmful to unborn children. In Europe centuries of experience had shown that lead adversely affects reproduction. By the late nineteenth century several countries had enacted labor codes that excluded women from lead industries (Lin-Fu, 1982).

In the United States World Wars I and II brought an influx of women into factories, smelters, blast furnaces, and other operations, and prompted research on the effect of toxic exposures to the fetus. However, women in the lead trades were replaced by men after World War II and interest in reproductive hazards subsequently declined. Only under protection of equal employment laws passed in the 1960s did significant numbers of women enter the American work force in nontraditional jobs, including employment in the lead industry (Hricko & Brunt, 1976).

To prevent possible fetal damage, a number of major corporations—including the General Motors Corporation of Canada and the United States (Delco-Remy Division); the DuPont Corporation of Wilmington, Delaware; the Olin Corporation of East Alton, Illinois; and St. Joe's Mineral Corporation of Monoco, Pennsylvania—have implemented corporate policies preventing female employees of childbearing age from working in positions that would expose them to lead (Hricko, 1978; Vanderwaerdt, 1983; McGhee, 1977).

BUNKER HILL'S EXCLUSIONARY POLICY

One of the first companies to institute an exclusionary policy was the Bunker Hill Company of Kellogg, Idaho. This chapter examines the

consequences of the implementation of Bunker Hill's exclusionary policy.[1]

Methodology

Data on the exclusionary policy were gathered through interviews and written surveys of individuals involved with the implementation of the policy at Bunker Hill. A total of 94 individuals participated, including 13 female employees affected by the policy, 12 government agency officials, 10 company executives, 7 union officers, 10 community residents, 24 representatives of private interest groups, and 18 other persons, including newspaper reporters and court officials.

Several different research methodologies were employed to collect the data. The principal research technique employed was an open-ended questionnaire with slightly different versions designed for different groups of respondents (i.e., female employees, company executives, and so forth). The questions sought to reconstruct the history of the controversy. The different versions contained the same questions so that responses could be compared. Telephone interviews and a Freedom of Information request were used to obtain information from federal and state regulatory agencies concerned with the policy (e.g., Occupational Safety and Health Administration, Equal Employment Opportunity Commission, and Idaho Human Rights Commission). Data on the policy were also obtained from archival research of newspapers and professional journals. Finally, private groups and organizations such as the Industrial Health Foundation and the Coalition for the Reproductive Rights of Workers, supplied data on employment problems facing women in toxic work environments.

Bunker Hill's Exclusionary Policy

The Bunker Hill Company, founded in 1887, is a mining company in central Idaho that operates a zinc refinery, fertilizer plant, and lead smelter. There have been few women production workers at Bunker Hill, as at lead smelters elsewhere. Women were first hired at Bunker Hill as production workers during World War II to aid the war effort, but no more than 100 women were employed in this capacity. After the war, the women gradually quit their jobs. They did so for a variety of reasons: They did not like the working conditions; they did not care for the type of work; or men coming back from the war replaced them. Only two women hired by Bunker Hill during the war continued their employment.

In 1972 Bunker Hill opened production jobs to women in response to pressure from the Equal Employment Opportunity Commission (EEOC). Between 1972 and 1976, 45 women were hired as production workers. Thirty were placed in the lead smelter and fifteen in the zinc plant. Both locations involved exposure to lead because zinc ore contains some lead and zinc smelting can produce lead poisoning.

The calm surrounding the hiring of women as production workers at Bunker Hill was disrupted in 1975. In early April, the physician on contract with the Bunker Hill Company attended a lead industries conference and was advised by a number of nationally known experts to encourage the company to remove the women employees from the smelter due to potential harm to the unborn fetuses (Tate, 1975; U.S. OSHA, 1981). Upon his return to Kellogg, the physician advised the president of Bunker Hill that no women of childbearing capacity should be allowed to work in jobs with lead exposure due to possible damage to the fetus.[2]

After an executive meeting, the president informed the 29 women working in the lead smelter and the upper part of the zinc plant (the part of the plant where exposure to lead is the greatest) and their union of a policy change. The women were informed that they could no longer work in lead operations due to the possible harmful effects of lead on the fetus. As a company executive explained, "We don't want to take a risk with women. The policy resulted because we simply don't know what level is harmful for the fetus, we just don't know."[3] The female employees were told, however, that women were particularly susceptible to the effects of lead because females absorb a greater amount of lead from the environment than men. The new policy was that fertile women would no longer be allowed to work in the smelter and zinc plant. Those women desiring to maintain their jobs in the smelter and zinc plant would have to show proof of sterilization (as no other form of birth control was deemed acceptable) from their physician before they could return to their jobs.

The women were also told to report to the mine yard crew (where they would be assigned to general yard work) until permanent jobs could be found for them in "safer" areas. Because they were being transferred out of their departments, the women were informed that their departmental seniority was immediately stopped. Finally, the women understood that if they disagreed with the policy, they would be fired.[4]

The policy generated considerable opposition. The female employees affected directly by the policy resented the change in corporate policy and its seemingly negative effect upon their lives. Some of the women were upset with their new work schedule; a number were upset at the abrupt manner in which they were informed of the policy; others

enjoyed the work in the smelter and did not want to leave; some felt that their privacy was being invaded; and still others felt the policy discriminated against women, as fertile men were not excluded from the work place.

The women also reported economic pressure to consent to sterilization. About one-half of the women employed at Bunker Hill were single parents.[5] Jobs were scarce in Kellogg; Bunker Hill was the largest employer; and the women employees could be replaced easily by men.[6] Women employees felt that they could apply for only a limited number of openings as waitresses, bartenders, nurses, clerks, secretaries, teachers, and beauticians—all at substantial wage cuts.[7] In 1975 starting wages for positions in the smelter and zinc plant were high, ranging from $3.97 to $4.03 per hour (U.S. OSHA, 1981). Several women complained that they suffered a sizable loss in their monthly income with the transfer. The new job lacked night and holiday work, overtime opportunity, and the incentive earnings that were offered in the lead smelter and zinc plant.

The women were most upset at losing their departmental seniority. Without it, the women would lose all the rights and privileges they had worked to build up. One women described the situation: "We were put into the mud trenches and had to start all over again."[8]

Individual Action

Along with their widespread dissatisfaction, the women were quite undecided about what to do about the policy. Six of the women interviewed had undergone sterilization before the policy was enacted. The reasons for their operations were diverse and unrelated to occupational exposure to lead. For these women, the choice of action was obvious: They simply obtained a letter from their physicians attesting to their operations and returned to their former jobs shortly afterwards. Other women maintained they underwent sterilization in order to return to their former jobs (Accola, 1980, p. 1A; U.S. OSHA, 1981). The precise number of women who sought sterilization solely to keep their jobs is unknown. However, in 1980, a female physician sent by OSHA determined that at least three women obtained sterilization procedures and physician letters within two to three months after the policy was enacted solely to be allowed by the company to return to their former jobs. In total, 17 of the 29 affected women returned to the smelter and zinc plant.[9]

The unsterilized women were permitted neither to return to their former jobs nor to obtain any job in a lead exposure area. The company attempted to place these women in "safe areas" throughout the plant.

However, the company had difficulty finding areas of the plant that were "safe" for women. As the lead smelter and a major portion of the zinc plant were no longer open to fertile women, the women could be transferred only to the melting and purification plants, which had a limited number of openings. The company began to accept applications from women to work underground as miners in mid-September 1975 in an effort to place more of the transferred women into permanent positions (Kuglin, 1977, p. 3A).[10]

Collective Action

Several women decided to take collective action to protest the company's policy. Their first effort was to contact a civil rights lawyer. Even though they never formally retained him, the women maintained they wanted to show the company that they did not accept the policy change.[11]

The women also protested the exclusionary policy to their local United Steelworkers of America (USWA) office. The local union filed a grievance about the policy to the company and contacted the international headquarters of the USWA in Pittsburgh, Pennsylvania, for advice and information.

Although the international office of the union was sympathetic to the plight of the women, the USWAs efforts to protest the treatment of the women had little effect. A union official explained that the union was fearful of antagonizing Bunker Hill because the union wanted the company to continue to hire females as production workers.[12] Moreover, a lawyer for the company claimed that "it was easier to deal with union protests over the exclusion of women than with a damage trial in 1990 where a jury would be confronted by a horribly deformed human being" (Robinson, 1979, p. 4).

One of the women filed a complaint to the Idaho Human Rights Commission (IHRC), which, in turn, drew up a "Memorandum of Understanding" to be signed by company executives and women workers. The memorandum stated that the company's removal of all fertile women from lead exposure areas was justified and reasonable, but that female employees must be reimbursed for any wage differences between the employee's former position and the interim "make work" job. The memorandum had little impact. According to a company executive, Bunker Hill officials refused to sign the understanding.[13]

In addition to contacting the IHRC, 18 of the 29 affected women filed sex discrimination charges with the Equal Employment Opportunity Commission (EEOC).[14] An EEOC representative was sent to investigate

Bunker Hill's exclusionary policy in response to these complaints in February 1976 and negotiated a settlement for the women.

According to the terms of the settlement, the women recognized that lead had a negative effect on their reproductive health and that fertile women could not work around lead. To reimburse the women for lost wages, women's earnings for the six months prior to the enactment of the policy were averaged and their earnings for the subsequent six months were averaged. The two averages were compared and the women were paid the differences in a lump sum by the company. All of the women were guaranteed that as long as they could perform their job, they could work for Bunker Hill and the controversy would have no effect on their employment at the plant.[15]

After the terms of the settlement had been agreed upon, each of the women was met with separately and an individual monetary settlement was negotiated. Each of the women agreed to the settlement. By mid-March 1976, all charges filed by the women to the EEOC had been dropped, financial arrangements were made concerning each woman, and the company's exclusionary policy was allowed to stand.[16]

Although the women agreed to drop all sex discrimination charges with the EEOC, not all the women were satisfied with the financial settlement. Some felt that they had been "bought out" and would have preferred that the EEOC make a decision about the legality of the company's exclusionary practice.[17]

It was over four years before the controversy was reopened. In April 1980, Occupational Safety and Health Administration (OSHA) representatives from Washington, D.C., conducted an intensive examination of the health and safety conditions at Bunker Hill in response to a request from union leaders.

The OSHA representatives then returned to Washington, D.C., to review the data that had been collected. Five months later, on September 11, 1980, OSHA issued a citation against Bunker Hill for 108 violations of occupational safety and health regulations discovered during the inspection.[18] One of those violations was the maintenance of a "sterilization policy." The proposed fines for the 108 violations totalled $82,765; the proposed fine for the sterilization policy alone was $10,000.

OSHA relied upon the general duty clause (19 U.S.C., Section 654 [a] [11] of the Occupational Safety and Health Act of 1970 as a basis for the violation.[19] In this clause, employers are required "to provide employment and a place of employment free from recognized hazards causing or likely to cause death or serious physical harm" ("OSHA Proposes," 1980, p. 1).

OSHA claimed that Bunker Hill could not legally seek to eliminate the health hazards lead presents to the fetus by compelling women "to choose between their jobs and sterilization, thereby incurring serious and irreversible impairment to their reproductive systems" ("OSHA Proposes," 1980, pp. 1-2). OSHA contended that Bunker Hill, rather than instituting a "sterilization policy," should reduce lead hazards to a level such that all workers, male or female, could work there without damage to their health. Steve Mallinger, an OSHA official in Washington, D.C., explained that OSHA's position was that a company should not seek to change its workers but, rather, should attempt to change the work place to eliminate hazards (Schlender, 1980).

Bunker Hill's exclusionary policy was not the first such policy to come to OSHAs attention. OSHA cited the American Cyanamid Corporation on October 9, 1979, for a "fetus protection" policy. Under this policy, all female employees under 50 years of age were required to show proof of sterilization in order to retain employment in the lead pigment section of the plant. The policy went into effect in early October 1978. Five females were sterilized between January and July 1978 in order to continue work in the lead pigment section, which paid higher salaries than did other sections of the plant.

While OSHA was reviewing the issue at American Cyanamid, the agency cited Bunker Hill for the 108 safety and health violations. By involving Bunker Hill, OSHA believed its actions would give an incentive for lead companies to reduce lead exposure to safe levels and would discourage other companies from employing exclusionary policies (Harris, 1980). As Susan Fleming, a spokesperson for OSHA, explained:

> Bunker Hill, like a lot of other firms, refuses to allow women who can bear children to work at lead smelting operations. OSHA is discouraging this policy. Employers should know that we're going to pressure them on the issue, and employees should know they needn't put up with this policy. (Harris, 1980, p. 1)

Bunker Hill executives claim they were taken by surprise by the citation.[20] On September 19, 1980, Bunker Hill formally contested the citation through a Notice of Contest to OSHA. Bunker Hill denied wrongdoing and promised to contest not only the sterilization charge and the $10,000 fine, but the other 107 violations as well. With Bunker Hill's denial of wrongdoing, the case was scheduled to be heard before an administration law judge.

On April 18, 1981, the Federal Occupational Safety and Health Review Commission decided OSHA's case against the American

Cyanamid Corporation: OSHA lost. The Commission maintained that the matter did not lie within OSHA's jurisdiction and that the impact of the company policy was outside the reach of the Occupational Safety and Health Act ("Companies Permitted to Exclude," 1981, p. 45).

Due to the similarity of the Bunker Hill controversy to the American Cyanamid case, OSHA reconsidered its citation against Bunker Hill during the summer of 1981.[21] OSHA lawyers decided to drop the citation for a sterilization policy against Bunker Hill. On July 21, 1981, the citation against Bunker Hill for the exclusionary policy was officially dismissed. Whereas some of the women who had been affected by the policy were not concerned about the dismissal of the citation, others were bitter.[22] These women stated that they believed that the government was unwilling, or at least unable, to resolve the issue of exclusionary policies.

The Aftermath

Despite the attempts by the women to enlist the aid of the USWA, IHRC, EEOC, and OSHA, the policy still remains in force. As expected, the exclusionary policy has significantly changed the processing of female applicants at Bunker Hill. Female applicants for positions at Bunker Hill before April 1975 were never asked in the personnel office if they were incapable of bearing children or had undergone sterilization. After the policy was enacted, all women applying for jobs in lead exposure areas were asked in the personnel office if they were incapable of bearing children. The women were informed that this information was a condition of employment, and those women who could not produce a doctor's letter stating that they were infertile were not hired for work with lead. The company did not ask women who were not of childbearing age (50 years of age or older) whether they were capable of bearing children. Nor did the company request any information about fertility from male applicants (U.S. OSHA, 1981).[23]

Due to recent events at Bunker Hill, it is unlikely that the women will reopen the controversy over Bunker Hill's exclusionary policy or once again file sex discrimination charges. In 1981, Gulf Resources, the owner of Bunker Hill, announced its intentions to close the plant. Union and worker interest in the controversy was overshadowed by concern with the pending closure of the plant. Agencies such as EPA, OSHA, and EEOC were unwilling to press lead-health issues and to enforce stringent policies for fear of being blamed for prompting the closure of the major employer in North Idaho.[24] Today only a skeletal force is employed at one of the company's mines and the plant, under the new ownership of Bunker Ltd. Partnership, remains closed.

IDENTIFICATION OF KEY ISSUES

The corporate practice of excluding fertile females from toxic work environments raises a series of complex and interrelated issues that involve workers, employers, and the government.

Medical Issues

Only limited medical research has been conducted on the effect of lead on male and female reproductive systems. Available research indicates that both male and female reproductive abilities are damaged by exposure to lead (U.S. Department of Labor, 1979). Occupational exposure of male workers to high levels of lead can lead to reduced sexual drive, impotence, decreased ability to produce normal sperm, and sterility (Gold, 1981). Occupational exposure of females can lead to abnormal ovarian cycles, menstrual disorders, sterility, premature birth, miscarriage, and stillbirth (Hricko & Brunt, 1976). Thus current medical evidence reveals that the reproductive health of both sexes is damaged by toxic exposures.

Lead can also affect the nervous system of the developing fetus, resulting in learning disorders and psychological impairments (Hricko, 1978, p. 396). However, medical evidence is inconclusive about whether lead can act through both the male and female to produce neurological damage in the child. In addition, the precise nature of neurological harm to the fetus and the level of lead exposure at which such damage occurs cannot be determined with certainty.

Due to the ambiguous medical research on reproductive hazards in the work place, a comprehensive examination of work place hazards to the reproductive systems of male and female workers and to the developing fetus is being undertaken by the Office of Technology Assessment. The 16-month study, scheduled to be completed in February 1985, should help clarify the medical effects of lead and indicate the need for a federal reproductive hazard policy similar to that developed for cancer risk.

Economic Issues

The economic repercussions of allowing fertile men to work around lead are not perceived by industry to be particularly troublesome. Any male employee alleging that his exposure to lead caused his wife to have a deformed child would have to prove paternity to win a lawsuit. According to Dr. Nicholas A. Ashford, this extra burden of proof would make it unlikely that a lawsuit would succeed (Severo, 1980).

On the one hand, corporations are apprehensive of legal and economic liability if a female employee working in a toxic environment gives birth to a damaged child. Stillman (1978) observes:

> The media exposure and adverse publicity arising from a personal injury lawsuit involving an injured child can be far more devastating for a company than publicity about an employee discrimination action. Additionally, the dollar liability from such a damages lawsuit can be astronomical compared to an employment discrimination back pay award. (p. 608).

To minimize their liability, corporations have sought to exclude all fertile women from toxic work places.

Women's advocates reject this line of corporate reasoning and maintain that a number of viable alternatives to the exclusion of women from the work place exist. Exclusionary policies are favored, they insist, because they are much cheaper than instituting engineering controls that would protect the reproductive health of both male and female workers. "The costs of such a policy," contends Win-O'Brien (1980, p. 509), "are borne by the women who must leave their jobs in order to protect their ability to have children or the women who'll never be hired into these workplaces." Moreover, although employers can set forth a cost-based defense of exclusionary policies,[25] it is unlikely that the courts will accept such a line of argument (Howard, 1981, p. 832).

Economic concerns are central to many of the female workers affected by exclusionary policies. The U.S. Department of Labor (1980) reports that in 1979 nearly two-thirds of all women in the labor force were single, widowed, divorced, or separated, or had husbands earning less than $10,000. Hricko (1978, p. 400) contends:

> Women work because they *must*. . . . The refusal to hire women in certain industrial jobs will help to perpetuate the disparities between male and female earnings. For example, someone working in a lead battery plant might earn $5-7 per hr., a bank teller or file clerk might earn $3.50 per hr., and a waitress, $1.70 per hr., plus tips. Moreover, in certain areas where battery plants or smelters are located, there may be few industrial jobs available that don't involve lead exposure.

A woman explains the economic pressure to get sterilized:

> It seemed that you could have a tubal ligation in a very short period of time. It cost about $800 and it seemed to be less than what one would pay for an employment agency to find you a job. ("A New Twist," 1981, p. 7)

For women faced with a substantial cut in income, a sterilization procedure that will allow them to keep their high-paying jobs becomes very attractive.

Social Issues

Exclusionary policies also raise a topical social concern: Equal employment opportunities for women. Gold (1981, p. 10) writes that

during the 1970s, nearly 12 million additional women entered the labor force in this country and, in the process, dramatically changed its composition. At the beginning of the decade, 43 percent of all women over 16 were in the labor force; 10 years later, 51 percent of all women over 16 were either employed or actively seeking employment.

Women who work outside the home now comprise 44 percent of the American labor force, and approximately 80 percent of this group will become pregnant at some point (Catalyst's Career and Family Center, 1984).

Women's advocates view exclusionary policies as an attempt to deny equal employment opportunities to women. Their objections focus on five concerns. First, widespread adoption of exclusionary policies would significantly diminish women's employment opportunities in traditionally male-dominated industries such as the lead trade. Hricko (1978) estimates that if women of childbearing age are not allowed to work where there is lead exposure, almost two of every three female applicants for an estimated 1.3 million jobs would be turned away. If all industries with toxic work places adopt exclusionary policies, approximately 20,000,000 jobs would be closed off to women (Andrews, 1983). Clauss and Bertin (1981, p. 3) maintain:

Such policies . . . threaten to curtail the employment opportunities of significant numbers of women, often denying them access to lucrative employment in industries which have only recently become sex segregated.

To support their claims, women's advocates point to the different manner in which the issue of reproductive health is treated in hospitals, dental offices, beauty parlors, and the textile industry. In these areas in which most of the employees are female, the employment of fertile women is unregulated although chemicals such as ionizing radiation are *known* to cause birth defects (Stellman, 1977). In addition, women have been barred from heavy industrial jobs entailing lead exposure, but not from lower-paying jobs in certain industries (such as pottery work) that also entail lead exposure (Stellman, 1977). Williams (1981) predicts that exclusionary policies will determine the ultimate place of women in the work force. She asks, "To what extent will women's recent gains in employment be eroded by new, 'scientifically based' exclusions, which

may be a reemergence of the old women's protective legislation in a new and 'respectable' guise?" (p. 643). Will women be "protected" in high-paying jobs, but not in low-paying jobs?"

Second, women's advocates object to exclusionary policies because the policies reflect the following stereotypical assumptions about women:

- Women are always potentially pregnant and thus must be treated as if they are always actually pregnant.
- Women are unable to prevent pregnancy.
- Women alone are responsible for the health of their offspring.
- Harm to future children can only occur through maternal exposure. (Clauss & Bertin, 1981, p. 13)

Moreover, exclusionary policies reject the female worker as a person with options. Surgical sterilization is required by the policies regardless of whether the female has chosen not to have a family, her sex partner has a vasectomy, or she is using another form of birth control (Win-O'Brien, 1980).

Third, women's advocates find exclusionary policies offensive because women are the only objects of the policy. Exclusionary policies ignore the threat of damage to unborn children of male workers. Such policies assume that the future children of female workers are at a greater health risk than the unborn children of male workers. The effect of such a policy discriminates against men:

> We can also ask if it is discrimination against men to allow them to work under conditions that may adversely affect their health, while providing fertile women with protection from these conditions. (Stellman, 1977, p.183)

Thus as the sole objects of the policy, women may not only suffer the impact of the policy but also the "burden" of protection.

Fourth, there is the privacy issue. Clauss and Bertin (1981) contend that such policies are an unwarranted invasion of a woman's privacy. An exclusionary policy

> subjects all women to special scrutiny about their child-bearing intentions, sexual activities, and birth control methods and, thus, operates to invade their personal privacy in a most sensitive area. Any woman who remains in a restricted job is forced, per se, to publicly reveal her sterility. . . . Men, on the other hand, are not asked if or when they intend to have children, even though their exposure to toxic substances could also result in injury to a future child (p. 22).

Finally, should women's employment rights be sacrificed to protect the health of future generations? On one hand, the health of unborn children is of great moral concern to our society. The matter of fetal protection is clearly central to the health of current and future generations. Furthermore, given the social and economic costs of caring for deformed children and the likelihood of fetal damage through worker exposure, Howard (1981, p. 836) argues that it is justifiable to exclude certain groups of workers "as long as the exclusion is in fact narrowly tailored, objectively applied, and based upon credible scientific evidence." Yet women have attained the right to equal employment opportunities. As some argue, this right is so important that a female employee should be able to assume fully the risk of harm to herself and to any unborn children (Howard, 1981, p. 836).

The social impact of such policies may go beyond sex discrimination. Burnham (1976, p. 42) points out that a policy that excludes one sex may also be used to exclude certain races from the work place. Lead may pose special health problems for blacks who might have sickle cell disease. Therefore, if fertile women can be excluded from toxic work environments on inconclusive medical evidence about fetal susceptibility to lead, the same type of evidence may be used in the future to exclude blacks.

Technological Issues

Lead smelting (one of Bunker Hill's major operations) generates the largest share of lead poisoning (National Research Council, 1980). Yet industry maintains that the technology does not presently exist to make work places, such as lead smelters, completely safe for either worker or fetus. At OSHA hearings on the lead standard, Jerome F. Cole, Director of Environmental Health for the Lead Industries Association, pointed out the economic repercussions of requiring work environments to be made safe for the fetus:

> There may be many jobs in the lead industry where blood levels simply cannot be kept at levels to be safe for the fetus. If OSHA decides that it must set a standard so that it's known to be fully protective of the fetus, then we all must bear in mind that there will be very few jobs, indeed, in the lead industry for either men or women. (Ricci, 1977, p. 36)

Thus to some in industry the choice is simple: Exclusion of fertile females must be allowed or the work place will have to be closed down.

Others assert that technology exists to make the work place safe for the fetus. Trebilcock maintains that employers can improve the work place, but employers would rather hire "superworkers" who can

withstand toxic exposures instead of going to the expense of cleaning up the work place (Hyatt, 1977). Furthermore, Weiksnar (1976) alleges that safe work places, including lead battery plants, are technologically feasible and will be built—when time and money permit.

Legal Issues

Exclusionary policies raise a legal dilemma: Some employers may feel that they must choose to obey either the Occupational Safety and Health Act of 1970 (in which employers are charged with the responsibility of providing a safe and healthy work place) or Title VII of the Civil Rights Acts of 1964 (in which workers are given a right to equal employment opportunities). If the employer assumes that the female worker is more susceptible to toxic exposures than males and that it is not economically feasible to clean up the work place to a point at which fetal health is not threatened, the employer's options are limited. To conform with OSHA's standards requiring a safe work place, the employer may exclude the fertile female from the work place in order to protect her fetus. Yet by excluding women, the employer may violate Title VII.

If, on the other hand, the employer seeks to comply with equal employment laws, employers may violate OSHA's laws by endangering the reproductive health of female employees. Moreover, the employer may be liable for any damages to the child (Hyatt, 1977). A child born with defects or diseases caused by parental exposure to toxic chemicals may bring personal injury actions against the company. The parent cannot legally waive the right of an unborn child to sue for damages in the future.

By adopting exclusionary policies employers have privately resolved their dilemma. Exclusionary policies represent a judgment, subject to legal challenge, that "the goal of equal employment is secondary to that of worker safety and that a trade-off can be made between the two" (Andrade, 1981, p. 72). Thus many corporations would prefer to risk violation of the equal employment laws than to risk a suit for fetal damage.

Political Issues

Finally, exclusionary policies raise a host of political issues. A multiplicity of government and private agencies are charged with the responsibility of creating equal employment opportunities for women, maintaining safe and healthful work places, preventing fetal deformities, and ensuring the economic viability of industry. Government agencies

have developed many guidelines to help carry out these responsibilities. The result has been a plethora of regulations and a lack of consistency among the rules of various agencies applying to women in toxic work places. Until a unified code of federal regulations is set forth, industry will be subject to a political battle among government agencies.

Hence, the federal government is faced with a policy decision that involves several controversial and conflicting elements: Equal employment opportunity, protection of worker health, protection of the health of the unborn child, the economic interests of the women and the company, the right of a large company to regulate the reproductive ability of its employees, the proper role of the government, and a host of unresolved scientific and technological issues.

FEDERAL POLICY

At present, the federal government has not adopted a policy on the use of corporate exclusionary policies and is not likely to provide direction in the near future. A major stumbling block is the lack of agreement among government agencies on the most appropriate stance to adopt toward corporate exclusionary practices. The National Research Council (1980) describes the present situation that surrounds the regulation of lead-related issues: "Each agency has pursued its own policies under its own interpretations of its legislative mandates, paying some attention to other agencies' activities where possible" (p. 231). EEOC's emphasis is clearly on equal employment opportunities; OSHA's interest is in worker safety and health; the National Institute of Occupational Safety and Health's (NIOSH) focus is on occupational research activities; and the Office of Federal Contract Compliance's (OFCC) interest lies in the compliance of federal contractors with antidiscrimination legislation. The effect of the regulatory action and inconsistent demands by these agencies was evident at Bunker Hill: The company complained that it was faced with the legal dilemma of meeting both OSHA's and EEOC's regulations.

One feasible alternative may be for an existing government agency to be formally designated to be in charge of enforcing a comprehensive statute on corporate exclusionary practices. This would prevent a diffusion of responsibility and the power of that agency would be increased. The Bunker Hill controversy illustrates the difficulties faced by regulatory agencies lacking official mandates to regulate exclusionary policies. EEOC had entered into the Bunker Hill conflict at the request of the women affected by the corporate policy. The women believed that they had a legal right to an investigation by the EEOC

because they filed a sex discrimination charge. Yet EEOC did not have nor did it seek jurisdiction over exclusionary policies. As a consequence, EEOC settled the claims as sex discrimination charges.

After the EEOC "settled" the Bunker Hill controversy in 1976, the agency began to receive complaints of exclusionary policies from women in other companies. About 50 women filed complaints to the EEOC that they were being involuntarily transferred from their jobs due to corporate exclusionary policies. In the last year of the Carter Administration, the EEOC proposed a policy statement on corporate exclusionary practices. On February 1, 1980, the EEOC, in conjunction with the Office of Federal Contract Compliance (OFCC), proposed guidelines to eliminate sex discrimination by companies for safety and health reasons (45 Fed. Reg. 7514, February 1, 1980). Due to the mixed reactions to the guidelines, the EEOC chose not to issue them and withdrew the controversial guidelines before the Reagan Administration assumed office (46 Fed. Reg. 3916, January 16, 1981). In June 1983, the EEOC incorporated a section on fetal hazards into its compliance manual, but no active effort to apply the guidelines has resulted. The EEOC is instead relying upon Title VII to bring suits for employment discrimination (see *Wright* v. *Olin Corp.,* 697 F. 2nd 1172, 4th Cir. 1982).

OSHA's efforts to develop a policy on exclusionary practices have not been totally successful. In 1978 OSHA promulgated a standard limiting the amount of lead to which male and female workers could be exposed. The standard was OSHA's first formal attempt to present a policy dealing with potential reproductive hazards in the work place. The standard has been widely regarded as an important step toward dealing with reproductive risk. Although the lead standard was upheld in court, OSHA has not aggressively enforced it.

OSHA's future role in the regulation of exclusionary policies may be limited. On August 24, 1984, the U.S. Court of Appeals held that the general duty clause of the Occupational Safety and Health Act does not apply to a policy as contrasted with a physical condition of the work place and that the employer's policy was not a hazard for the purposes of the general duty clause of the Act (*Oil Chemical and Atomic Workers International Union* v. *American Cyanamid,* 741 F.2nd 444).

The federal courts are presently attempting to place exclusionary policies in the context of Title VII. Three major court cases reflect judicial intent to control exclusionary policies. In *Zuniga* v. *Kleberg Co. Hospital* (30 E.P.D. para. 33213, 5th circuit, 1982), an employee was forced to resign from her job as an x-ray technician when she told her boss she was pregnant. In December 1982, the federal court ruled the hospital had discriminated against her. It held that she need not have

been fired; she could have been transferred, put on leave, or allowed to continue to work with a protective apron.

Also in December 1982, in *Wright* v. *Olin Corp* (697 F. 2nd 1172, 4th Cir., 1982), the federal court ruled that Olin Corporation could not exclude women from specific jobs without proving that women are at greater risk than men from reproductive hazards on the job. The decision recognizes that exclusionary policies treat women as always potentially pregnant and that risks to men and women are not treated equally. The decision is the first instance in which a federal appellate court has explored fetal protection policies.

Finally, in *Hayes* v. *Shelby Memorial Hospital* (726 F.2nd 1543, 1984), a female x-ray technician brought employment discrimination charges against Shelby Memorial Hospital. The federal court ruled that the hospital violated the Pregnancy Discrimination Act of 1978 by firing Hayes once it was informed of her pregnancy. The hospital failed to consider less discriminatory alternatives to dismissing her.

Thus although federal regulatory agencies are not actively seeking to limit the use of exclusionary policies, such precedents set by federal courts are encouraging. The findings reflect an awareness that less discriminatory alternatives to exclusion must be considered, that such policies stereotype women, and that potential reproductive risks to males as well as females must be addressed.

DEVELOPING AN EFFECTIVE POLICY

An effective policy on reproductive risks in the work place should place responsibility on the employer, the government, and the worker. Removal of toxic substances from the work place is viewed by many as the most preferable, and most effective, alternative to exclusionary policies. Industry would seek to clean up the work place and to substitute less harmful products so that the work place would be safe for male and female employees and unborn children. Effective engineering controls, robotization, and improved work practices can all combine to minimize the impact of toxic substances. The costs and the feasibility of removing or minimizing the impact of hazards are the primary limitations of this alternative. The courts will undoubtedly assume a major role in the assessment of available technology and the feasibility of imposing clean-up costs on industry.

If employers cannot eliminate hazards, they can temporarily remove or transfer employees to "safer" environments. Some employers use a policy in which all employees are periodically removed from toxic environments ("shift rotation") to reduce the amount of exposure to

toxins. In other cases only those employees planning families are temporarily transferred to safer work places. OSHA's program of Medical Removal Protection (MRP) provides a model standard for a temporary removal and transfer policy (43 Fed. Reg. 52952). MRP provides temporary medical removal for workers discovered through medical surveillance to be at risk of health damage from continued exposure to lead. The worker maintains earnings, seniority, and benefits. After medical surveillance reveals the individual to be out of danger, the individual is permitted to return to his or her former job. Again, court cases involving the MRP of OSHA will reveal the willingness of the court to accept any cost-based arguments set forth by employers.

Further, it is essential that the government require employers to provide the best available information on hazards to their employees and to develop and maintain record-keeping mechanisms. Government support for research into reproductive risks is also needed. Only with an educated work force and greater information can an effective policy on work place hazards be developed.

IMPLICATIONS

Although the development of a uniform federal policy on exclusionary practices is currently remote, such practices are becoming much more prevalent. Major firms such as Exxon, Monsanto, DuPont, Dow Chemical, Firestone Tire and Rubber, Allied Chemical Corporation, and B.F. Goodrich have developed their own versions of exclusionary policies (Holcomb, 1983; Vanderwaerdt, 1983; Ricci, 1977; McGhee, 1977; Howard, 1981). It is highly likely that exclusionary policies will become common throughout industry if corporations are allowed to attain the power to control exclusionary practices and to provide their own answers to health hazards. Without direction from federal agencies, employers have generated "confusing policies on their own, often leaving men unprotected in face of known hazards and women overprotected from unproven hazards" (Holcolm, 1983, p. 4). Such policies provide insurance for corporations against a costly reproductive suit, and such policies will undoubtedly be developed not only to deal with lead and ionizing radiation, but also with a wide range of other toxic substances in the work place.

One toxin that will probably generate problems in the future is ionizing radiation. Ionizing radiation is a highly controversial toxin because it is characterized by an uncertain risk-benefit ratio. The use of ionizing radiation raises a complex dilemma similar to that raised by the use of lead: How should the possibility of reproductive harm be dealt

with? Large numbers of fertile women began seeking employment in radiation environments as hospital workers and significant numbers entered into the nuclear industry in which they were exposed to accelerators, radium sources, radionucleides, and power reactors (Hunt, 1978). Although radiation provides ample job opportunities for women, the toxin can have a severe impact on the fertility of exposed females. Thus employment benefits must somehow be balanced against the very possible health risks.

In the mid-1970s, the Nuclear Regulatory Commission (NRC) attempted to deal with the problem of fertile women exposed to ionizing radiation. The Commission decided that female employees should be informed of hazards and allowed to choose whether to work while pregnant (Section 8.13 of the Nuclear Regulatory Guide). Thus even though ionizing radiation is known to cause fetal damage and lead only suspected of doing so, radiation has not been the basis of exclusion in industry. Objective conditions are not sufficient to explain the NRC's response to the health threat posed by ionizing radiation.

The different approaches to lead hazards and ionizing radiation hazards raise certain questions: What will be the eventual impact of these two very different approaches to reproductive harm? Under what circumstances should fertile females and males be prohibited from working in toxic environments? Should government agencies develop separate positions on exclusionary policies for specific industries or should one position on all such policies be set forth? As technology progresses and the use of such toxins as ionizing radiation becomes more common, these troubling questions may be raised more frequently.

CONCLUSIONS

The exclusionary policy at Bunker Hill is no longer at issue. The controversy at Bunker Hill effectively ended with the closure of the plant. However, women in other organizations will continue to be affected by exclusionary policies and future technology may well generate new toxins with impact on women's reproductive health similar to those presented by lead.

Reproductive risks in the work place must be recognized as a problem that involves men too. All workers need sufficient health protection. With the strong societal interest in protecting the health of future generations, the federal government must join with employers and workers to ensure fetal protection. The multitude of issues raised by the use of exclusionary policies must be given careful consideration and an

acceptable alternative policy—one that does not pose such a heavy economic burden on women—must be developed. As demonstrated in the Bunker Hill controversy, the wide-ranging implications of exclusionary practices for women in organizations demand that the federal government, employers, and workers explore alternatives to exclusionary policies.

NOTES

1. One of the common purposes of a case study approach is to provide an in-depth analysis of a single issue or organization. Case studies are an appropriate technique for obtaining detailed information about a subject and for finding clues and ideas for further research. No attempt is made in the present case study to confirm or falsify hypotheses, as one cannot generalize from a single case study.

2. Interview: Corporate official. Some of the data used in the research have already been published and are classified as public information. As the data source is available to the public, the identities of individuals making statements will be noted in the text. If the data were gathered from interviews by the researcher and the interviewee was guaranteed confidentiality, the name of the individual making a statement will be omitted. Although it would be desirable from a scholarly point of view to identify the names of individuals, the only condition under which most of the respondents would consent to be interviewed was through a guarantee of anonymity.

3. Interview: Corporate official.

4. Interviews: Women affected by the policy.

5. Interview: Union official.

6. Interviews: Local union officials and corporate officials.

7. Interviews: Female employees and women affected by the policy.

8. Interviews: Women affected by the policy.

9. Interview: Local union official.

10. Interview: Local union official.

11. Interview: Woman affected by the policy.

12. Interview: Local union official.

13. Interview: Corporate official. The Idaho Human Rights Commission was asked to verify this information; however, the agency would not divulge whether the company had signed the agreement.

14. Interview: Corporate official.

15. Interview: Corporate official.

16. Interview: Corporate official.

17. Interview: Woman affected by the policy.

18. The 107 other violations involved allegations that the company exposed workers to excess levels of lead, arsenic, and cadmium, allowed lead exposure in eating areas, violated record-keeping requirements, failed to provide adequate respiratory protection, and failed to comply with provisions of a federal lead standard involving biological monitoring.

19. Interview: OSHA official.

20. Interviews: Corporate officials.

21. Interview: OSHA official.

22. Interviews: Women affected by the policy.
23. Interviews: Female employees.
24. Interview: Local union official.
25. Evidence in the OSHA citation hearing for American Cynamid suggested that a "technically feasible retrofit" of the plant to reduce lead exposure in certain areas would cost \$2.6 million (*Secretary of Labor* v. *American Cynamid Co.*, OSHRC Docket No. 79-2438 at 18, August 20, 1980). Moreover, Ashford (1975) notes that the most profitable firms in an industry are typically also the safest and firms clearly suffering from health and safety problems tend to be economically marginal and cannot afford the needed improvements.

REFERENCES

Accola, J. (1980, September 28). Bunker Hill women: Company officials told us to "get fixed." *The Idaho Statesman*, p. 1A.

Andrade, V. M. (1981). The toxic workplace: Title VII protection for the potentially pregnant worker. *Harvard Women's Law Journal, 4*(1), 7-103.

Andrews, L. B. (1983). Is your job hazardous to your pregnancy? *Parents, 58*(8), 22-28.

Burnham, D. (1976, March 14). Rise in birth defects laid to job hazards. *New York Times*, pp. 1, 42.

Catalyst's Career and Family Center. (1984). *Preliminary Report on a Nationwide Survey of Maternity/Parental Leaves* (Perspective No. 17). New York: Author.

Clauss, C. H., & Bertin, J. E. (1981). *Brief of the American Civil Liberties Union Women's Rights Project et al., Amici Curiae*. New York: American Civil Liberties Union Foundation.

Companies permitted to exclude fertile women from some employment. (1981). *Family Planning/Population Reporter, 10*(3), 45-46.

Equal lead safeguards upheld for both sexes. (1980). *Occupational Health Resources Center News, 2*(3), 1.

Gold, R. (1981). Women entering labor force draw attention to reproductive hazards for both sexes. *Family Planning/Population Reporter, 10*(1), 10-13.

Harris, W. (1980, September 16). OSHA fines Bunker Hill on sterility policy. *Metals Daily*, p. 1.

Holcolm, B. (1983). Occupational health. *Ms., 11*(11), 40-42.

Howard, L. G. (1981). Hazardous substances in the workplace: Implications for the employment rights of women. *University of Pennsylvania Law Review, 129*(4), 798-855.

Hricko, A. (1978). Social policy considerations of occupational health standards: The example of lead and reproductive effects. *Preventive Medicine, 7*, 394-406.

Hricko, A., & Brunt, M. (1976). *Working for your life: A woman's guide to job health hazards*. Berkeley, CA: Labor Occupational Health Program and Public Citizen's Health Research Group.

Hunt, V. (1978). Occupational radiation exposure of women workers. *Preventive Medicine, 7*, 294-310.

Hyatt, J. (1977, August 1). Work safety issue isn't as simple as it sounds. *The Wall Street Journal*, p. 1.

Kinnersly, P. (1973). *The hazards of work: How to fight them*. London: Pluto.

Kuglin, J. (1977, January 27). Women take plunge to work at Bunker Hill. *Lewiston Morning Tribune*, p. 3A.

Lin-Fu, J. (1982). The evolution of childhood lead poisoning as a public health problem. In J. J. Chisolm, Jr., & D. M. O'Hara (Eds.), *Lead absorption in children* (pp. 1-10), Baltimore-Munich: Urban and Schwarzenberger.

McGhee, D. (1977). Workplace hazards: No women need apply. *Progressive, 41*(10), 20-25.

National Research Council. (1980). *Lead in the human environment.* Washington, DC: National Academy of Sciences.

A new twist to exclusionary policies: The case of synfuels. (1981). *Coalition for the Reproductive Rights of Workers Newsletter, 1*(1), 3, 7.

OSHA proposes $82,765 penalty for alleged health violations at Bunker Hill Company. (1980, September 12). *U.S. Department of Labor News*, pp. 1-2.

The poisoning of America. (1980, September 22). *Time*, p. 58.

Ricci, L.J. (1977). Chemicals give birth to human reproductive woes. *Chemical Engineering, 84*(16), 30-36.

Robinson, G. (1979). The new discrimination. *Environmental Action, 10*(20-21), 4-9.

Schlender, B. R. (1980, December 9). Sterilization is main issue in OSHA suits. *The Wall Street Journal*, p. 25.

Severo, R. (1980, September 24). Should firms screen the workplace or the worker? *New York Times*, p. 22E.

Stellman, J. (1977). *Women's work, women's health.* New York: Pantheon.

Stillman, N. G. (1978). Women in the workplace: A legal perspective. *Journal of Occupational Medicine, 20*(9), 605-609.

Tate, C. (1975, April 17). Women shifted from Bunker smelter jobs. *Lewiston Morning Tribune*, p. 1A.

U.S. Department of Labor. (1979). Lost in the workplace: Is there an occupational disease epidemic? *Proceedings from a Seminar for the News Media.* Washington, DC: Government Printing Office.

U.S. Department of Labor. (1980). *Facts on women workers.* Washington, DC: Government Printing Office.

U.S. Occupational Safety and Health Administration. (1981). *Freedom of Information Act Request.* Washington, DC: Government Printing Office.

Vanderwaerdt, L. (1983). Resolving the conflict between hazardous substances in the workplace and equal employment opportunity. *American Business Law Journal, 21*, 157-184.

Warshaw, L. (1979). Non-medical issues presented by the pregnant worker. *Journal of Occupational Medicine, 21*(2), 89-92.

Weiksnar, M. (1976). To hire or fire: The case of women in the workplace. *Technology Review, 79*(1), 16-18.

Williams, W. W. (1981). Firing the woman to protect the fetus: The reconciliation of fetal protection with employment opportunity goals under Title VII. *Georgetown Law Journal, 69*(3), 641-704.

Win-O'Brien, M. (1980). Law in conflict: Another view. *Journal of Occupational Medicine, 22*(8), 509-510.

11

Federal Job Training
Policy and Economically
Disadvantaged Women

SHARON L. HARLAN

This chapter critically reviews the impact of federal job training policy on economically disadvantaged women. It focuses on the 1982 Job Training Partnership Act and its predecessor, the Comprehensive Employment and Training Act, which are intended to create job opportunities for individuals who lack job skills, basic educational credentials, or the means of looking for work. Three issues that affect women's access to programs are examined from a national policy perspective and from the perspective of local communities, educators, and private sector employers who carry out national policy: Opportunities for enrollment, participation in different types of training, and occupational sex segregation. Evaluations of job training programs are criticized, identifying several serious shortcomings in how they address the basic question: Are women better off after participation than they would be without the programs?

Future studies should link economic conditions and institutional arrangements to participants' labor market outcomes and devise more meaningful ways of measuring program benefits. I conclude that poor women's opportunities to benefit from job training programs ultimately depend upon the enforcement of laws that guarantee equality of educational and employment opportunities in the institutions that operate programs.

This chapter critically reviews the impact of federal job training policy on economically disadvantaged women.[1] It examines research on enrollment opportunities and economic benefits for women in job training programs currently authorized under the 1982 Job Training Partnership Act (JTPA).[2] JTPA and its predecessor, the Comprehensive Employment and Training Act (CETA), have historical roots in two decades of federal legislation that has attempted to alleviate the

AUTHOR'S NOTE: This chapter was prepared under a grant from the National Science Foundation. The views expressed are mine and should not be attributed to the National Science Foundation. I gratefully acknowledge the helpful suggestions on an earlier draft made by Edward J. Hackett, Lois Haignere, Judith M. Gerson, and anonymous reviewers.

problems of unemployment and low wages among individuals who lack job skills, basic educational credentials, or the means of looking for work. The goals of these programs are to achieve higher employment rates, better jobs, and higher wages for participants.

There are two ways in which federal job training policy can create better job opportunities for women: (1) Training and education programs that increase women's productivity and job performance; and (2) equal opportunity regulation that attacks discrimination in the educational institutions and firms that receive program funds. Both strategies—individual improvement and institutional change—are important for meeting JTPA's objectives.

By itself, more education for women will not necessarily produce substantial improvements in their job opportunities or reduce economic inequality between the sexes. Since 1950, an increasing proportion of women have enrolled in programs of higher education, male and female college attendance rates have converged to a point of equality, and the percentage of degrees earned by women has increased markedly (Heyns & Bird, 1982). Despite this trend, indexes of occupational segregation by sex and the earnings gap between men and women have remained quite stable over the period (e.g., U.S. Commission on Civil Rights, 1978). The argument that women need more training has been misused by employers (and others) who claim they cannot find "qualified" women to hire and promote. This situation has caused many to doubt the efficacy of using education to pursue social objectives, such as occupational and earnings equality.

Nevertheless, it can be reasonably argued that among the population eligible to participate in federal job training programs, a large proportion of whom are young and undereducated, many women (and men) can benefit from specific types of training. The most important of these are courses leading to high school equivalency diplomas for dropouts, English language instruction for immigrants, and vocational training for skilled jobs that are nontraditional for women.

The acquisition of skills for traditionally male and "mixed-sex" occupations is necessary to ensure that women are qualified for well-paying jobs with advancement opportunities when they leave the program. Occupational segregation is an important issue for women of all socioeconomic backgrounds, but its economic consequences are most severe for women, such as those eligible for JTPA, who do not have the option of attending college to prepare for professional or managerial careers. For example, in 1979, nearly half of all currently employed women who only graduated from high school or who had less than four years of college worked in clerical occupations (U.S. Department of Labor 1980, Table 45). Yet the median annual earnings

of all year-round full-time clerical workers in 1979 was $9,158 (U.S. Department of Labor 1980, Table 62), barely enough to support a woman and two children above the poverty line. Most women with less than a high school education worked in service and operative occupations with even lower average annual earnings. Higher-paying jobs that do not require a college degree, in maintenance, repair, crafts, construction, and protective services, are predominantly done by men.

To understand occupational segregation requires an institutional, rather than an individual, perspective on job training programs. The institutional perspective maintains that the most intractable barriers to women's opportunities are in the discriminatory practices of schools and employers that control the conditions under which women enter the labor market. Training programs, such as JTPA, cannot be faulted for shortcomings in the regulation and enforcement of federal equal employment policies generally, but they do bear a measure of responsibility for the actions of organizations that receive training funds. There are two areas in which institutional factors bear directly on the opportunities of women who are eligible to participate in JTPA, and these shape the analysis presented in this chapter.

First, JTPA-funded programs are an integral part of the whole institutional network that provides most of the postsecondary education and training for people who do not attend college. Its problems are illustrative of those concerning women's enrollment opportunities and sex-segregated training in a large number of public and private vocational programs. By studying JTPA, we can learn something about the institutional mechanisms that segregate working- and middle-class women into educational tracks that lead to clerical and other low-paying occupations.

Second, JTPA breaks with training efforts from the 1960s and 1970s in a way that is consistent with the Reagan Administration's political philosophy. The role of private sector employers in establishing program priorities and controlling access to its resources is substantially increased by the new legislation. Public service employment, a program that enrolled participants as employees of federal, state, and local governments, consumed the major portion of CETA resources under the Carter Administration. Under JTPA, public service employment no longer exists; only private sector jobs can be subsidized through increased use of on-the-job training programs. Furthermore, the JTPA policy framework mandates closer cooperation in training programs among private employers, the U.S. Employment Service, vocational educational programs, economic development agencies, and social services, and it authorizes local Private Industry Councils to direct their

activities. Thus a major concern about the future of employment and training policy is whether sex discriminatory attitudes and practices in the private sector will be less subject to scrutiny by all levels of government.

Before proceeding with an analysis of JTPA, it is worth noting that the federal government contributes to or supports many other programs that provide job training. Some of these are vocational education, summer youth employment, the Work Incentive Program (WIN) for welfare recipients, and apprenticeship training. However, a review of all programs, in the space of a single article, would be a highly superficial treatment of their diverse missions and target populations. I am focusing more narrowly on JTPA because it is intended for a cross-section of the economically disadvantaged population, the majority of which are women. Throughout this chapter, I will show that the barriers to women in JTPA are common in these other programs as well.

The first section of this chapter provides evidence on the extent of female poverty in the United States, which helps to document the need for job training programs among women. The second section analyzes the factors that affect women's enrollment opportunities in job training programs from the perspective of national priorities and from the vantage point of local experiences in administering training programs. The third section evaluates empirical research about the effect of participation on women's later employment and earnings, and suggests ideas for a future research agenda in this area. My conclusions focus on the longer-range prospects for achieving equal opportunity for poor women in federal job training programs.

POVERTY AMONG WOMEN: THE NEED FOR FEDERAL JOB TRAINING PROGRAMS

One of the major issues confronting federal employment policy is that millions of women need jobs—not just jobs that supplement the earnings of husbands or other family members, but jobs that pay enough to support themselves and their families. In 1982, 9.5 million, or 15.4 percent of all families, were headed by women with no husbands present (U.S. Department of Commerce, 1984, Table 34). A disproportionate number of female-headed families were black and minorities of Spanish origin. Moreover, the proportion of women who will ever head families is growing rapidly. Between 1974 and 1982, female-headed families increased by 32.5 percent (over 2 million additional families), whereas married couple families increased by only 4.7 percent (U.S. Department of Labor, 1983, Table 58).

Families maintained by women are far more likely to be poor than other families. In 1982, 36.3 percent of female-headed families, compared to 7.6 percent of married couple families, had incomes below the official government poverty threshold ($9,862 for a family of four [U.S. Department of Commerce, 1984, Tables 26, A2]). The number of families with inadequate living standards, however, includes many of those who are not officially classified as poor. In Massachusetts, for example, it is estimated that a sufficient annual income for a mother supporting two children is $18,512 (Massachusetts Executive Office of Economic Affairs, 1984). By this standard, most female-headed families have insufficient incomes, as the national median income of all such families was $10,802 in 1981 (U.S. Department of Labor, 1983, Table 58).

Certain kinds of women have a higher incidence of poverty than others. Half of all female-headed families with children under 18 are below the federal poverty line. Female-headed families are far more likely to be poor if they are black (56.2 percent) or minorities of Spanish origin (55.4 percent) than if they are white (27.9 percent). More than two-thirds (70.5 percent) of females between the ages of 15 and 24 who maintain families are poor. These young women are poorer than others: The mean annual income for all poor female-headed families in 1982 was $4,647, but the mean for families headed by young women was only $3,665 (U.S. Department of Commerce, 1984, Tables 5, 26, 34, 38).

Most women who maintain families work outside the home. In 1982, 60 percent of female family heads were employed, most of them full-time. The poverty rate was much higher among families in which the women did not work: More than half (57.2 percent) were poor. Most of their income came from Aid to Families with Dependent Children (AFDC) and other forms of public assistance. However, even among those who were employed, 17.2 percent of white women and 35.6 percent of black women were poor (U.S. Department of Commerce 1984, Table 26).

The incidence of poverty among working women indicates that the need for job training and employment programs is not limited to women who are unemployed or out of the labor force at any given time. In addition to helping women on welfare to enter employment, the programs should assist those already working to find jobs that pay a living wage. Minority women and young women are critical target groups for job training programs. The programs have a role in preventing poverty among married women who are not currently maintaining families alone, but who may find themselves in that position in the future.

POLICY ISSUES FOR ENROLLMENT:
FROM CETA TO JTPA

This section reviews three aspects of job training policy that affect women's access to federally sponsored programs and, ultimately, to the longer-term economic benefits that might result from participation. These are policies and practices affecting women's level of enrollment, their rate of participation in different types of training, and their distribution among occupations. One theme in this section is to highlight national policies that influence women's enrollment opportunities and to assess the probable consequences of legislative and regulatory changes between JTPA and CETA. A second, equally important theme is to analyze the institutional framework of job training programs in local communities that carry out national policies.

JTPA was fully implemented for the first time in fiscal 1984. In some fundamental ways, it altered the course of national policy from the way it was under CETA. CETA, the first legislation to decentralize the administration of programs, established a framework in which municipal and county governments were directly accountable to the U.S. Department of Labor for designing programs, selecting participants, and meeting performance standards in accordance with the Department's regulations. JTPA changed the balance of authority among federal, state, and local governments. Under JTPA, the federal government delegated most of its oversight and enforcement functions to the executive branch of state governments.

Unlike CETA, which placed control of local programs solely in the hands of elected officials and social service administrators, JTPA creates a much more active role for private sector employers in initiating and approving policy decisions at the state and local levels. Each local service delivery area must establish a Private Industry Council (PIC) that selects organizations to receive training grants, approves plans of service delivery, and decides policy directions in conjunction with local elected officials.

JTPA also reduced the level of funds for job training programs. The JTPA Title IIA training budget for fiscal year 1984 was $2.6 billion, less than the CETA budgets for similar activities in previous years (Walker et al., 1984, p. 4). Prior to the Reagan Administration, which began reducing job training budgets in fiscal 1982, the long-term trend from the 1960s onward had been toward increasing expenditures. The creation of the states' intermediary role, the increasing voice of business, and dwindling resources are examined in relation to national policy.

Previous analyses of women's enrollment opportunities have scruti-
nized the ways in which legislative and regulatory provisions encourage
or discourage women's participation in programs. Although the identi-
fication of sex bias in federal laws is important, this perspective alone
defines the barriers to women's participation too narrowly. It overlooks,
for example, the pervasive sex bias and discrimination in organizations
that operate training programs. JTPA (and each of its predecessors) is
only a "mechanism for placing resources into the hands of training
institutions" (Levitan & Mangum, 1981, p. 49) with the hope that they
will function more effectively in serving the economically disadvan-
taged. To guarantee women equal access to job training programs, the
"mechanism" itself must not be discriminatory. But each of the
institutions involved in the process—local governments, firms, voca-
tional and technical schools, community colleges, community-based
organizations, and social service agencies—ultimately determines who
will be served and how. Once the connection is established between
access to job training programs and educational and labor market sex
discrimination, a much wider range of research and theory can be used
to explain the barriers to women's participation.

Enrollment

Historically, women participants have been a minority in federally
sponsored training activities similar to JTPA and CETA (Sexton, 1978;
Perry et al., 1975). By fiscal 1980, however, women made up 53 percent
of enrollees in CETA Title IIB training (U.S. Department of Labor,
Office of the Secretary, 1981, Table F-10.3). Rising female labor force
1981, Table F-10.3). Rising female labor force participation throughout
the economy has produced an increasing supply of women eligible for
program participation. In conjunction with factors influencing the
number of eligible women, the upward trend in female enrollment is also
attributable to changing perceptions about the nature of poverty and
changes in the politics of distribution of job training resources.

Programs of the 1960s (many authorized under the Economic
Opportunity Act of 1964) were intended for men. An influential theory
of the time held that poverty (and a host of other family problems) was
caused by the joblessness of black men who left their families because
they could not support them (e.g., U.S. Department of Labor, 1965).
One strategy for fighting poverty was improvement of the education and
employability of black male youths. Today, there are still vestiges of
male bias in job training programs (Underwood, 1979), but changing

social norms concerning divorce, children born to unmarried mothers, and women's labor force participation make policymakers more likely to reason that families without men are poor because women cannot support them. It is also more widely understood that white women head more of the nation's poor families than black women.

The passage of the CETA legislation also coincided with an era of increasing strength in the Women's Movement. Steinberg and Haignere (1983) point out that the Women's Movement began to acquire in the 1970s the same legitimacy and political "muscle" that the Civil Rights Movement had in the 1960s. The political process that brought about changes in CETA between 1973 and its reauthorization in 1978 reflects the efforts, advocacy, and lobbying capabilities of groups such as Wider Opportunities for Women, the League of Women Voters, the Women's Bureau in the U.S. Department of Labor, and many grass-roots women's organizations.

National priorities. Regulations issued by the U.S. Department of Labor after the 1978 CETA reauthorization contained many provisions that were favorable to women, much more so than any previous program.[3] Localities were required to provide employment and training opportunities on an equitable basis to women (676.54 a). They were directed to establish affirmative action plans designed to achieve objectives within specific time frames; to take positive steps to ensure that planned levels of service were realized; to take corrective action if service levels to women differed by more than 15 percent of the eligible population; and to eliminate "artificial barriers" (such as sex, race, parental status, or absence of part-time work schedules) to enrollment (676.52-676.54). Even before the regulations were officially implemented, the Department of Labor began to encourage higher enrollments for women (Steinberg & Haignere, 1983).

It is too early to tell whether women's enrollments will continue to increase under JTPA. The legislation requires localities to serve the population most in need of training and to "make efforts to provide equitable services among substantial segments of the eligible population" (Sec. 141a). It states that AFDC recipients should be served on an equitable basis (Sec. 203b3). The act prohibits discrimination against women (Sec. 167a2), but neither the act nor the regulations contain specific affirmative action guidelines for state or local plans, and the extensive provisions of CETA that recognized special barriers to women's enrollment are absent from JTPA.

JTPA's lack of specificity about affirmative action is a problem in two respects. First, the absence of blatantly discriminatory practices does

not guarantee that women will have equal access to enrollment opportunities. This is because many of the barriers to women's participation are the subtle factors recognized by CETA, such as child-care responsibilities or inflexible work and training schedules. Second, progress in equal employment opportunity for women and minorities has usually depended upon strong federal leadership in establishing goals and enforcing standards for meeting those goals. The lack of specific guidelines and decentralization of oversight and enforcement will make it more difficult to keep the issue of female enrollment at the forefront of the political agenda in each state. The trend toward smaller budgets every year also makes the choice of whom to serve even more difficult than in the past.

Despite the progress in women's enrollment levels under CETA, women were still underrepresented compared to their proportion of the population eligible to participate in training programs (National Commission for Employment Policy, 1981, p. 91). This underrepresentation was attributable in part to federal eligibility requirements that favored men, such as veteran's preference, means tests based on family income instead of individual earnings, and upper age limitations in apprenticeship programs (see Underwood, 1979; Harlan, 1981; National Commission for Employment Policy, 1981; Steinberg & Haignere, 1983). In addition, the enforcement of federal affirmative action requirements under CETA was cumbersome, requiring a lengthy process of administrative complaint to the Labor Department (National Congress of Neighborhood Women, 1979; U.S. Department of Labor, Office of the Secretary, 1981).

Important as these barriers were, probably none had so great an impact on women's enrollment opportunities as the limited availability of public resources for child-care assistance. Research on WIN, vocational education, and CETA consistently shows that access to child care is a critical factor in determining whether women are able to enroll in and complete job training and educational programs (U.S. Commission on Civil Rights, 1981). Under the CETA regulations of 1978, localities were authorized to use CETA funds to pay for child care and other supportive services (676.25-5c), and employers of CETA enrollees could be reimbursed for the costs of child care (676.25-2). Although no limits were placed on the proportion of funds that could be used for supportive services, local program administrators were left with difficult choices about how to apportion their resources. On the one hand, federal regulations encouraged greater enrollment opportunities for groups that required a more intensive investment of resources. On the other hand, diverting funds away from the central mission of training

meant that localities would enroll fewer participants. Federal performance standards for localities, which relied heavily on numbers served, numbers placed, and cost per placement to measure success, were disincentives to enrolling women (Zornitsky & McNally, 1980).

JTPA added other disincentives for localities to provide child care by placing a limit on the proportion of allowable costs that are not directly related to training (Sec. 108b1). Walker, Grinker, Seessel, Smith, and Cama (1984, p. 73) have estimated that this will mean that "around 15 percent of total JTPA expenditures are reserved for costs that under CETA ranged from 30 to 40 percent." By creating greater involvement for private sector employers, JTPA may have contributed to a mood less favorable to serving those who require more resources. Walker's survey of 57 local PICs indicates that more than half believed expenditures for supportive services under JTPA should be kept to a minimum. Reflecting the majority view that JTPA's primary mission is to serve the needs of employers, not specific target groups, one PIC chair reported:

> With as little money as we've got and so many people eligible for JTPA, who in his right mind would try to bring into our programs the people hardest to train? Our job is to make this JTPA System serve employers quickly and at the lowest possible cost. (Walker et al., 1984, p. 41)

Not only is JTPA child-care support likely to be lower than the CETA level, but the Children's Defense Fund has recently reported that Reagan budget cuts have significantly reduced other sources of child-care aid for low-income families (New York Times, September 25, 1984, p. A25).

Local control. Women's enrollment opportunities are affected by decisions at the national level regarding eligibility, appropriations, and program priorities. However, decentralized authority under CETA and JTPA gives local communities considerable leeway in how they define and serve the population in need of job training. Studies of the implementation of CETA at the local level have found wide variation across communities in the proportion of women enrolled (Baumer, Van Horn, & Marvel, 1979; Mirengoff & Rindler, 1978; Harlan, 1979; Levitan & Mangum, 1981). These studies agree that the proportion of women among the local eligible population is not the decisive factor in determining women's enrollment level. Instead, some communities offer women greater enrollment opportunities than others because of differences in programmatic decisions, training resources, and local labor markets.

Enrollment patterns are influenced by the preferences of many local decision makers who control job training policy. Under CETA, Baumer

et al. (1979) found that the professional employment and training staff in each community exercised the greatest influence on selecting target groups. Their choices were related to how they perceived labor market conditions and client needs. Harlan (1979) found some evidence that decisions about whom to serve were related to the staff's educational and employment background; that is, communities in which the staff directors had advanced degrees and past experience in social services had higher female enrollments. Both studies suggest that staff were influenced in their decisions by the strength of various interest groups represented on local advisory councils, including local politicians, social services organizations, schools, community-based organizations (CBOs), labor groups, and private employers.

Projecting these findings into the future of JTPA, it seems significant that representatives of private industry are now required to be a majority of local PIC members (Sec. 102a1) and that the PICs have a stronger role than CETA advisory councils in initiating and approving local service plans. If the negative attitudes toward child care and serving hard-to-employ target groups are as widespread among PICs as Walker et al. (1984) suggest, then these changes at the national level will be detrimental to women. However, communities may still exercise choices in deciding which business executives are appointed to the council and in selecting other interest groups for representation on the PICs.

First, local elected officials might be persuaded to consider affirmative action records and other demonstrations of concern for female workers in selecting employers for PIC membership. Second, JTPA regulations permit up to half the PIC membership to represent other community interests, including education, labor, and CBOs (Sec. 102a2). Pressure by women's advocacy organizations in local communities may result in the appointment of members who understand women's needs. Third, some states may step in and attempt to protect women's interests. For example, the Massachusetts legislature is considering a bill that would require economically disadvantaged individuals (including AFDC recipients) to serve on each local PIC (Mass. S. 784; Mass. H. 3491). The bill would also require PICs to use up to 10 percent of their funds for provision of social services to applicants in need of child care or other services.

Local communities also influence enrollment patterns through their choices of contractors to run training programs, particularly contractors responsible for client intake and referral (Mirengoff & Rindler, 1978). Local contractors might include, among others, the U.S.

Employment Service, vocational schools, CBOs, community action agencies, and private employers. These organizations have diverse functions in the community and different motivations for involvement with job training. Because they typically establish their own recruitment and selection criteria for applicants (Baumer et al., 1979), their ability and commitment to serve women is reflected in local enrollment patterns.

The choice of contractors is related to the kinds of training offered to participants, as are many other factors. For example, Levitan and Mangum (1981) report that rural areas were more likely to implement small on-the-job training programs than classroom programs. Presumably, this is because vocational or technical training centers are less common than in urban areas and because the majority of the rural population lives far from them. On-the-job programs were also used more in urban areas that had developed a network of cooperating businesses (Mirengoff & Rindler, 1978). Classroom programs were more feasible where educational facilities already existed, as no localities received enough CETA money to create such institutions (Levitan & Mangum, 1981).

In turn, the type of available training programs helps to determine the characteristics of local participants. Two studies agree that communities that devoted more resources to on-the-job training programs enrolled fewer women (Baumer et al., 1979; Harlan, 1979). Other research, discussed below, also finds that men and women were differentially enrolled in on-the-job and classroom training. The next section looks at the causes of sex differences in program assignments.

Types of Training

Participants in on-the-job training (OJT) work for private sector employers during the period of program enrollment. In exchange for a federal wage subsidy for participants, employers provide training in a specific occupation. OJT offers participants skill development, the opportunity to earn while learning, and a chance to continue in unsubsidized employment with the same firm after leaving the program. In fiscal 1980, OJT accounted for about 11 percent of enrollees in CETA training (Levitan & Mangum, 1981, p. 25); under JTPA, OJT enrollments are expected to increase to about 20 percent of enrollees (Walker et al., 1984, p. 76).

Classroom training takes place in community colleges, vocational schools, or other specialized training facilities. It can be either general

education (high school equivalency programs or English language instruction) or job skills training in specific occupations. Classroom training participants lack direct employer contact during enrollment, and unlike OJT participants, their training is not employer-specific. Under JTPA, the great majority of classroom trainees will not receive any financial support while they are enrolled in the program (Sec. 108). About half the fiscal 1980 CETA training enrollees were in classroom programs (Levitan & Mangum, 1981, p. 16), whereas under JTPA the figure is likely to be 80 percent (Walker et al., 1984, p. 76).[4]

Neither CETA nor JTPA imposed regulations that directly affect the sex distribution of participants in these programs, but women are a much smaller percentage of OJT enrollees. In fiscal 1979, women made up only 37 percent of OJT participants, but they represented 60 percent of participants in classroom programs (National Commission for Employment Policy, 1981, p. 91). Proportionately more black women than white women were in classroom programs and proportionately fewer were in OJT (Harlan & Hackett, 1985). However, Waite and Berryman (1984) found that race and ethnicity, per se, had small or insignificant effects on women's program placements. It is not clear from either analysis why black women were less likely to be in OJT.

The "qualifications" and "preferences" of female enrollees are often cited as reasons for sex differences in enrollment patterns. Oblique references to these reasons often appear in the evaluation literature, but not a single study can be cited that adequately defines "qualifications." Neither has anyone demonstrated that women more often prefer classroom training over on-the-job training. In fact, Berryman, Chow, and Bell (1981) found that being a woman rather than a man increased the probability of placement in classroom training rather than OJT independently of characteristics such as labor force experience, education, age, poverty status, and desired CETA services.

In my view, the evidence indicates that the structure of the training system is a more important determinant of program assignment than the qualifications and choices of individual female participants. OJT positions involve paid work and are in short supply. Therefore, administrators of job training programs may be responding to deeply ingrained social attitudes about the inappropriateness of giving jobs to women rather than to unemployed men (Harlan, 1981).

The underrepresentation of women in OJT could also reflect sex discrimination in the hiring practices of private sector firms. OJT positions are in short supply because the creation of subsidized jobs depends upon administrators' ability to convince local employers to hire

participants. In order to ensure employers' cooperation, program administrators must respond to the employers' demands for workers with certain characteristics. Although we lack extensive research on the employer selection process for OJT workers, a report on OJT in the WIN program indicated that employers often preferred men and were reluctant to hire women (U.S. Commission on Civil Rights, 1979). Private sector employers are more discriminatory than the public sector in the wages they pay women (Smith, 1976), but it is not certain that they were more discriminatory in hiring female CETA participants. In CETA public service employment programs, women were also under-represented compared to their proportion of the eligible population. In all CETA programs, the kinds of available positions affected whether women were selected.

Occupational segregation and sex-stereotyping contributed to enrollment differences in OJT and classroom programs. Compared to the occupational distribution in other CETA programs, OJT contained the largest proportion of blue-collar positions and classroom training programs contained the largest proportion of clerical positions (Levitan & Mangum, 1981; Waite & Berryman, 1984). The association between type of training and occupational categories reflects, more generally, how women and men prepare for sex-typical occupations. For example, a business office where tasks involve typing, filing, and other clerical work, can easily be simulated in a classroom. Some training for blue-collar jobs is also available in vocational schools (e.g., electrical circuitry or drafting), but the large and expensive equipment used in many operative jobs is located in factories. Skilled crafts are traditionally learned through formal apprenticeship programs and "hands-on" training.

For these reasons, then, administrators have found it easier to accommodate women (as well as minorities and other enrollees who are not preferred job candidates) in classroom programs (Mirengoff & Rindler, 1978). Different methods of training men and women contribute to inequalities in short- and long-term benefits. Women are less likely to earn wages during the period of training; they have lower rates of immediate job placement; they have fewer opportunities to develop employer-specific skills that contribute to later job advancement; and they are trained in traditionally female occupations that will pay lower wages when they leave the program. These aspects of federal job training programs reflect the institutional linkages between the educational system and the labor market for noncollege women.

Occupational Segregation

Sex-stereotyping is important in directing women and men to different kinds of training programs, but occupational segregation also occurs within each type of program. Berryman et al. (1981) found that about three-quarters of the women in classroom programs and nearly half the women in OJT were preparing for female-dominated occupations. Considering that OJT has a much higher proportion of male-dominated and "mixed-sex" occupations, women in OJT actually had a much greater probability of being placed in a female-dominated occupation than women in classroom training.

Based on national data for fiscal 1976 CETA participants (Continuous Longitudinal Manpower Survey, unpublished data), half the white women and 60 percent of the minority women in OJT, vocationally-specific classroom training, and work experience had lower white-collar occupations. The most common job categories were typists, bookkeepers, keypunch operators, and (unspecified) clerical. Service occupations, the second largest female category, included practical nurses, health care workers and other aides, hairdressers, cooks, and food service workers. About 40 percent of the men (all races) were in semiskilled blue-collar jobs such as welders, machine operators, construction laborers, and groundkeepers. Another 40 percent of the men were in blue-collar crafts, such as machinists, carpenters, auto-mechanics, and equipment repair persons.

After the reauthorization of CETA in 1978, federal regulations were amended to confront directly the problem of occupational segregation by sex. The revised regulations stated that, "all programs, to the maximum extent feasible, shall contribute to the elimination of sex stereotyping" (676.52c). Local administrators were directed to "recruit for, and encourage, female entry, through such means as training, into occupations with skill shortages where women represent less than 25 percent of the labor force" (676.52c1). Using national data for classroom and OJT participants in the fiscal 1976 to 1978 cohorts (prior to reauthorization), Berryman et al. (1981, p. 33) found very slight increases over time in the percentage of women trained in traditionally male and "mixed" occupations. Evidently, the occupational distribution of later CETA cohorts has not been analyzed, so we cannot determine the effect of the regulatory changes on occupational desegregation.

To understand occupational segregation in federal job training programs, one must turn again to systemic barriers in the educational

and employment establishments that operate the programs. It would appear that most of these institutions lacked the expertise and the will to recruit and train women for nontraditional jobs.

The curriculum of state vocational schools, which were entitled to receive CETA (and JTPA) funds for classroom training, are highly segregated by sex. A report by the National Commission for Employment Policy (1981, pp. 4-5) summarized vocational education enrollment patterns:

> Of the seven defined occupational areas, three (health, home economics, and business and office) are "traditionally female," i.e., over 75 percent of those enrolled were female in both 1972 and 1978. Three others (technical, agriculture, and trade and industrial) are "traditionally male," i.e., over 75 percent of those enrolled were male in both 1972 and 1978. Only one occupational area (retail sales) is "traditionally mixed," i.e., females numbered 45 percent of the enrollment in 1972 and 42 percent in 1978.

According to a study by the American Institutes for Research, reported by the Commission, neither states nor localities were responding vigorously to federal legislation (1976 Amendments to the Vocational Education Act) that required schools to make progress toward sex equity. The JTPA legislation continues CETA's policy of close cooperation with the vocational education system without requiring it to demonstrate commitment to sex equity in education (see Sec. 107c, Selection of Service Providers, and Sec. 123, State Education Coordination and Grants).

In OJT programs, a disproportionate number of employers were small, marginally profitable firms for which the federal wage subsidy was attractive (see Mirengoff & Rindler, 1978; Levitan & Mangum, 1981). (Larger, more profitable firms were reluctant to deal with government red tape and less willing to tolerate workers with employment problems). High labor turnover and thin profits among the small firms meant that they were unlikely to expend scarce resources for the intensive training required to integrate women into unfamiliar work environments. Moreover, they had less reason to do so than other companies because they were less likely than large corporate employers to be the target of federal efforts to enforce equal opportunity legislation (O'Farrell & Harlan, 1984).

Economic conditions did not provide incentives for training program administrators to make educators and employers adhere to CETA regulations regarding occupational desegregation. The obvious demand for workers in clerical and health occupations provided a steady source

of placement for female trainees in sex-segregated jobs. At the same time, changes in the economy that eliminated jobs and caused high unemployment in manufacturing industries have made it harder to identify traditionally male blue-collar occupations in which there are labor demands (Levitan & Mangum, 1981). Available jobs are filled by an oversupply of men.

Other administrative disincentives to desegregate programs arose from the performance indicators devised by the federal government to determine fund allocations and to measure local programs' success. I have already alluded to the fact that performance standards, which seek to maximize the number served and to minimize program costs and duration, act as barriers to women's enrollment. In addition, these short-term criteria of successful performance discourage nontraditional training for women because administrators may view it "as desirable but too risky, given . . . the existing emphasis on the production of a large volume of low cost placements" (Zornitsky & McNally, 1980, p. 15). Yet short-term indicators are not valid measures of lasting program effects (Gay & Borus, 1980), and so the potential long-term cost-effectiveness and benefits of nontraditional training are ignored.

Given the meagerness of CETA or JPTA resources compared to the entire employment and training system, it is unrealistic to expect great strides in occupational desegregation without profound institutional changes. The overall pattern of sex segregation in the wider labor market was reflected in CETA. However, there were also important exceptions in which CETA funds provided essential seed money that helped to create institutional change. Many successful programs had the single purpose of recruiting and training women for nontraditional, skilled blue-collar jobs (National Commission for Employment Policy, 1980; Steinberg & Haignere, 1983). For example, the Women's Technical Institute in Boston, the first nationally accredited technical training school for women, was originated with support from CETA in the mid-1970s. The director says that the school has "trained and placed more women as electronic technicians than has the city's largest technical school in its 75 year history" (Women's Technical Institute, 1981, p. 4). Deaux and Ullman's (1983) account of job integration in the steel industry after the 1974 consent decree includes a description of how one mill used a local CETA program to recruit women applicants for a company-operated craft training school. "Many [of these women] . . . would not otherwise have found their way to the blue-collar jobs of the steel industry" (Deaux & Ullman, 1983, p. 158).

The experimentation of programs like these has helped to create a base of knowledge about the kinds of institutional changes that are

necessary to integrate women into higher-paying, skilled jobs. Steinberg and Haignere's (1983) review of the elements of successful nontraditional training programs agrees closely with O'Farrell and Harlan's (1984) conclusions about successful corporate strategies for job integration based on the experiences of many companies. These are: (1) Recruitment methods targeted explicitly to women, that is, counseling and exposure to unfamiliar jobs; (2) prior preparation for trade or technical programs that familiarize women with tools and terminology; (3) support for child care to help women meet home responsibilities and job demands; (4) convincing employers to change employment practices that make it difficult for women to operate in all-male work environments; and (5) follow-up on women's progress and development of network and support groups to increase job retention during the transition from school to work.

In some cases, then, CETA programs acted as catalysts for change in a sex-segregated employment and training system. Unfortunately, the funding for many innovative women's programs was diminished or completely eliminated under budget reductions that began in the early 1980s. What is the outlook for occupational desegregation under JTPA? The JTPA legislation does state that, "efforts shall be made to develop programs which contribute to . . . development of new careers, and overcoming sex-stereotyping in occupations traditional for the other sex" (Sec. 141d2). However, this is less forceful than CETAs mandate, and the Labor Department has not further articulated the topic of sex segregation in its regulations. The absence of strong affirmative action guidelines for local service delivery areas reduces the pressure on states and localities to innovate. Walker et al.'s (1984) study of early JTPA implementation plans found that most localities were expecting to operate programs of lower cost and shorter duration than those under CETA. Local officials said these changes were necessary to keep costs per participant down while enrolling the maximum number of participants, as JTPA requires. Given past experience with the intensive investments necessary to break down barriers for women in nontraditional jobs, these priorities of JTPA are unlikely to advance progress toward occupational integration.

RESEARCH ON PROGRAM IMPACT:
OLD APPROACHES AND NEW DIRECTIONS

Most research that is explicitly about women and federal job training policy deals with sex differences in access to program resources. The

whole scope of the problem, however, includes an evaluation of long-run improvement in women's labor market position and of reduction in sex inequalities between male and female participants. The basic question for evaluating the impact of programs is whether women are better off than they would be otherwise. How has past research answered this question?

Evaluation studies of job training programs, which appear in the economics literature, usually take individual earnings increases as the single indicator of program impact. Many of the recent studies measure the "net impact" of programs by comparing change in participants' preprogram and postprogram earnings to change in the earnings of nonparticipants with similar characteristics during the same period of time. This method of calculating impact separates the component of earnings change due solely to program participation from change that would have occurred anyway, even without the program.

The most reliable and carefully designed evaluations are consistent in showing that female participants in job training programs make statistically significant earnings gains of about $500 to $1300 per year relative to comparison groups of nonparticipant females (Goodfellow, 1979; Kiefer, 1979; Masters & Maynard, 1981; Westat, 1981; Congressional Budget Office [CBO], 1982; Bassi, 1983). Within this range, there is some disagreement about whether earnings gains were greater for minority women than for white women and whether OJT or classroom training produced greater gains. The CBO study, for example, found no significant differences in earnings gains between the two programs. (Bassi found that program effects on women's earnings differed by race.) However, all the studies that evaluate both men and women agree that female participants gained more compared to other females than male participants gained compared to male nonparticipants.

The earnings impact studies demonstrate that women do benefit from participation in job training programs. But from a sociological standpoint, these studies have three serious shortcomings. First, they fail to place earnings gain in a meaningful context of family or individual economic well-being. Second, average earnings gain is an inadequate indicator of labor market outcomes. Third, an earnings comparison between participants and nonparticipants is too limited to be the sole standard for assessing program benefits.

Let us consider first whether an increase of several hundred dollars per year in a woman's earnings is large enough to make a difference in family economic status. In the year after leaving CETA, the fiscal 1975 and 1976 female cohorts earned an average of $4300 (CBO, 1982, p. 27;

estimates based on the Continuous Longitudinal Manpower Survey and reported in 1980 dollars). Thus the average absolute level of female earnings was barely high enough to support a single individual at the official poverty line.

Because welfare recipients are a target population for enrollment in job training programs, it is important to consider the effect of earned income on welfare benefits. Evidently, there has not been much research on this topic. In a follow-up study of participants in job training programs prior to CETA, Goodfellow (1979) found that women lost transfer income after participation, which offset their gains in earnings. The loss or reduction of AFDC, and other benefits such as health insurance, child-care assistance, or foodstamps, could actually reduce the total income of participants and their families, even if a larger proportion of family income is earned. In order to arrive at meaningful substantive conclusions about women's economic status, the absolute level of postprogram earnings and the effect of earnings on the family's total income must be considered.

One should also consider whether earnings gain is a sufficient indicator of program impact. Job training programs can influence average postprogram outcomes in a variety of ways by increasing the number of people working and the number of hours worked, and causing greater employment stability, or higher wage rates. The extent to which each of these factors contributes to earnings gains in the postprogram period has implications for how program benefits are distributed among participants and for the quality of their employment.

In the comparison group studies, which focus on average earnings of participants and nonparticipants, it is easy to lose sight of the fact that a majority of CETA applicants were not employed when they entered training programs and that between one-half and one-third of the participants leave without employment (Harlan & Hackett, 1985). Thus although some women have higher earnings when they leave, others still earn nothing because they do not have jobs.

For participants who have jobs, do women's average earnings gains represent primarily an improvement in the quantity or the quality of employment? The CBO (1982, p. 21) study estimated that 78 percent of women's earnings gain was due to factors that increased the amount of time women were employed, whereas only 22 percent was due to increased wage rates. Increases in the amount of employment may mean that training programs help women to enter the labor force for the first time (or reenter after an absence), improve their ability to hold a job, or facilitate a shift from part-time to full-time employment. However, the

relatively small component of earnings gain due to rising wages suggests either that training may not upgrade women's job skills (CBO, 1982, p. xvii) or that the skills women acquire are not in high-paying occupations. One study speculates, "Perhaps what CETA does best is prepare participants for low-paying, entry level jobs. This preparation seems to represent an improvement in the labor market status of women" (Bassi, 1983, p. 549). Thus it is necessary to know much more about employment rates and stability, future wage increases, and advancement potential in these entry-level jobs in order fully to assess program impact.

Finally, let us consider whether women who do not participate in job training programs represent an adequate standard of comparison for female participants in the earnings impact studies. There are complex methodological aspects of this question that cannot be addressed within the scope of this chapter (see Bloch, 1979; Westat, 1977, 1981, for relevant discussions). Suffice it to say that the accuracy of earnings gain estimates derived from these studies depends upon strict comparability of the populations from which the participant and nonparticipant samples are selected. To the extent that female participants might be more capable, more motivated, more "work-oriented," or more desirable enrollees from an administrator's or employer's perspective, then the component of earnings gains due to program participation will be overstated relative to the comparison group (see Goodfellow, 1979; Kiefer, 1979; Gay & Borus, 1980, for assessments of female comparison groups).

More importantly, the focus on nonparticipant groups deflects attention away from relevant comparisons between categories of participants. For example, male participants have higher job placement rates, wages, and earnings than female participants in the postprogram period (CBO, 1982; Westat, 1981; Marcus, 1980), even though the training programs are not responsible for any significant earnings gain for men. Zornitsky and McNally (1980) point out that the sex differential in participants' earnings changed hardly at all between the pre- and post-CETA enrollment period (see also Simeral, 1978, on the Public Employment Program). Thus if we define program benefits for women as decreasing labor market inequalities between women and men, the training programs do not seem to be contributing to this goal. Neither do the participant/nonparticipant comparisons tell us if different treatments—types of training, occupations, supportive services—have lasting effects on inequality in labor market outcomes. Do

women from OJT programs or those few trained in nontraditional occupations get jobs with faster-rising wages or more employment stability than their counterparts in classroom programs and clerical occupations? Could the employment and earnings benefits be greater for women if they were distributed proportionately to white men in programs and occupations? From a policy standpoint, these are important questions that have not received much attention.

One study has compared the effects of CETA program assignments on participants' postprogram employment (Harlan & Hackett, 1985). We found that, overall, white men were more likely than women or black men to be employed immediately upon leaving CETA. White men who left CETA without a job also entered employment more rapidly than other sex/race groups. Their average spell of nonemployment lasted 6.2 months compared to 9.4 months for black men, 11.8 months for white women, and 16.4 months for black women.

Within each sex/race group, however, the type of training had a significant effect on the odds of immediate employment independent of differences in participants' backgrounds and labor force experience in the year prior to training. White women enrolled in OJT were almost 4 times as likely as those in classroom training to leave CETA with a job; black women in OJT were 2.4 times more likely than black women in classroom training to leave with a job. (The odds of immediate employment for OJT compared to classroom training were 3 times greater for white men and 1.7 times greater for black men.) OJT participants who left CETA without a job also found employment more quickly compared to others of the same sex and race. Overall, during the postprogram period of approximately three years, OJT participants had a higher probability of being employed than participants of the same sex and race in classroom programs. These results begin to examine the employment consequences of different types of training for women, but much more extensive analysis is needed about the relationship of program experience to job stability and job quality.

The question is whether the data and the resources for such research will be available. The trend in employment and training evaluation has been toward the use of large-scale longitudinal surveys that are nationally representative of participants, programs, and localities. The surveys are designed with the object of primarily answering one question: Earnings impact. This approach has produced higher-quality studies of a certain type, but it also limits the information and funds available for other research.

Data that would be needed to address other issues either are not included in the surveys or are of poor quality. Consequently, many valid questions about program outcomes have all but disappeared from the research agenda. The prodigious amount of resources required to develop and maintain massive national surveys reduces the funds available to study other issues. For example, the number of women in nontraditional blue-collar occupations in the national survey (Continuous Longitudinal Manpower Survey) is too small to perform comparative statistical analyses with women in traditional occupations. Yet directors of nontraditional training programs for women complain that they cannot get money to conduct follow-up studies of their participants. This leads to a more general issue that has far-reaching consequences for the quality of available data on job training programs. The broad scope of the large surveys prevents them from capturing the nuances and diversity in program strategies and local labor markets. Lacking the community and institutional context, analysts have no choice but to adopt a "black box" approach to comparing general program categories rather than analyzing specific internal differences among programs.

In light of these criticisms, what kinds of studies should be done in the future to determine if women (and men) benefit from participation in federal job training programs? Any consideration of the choices for new research directions should ask if it is worthwhile to invest in more studies of earnings impact. The principal contribution of each successive generation of studies has been to increase the precision of earnings estimates by improving the quality of nonparticipant comparison groups. But more precise, unbiased estimation techniques have not changed the basic conclusion of the research or made substantial new contributions to knowledge about individual and family economic well-being.[5] Therefore, I argue that the future research agenda ought to include support for a greater variety of topics, even if this must be at the expense of large-scale survey efforts.[6]

Future studies should consider the institutional contexts of the firms, schools, and other educational facilities in which participants are trained. We need studies not only of impact but of access: How are participants selected and assigned to programs? What are the characteristics of employers that hire women in jobs with opportunities for advancement? How do other employers keep women out? Studies of program impact should relate employment and earnings outcomes to the effects of occupational segregation and different training strategies.

More attention to occupational mobility, wage rates, and job quality in the postprogram period is needed. Finally, we should not insist that every study be nationally representative of participant characteristics and program strategies. Research on programs that prepare women for nontraditional jobs or that serve specific populations of women, such as minorities (blacks, Hispanics, or Asians) and teenage mothers, are especially important.

This is not an appeal to substitute more case studies of local program implementation for rigorous quantitative research on program impact. Instead, it is a challenge to link location-specific economic conditions, institutional arrangements, and characteristics of client populations to labor market outcomes, and to devise more imaginative and meaningful ways of measuring program benefits.

CONCLUSIONS

It is customary to conclude policy reviews with a list of specific recommendations for change. I do not believe, however, that such recommendations would serve a useful purpose at this moment in the development of federal job training policy. Past experience with CETA has shown how ephemeral these sorts of changes can be, even when the recommendations are enacted. The long, hard-fought battles over the 1978 CETA regulations, which resulted in substantial improvements for women (e.g., clauses pertaining to enrollment opportunities, occupational desegregation, affirmative action), were swept away in a single stroke by a change in legislation under a new administration with different priorities.

I have two concluding thoughts about women and job training policy. These reiterate the importance of my two themes—national policy priorities and local program control—in affecting women's participation.

First, opportunities for poor women in job training programs ultimately depend upon the enforcement of federal laws that guarantee equality of educational and employment opportunities in the institutions that operate these programs. This is because JTPA funds for training economically disadvantaged individuals are only a small part of the public and private resources that these institutions control. Although there are possibilities for JTPA programs to act as catalysts for change, these programs tend to reflect rather than to remove barriers to women's labor market equality with men. The entire infrastructure of

the training and employment system must be the object of efforts to eliminate discrimination against women because limited reform in a single program cannot prevent the reproduction of existing patterns of inequality. Based on past experiences with CETA, the systemic approach is a better way to achieve more permanent and extensive change.

It has been difficult, in the past, to focus public attention on equal opportunity efforts directed explicitly at women without a college education. Many of the celebrated media accounts of breaking down barriers in traditionally male jobs are about women in professional careers. Colleges, universities, and professional schools have been the target of public controversy over sex discrimination more often than vocational or technical schools. Invariably, corporate managers' ideas of affirmative action progress is to hire and promote women managers. Fewer corporate resources have been put into integrating nonprofessional jobs. However, in order to change the opportunity structure for poor women, and for other women without a college degree, researchers and policymakers must redouble their efforts to understand the structure of the training facilities and work places of these women.

The second conclusion is that local communities can play a more positive role in protecting women's interests in job training programs than has been previously recognized. The effects of decentralization have often been ignored or dismissed as being detrimental to women. But this analysis has tried to show that localities vary in their commitment to enrolling women and to suggest that a future research question should be why women fare better in some localities than others. In the current national political environment, states and localities may offer better prospects for achieving equal opportunity in job training programs.

After 10 years of experience with decentralization under CETA, grass-roots women's advocacy groups have developed considerable expertise in influencing policy. These advocates, as well as some women and men in state and local governments, are aware of the issues and will act on behalf of women's rights.[7]

States and communities also have a new responsibility in managing the involvement of the private sector in JTPA. The participation of local businesses in setting policy and operating training programs might become a stumbling block for enrolling women. But states and localities can help women capitalize on training strategies that attempt to forge closer ties between schools and employers. To do this, they should

monitor the enrollee selection process to see that it is in the social interest, not just for the convenience of employers. They should plan to give training subsidies to new and developing firms in which chances for achieving job integration are better than in industries with slow or declining employment. They should undertake evaluation research that does not simply replicate national earnings impact studies, but that complements them with new ideas about how to assess program benefits for women. The task of ensuring women's access to and equitable treatment in these programs will not be made easier by the lack of specific guidelines in JTPA. This means that states and communities have an even greater responsibility for meeting women's needs.

NOTES

1. The term "economically disadvantaged" applies to individuals or members of families who receive public assistance and to individuals or members of families who have a total family income that is either less than the poverty level set by the Office of Management and Budget or less than 70 percent of the lower living standard income level.

2. The programs discussed in this chapter are authorized under Title IIA of the Job Training Partnership Act and were formerly operated under Title IIB of the Comprehensive Employment and Training Act. These are training programs in which all economically disadvantaged youth and adults are eligible to participate. (JTPA allows up to 10 percent of all participants to be nondisadvantaged if they have encountered employment barriers.) JTPA authorizes smaller programs for specific groups of workers, for example, Title III Employment and Training Assistance for Dislocated Workers and Title IVB Job Corps.

3. Regulations issued by the U.S. Department of Labor pursuant to the 1978 reauthorization of CETA Titles I, II, VI, and VII are codified at 20 CFR (Code of Federal Regulations), Parts 675 through 679. I will cite only the numbered parts in the text. For JTPA, I will cite the relevant sections from the act itself (PL 97-300, 1982). The JTPA regulations are much less extensive than CETA's. In the preamble to the proposed JTPA regulations, the Labor Department states, "The Secretary believes that the Act is sufficiently clear and, therefore, requires only limited and selective interpretation via regulations" (Federal Register, January 18, 1983, p. 2292).

4. Under CETA, a substantial proportion of participants were enrolled in work experience programs that were temporary jobs, usually in public or nonprofit organizations. JTPA discourages the use of work experience by limiting the proportion of costs that the federal government will pay (Sec. 108b2).

5. To illustrate this point, suppose new studies showed that, instead of gaining an average of $500 to $1300 per year, women really gained twice that amount. In the rare event that the estimates did change this much, the improvement for poor women and their families would be slight and all the criticisms outlined above would still apply to these studies.

6. An anonymous reviewer suggested that it would be desirable to continue studies of employment and earnings outcomes that separate JTPA program effects from the effects

of participant characteristics and other sources of change. JTPA participants may have higher job placement rates and earnings than CETA participants. However, these results may not be due to the effectiveness of JTPA, but rather to the kind of people who are enrolled. If employers are permitted to select workers whom they would otherwise have trained with private dollars, leaving the most disadvantaged individuals without assistance, then the needs of the eligible female population will not be well served.

7. This statement is based on my observation of the implementation of JTPA in the state of Massachusetts. Some of the activities that focused on women during 1983-1984 were: (1) A state senator sponsored a heavily attended public hearing entitled "Focus Women: Job Training and Dislocated Workers;" (2) the Governor's Advisor on Women's Issues notified women's groups around the state about local PIC hearing dates; (3) the Executive Office of Economic Affairs established a Welfare Task Force to make recommendations on AFDC recipients and JTPA; and (4) the Massachusetts Law Reform Institute lobbied for passage of state legislation affecting women's rights under JTPA.

REFERENCES

Bassi, L. J. (1983). The effect of CETA on the postprogram earnings of participants. *Journal of Human Resources, 18*, 539-556.

Baumer, D. C., Van Horn, C. E., & Marvel, M. (1979). Explaining benefit distribution in CETA programs. *Journal of Human Resources, 14*, 171-196.

Berryman, S. E., Chow, W. E., & Bell, R. M. (1981, May). *CETA: Is it equitable for women?* Santa Monica, CA: Rand.

Bloch, F. E. (Ed.). (1979). *Research in labor economics: Evaluating manpower training programs.* Greenwich, CT: JAI.

Congressional Budget Office and National Commission for Employment Policy. (1982, July). *CETA training programs: Do they work for adults?* Washington, DC: Congressional Budget Office.

Deaux, K., & Ullman, J. C. (1983). *Women of steel: Female blue-collar workers in the basic steel industry.* New York: Praeger.

Gay, R. S., & Borus, M. E. (1980). Validating performance indicators for employment and training programs. *Journal of Human Resources, 15*, 29-48.

Goodfellow, G. P. (1979). Estimates of the benefits of training for four manpower training programs. In F. E. Bloch (Ed.), *Research in labor economics: Evaluating manpower training programs.* Greenwich, CT: JAI.

Harlan, S. L. (1979). *Participation of disadvantaged groups in employment and training programs (CETA) in New York and Pennsylvania.* Final Report, prepared for the Office of Research and Development, Employment and Training Administration, U.S. Department of Labor.

Harlan, S. L. (1981, Winter). The social context of employment choice: Women in CETA. *New England Sociologist*, p. 31-39.

Harlan, S. L., & Hackett, E. J. (1985). Federal job training programs and employment outcomes: Effects by sex and race of participants. *Population Research and Policy Review, 4.*

Heyns, B., & Bird, J. A. (1982). Recent trends in the higher education of women. In P. Perun (Ed.), *The undergraduate woman: Issues in educational equity.* Lexington, MA: Lexington Books.

Kiefer, N. M. (1979). The economic benefits from four government training programs. In F. E. Block (Ed.), *Research in labor economics: Evaluating manpower training programs.* Greenwich, CT: JAI.

Levitan, S. A., & Mangum, G. L. (Eds.). (1981). *The T in CETA: Local and national perspectives.* Kalamazoo, Michigan: W. E. Upjohn Institute for Employment Research.

Marcus, S. S. (1980). *Influencing termination success: An evaluation of Massachusetts CETA programs.* Policy and Evaluation Division, Massachusetts Department of Manpower Development.

Massachusetts, Executive Office of Economic Affairs, Welfare Task Force. (1984). *Proposed recommendations of the program strategies subcommittee.*

Masters, S. H., & Maynard, R. (1981, February). The impact of supported work on long-term recipients of AFDC Benefits. *Final report on the supported work evaluation* (Vol. 3). Manpower Demonstration Research Corporation.

Mirengoff, W., & Rindler, L. (1978). *CETA: Manpower programs under local control.* Washington, DC: National Academy of Sciences.

National Commission for Employment Policy (1980, September). *Conference on the Experience of Women in Employment and Training Programs.* Presentations by S. Gilbert (Wider Opportunities for Women), S. Carruthers (Better Jobs for Women), and B. Jacobus (Creative Employment Project). Washington, DC.

National Commission for Employment Policy. (1981, January). *Increasing the earnings of disadvantaged women.* Washington, DC.

National Congress of Neighborhood Women, National Organization for Women, New York City Chapter. (1979, November). *Administrative complaint against the city of New York before the U.S. Department of Labor, Employment and Training Administration.*

O'Farrell, B., & Harlan, S. L. (1984). Job integration strategies: Today's programs and tomorrow's needs. In B. F. Reskin (Ed.), *Sex segregation in the workplace: Trends, explanations, remedies.* Washington, DC: National Academy Press.

Perry, C. R., Anderson, B. E., Rowan, R. L., & Northrup, H. R. (1975). *The impact of government manpower programs.* Philadelphia: University of Pennsylvania Press.

Sexton, P. C. (1978). *Women and work.* R&D Monograph No. 46. Washington, DC: Employment Standards Administration, U.S. Department of Labor.

Simeral, M. H. (1978). The impact of the public employment program on sex-related wage differentials. *Industrial and Labor Relations Review, 31.* 509-519.

Smith, S. P. (1976). Government wage differentials by sex. *Journal of Human Resources, 11,* 185-199.

Steinberg, R., & Haignere, L. (1983). *New directions in equal employment policy: Training women for nontraditional occupations through CETA.* Albany: Center for Women in Government, State University of New York.

Underwood, L. A. (1979). *Women in federal employment and training programs.* Washington, DC: The Urban Institute.

U.S. Commission on Civil Rights. (1978, August). *Social indicators of equality for minorities and women.*

U.S. Commission on Civil Rights. (1979, July). *Women: Still in poverty.* Clearinghouse Publication No. 60.

U.S. Commission on Civil Rights. (1981, June). *Child care and equal opportunity for women.* Clearinghouse Publication No. 67.

U.S. Department of Commerce, Bureau of the Census. (1984, March). Characteristics of the population below the poverty level: 1982. In *Current Population Reports, Consumer Income,* Series P-60, No. 144. Washington, DC: Government Printing Office.

U.S. Department of Labor. (1981). *Employment and Training Report of the President.* Washington, DC: Government Printing Office.

U.S. Department of Labor, Bureau of Labor Statistics. (1980, October). *Perspectives on working women: A databook* (Bulletin 2080). Washington, DC: Government Printing Office.

U.S. Department of Labor, Bureau of Labor Statistics. (1983, December). *Handbook of labor Statistics* (Bulletin 2175). Washington, DC: Government Printing Office.

U.S. Department of Labor, Office of Policy Planning and Research. (1965, March). *The Negro family: The case for national action.*

U.S. Department of Labor, Office of the Secretary. (1981, January). *Final determination: National Congress of Neighborhood Women et al. v. The City of New York.*

Waite, L. J., & Berryman, S. E. (1984). Occupational desegregation in CETA programs. In B. F. Reskin (Ed.), *Sex segregation in the workplace: Trends, explanations, remedies.* Washington, DC: National Academy Press.

Walker, G., Grinker, W., Seessel, T., Smith, R. C., & Cama, V. (1984). *An independent sector assessment of the Job Training Partnership Act, Phase I: The initial transition.* MDC, Inc.

Westat, Inc. (1977, March). *Continuous longitudinal manpower survey: Methodology.* Technical Report No. 1. Rockville, MD.

Westat, Inc. (1981, March). *Impact on 1977 earnings of new FY 1976 CETA enrollees in selected program activities.* Net Impact Report No. 1. Rockville, MD.

Women's Technical Institute. (1981). *Annual Report.* Boston, MA.

Zornitsky, J., & McNally, M. (1980, September). *Measuring the effects of CETA on women: Issues in assessing program performance.* Conference on the experience of women in federal employment and training programs, National Commission for Employment Policy. Washington, DC.

ABOUT THE AUTHORS

FRANCINE D. BLAU is Professor of Economics and Professor of Labor and Industrial Relations at the University of Illinois, Urbana-Champaign. Within the field of labor economics she has been particularly interested in studying the problem of labor market discrimination and the economic behavior of women. She is the author of *Equal Pay in the Office* and has contributed extensively to professional journals and collections of essays. With Marianne A. Ferber she is author of the forthcoming *Economics of Women, Men, and Work*.

FAYE CROSBY received her Ph.D. in Social Psychology at Boston University in 1976. She is the author of numerous articles and a book entitled *Relative Deprivation and Working Women*, published by Oxford University Press (1982). She is currently an Associate Professor of Psychology at Yale University.

CAROLYN R. DEXTER received her Ph.D. in Sociology from Columbia University in 1967. She has directed research at John Hancock, Girl Scouts U.S.A., and at Columbia University in the Bureau of Applied Social Research. She is an Associate Professor of Management and Marketing at Pennsylvania State University-Capitol Campus and is acting head of the division of business administration. Her research interests are in the interface of work and family. She is presently writing a monograph on the employment experience of the first post-World War II generations.

MARIANNE A. FERBER is Professor of Economics at the University of Illinois, Urbana-Champaign. She was Director of Women's Studies at the same institution during 1980-1983. Within the broad field of the economic status of women she has been concentrating particularly on the standing of women in academia, the family as an economic unit, and international comparisons in the position of women. She has published extensively in professional journals. With Francine D. Blau she is author of the forthcoming *Economics of Women, Men, and Work*.

SHARON L. HARLAN is affiliated with the Center for Social and Demographic Analysis, State University of New York at Albany. She holds a Ph.D. in Sociology from Cornell University. Her recent research is about job mobility in organizations, sex segregation in blue-collar occupations, and the employment problems of disadvantaged workers.

JERRY A. JACOBS received his Ph.D. in Sociology from Harvard University in 1983. He is an Assistant Professor of Sociology at the University of Pennsylvania. His current research is in the area of the sex segregation of occupations and women's career patterns.

WILLIAM A. KAHN is a doctoral student in the psychology department at Yale University. His major research interests concern organizational change. He has published articles in this area and in the area of humor.

ALICE KESSLER-HARRIS is Professor of History at Hofstra University where she also codirects the Center for the Study of Work and Leisure. She is the author of *Out to Work: A History of Wage-Earning Women in the U.S.* (Oxford) and of *Women Have Always Worked* (Feminist Press), as well as the numerous articles in scholarly and popular journals. She is currently exploring the culture of women at work in the 1920s and 1930s.

JANICE FANNING MADDEN received her Ph.D. in Economics from Duke University. She is currently an Associate Professor in Regional Science at the University of Pennsylvania. Her current areas of research are women in the labor market and the labor markets in declining areas.

VERONICA F. NIEVA is Director of Organizational and Marketing Research at WESTAT, a private, employee-owned research company in the Washington, D.C., metropolitan area. She is an organizational psychologist with a Ph.D. from the University of Michigan. Her research is concentrated on various aspects of organizational effectiveness and working women.

JUNE O'NEILL is Senior Research Associate and Director of the Program of Policy Research on Women and Families at the Urban Institute. Her current research areas include economic issues related to the employment and income of women; higher education finance; determinants of child support; and the tax treatment of the family. She has served as the Chief of the Human Resources Cost Estimates Unit of the Congressional Budget Office (1976-1979) and as a member of the Senior Staff of the President's Council of Economic Advisers (1971-1976). She participated in the formation of a working party to study economic policy issues concerning women at the Organization for Economic Cooperation and Development (OECD) and headed the U.S. delegation to the working party. Prior to her government experience, O'Neill was a Research Associate at The Brookings Institution (1968-1971) where she authored two books on the economics of higher education; she also taught at Temple University (1975-1968). She received her Ph.D. in economics from Columbia University.

DONNA M. RANDALL received her Ph.D. in Sociology from Washington State University in 1982; her MBA in 1984. She is currently an Assistant Professor in the Department of Management Systems at Washington State University. Her research interests include white-collar and corporate crime. She is currently studying the impact of the media on the corporate image.

JAMES E. ROSENBAUM is an Associate Professor of Sociology and Education at Northwestern University. Previously he was an Associate Professor of Sociology at Yale University. His work focuses on institutional mechanisms within organizations that affect employees' career attainments and compensation. He has just completed a book on this to be published by Academic Press and is extending this work in a project funded by the Russell Sage Foundation. He received a B.A. from Yale University and M.A. and Ph.D. degrees from the Department of Social Relations at Harvard University.